BECOMING FORREST

ONE MAN'S EPIC RUN ACROSS AMERICA

ROB POPE

Harper
North

HarperNorth
111 Piccadilly,
Manchester, M1 2HY

A division of
HarperCollins*Publishers*
1 London Bridge Street
London SE1 9GF

www.harpercollins.co.uk

HarperCollins*Publishers*
1st Floor, Watermarque Building, Ringsend Road
Dublin 4, Ireland

First published by HarperNorth in 2021

3 5 7 9 10 8 6 4 2

Copyright © Rob Pope 2021

Rob Pope asserts the moral right to
be identified as the author of this work

A catalogue record for this book
is available from the British Library

HB ISBN: 978-0-00-847251-1
TPB ISBN: 978-0-00-847252-8

Printed and bound in the UK using 100%
renewable electricity at CPI Group (UK) Ltd

MIX
Paper from
responsible sources
FSC
www.fsc.org FSC™ C007454

This book is produced from independently certified FSC™ paper
to ensure responsible forest management.

For more information visit: www.harpercollins.co.uk/green

To my mum, Nadine and Bee.
You made the difference.

BECOMING
FORREST

The route

Marshall Point Lighthouse, ME

Beaufort, SC

START, Mobile Alabama.

5th leg

4th leg

3rd leg

2nd leg

1st leg

END, Pretty Tired Now
Monument Valley, UT

Santa Monica Pier, CA

San Francisco, CA

Key:

1st Leg
AL, MS, LA, TX, NM, AZ, CA
2,259.45 miles

2nd Leg
CA, NV, AZ, NM, TX, OK, AR, TN, VA, Washington DC, MD, DE,
PA, NJ, Boston Marathon, NY, CT, MA, NH, ME
3,759.3 miles

3rd Leg
ME, NY, PA, OH, MI, IN, IL, WI, MN, ND, MT, ID, WA, OR, CA
4,163.05 miles

4th Leg
CA, NV, UT, WY, CO, NE, KS, MO, IL, KY, TN, NC, SC
3,140.77 miles

5th Leg
SC, GA, AL, MS, AR, OK, TX, NM, AZ, UT
2,266.9 miles

CONTENTS

LEG 1

15 September–30 November 2016

1:	Time to Roll (Tide)	3
2:	Mississippin'	13
3:	Things Ain't So (Big) Easy	19
4:	The Big One	27
5:	From Green to Yellow	36
6:	I Walk the Line	49
7:	Welcome to the Wild West	55
8:	California Dreamin'	65

LEG 2

13 January–28 April 2017

9:	No Easy Way Out	79
10:	Getting Lucky	88
11:	Arizona Sunsets Will Get You Every Time	91
12:	The New Mex Files	101
13:	TX2	109
14:	Sooner Than You'd Think	115
15:	Hope Springs Eternal	119

16: A Change Is Gonna Come 127
17: Going Pramsolo 134
18: Mostly Sweet Virginia 150
19: Meeting George and Mary, While Sampling
 Dela's Wares 159
20: The Gritty Cities 164
21: Boston Strong 171
22: An Apple a Day 178
23: A New England 183
24: The Maine Event 187

LEG 3

29 April–30 September 2017

25: Becoming a Tripod 195
26: How I Learned to Stop Worrying and
 Love Brussels Sprouts 201
27: The Flattest of Rollercoasters 209
28: The Oceans Between the Waves 213
29: If You Leave Me Now 218
30: One Vision 225
31: Too Kwik a Trip 229
32: Highway 61 Revisited 234
33: Us 237
34: Far-go 245
35: Big Skies 250
36: Bigger Skies 257
37: Sunshine on Leith 263
38: Burning 269
39: The Prefontaine Pilgrimage 274

LEG 4

1 October–17 December 2017

40: Inspiration Point 285

41: Only the Lonely 289

42: Utah Saints 297

43: Wynter is Coming 301

44: All Downhill from Here 307

45: The Center of the Universe 312

46: Breaking Point 318

47: You Can Go Your Own Way 325

48: Back to Where I Belonged 330

49: Summit to Sea 335

LEG 5

5 January–29 April 2018

50: Re-becoming Forrest 343

51: One. Last. Push. 348

52: Peaches and Screams 353

53: Sweet Home Alabama 359

54: Keep Moving Forward 366

55: A Return to Hope 371

56: Getting My Kicks 375

57: Panhandlin' 384

58: From the Bottom Up 389

59: A Line in the Sand 396

The Most Beautiful Thing I've Ever Seen 401

60: I'm Pretty Tired. I Think I'll Go Home Now. 405

Becoming Forest: Fascinating (I Hope) Facts and Stats 417

Acknowledgements 419

LEG 1

15 September – 30 November 2016

Alabama, Mississippi, Louisiana, Texas,
New Mexico, Arizona, California

2,259.45 miles

Chapter 1

TIME TO ROLL (TIDE)

Alabama

Days 1–3

49.04 miles

Roadkill count: 7 (3 armadillos, 2 possums
and 2 raccoons)
Chased-by-a-dog count: 1 (Chihuahua)
Enquiries after my sanity: 1
Encounters with potentially life-
threatening spiders: 1

'What would you like?' the barber asked. I've always found it a strangely intimidating question – today even more so. I'd been waiting an hour before sitting in his chair and had watched him meticulously groom a procession of locals with clippers and a flashing cut-throat. Tentatively, I produced a photo of Tom Hanks. Or more to the point, a photo of his hair 'do' from the film *Forrest Gump*. To help, I also quoted a number at him from the menu of styles pinned to the door. 'Like number 24, please.'

He looked at me with a raised eyebrow. 'You wan' a *high an' tight*?'

'Yep. Yes, please.'

'Are you *kidding me, man?*'

It seemed only polite to explain why a veterinarian from Liverpool had travelled all the way to Fluke's Barbers on North Broad Street in Mobile, Alabama on the morning of Thursday 15 September 2016. Before my journey was through I'd get very used to telling this story.

'I'm recreating the Forrest Gump run.'

'From the *movie?*'

'Yeah. I'm going to run from here to Santa Monica in California.'

Forrest made five crossings in total, and someone has calculated that this was a distance of 15,248 miles all told, apparently, for 'no particular reason'. A number of athletes had already made a single crossing, but as far as I knew nobody had ever done five. People had written articles about whether it was even possible. I wasn't sure, but I wanted to be the guy who tried. That said, I'd only mentioned the possibility of doing five crossings to one person: my girlfriend Nadine (aka Nads). That much running seemed like a pipe dream, so the official version was that I'd try one crossing and take it from there.

The barber was incredulous, even about one crossing. 'That's a long way …' He couldn't suppress his grin. 'You done this kind of thing before?'

I shrugged. 'Not exactly. A few marathons and one ultra-marathon.'

He nodded. 'An' how far have you got?'

I was bursting with excitement. 'This is day one. A local news station is filming the start. So I wanted to look the part.'

'Well, good luck to yer, man!' he said, chuckling to himself as the first locks drifted to the floor while everyone in the shop cast sideways glances.

Forty minutes later, I was fit for the US Marine Corps – in looks, at least – and I spent the next few hours enjoying the

novelty of touching the back of my newly shorn head and my face. Several blocks away, the WKRG local news team were waiting for me. It was time to begin.

I've always had a vivid imagination. Maybe it's the lot of a single child, or maybe it's just the way my brain works, but I always knew it might get me into trouble someday. I got into running at an early age. I was already a marathon veteran by the time I got my PhD in Veterinary Medicine in 2010. I relocated to Melbourne, Australia, where I came 10th overall in the IAAF gold-rated 2015 Sydney Marathon, which qualified me for the Rio Olympics and made me Australian champion to boot. For various reasons, which centred around my not *really* being fast enough, I wouldn't go to Rio, but a year later everything in my life fell into place for me to fly to the US to attempt the impossible.

So, of all the running stories I might have chosen to emulate, why Forrest Gump's? Well, if you're a runner who's had the pleasure of passing a gang of youths or a bar, especially if you have long hair and, God forbid, a beard, I'd be willing to bet you've heard the shouts of 'Run, Forrest, Run!' His assimilation into the perception of the world of running, despite his distinguished military career and stint as a top-level ping-pong player, is so complete that anyone who undertakes a challenge more than a few marathons long seems to be labelled as the '[*insert adjective or nationality here*] Forrest Gump'.

I was thirty-eight when I started – the same age as Tom Hanks when he filmed the movie – and while that's not young for an athlete, it's not a terrible age to attempt a long-distance run. And America had always represented magic and excitement to me. It was a country of music and film legends, of stories and adventure. Whether it was Bob Dylan, Bruce Springsteen or even a non-American singing about a place where the streets were

nameless, I'd been inspired to dream of running through the Nevada Desert, the Joshua Tree National Park and Chicago, across the Mississippi, past Atlantic Records, Graceland and the Big Rock Candy Mountain.

I spent endless hours poring over previous crossings and possible routes, studying the weather in different states at different times of the year, wondering whether I could actually hack it. Forrest says in the movie that he ran for three years, two months, fourteen days and sixteen hours. Many commentators have argued that his achievement was not physically possible, that the human body could simply not withstand the daily grind of running such distances for so long. Then, one day, I came across a book by a British chap named Nick Baldock, who had run from San Francisco to New York in 1999. He described the epic scale and beauty of the country in a way that utterly captivated me. I was hooked.

I emailed him ten years after his feat, in May 2009, with the subject field 'Forrest Gump 2', and he replied with some advice.

Funding was (apart from the running itself) the single biggest challenge. I gave myself a good 12–14 months to prepare both financially and fitness wise. You no doubt are younger and fitter so that may not be the case with you. Rob, it is a wonderful thing to do. I could never tell you just how hard it was. But equally it was truly a life-changing experience for 132 days for me. THE best way to see America.

Duly inspired but duly warned, Nadine and I worked our butts off in the veterinary surgery, pooling together enough savings to keep us going for as long as possible. In terms of the physical preparation, I knew I was a half-decent runner, but this was the

complete unknown. I couldn't even call myself a true ultrarunner – the title reserved for those who had gone beyond the marathon distance – but a couple of months before I was due to depart for the Forrest run I entered the Runstock Ultra with a friend from Australia, Flynn Hargreaves. I clocked up seventy-five kilometres, or forty-seven miles in old money, and while it wasn't exactly a breeze, it did feel 'doable'.

I ran for the WWF (World Wide Fund for Nature) in that event. As a keen animal lover, the WWF have always had a place in my heart, and I decided to fundraise for them during the Forrest Gump run too. I would also be running for Peace Direct, a charity dedicated to stopping war and building lasting peace in some of the world's most fragile countries. And if these organisations weren't enough, there was one other source of inspiration for me, perhaps the most important and fundamental of all. My 'momma', as Forrest would say. My mum, Cathy Pope, was a medical laboratory scientific officer and a hard-working single mother. She was my rock and my best friend. She was only too pleased I had also chosen a scientific career, and as a passionate supporter of my running she took me to my races and marathons and even to the 1997 New York Marathon. She was diagnosed with cancer, but that didn't stop her enrolling at university to study law, and she was top of her class before she became too ill to continue. If I'd inherited even a fraction of her grit, I knew I'd be okay.

While she was sick, she had made me promise one thing to her: 'Do one thing in your life that makes a difference.' That promise has stuck with me since then, and it has become a part of everything I hope to achieve. She passed away in 2002. She is my inspiration, my frustration, my warrior queen, my support-crew leader. I still miss her now.

* * *

And so, for these particular reasons, on Thursday 15 September I stepped out of Fluke's Barbers and decided to go for a little run. Gump movie fans will of course know that he is from Greenbow, Alabama, where he was raised dutifully by his momma and where he would meet Jenny, the love of his life. From there he would take the first steps on what turned out to be a remarkable journey. The problem was that Greenbow does not exist and never has. The Gump family home was even built especially for the film and no longer stands in its South Carolina location, so I couldn't even bend the narrative and start from there. The book on which the film was based, however, was by Mobile native Winston Groom, and so it came to pass that Forrest's and therefore my story began there too.

I was in full Gump paraphernalia – chinos, check shirt, a pristine new pair of white Nike Cortez – and sitting in a chair out front of the Bragg-Mitchell mansion, a grand Greek Revival plantation house on the outskirts of the city and the closest thing I could find to the now razed Gump boarding house in the district. I put on my red Bubba Gump Shrimp Co. cap, rose slowly and broke into a walk, then a jog, then a run …

I ran to the end of the road, and when I got there I thought maybe I'd run to the end of town. On reaching a fork in the road, I decided to go right rather than left and got a bit lost. It wouldn't be my first wrong turn. Hot, humid night had fallen like a stone over the Mobile skyline and I was running blind. I headed over to the parking lot of a Family Dollar store and tapped on the window of a lady sitting in her car. She lowered her window around half an inch, looking completely petrified behind the glass – but she thankfully pointed me in the right direction.

Of course, I was yet to adjust to the life of a guy who just eats, runs and sleeps, so when I finally caught up with her, Nadine was hugely relieved to see me again. She'd been on the verge of filing

a missing person's report with the police. We went out to a little place called the OK Bicycle Shop, where no bicycles were available for sale or rent, but the beer was good and the proprietors, Jim and Woody, bought into the idea of the run. They promised me they'd get in touch with Winston Groom (may he sadly, now, rest in peace) and I told them I'd be back soon as I headed out of the door unsteadily enough to suggest I'd run a lot further than the five miles I'd covered that evening. As is the way of many a bar room conversation, neither of these things ever happened, but we were all richer for the thought.

We indulged in a comfortable night in the Malaga Inn, a last little touch of luxury that I felt Nadine deserved after the previous few days in America getting ready for this and the months of turmoil before. We weren't going to be able to get into a proper rhythm until we had the RV, which we were picking up in Houston, Texas, so in the meantime we were making do with motels and car hire. I lay in bed staring at the ceiling, listening to the distant sounds of the city winding down. I was convincing myself that it would all be fine and that we'd get to Bayou la Batre, a marathon or so from downtown Mobile, by the close of play the next day.

Waking up in the morning, it felt like the real deal. I'd woken up in countless hotels and friends' houses over the years prior to a big race, and this had the same buzz about it. Wearing slightly more suitable attire than the previous day's outfit, which was barely dry after being soaked in sweat the evening before, I stepped into the morning. In Liverpool parlance, the sun was cracking the flags as I took a deep breath and began the journey. I passed some antebellum houses and some street art telling me to 'Get the Party Started' on the way to Highway 90.

It was already 30°C by 11 a.m. and starting to feel pretty oppressive under rapidly greying skies. The heavens ruptured in

a deluge, ensuring that within minutes of getting the party started I was running through a two-inch deep urban torrent. This was my lot for the rest of the day, though it was a novel feeling to be running in rain that felt like a hot shower. I prematurely called it quits at a gas station at the intersection for Bayou la Batre and managed to watch Liverpool win their 'soccer' match against Chelsea over a pint of Fat Tyre pale ale and a gallon of lemonade to wash down the first of my mega meals on the run.

Bayou la Batre was a twenty-mile detour that I vowed to avoid making a habit of, but I'd have felt a betrayal of Bubba, Forrest's best good friend (played by Mykelti Williamson in the movie), who hailed from the town, not to have gone to pay my respects. Forrest would have wanted it that way. Staring down the cypress-lined Padgett Switch Road on my approach the next day, I pressed play on the most appropriate music for the time and place. Only Creedence Clearwater Revival would do.

I ran past a Portaloo with a 'Gotta Go' slogan embossed on the side, and as Forrest said, when he needed to go ... he went. So I did. Approaching the bay, I ran past a lot of shrimping boats in the final mile or two and watched a few head out into the Gulf of Mexico beyond. I got in (well, paddled) and took a sample of water, which I hoped to mix with some water from the Pacific if I got there and tick 'trans-continental run' off the list.

I reached the water's edge to find that Nads and her camera had already located the local wildlife, with pelicans kamikaze-diving into the bay and hermit crabs hiding if you got too close, only to re-emerge about ten seconds later to check that you'd left them to their business. I'd have laid low a little longer, personally.

Nadine and I stood silently, taking it all in, before I set off on a short run back to town to rendezvous with Nadine at the Waffle House. By this stage I was hot and bothered and a bit shaky, which was likely a touch of heatstroke.

Waffle House was a chain of restaurants whose calorific, tasty and inexpensive food would serve me well on this trip. The staff were lovely, and our server, Leigh, in particular, was fascinated by it all and gave us ten dollars for the WWF because, as she put it, she 'LOVES her animals!' This was the first of many acts of kindness I was to experience across the country, and my heat stress, helped by the wonderful air-con, had miraculously vanished.

I got about 1,500 calories in, in the form of hash browns covered in chilli, a burger and four refills of Coke. I was trying to get a full marathon on the board today, knowing I'd need to start covering more distance if I was going to make Santa Monica in seventy-five or so days. I set off a bit quickly, my heavy, fizzy stomach felt rough for the next five miles and was probably instrumental in the lack of concentration that led to my missing my scheduled turning and ending up not too far from where I'd started. An extra four or five miles hurts that late in the day. Wayfaring missteps were already becoming a worrying habit and I was in a stinker of a mood. I very nearly packed it in for the day, but finally decided to push on.

I reached a town called St Elmo, where I could see the first of the huge water towers that had perhaps lain dormant since the 1938 *War of the Worlds* radio broadcast. They'd be signposting my way for the whole route and, as I made this my first full marathon day, I finished feeling victorious. We headed out for a Mexican to celebrate and, walking down the parade of shops on the way, I spied a display of Trump and Clinton Halloween masks. I thought about getting a couple to run in, but something told me that was a bad idea. There was an election on the horizon, and I wasn't sure if my sense of humour was quite in tune with the mood of the country.

* * *

I kicked off day four wearing my Victoria vest, last worn in the Australian Marathon Championships. But in truth most of my kit choices were fleeting because at each rest break I would change into fresh clothes and throw my sodden gear into a bag. I could have filled a pint glass when I wrung them out first.

A few miles down the road, I had to go (again) ... so I went. I crept through a gap in the trees and a spider web lightly brushed my face. Having gained valuable front-line experience in Australia, I instantly stopped and checked to see what the situation was. A tiny spider on a big web seemed a bit strange, but ... *wait a minute!* An absolute behemoth with pointy, yellow-striped legs was the main breadwinner here and was making a beeline towards me. I was out of there fast. When I looked into it later, I learned that this was a female black and yellow garden spider, which might not sound too scary, but you weren't there. Its bite is akin to a nasty wasp sting and if you see a picture of one – you'll know, man.

Today was a big day, as we were making our first State line crossing, with the strains of 'Ultraviolet (Light My Way)' by U2 coming through my earphones as the UV beat down heavily from above. I'd done it. I'd run 'cross the Great State of Alabama, just like Forrest. Like the man himself, though, we had more to do. I was having a lot of trouble regulating my pace. I typically run easy around 6.45 minutes per mile and jog at around 7.30, but a number of experienced runners had advised me this was just too fast to sustain over trans-continental distances. Often I'd average under seven minutes for my early stints and struggle later in the day, so I would need to mellow out to eight minutes per mile or even slower paces when I took on Mississippi.

Chapter 2

MISSISSIPPIN'

Mississippi
Days 4–6
86.38 miles

Roadkill count: 1 snake, 1 alligator. Too many
other animals
Blisters: 1 (a whopper on the ball of my left foot)

Highway 90, as it entered Mississippi, was super straight, and
there wasn't much in the way to see beyond the trees lining the
road, so I occupied myself by seeing who'd wave back if I waved
at them. Occasionally, I'd get an enthusiastic reaction or a double
honk on the horn, which would set off a Mexican wave of
acknowledgement down the queue of traffic. The South seemed
to be showing its renowned sunny side. I passed a gator ranch
and a scrapyard that had a rusting 1950s Cadillac straight outta
Havana for a centrepiece. 'I'll come back for you!' I shouted as I
ran by.

I went out on my last five miles at 7 p.m. I knew it got dark
quickly round here, but outside of the Gautier city limits it got
very dark indeed. Luckily, the hard shoulder was wide and I only
got beeped once, which was fair enough, seeing as I had no

reflective kit or lights on. I also didn't need the daylight to help me avoid the roadkill – I could smell it a mile off.

I reached my end point for the day and spotted a worried-looking Nadine, peering into the gloom at a Dollar General. I crossed the central reservation, which turned out to be a genuine swamp underfoot, and instantly sunk to mid-calf level. We headed back to the motel in Gautier with my lovely new Nikes covered in stinking mud to find the key didn't work and that the maintenance guy would be there in half an hour to fix it. Ninety minutes later, we were in to our cheap room, which reeked of cigarettes and damp and only had one pillow. My time in Mississippi had got off to an average start, to say the least.

The next morning, I was still working out whether the first run of the day was meant to be getting so much harder. Where was my limit? How sore would I get? It was probably as hard as the business end of marathon training. As I got to the third mile of each day, the initial novelty of running again would begin to wear off and my motivation would start plummeting, so I was trying out different strategies.

Today, I decided to try two initial runs of eight miles, with smaller ones afterwards, which might have been a good idea if I'd started at 6 a.m. rather than 9. It was baking hot already at that time in the morning and crossing the bridge into Biloxi was an ordeal, despite the procession over a pedestrian-friendly, mile-long viewing gallery over Biloxi Bay. Or at least it was until I met a seventy-one-year-old member of the Gulf Coast Running Club named Art (I think that's what he said – I was still getting used to the Southern drawl), who had a stellar marathon record of his own and was trying to get back up to speed again. He was very interested in the charities I was running for and made me feel so pumped for the run and life in general that it made me hope I'd be running over the Biloxi Bay Bridge in thirty-plus years' time.

Biloxi is the Vegas of the Deep South. There was a Bubba Gump Shrimp Co. restaurant at the Golden Nugget Casino. Though it was too early to sample their wares, we got talking to the staff and learned about the Gary Sinise Foundation and its work. Gary Sinise, of course, played Lieutenant Dan in the *Forrest Gump* film. When Dan returned home from Vietnam, he was disabled and down on his luck, badly let down by the system. Regardless of your opinion on the various military interventions going on around the world, it is impossible to ignore the fact that a lot of brave young men and women put their lives on the line for something they believed was right (it certainly wasn't for the money), and a large number of them were failed by the authorities at the end of their service. Many were left with physical and mental scars as a result of what they'd seen.

I'd passed the Mississippi Vietnam memorial a few miles earlier and took some time to walk around it. So many of the dead would have been enlisted men, guys like Bubba and Forrest, who didn't know what they were getting into. The Gary Sinise Foundation is trying to help however they can, and as part of their association with the Bubba Gump company, you could buy cardboard beard masks with the phrase 'I Just Felt Like Running' on. This was probably a safer bet than the Hillary or Donald masks I'd been thinking of sporting.

Thoroughly cooled down, as only a period in an icy-cold casino environment can do, I trundled off again, just to be dripping wet with perspiration again within five minutes. My running shoes audibly squelched as I slapped rubber on asphalt. I worked out that I needed about 150–200 millilitres of water per mile on the run. I'd worked up to 30-mile days now, so with my increased metabolic demands I was probably putting away ten to twelve litres daily and getting through five or so kit changes.

I ran along the Biloxi seafront with the huge casinos of the Gulf Vegas calling to me with offers of untold riches and the pure white sands with parasols that screamed at me to come on over. I nearly listened. The mercury was topping 41°C (108°F) in the sun, so I resolved to do shorter runs.

I'd made contact with the Gulf Coast Running Club and Molly, one of their members, came out to run the last few miles with me as an amazing sunset started to form on our left, with the grand old mansions of Gulfport on our right providing a contrast to the new money of Biloxi. Molly was preparing for an ultra in Florida and, despite being well accustomed to the climate here, she said that the heat in the last few days had been worse than usual. She waved her goodbyes as she carried on her run and left Nadine and me to enjoy the sunset where the sea just seemed to blend into the beach as if it was liquid sand.

We'd recently seen our first roadkill snake, which was about three feet long, midnight black and had a fat head, but soon enough I topped that with what initially appeared to be another in the long line of mammalian skeletons that lined the road. But when I got closer I could see it was an alligator's – around six feet in length. Only in America. I briefly contemplated taking some sort of tooth or bone as a memento, but a weird feeling came over me as a flock of ibis suddenly scattered in the distance towards the tall cypress trees. Deep in hoodoo country, I thought better of it.

A continued lack of good refuelling stops ensured that the last few miles were a real ordeal, with the first real doubts about my ability to string big distances together making their presence felt as I crossed some beautiful bayous. The sky was mirrored in the black water, with untold numbers of things that would take your leg off hiding below the surface. It was up to me to focus on moving forward and not sinking into the depths.

My final run of a short but brutally hot day was extended, because it seemed rather silly not to add 0.7 miles on to cross into our third state. Armed with my GoPro, I ran over one of those classic American girder bridges with no sidewalk and into Louisiana – the Sportsman's Paradise, which would suit me fine.

The next day would see a pause in the running schedule, as we had a seven-hour Megabus trip to Houston to pick up the RV and hot foot it back to my finishing point on the Louisiana line to continue the journey proper.

At the start of this trip, a week before we started the run proper, Nadine and I had landed in Houston, Texas, late on a humid day and dragged far too many bags on the bus, meeting a particularly unhelpful driver on the way, which brought to mind Forrest's first day on the school bus. That driver was hardly a barrel of laughs, either.

Our first port of call had been a large RV dealer. I'd done my reading and found a few suitable candidates for a support vehicle, with the main criteria being cheap and big. Nads and I would both need our space on this adventure, and it would be good to spare her the smell from my feet from time to time. Agonising over an incredible 1983 Chevy Foretravel that made me want to grow my sideburns long, don vintage Ray Bans and brown check trousers and then head off on a Hunter S. Thompson-esque voyage of discovery, I snapped back into reality on seeing a thirty-foot Fleetwood Jamboree with room for six, a separate shower and toilet, and black-out windows. We made the acquaintance of salesman Randy Lane – his real name, and the huge moustache he sported was also very real and very Texan.

'So, who's going to take the test drive?' he drawled.

I looked at Nadine with guilty eyes, as we'd hoped for big but not this big, and we'd be heading almost instantly onto one of

the country's biggest road systems, driving a six-wheeled cruise liner with the kind of turning circle you'd expect, on the wrong side of the road. I'd be doing the running, but it was Nadine who'd need to get around in the RV.

As we headed to Texas again, Randy Lane awaited with the keys to the mothership. As nautical lore dictates, it's bad luck to have a boat and not give her a name. I'd never named a boat before, but there was only one I could think of.

We named her Jenny. Jenny Jamboree.

Chapter 3

THINGS AIN'T SO (BIG) EASY

Louisiana
Days 7–14
293.19 miles

New roadkill species: 1 otter
Blisters: Now on both feet, covering about a third
of the contact area
Choice fuel: Dr Pepper (Forrest's favourite drink)

The dull drag back from Houston did at least have the highlight of driving over a 23-mile-long bridge across Lake Pontchartrain. Flat-earthers would be petrified: if ever there was a conveyor belt to oblivion, it would look like this. New Orleans eventually appeared, and we got back to the Mississippi–Louisiana state border as the sun was already going down. This is one of my favourite times of the day to run, though by now the hoped-for 20 miles was completely off the table. I set off into a sunset over the Pearl River Wildlife Management Area, across bridges and bayous. I was sorely tempted to call Nadine back for the night tour, but I had to keep moving, so on I plodded into the night, using my LEDs for the first time, eyes peeled for the gators I'd been told were in great numbers in these parts.

We'd arranged to rendezvous at a bar called Crazy Al's, which, according to Street View, didn't seem to exist. It turned out that Hurricane Katrina had had something to say about that, and a newly rebuilt version blinked 'Open' in neon tones. This was a proper Southern bar – like *Cheers* but with a Cajun brogue. The cast inside included a Brazilian bait shop owner; Captain Kirk (his real name), the local fire chief, pizza guy *and* reporter with his crew; a Harley-riding biker who freely confessed his plan to kidnap Nads; and last, but not least, the owners, Donna and Art, two karaoke-singing Trojans.

Parking at the side of Highway 90 meant a fitful rest, and the local bird species got me out of bed for an 8 a.m. start. After yesterday's long ride to Houston and back, today was about making progress. I ran through the Bayou Sauvage National Wildlife Refuge, emerging through a massive levee barrier with a STOP sign so large that the thought of it being called into action made me feel decidedly uneasy, given this area's recent traumatic history with Katrina and flooding. Soon the verdant swampland gave way to concrete overpasses and skyscrapers – the first real metropolis since my start back in Mobile.

New Orleans is a party town and I would have loved to have stayed longer, as the place was absolutely jumping for the Louisiana State University (LSU) football game, but I had to push on – through the eastern suburbs, the French quarter, the markets and the uptown area, taking in the grand mansions, churches and universities of St Charles Avenue, and then running down the tram tracks before mounting a levee for the final mile or so.

I found a very stressed and tired Nadine at the meeting point. Having clocked almost forty miles, dipping well under seven-minute mile pace at times, and knowing my work was all but done, it was tough not to get exuberant when she was still on

shift, and it was worth remembering how difficult driving the juggernaut Jenny all day could be.

Today was the start of a three-day push to get to the Mississippi. The weather was as per usual – 33°C (92°F) and humid – and about three miles in I recognised a familiar feeling: complete loss of energy, feeling of dread, pins and needles in my fingers. I didn't know exactly what it was – maybe a bout of hypoglycaemia – but usually this happened midway through or at the end of marathons, not this early in the day. I would supplement my breakfast with a handful of gummy bears to avoid the possibility of another rough low-glucose start tomorrow. My physiological-minded brain would try to convince me that they weren't needed, but hey, I like gummy bears.

I was running down Highway 61, made famous by Bob Dylan for the many outlandish sights you'd see along the road, but it was now largely bayous and sugarcane fields. What had struck me so far, whether in the Alabama bayou, the Biloxi beachfront or the Louisiana highway system, was the volume and size of the insect life. Swallowtail, eastern tiger and monarch butterflies, crickets and dragonflies, some of which were so large it was as if they'd come from a land that time forgot. I winced every time I saw them dart across the road, but mostly they seemed to get away with it.

It wasn't just half a zoo that I'd see littering the highway in the dispiriting form of roadkill, but a maddening amount of trash. In the course of the day I managed to rescue a butterfly, a craw-fish and an eastern lubber grasshopper, and picked up a hundred pieces of rubbish. I felt I'd done my bit.

Being honest, I hadn't enjoyed as many of the runs as I should have done over the last few days. They'd all been different and interesting, but the mileage, the diet, the hydration, the weather

– you get the picture – had created a good few troughs alongside the peaks. And sleeping in roadside overnight stops was proving variable. Our first foray into the world of truck stops was no exception. We hid ourselves away from the scary big rigs, usually parked with their generators churning away overnight to keep someone's apple pies fresh, but the traffic noise still was a bit of a killer. I needed to get some decent earplugs.

The next morning, Khadevis Robinson, two-time Olympian (800m in 2004 and 2012) and now assistant head coach at LSU in Baton Rouge and all-round inspirational dude, met me at the LSU track with a reassuringly Olympian handshake and an 800m wide smile. He gave a guided tour of the insane facilities that the college athletes have, including ice baths, free smoothies and top-class gym. How I wished I could have been a part of that at one time. We shared a lap around the track, where I was happy to say I kept pace. He had squatted 600 pounds that morning, having moved away from athletics to powerlifting, so he was a little off his former pace. He told Nads that I was pretty fast for this sort of thing, a compliment that left me feeling like I could get to Santa Monica next *week*.

As we rolled on through one of the less salubrious parts of town, I was almost accosted by a guy resembling a zombie, who was out of it on *something*. It was a stark contrast with earlier in the day, when I'd stopped to chat to a crew of Nirvana-loving builders who were working on a golf course mansion that was to have a movie theatre and a bowling alley inside. The gap between the haves and have-nots was as wide as the Mississippi herself.

On arrival at Happy's Irish Pub, which has a running club, a few hours later, I was pleasantly surprised to see about a hundred or so runners in attendance. Apparently there were usually more, but the weather had put some people off. I received a lovely

introduction from ringleader Bobbi Jo, and we set off onto almost deserted city streets, like an urban parkrun, with police guarding the junctions while we moved past the State Capitol building and along the banks of the Mississippi before finishing back at the pub. The conversation inevitably veered towards the topic of the Trump–Clinton Presidential (in name only) Debate of the previous evening. Opinions were varied, but most felt disappointed in the schoolyard tactics on display.

I awoke in a confused state for what was to be a near-suicidal dash across the Mississippi. Our route planning had indicated that I was facing potential death on the behemoth that is the Huey P. Loooooooooooong Bridge (1,792 metres). As I approached the bit where the breakdown lane disappeared into a concrete barrier, my heart was in my mouth. I pressed play on Guns N' Roses' 'Welcome to the Jungle' and turned up the volume.

I'm not a worrier. Partially, this is because I'm an idiot, but mostly because I tend to think everything will be alright most of the time, and as long as I'm not there when it isn't, I'll still be alright. Also, I'd found American drivers to be very courteous to people on foot on roads, in contrast to their attitude to letting RVs change lanes.

I'd decided against filming this dash, but the devil on my shoulder called 'Action!' and I recorded numerous lorries and trucks fizzing past, as well as a few choice words. It was scarier than when I jumped out of a plane in Australia. I looked at my watch at one point and saw I was doing 5.45 pace, almost as quick as I race marathons and certainly not a wise pace for this run. Somehow I survived, and as a thank you to Axl Rose for getting me over the bridge I listened to the rest of *Appetite for Destruction* on the next section. It seemed appropriate.

I continued my amble through the towns of Erwinville, Torbert, Livonia and Lottie, frustrated that the great blue herons weren't concerned by huge trucks rattling by, but would fly off before I could get within fifty metres with a camera. I wondered if this was conditioned by local hunting.

Spirits were sky-high by the time we reached our free campsite in a nature preserve – which weirdly also had a rifle range. But then our generator conked out, meaning that it was baked beans on the stove for tea. Now, America, I feel I must address this. Standard cans of beans in the USA contain bacon, while the vegetarian beans are labelled as such, as if this is a special thing. You've got this the wrong way around. Beans are *for* vegetarians. And take the cheese out of your spaghetti hoops while you're at it. As a rennet-intolerant runner, it would have been a disaster for me to get caught short in the wetlands, miles from the next stop-off point. It wasn't all bad, though. The propane fridge kept its end of the bargain, meaning the beers were still cold.

In the morning, we learned that the diagnosis for the generator wasn't fatal; it had only tripped, and we were back in business. I'd also had an amazing sleep thanks to the cooler temperatures and I was ready for miles.

I passed through a strangely divided town called Opelousas, which was beautiful on the eastern side but the western side was nigh-on derelict and full of boarded-up stores. It always makes me sad to imagine how much somebody put into those businesses, physically, financially and emotionally, only to see them fail.

There were the fantastically named towns of Basile, Kinder and Reeves along Highway 190, but the place I was excited about getting to was called Elton. In tribute, I had *Elton John's Greatest Hits* on, and sure enough I was still standing when I reached my resting point. The blister on the ball of my right foot

had popped earlier, and while I'd tried to adapt my gait to cater for it and seemed to be doing reasonably well, by the time we got to our RV park my foot had become quite hot and swollen, and the edges of the blister were looking red and nasty. There was no obvious infection, but as a recent trans-USA run had ended due to cellulitis of the foot, I was justifiably concerned.

A cabal of doctor friends were assembled online and well-meaning but essentially useless advice of rest was given alongside calls for drugs, elevation, proper dressings and messages of good luck, which I'm sure were given with a degree of concern. My mind was in a tumult as I went to bed, still cooking from bodily repair processes, knowing I was going to wake up too hot or cold at some point – if I ever got asleep. Like so many of the other RV parks we'd stayed at, it was located by a loud train line.

My morning state of mind was one of trepidation. But music is one of my major grounding points and source of inspiration when I'm up against it, and today I wanted to lose myself in my surroundings and elevate myself into the third person, observing the run from above. My soundtrack for moments such as this regularly features the work of Nick Cave and the Bad Seeds, who are able to conjure a cinematic accompaniment to almost any moment. I kicked off with an eleven-mile run into the retreating sun shimmer, to the small junction town of Ragley, the pain in my right foot forgotten temporarily.

I was thirty-four miles in, seven to go to end the day, when a growing niggle in my left shin that had started to make itself known sporadically in the last twenty-four hours became unbearable on impact, lingering beyond each thud, even with walking. It was sore to the touch and I was making the call for a possible med-evac when I remembered the advice of my physios back home. Some had suggested this wasn't shin splints, but

potentially a tight *tibialis anterior* muscle and, by stretching the crap out of it, I managed to do the last few miles with relative ease – or as much as it can be easy after forty miles.

Near the end, I took a photo of the 'ten miles to Texas' road sign and finished five short of the border – within striking distance. I was glad I'd pushed through this latest obstacle with a bit of rational thought and not given up. Louisiana had been paradise for this 'Sportsman', and there I was in Starks' truck stop café late at night, as the Lone Star state awaited, charging my laptop instead of lying in bed as I should have been.

'Why were you not in the RV?' I hear you ask. Simple. The generator was broken again and this time we didn't think it was a tripped switch.

Chapter 4

THE BIG ONE

Texas
Days 15–27
380.04 miles

Jenny issues: one replacement battery, one full-to-the-brim and suitably fragrant 'black' tank to empty

T-day had arrived. The big one. Up bright and early, in a fine ol' mood for a border crossing, I got talking to a service station owner called Dustin, who warned me not to be startled by the sound of gunfire. It was just a nearby squirrel hunt. Yes, squirrel hunts are actually a thing in these parts.

It's worth contemplating just how big Texas is. You can fit 2.86 United Kingdoms in, for starters, and it would be almost 900 miles – longer than Land's End to John o' Groats – before I'd reach New Mexico. Texans are very proud people and why not? The Lone Star flag flies everywhere, from churches and front porches to gun shops, but I was most interested in the creative town signs: the self-deprecating 'Reintarnation – Coming Back as a Hillbilly', an offer of a free rooster, an inventive church sign that was inviting people to come in and catch their Pokémon. I even saw a huge billboard declaring evolution to be a lie.

I met up with my old school friend Paul Duffy, who had flown in from San Francisco to join us for a few days and run some miles. I hadn't seen him for twenty years but we picked up like it was last week.

A couple of days in to Texas, my 'shin' was playing up again as we struggled in the heat to the shores of Lake Houston. I wasn't the only one in pain, however. Poor Nads had been bitten on the bum by a huge horsefly. This was a Texas horsefly, remember. You could fit 2.86 UK ones inside it.

After my lunch, I got up to resume my run and I thought it was strange that my chair had creaked. As I turned around to look at it, I heard another creak and realised it wasn't the chair – it was me that was creaking. More precisely, I was confident it was the *tibialis anterior* muscle and/or its tendon sheath that had creaked. My heart sank. This was big.

After lunch, I elected to walk the first few miles. Paul must have felt awkward, as I'd been gregariously upbeat throughout his time with us and now I was barely talking. It was stiflingly hot; we were dehydrated despite drinking like fishes and I was clock-watching *and* shin-listening. Creak.

Out of desperation, I called Chris Finill, a GB ultramarathoner of a similar pace and running history whose word, thanks to his USA trans-continental experience, was gospel. He'd been an invaluable source of information prior to the run, and I needed to listen to his instructions and stick to them. He'd reviewed my online speed data and highlighted two issues. One was my pace, which was too fast, as I'd already suspected. He had a similar issue on his trans-con run that forced him to walk a few days he had initially suspected he had a stress fracture, which was a worry of mine before the creak appeared.

Chris said that if I was insisting on running forty miles every

day without rest, I needed to take walking breaks at regular intervals. He'd adopted a pattern of running four miles, walking one, running one and then having a short break to refuel, and he suggested I consider doing something along those lines. There is a classic ultramarathon strategy of running twenty-five and walking five minutes that is very effective for all but those racing at the sharp end, and this was most certainly not a race.

It was Paul's last night with us, and although it was for the best that Chris had talked some sense into me, I ate dinner while saying barely a word before thanking Nads for her efforts and heading to bed.

I couldn't sleep. Sometimes it was the noise, at others it was the heat or poor hydration or over-hydration. Sometimes it was an ache somewhere or just my racing mind. I just couldn't sleep. And if I didn't sleep, I couldn't recover.

Paul and Nads waved me off in the morning and I walked for a mile or so before calling Leigh at the Chiro Clinic in Liverpool to have it confirmed that it was probably *tibialis anterior* tend-initis, a condition with a very variable recovery period – largely relying on rest. I was also advised to seek someone to provide some 'mild discomfort' to loosen my calves off and reduce the load on the tib-ant. Apparently walking can aggravate this muscle as much as running, and if that was the case I thought I might as well just run, so I did. I didn't feel any better, though.

I reached the 500-mile point of the journey. My heart wasn't in the mood to celebrate and I was hungry already, so I stopped at a gas station for a Gatorade and a Twix. The lady behind the register, on hearing my accent and noting my unusual appearance, asked me what I was doing. I retrieved some money out of my zip-lock bag that also housed my gummy bears and a hand-written 'business card' explaining my quest and giving my social media details. I was down to my last one and it suddenly hit me

that this could be the last card I'd ever give out. It was like a switch had been flicked, and suddenly I was in floods of tears. This had meant so much to me for almost ten years and it was under threat from an injury that I couldn't even pinpoint – and now I was sobbing in a bloody gas station. The lady and her co-worker gave me a hug and told me all would be well, which made it even worse. I thanked them for their support and went over the road, sinking down against a wall and hiding until I could stop crying.

I managed to put in a mere nine miles that day, during which Nadine had been calling local physios. Thanks to a ridiculous law that meant I had to see a doctor before I could see a physio – which struck me as pure money-making shenanigans or paranoia over legal action – I got in to see a physio later and already lighter of wallet than I'd hoped. But my spirits lifted on meeting Whitney from Houston (I'm not making that up), who concurred with my suspected diagnosis. She was fairly optimistic that it would be OK, in the way that you'd say to someone who was about to ignore the standard advice for rehab of such an injury. And I had to get the razor out, as it was time to lose my K-tape virginity. I'd previously thought that taping was a load of hokum, but I wasn't in a position to argue by this stage.

As you know, I couldn't sleep, so that night we took no chances and booked a motel. It had air con. It was quiet. My new regime for the morning run was a mile walk at the start of the day followed by sets of a four-mile run, a mile-long walk and a final mile run. Leigh had told me to be guided by pain and that the creak was there to stay for a while, so not to worry, which was good, because I had been worrying. The days of seventy-minute ten-milers were over – at least for now. Now, it was more like: *Lead off from toe … feather touch on and off the deck … was that too heavy? Where is the kindest camber? Run on the left,*

run on the right, run in the middle? Wave at cars … sorry, sorry!
Was that pain? Stretch that calf.

We failed in an unsuccessful dusk attempt to persuade a star-
tled local priest to let us stay in his parking lot (I'm not sure he
understood me), so we spent the night parked at a gas station. I
reached for my earplugs and managed a sleep so wondrous that
for the first time on the run I saw a sunrise the next morning. It
had only taken three weeks and a run-threatening injury.

I stuck to my walk-run regime and started to have a good time
again. I hit thirty-five miles for the day just as we entered what
is known as 'Hill Country'. The vultures were circling overhead.
Not today, boys, not today.

This would have been the day we might have caught the Austin
City Limits Music Festival if the RV delay and 'the creak' hadn't
happened. Now I'd adjusted our goals to just reach Austin's city
limits. It was cold enough to see my breath for the first time this
morning, and I was making a beeline for any shards of sunlight
peeking through the dense woodland lining the road. Around a
mile or so after running proper had commenced, I came across a
portly black and white chap sitting by a bin. I took a photo of
this poor abandoned stuffed panda, immediately consumed with
sadness. Who would discard such a prize specimen? Save for a
scuffed nose, he was unsoiled and in fine fettle, so, especially
considering my WWF allegiances, I decided he was coming with
me. 'Leave no panda behind.'

His weight and bulk meant it wasn't comfortable carrying
him, so when Nads drove past about eight miles later – already
anticipating he was in my possession the second she saw the
Instagram photo I'd posted – I was mighty relieved to stow him
aboard Jenny. Now this guy needed a name, so we soon settled
on Bubba.

I ploughed on towards Austin, through Bastrop, home to a fantastic collection of public art, until I reached a major bridge reconstruction project and the road that I needed to run on didn't seem to exist. I approached one of the construction workers: 'Hey, man, where's the bridge gone?'

'In the river.'

Right. I looked at the route, which meant trying to cross both carriageways of a road as busy as the Champs Elysées in rush hour and then run along a narrowed stretch for a mile with a hundred-foot jump-off as an escape route.

'I can give you a lift if you want,' he offered, sharing my evident concern.

'Thanks, but I have to complete the crossing on foot.' Safety was secondary to authenticity. I had to take every step of this journey myself or it wouldn't be legitimate.

He shrugged. 'Good luck, man.'

It was a harrowing mile of beeps and swerves before I got to Austin-Bergstrom Airport to meet Nads, but knowing that we would be out on the town in Austin, the Live Music Capital of the World, later made it all worthwhile. We stayed at a quaint, hippyish RV park near the centre and got down to Sixth Street for dinner and craft beer at the Austin Ale House, before calling in at the renowned Stubb's BBQ and eventually coming back in the small hours.

I woke up hung over, but a stroke of luck arrived in the form of James and his family arriving next to us in the RV park, who hailed from California but had sold up to travel the country and build a new life elsewhere – the American pioneer spirit in action. It transpired that James was a chiropractor and he set to work straightening me out. James and family had three sweet dogs in their RV too, so I declared my own professional hand and discussed a few minor ailments, clipped some claws and wished

them good luck on the new life hunt. You've got to love the barter society.

Thoroughly refreshed and able to run, I went back to my starting point and had a pleasant run in to town, aided by lots of little rests photographing Austin's quirky street art, houses and skyline. I chuckled at the array of Donald Trump piñatas outside a shop, with a sign for 'Bernie Sanders – President 2016' – the only one I'd seen – apparently abandoned at the side of the building. Austin did things differently to the rest of Texas, which explained its motto of 'Keep Austin Weird'. It was a city I could very much feel at home in.

Farewell, Austin. It was about 580 miles to El Paso, on the border with New Mexico. We hoped to reach it by Halloween, which was *huge* in the States, in nineteen days. The celebrations in El Paso were also Latin-tinged, with a Day of the Dead aspect that excited me more than the standard scream fest. In the meantime I had a couple of weeks to find a suitable costume.

The rolling hills and lack of suitable shoulder along the road made for tough running and it wasn't until after lunch that I felt okay and started to enjoy the physicality of it. My route took me past Willie Nelson's ranch in Spicewood, in lovely, gloomy cool weather.

Despite the hills, I felt good at the final stop just before Llano, which is Spanish for flat. I liked flat. I finished at thirty-five miles, and as we parked up at a local truck stop I heard the unmistakable sound of an umpire's whistle and thought, *Football!* Now, (American) football is a huge deal in Texas, judging by the monumental grandstands at small schools I'd seen on the way. I headed over to Llano Junior High and paid my four dollars to see games for both of their teams: the Llano Daubers (12–13 year olds) and the talk-of-the-town Yellow Jackets. The field was top-quality

artificial turf, with floodlights, and the plays were called by a live-action commentator. Amazing stuff. The Daubers had a bit of a bad day against their opponents the Texans, and my enthusiasm led to some curious questioning from a group of students. 'Why Llano?' they asked. I came clean and told them the real reason was that I'd heard of the mighty Jackets and their star quarterback Mason 'Moose' Brooks, and I'd made sure Llano was on my route. When one of the students suggested I check the Mason Punchers game out the next evening on my way, I replied that I was Llano for life now, which resulted in my being given my own Jackets fan shirt by the Brooks Fan Club sitting in front, who just happened to be his family.

Later that evening the group tentatively knocked on the RV. Mason wanted to meet me, so we took some photos, including a few with Mason and his sister wearing the Gary Sinise Foundation 'I Just Felt Like Running' beard. Maybe he'll pose for a photo with me in ten years or so when he's the MVP in the Super Bowl?

The following morning, wearing my Jackets shirt, I passed the school before I hit the centre of town, a beautiful old-time American setting like something out of *Back to the Future* – or indeed the one in *Forrest Gump*.

That afternoon, I saw some magnificent Longhorn cattle, the breed that Texas is famous for, just past the Llano Cowboy Church. I so wished it was Sunday so I could see the congregation, who'd maybe bring enough water in their ten-gallon hats to fill up that watering hole. A huge turkey vulture held court on a fence post over a very recently deceased deer, whose location I had determined by following the trail of blood from the road.

Running down a huge hill was the best way to end the day, I'd decided, and it was even better when accompanied by something as life-affirmingly soaring as 'Pride' by U2. I'd made it about

halfway across Texas and the countryside was visibly changing. Green fields were giving way to dry brown grasses and those endless, rolling Texan landscapes from John Wayne movies that I'd always dreamed of.

Chapter 5

FROM GREEN TO YELLOW

Texas
Days 29–45
545.04 miles

Roadkill: 1 diamondback rattlesnake,
1 tarantula hawk wasp

I woke up tired, rummaged around Jenny tired, ate tired and started running tired. At a later rest stop, I was about ready to catch a glimpse of Jenny when I got a message from Nads asking if she'd passed me, as she hadn't seen me on the way to the meeting point. Re-checking the map, I realised I'd taken a wrong turn. How far? Five miles with no cross-country way back. Nads came and picked me up and suggested that, as I'd done the miles, I should just start from Grit. That wasn't an option. I had to set foot on every part of the route from start to finish or I couldn't call it a true trans-continental run. I would have to run from where I went wrong. This was not what Nads wanted to hear when she was cooped up in the RV on a hot day, but despite our disagreement we were still talking.

It's so alien waking up in the dark to me. I know this might sound a little weird more than 800 miles into this run, but I'm

actually pretty lazy by nature and getting up at 6 a.m. has to be worth it. Today it was, thankfully. I got dressed in my hi-vis finery and cycle lights to inspire at least a pang of guilt in any motorist who happened to clean me out on the shoulder, and when I stepped into the pre-dawn I was greeted by an amazing full moon. I aimed to get as many miles done before it swapped shifts with the blazing sun. This would be the agenda for the next three days as the Texas summer raged against the dying of the light.

Nads picked me up to take us to an RV park in San Angelo, only for a bang to bring us to a halt. When we got out we could see remnants of our right inside tyre stretching back down the road. Nads trooped down the highway, chucking the larger bits to the shoulder as I sent out distress signals. While we were waiting for a breakdown truck, a friendly local trucker pulled up behind us to pass on some big-rig know-how. He reckoned we could limp to town if we let the air out of the stricken tyre and also advised us to change one of the other rear tyres. The drive was frustratingly and anxiously slow and I felt it best to bite my tongue to avoid stressing Nadine out any further. Three tyres and almost 500 dollars later, we were up and running, but frustrated to be lumbered with a big bill so soon after getting Jenny, especially as the *freshly painted* tyres all looked so good when we stepped aboard. I didn't rule out more. An owl, perfectly silhouetted against the post-sunset sky, ominously perched upon a Yield sign, before flying into the perfect panorama.

It was on to Eldorado. The Golden One. The Lost City of Gold. Famed for a John Wayne film of the same name. This Eldorado was none of these, of course, though it does apparently confuse a lot of foreign tourists. Eldorado was, however, the only town in Schleicher County and therefore the best one in the

county. Amazingly for mid-October, it looked as though the trees were in full blossom in a dazzling display of orange, black and white. It was only when we got closer that we realised these were not flowers, but monarch butterflies.

Unlike the butterflies Nick Cave refers to in his song 'Midnight Man', which only live for a day, the lucky butterflies of Eldorado were the fourth generation of the year and got to go to Mexico on holiday and live for up to eight months. Fascinating creatures, the bulk of the kaleidoscope – the wonderful collective noun for butterflies and my favourite acquired snippet of 2016 – had already moved on by the time we arrived, but there were still enough to make an impressive sight.

We met a local butterfly sage called Kathy, the editor, chief reporter and photographer of the *Success* – an excellent name for a newspaper. She informed us that we were just about to enter nothingness – the part of Texas that we were excited by and afraid of in equal measure. We'd scoured satellite maps for rare lay-bys and side roads able to accommodate Jenny.

Once the cotton fields faded from view, we were deep in the Texan badlands and slowly melting. I was dressed from top to toe in white to try to repel the sun's glare. I'd already posed for a comedy 'tongue-out' photo by the Salt Lick Ranch. For those not in the farming game, salt licks are provided for sheep and cattle to make sure they've got their required minerals. The herd seem to know when they need them, and boy, did I right now.

The bulk of the traffic was heading to and from the oilfields, which meant big trucks, dust, some scary oversized loads and the trade-off between getting lost in music and listening for traffic coming up behind me. My only human interaction apart from Nads and a phone call with Dylan Mathews, CEO of Peace

Direct, was with a friendly passing driver who asked if I needed a ride. What a gent. I was having a ball.

I was treated to my longest dog chase yet, thanks to a couple of Chihuahuas. I doubt they had a clue what they were doing, nor cared for the passing cars as they barked and wagged. One of these days I might have to deal with a dog that had a very good idea of what it was up to. I just hoped it was the same size and scared easily.

Three other fellas had been on my tail for a few days or so. These wily black-headed vultures circled overhead and seemed to think it was only a matter of a time before one of these trucks or the sun took me down and left me there for dinner. I honoured them by listening to Them Crooked Vultures and strangely, as if they realised that I'd cottoned onto their dastardly plan, I never saw my dead-end friends again.

I woke to a slight chill in the vultureless air and, stepping out of the RV into the murk as the sun rose behind the clouds, Texas seemed to open up before me. I turned around to see rays of sun stream through a gap in the clouds and felt as though the world had my back. At the same time I had a pang of sadness too. Was it homesickness or just missing a certain normality? I was experiencing mood swings in which I would be excited at this huge life experience Nads and I were on yet sad there weren't more people to share it with. I felt guilty, like a kid who'd stolen the last of the chocolate to go and hide under the stairs and eat it on his own. I'd be navigating strange thoughts like this on and off for the whole journey.

Not long after lunch, with only six miles to Iraan, I crested a hill to see a bird in the middle of the road – a living one at that. I got closer and it just looked at me and walked slowly towards the side of the road. Experience told this vet that he was

witnessing abnormal behaviour, so I walked closer to see if it was injured. So close, in fact, that I was able to pick it up. It was a roadrunner. An actual 'meep, meep!' roadrunner. This fella was missing a few primary wing feathers and had a superficial wound to the area, but no breaks – maybe another Wile E. Coyote near-miss. It looked fairly juvenile and my normal veterinary advice would be to leave it be, but this one was in the middle of the road and I wasn't thinking straight, so I signalled to Nads as she came over the hill to make roadrunner Jenny's latest passenger until we'd called a local vet for advice. As I stepped into the RV, I nearly tripped on a big old plank of wood in the long grass that someone had obviously just chucked there.

About a mile later, I emerged from a rock-lined gully to a huge, majestic expanse of mesas, valleys and peaks, the biggest 'wow' sight of the journey so far, and I yelled, 'TEXASSSSSS!' at the top of my lungs. I took a huge hill down to an ancient seabed near Iraan, where I caught up with a similarly speechless Nads at a picnic area halfway down the hill.

I called the local veterinarian's office in Fort Stockton for some advice on our newest crew member. They advised it was best to leave him at a safe spot near where we found him. Relieved that this met with our own advice, Nads and I headed back up the hill to the spot where we'd picked him up, and Nads came to a sharp halt at the side of the road.

Pffffff …

Instantly I knew. Another tyre. It was a huge screw from that plank someone had so carelessly discarded. Nads blamed herself instantly and broke down in tears. I reassured her it wasn't her fault as best I could – if anyone was to blame, it was whoever dropped it there in the first place. I took our roadrunner back outside, climbing down some rocks away from the road, half-expecting the rocks to shift, breaking my leg in the process, or

for a rattlesnake bite to cut short the run. I put the little fella down and wished him or her luck.*

Iraan is the second largest town in the second largest county in the second largest state in the US and has a population of just over 1,500 people. I find it somewhere between at least intriguing and maybe a bit less than mind-blowing that the equivalent in the UK is probably East Kilbride, which has a population of about 75,000. There are rumours of a secret underground city in Iraan, and a sign on the way in saying poison gas is occasionally released from the ground, all of which added to my fascination. Of course, all we were to see of Iraan was the inside of a tyre shop, a service station and a laundromat.

That was 600 bucks on a three-and-a-half tyres in a week. Apart from discovering the creak in my leg, this was the worst I'd felt on the trip. Such incidents felt like death by a thousand cuts sometimes and would wipe out the massive wins of the day. Nads asked me how much I was truthfully enjoying the run and, in my melancholy, I replied, 'Six or seven out of ten,' probably meaning a six. That wasn't good enough, and I knew that if it weren't for the charities and people at home willing me on, a persistent six would have meant home time.

I gazed out of the RV window at a solitary bird on a telegraph wire. I was reminded about the problems birds have in their life, and I sang along to Leonard Cohen's 'Bird on the Wire' during my next run. Leonard Cohen was fast becoming one of my go-to artists on the run. Like him and the bird and hopefully the roadrunner, I have tried in my own way to be free. And at least when people ask me how I got to the middle of Texas, I can always say 'Iraan'.

* I hope you made it, my little roadrunner friend. I still feel as though I did something wrong.

Iraan was a place built on oil, and I floated past countless oil derricks, but I was comforted to see lots of wind power on the horizon and on distant mesas too. I'd seen a sign earlier in Texas saying, 'No to Windmills, Yes to Heritage', which annoyed me a bit, as there'll be no importance in heritage if we don't take care of the future. I know some people think windmills are an eyesore, but it's not as if oil derricks are much different and I don't see why Texas can't become a world leader in renewables. It's got the sun, wind and space and it should be the oil companies' responsibility to make this happen.

One thing I wasn't aware of until experiencing it first-hand was just how much the oil derricks smell. (Funnily enough, wind turbines do not.) There's a petrol odour, as you would expect, but also often a heady whiff of sulphur. Strangely, the smell made me incredibly hungry.

At the end of the day, I got to the RV to see Nads brandishing the video camera. It was a trap! She gestured for me to turn around, and handing me my post-run shake was Olivia, a great friend of ours for many years. I didn't have the faintest idea that this was on the cards and was lost for words. We had beers at sunset and, as we were regaling each other with our recent travel adventures, a roadrunner hopped onto our wing mirror. I think it was a sign. Our mate was alright and our day had been upgraded to our first perfect ten.

Lesson for the day: Don't mess with Texas. I took a short cut across a slip road on the I-10 to avoid a hundred-yard detour, and I felt a searing pain shoot from my foot up my whole leg. Once I'd stopped cursing, I pulled off my shoe to see that a mesquite thorn had gone right through my sole and a good centimetre into my foot. The mesquite bush is the bane of Texan farmers, sucking the water and the life out of the plains with its

deep roots and forbidding defences that take many an unsuspecting hoof by surprise. Mesquite thorns weren't poisonous, as I'd been led to believe on this trip, but it bloody hurt for a good few days.

A wave of relief, pride and joy crashed over me as I hit a landmark distance a few hundred yards upstream of Nads and Olivia. Shaken with emotion, I picked up a rock and scrawled '1,000 Miles' on a bridge, a very personal piece of graffiti that would probably mean nothing to anyone passing by and reading it.

In the morning, after we bade an all-too-premature farewell to Olivia, I encountered my first diamondback rattlesnake, which was sadly rattling no longer after an argument with a truck. Later on, I stopped to pick up what appeared, from twenty feet away, to be another stray cricket, only to realise it was in fact a stricken tarantula hawk wasp, which is black with red wings and I'd been told had a sting likened to sticking a fork in a plug socket while having a red-hot branding iron plunged into your skin for ten minutes. One to avoid. I convinced myself it was done for and, though fearing a mesquite-esque plunging of the most fearsome stinger known to man into my tootsies, I brought my sole down upon it to end its misery.

Pecos is the site of the world's first rodeo in 1883. Over 25 per cent of its population lives below the poverty line, something I found hard to align with the fact that some people (probably not from the area) were getting *very* rich from the local resources. As Pecos is basically on the border with New Mexico at the eastern edge of the Chihuahuan Desert, it meant the road was not only busy, but also hot and dusty.

The area also seemed to be home to a lot of bad drivers, and during one heart-stopping moment a blast on a truck horn alerted me to an overtaking manoeuvre on the up of a blind hill

by an eighteen-wheeler with a pick-up ten feet from its rear wheel. I only lived to tell the tale thanks to the three seconds' notice the horn gave, allowing me to dive off the shoulder into the dirt, which an instant later was whipped up around my ears, cloaking any choice gestures I might have made towards the driver.

Day 38, I passed through Orla and was running towards the New Mexico border. I wouldn't cross it yet, but follow it for another week or so with the dust clouds and oil fires for company. I did, however, cross a time zone on foot, a surreal experience, before finishing for the day a tantalising fifty metres from the New Mexico border.

I clocked off early to allow us to drive across the border to the Carlsbad Caverns and see the bat flight that evening. The gateway to the caverns was a place called Whites City, a cool but peculiar place a bit like a Western resort, with a gift shop selling all sorts of unusual trinkets: giant bear statues, alien paraphernalia and lots of knives, of course – as well as a Zoltar machine, which brought to mind another Tom Hanks film. I was careful what I wished for.

Taking a good seat in the cavern amphitheatre, we listened to the ranger painfully trying to kill time, as he wasn't even sure if the bats had left the previous night to go on their holidays in Mexico (I hoped they didn't catch the migrating monarchs of Eldorado). But a few moments after a swirling flock of cave swallows swooped in for the evening, it started. A few hundred black zephyrs spiralling upwards and outwards, before thousands upon thousands of bats streamed out, creating a myriad of shifting shapes before disappearing into the distance as the local insect population beat a hasty retreat. The rangers estimated 300,000 headed out on their nightly mission. Nature is incredi-

ble. These little guys have to eat about 25 per cent of their body weight nightly just to get by. You'd think there wouldn't be enough insects in the world.

As part of the programme to keep Nads happy so that she didn't either wallop me or go home, the next day was a short one too, and our end point was the Guadalupe Mountains National Park RV camp at the base of Guadalupe Peak, the highest mountain in Texas. The visitor centre was at 5,695 feet above sea level and, as I was starting at 3,800 feet, I was going to need a good push up that hill. Music was my usual fuel, and my pal Simon Lapish had sent me a playlist that made me feel twelve feet tall. Commentary of Mo Farah winning his second Olympic gold, 'Chariots of Fire', 'You'll Never Walk Alone' recorded at the last Liverpool match I went to – I was effectively singing to myself. By the time I was finishing my second listen of the playlist and the final chorus of Bruce Springsteen's 'Wrecking Ball' was fading out, I'd eaten up nineteen miles and the visitor centre was in sight. I'd barely noticed the climb.

I had a quick look round the exhibits in the visitor centre and held the door for a thick-set chap on his way in. He looked like he could have strolled in from a scene in a Western that might have played out in Whites City. Noting my T-shirt from the Liverpool Rock and Roll Marathon, he said, 'Are you from the UK?'

'I'm a Scouser,' I told him.

'Me too! Where are you from?'

'Croxteth.'

'Old Swan!'

That's three miles from me. It seemed that wherever you went in the world, you'd meet a Scouser.

While Nads appreciated our easy days, I was even more appreciative of the day of downhill I'd earned on the other side of

Guadalupe Peak, though I got an unwelcome gift from the descent in the form of shin pain. Thankfully the Creak hadn't returned, but I didn't want to risk it, so I eased back on the pace and arranged an appointment later that evening for the razor and K-tape.

The Salt Flats were a great sight. They were once a vital source of income for the Native Americans and later Hispanic people, before the local grandees in El Paso decided they'd have some, in fact *all* of it. They fought a war, which the El Paso mob won. Progress? Seemed more akin to a bit of good old-fashioned robbery to me.

It was now late October, and the night on the Flats was the first in which I was consistently cold in bed. I kept waking up, pretending it wasn't really happening and, instead of putting on a T-shirt or getting another blanket, I'd rearrange my current blanket and try to go to sleep again – doomed to repeat the same mistake in twenty minutes' time.

I passed through Cornudas, stopping for an incredible 11 a.m. burger at May's Café, where Englishwoman Rosie Swale-Pope had passed through as part of her round-the-world run. Perhaps there was something in the Pope name? I'd been listening to nothing but Neil Young and Bob Dylan during the day, and that night I stood outside in the cloudless starry night sky, squinting to see the outline of El Capitan (not *that* El Capitan) watching me from the Guadalupes, despite being almost seventy miles away. I'd wave goodbye to him finally in the morning and then set my sights on El Paso, which was only a day away.

El Paso is the most westerly city in Texas, part of a larger urban sprawl, contiguous with Ciudad Juárez in Mexico yet divided in more ways than one by the US–Mexico border. These towns formed in the gap between the Franklin Mountain range on the

US side and the Sierra Madre on the Mexican side, and as its name suggests, El Paso was a major route of passage rather than a slog over the mountains. I was glad of the pioneers' foresight.

As I got into the outskirts proper of El Paso – all American cities seemed to be so spread out – I caught sight of two *vaqueros* (Hispanic cowboys), who waved hello through the window of the RV. Mutual road warrior respect, I reckoned.

Against general advice, I decided to run along the border for a bit as I generally found most written warnings to be overblown and, besides, surely I could talk myself out of trouble with my Scouse/English/Australian accent. Unsurprisingly, the trouble never came, despite my running the wrong way down a busy road in front of a border guard, but I found the sight of the border to be an uncomfortable experience. The high fences, barbed wire and searchlights gave the appearance of a prison rather than an amicable divide.

In the morning of our last full day in Texas, I began a brutal climb up N Mesa to Up and Running, El Paso's specialist running shop that might more accurately be called Up and Up and Up and Running. Perhaps sign writers charge by the letter. I was getting through shoes like nobody's business, and Henry 'The Soleman' Veloz took a look at my gait and noted that the same imbalance that James the chiropractor had seen (and corrected) in Austin had returned. He checked out my shoes and thought I might need a little alteration, so he pledged to make me some insoles for free when I returned the next day. After some of the meals we'd enjoyed on the house so far, it was some more of that famous Southern hospitality.

Unfortunately, the heat or my breakfast got to me when I left. Covering five miles, three of them uphill, all in the hot sun while checking my watch every hundred metres to see if that was a mile yet, I vomited a couple of times. I finally got to the hotel, where

a concerned Nads was waiting for me, but I needed rest, which unfortunately meant we wouldn't make the Halloween Parade. However, we needed to celebrate our conquest of Texas in some capacity, as we'd hit New Mexico in the morning. So, we did head in later for a little nose around the city centre, where it was quite weird to see that lots of trick-or-treating was going on in stores. Talk about 'give my kids candy or you'll never see me back' ransom demands. There was no hiding behind the couch with the curtains closed here.

I crossed the Rio Grande as it turned northwards in El Paso, and, in a flash, there it was. The Land of Enchantment lay before me and 893 miles of Texas was in my wake. The scheduled brass band tribute and civic ceremony must have been a bit late, so we made do with a fella selling chillies and watermelons. I posed for a photo propped up against the state line sign with my arms folded across my chest, looking suitably satisfied. 'The Lean', my signature pose for such occasions from now on, was born.

Chapter 6

I WALK THE LINE

New Mexico
Days 46–49
150.76 miles

So this was New Mexico. Last night had been a late one. Over a few beers we'd decided an impromptu rendition of 'Thriller' complete with copious amounts of eye-liner was in order. It was just after Halloween, after all. But I hadn't been prepared for the repercussions of not removing my make-up before bed, and despite some solid scrubbing this morning I was still wearing eye-liner.

We were going to hug the Mexican border on this run, which meant leaving most signs of civilisation behind – though we weren't expecting the road to end in quite such an abrupt manner. Some local road workers were queuing for their breakfast burritos so I asked them whether I could run further in that direction. They found either this or my eye make-up wildly amusing and told me to watch for coyotes and border guards. Having the sun burn only the left side of my body as my sophisticated navigation technique, I was able to make my way across three miles of desert and scrub and under a barbed-wire fence back onto Highway 9. The next marker down the road was 144 miles – all the way to the end of Highway 9 and, to all intents and purposes, Arizona,

a state I was eagerly anticipating. The state insect of New Mexico is the tarantula hawk wasp; the two-tailed swallowtail butterfly of Arizona seemed far less painful.

My mind wanders a lot when I run if I let it, and with the roads being so quiet and the mountains of El Paso still over my shoulder, I thought a lot about Texas and how varied it had been. It's an incredible feeling to see the land turn from green to the desert in a subtle and steady way. As George Harrison once said, all things must pass, and I started to take in my new surroundings, which, while not exactly a departure from west Texas, were pretty magical in their own right and really gave the feeling of the open road. And then *it* made its first appearance of the trip – *it* being the song 'Born to Run' by Bruce Springsteen. I'd decided not to listen to this song deliberately before as it would have felt too contrived, but thanks to what you might assume was some sort of convoluted computer shuffle algorithm but I believe was the God of Rock and Roll himself declaring from on high, the time was now – on Highway 9 as I passed a STOP sign riddled with bullet dents.

The next day, in cloudy conditions, we reached Columbus for lunch, a town named in honour of old Chris himself. It was once a huge trading town, but had declined following the withdrawal of the train service. It's also famous for a raid by that cheeky bandito Pancho Villa in 1916, which prompted a huge US expedition to try to find him, but Pancho was an elusive sort and escaped to fight another day. I got some photos of the saloon, which saw a lot of the Pancho action, and also the old train station, which is now a museum, as well as a few quirky shops and installations from a few artists who had moved to the area and would hopefully give Columbus a second wind in the future.

Twelve miles down the road I found Nads and Jenny for a dinner of sausages, bacon, potatoes and sweetcorn in a tomato

sauce. I'd started to get into a real rhythm with my eating and hydration now that the hot weather that had so cramped my appetite in the earlier states had subsided. It seems as good a time as any to list what I'd get through on a typical day, each of which would be separated by a run.

First breakfast: Glass of water. Couple of cereal bars and, if I had any, a protein shake. I usually didn't take water with me on the first run.

Second breakfast: Pint of squash – or diluted water enhancer, as no one in the US knows what squash is. Large bowl of oatmeal with added maple syrup, jam (jelly) and chopped-up bananas. Litre of water for the road.

Mid-morning snack: Whatever I could get that was a nutritionist's worst nightmare – donuts, pies, chocolate or similar, and often a full-sugar fizzy drink, ideally Dr Pepper, Forrest's favourite drink, for authenticity, of course. Another litre of water for the road.

Lunch: Almost every single day I would have two large ham and salad sandwiches with pepper and Kraft Catalina dressing, which I'd never even heard of until I started the run. This helped with my fruit and vegetable intake, and I'd usually have a large bag of crisps – OK, chips in local parlance – to keep up my sodium levels. I would often be in great need of hydration at this point, so I would often put a large amount of liquid away, including another caffeinated soda if I was feeling sluggish. I don't do coffee.

Mid-afternoon snack: Sometimes I stupidly wouldn't bother or I'd forget, but I would often be on the hunt for sugar, be it from candy or cake. If I just couldn't be bothered to have a big rest and eat, I'd take some gummy bears with me.

Dinner: Nadine would have a protein shake ready for me most evenings as I arrived back. She would cook up a feast for us, and occasionally we'd eat at a truck stop, fast-food restaurant or occasionally as a real treat, we'd get takeaway pizza. I promised I'd try to take Nads for some fancy meals, but as we were on a budget they were few and far between.

Supper: Governed by whatever was in the treat cupboard and how much water I could drink without peeing like a racehorse all night.

The Hatchet Mountains and the Animas Range provided some stunning scenery, and I happened upon a curious town called Hachita ('Little Hatchet'), which was on its way to becoming a true ghost town. Most buildings, including the church, saloon, store and gas station, were closed and in disrepair, and a lot of the houses were going the same way, with many people living in RVs in their front yard. A few people were going about their daily business, but I felt like I was intruding. The place was once a thriving community of around 800 people, serving time as a military outpost, then a smelter base, but as the jobs moved so did the railroad, and the town was now on borrowed time.

On the way to meet Nads and finish up for the day I saw a twenty-centimetre millipede crossing the road, which of course needed rescuing before it didn't have a thousand legs to stand on. I'd been told centipedes bite here and millipedes were fine, so I braved it with my hands, though as it reared up to have a look I got all squeamish and dropped it unceremoniously in a bush. In the Boot Heel region no one can hear you scream. By the bush I saw a lone Scottish thistle in bloom – like me, a long way from home.

Day 49 saw an early start, as we were expecting a very important delivery. I'd have to hurry to Animas, twenty-two miles away, before we drove to Lordsburg for the pickup. On the way, I ran up to a group of cyclists on a 400-mile bike ride to raise money for the Rancho Feliz Charitable Foundation.* One of them cycled up beside me and gave the now-familiar cry: 'Run, Forrest, Run!' They helped me float all the way up to the Continental Divide at 4,520 feet, the imaginary line on the continent where, theoretically, a raindrop falling an inch either side would make its way to either the Pacific or the Atlantic.

Our very important delivery wasn't an aid package or fan mail – fat chance of that – but instead a living and breathing run buddy, Rick Beer – a former teammate in the Royal Veterinary College Football Club. He would be with us for two weeks, and to celebrate we set up camp in the local Mexican café. The lady who served us filled us in with the sad situation in Animas. They'd had an all-conquering high school football team, but since 1991, with the added demise of the local copper smelter, the town's population and the football team had nosedived. She felt Animas wouldn't go the way of Hachita, given the number of ranches in the area, and I hoped she was right.

Despite a mammoth ten-hour flight and an overnight 'sleeper' (a term used loosely, apparently) train, Rick was up for a run to end day 49. He'd done his training and wasn't going to miss any chances to hit the road. After a twenty-minute wait for a train to move on at a crossing, and the possibly unwise decision to give up and climb between the carriages, an impressive six-and-a-half miles out of Animas ensued and he wasn't bent over gasping for air like I've seen him on the football pitch a few times. It was another eight miles to the end of Highway 9 and Rusty's RV

* Check them out at www.ranchofeliz.com

Ranch before sunset. Rusty's place is frequented by astronomers due to the clear skies and lack of local light pollution, but their numbers fluctuate in sync with the lunar calendar. As the moon was in full view, it meant it was sparsely occupied and we had the hot tub to ourselves to observe the cosmos. It looked impressive to us, even with the moon in the way – especially with a cold beer in hand. I do believe they call this winning.

Chapter 7

WELCOME TO THE WILD WEST

Arizona
Days 50–61
436.86 miles

Meeting people on the road was always a highlight. Rick and I bumped into two French cyclists, riding from Montana to Florida. I was able to impart some useful advice about my old friend, Highway 9, and then, at our next stop, we came across a Swiss motorcyclist riding from San Diego to Florida. He was worried about running out of gas. 'No worries, I can tell you just where to go on Highway 9 …'

He met us while we were having lunch at the monument commemorating the surrender of Geronimo, the famous leader of the Apache tribe. This marked the end of all war with Native American people – good for the settlers, though the result could best be described as mixed for the natives, and even then only if you're wearing rose-tinted, star-spangled glasses.

I worked off lunch up a narrow road, meandering into the mountains where I could easily imagine the silhouettes of warriors on horseback on a distant crag. Arizona's scenery was as spectacular as New Mexico's with the added flavour of being in

real Wild West country. I hit Highway 80, where a marker said 415 miles to the Pacific. That was a big number.

When I later reached Jenny, the guys had parked up at the side of the road and not where I'd advised. They explained that the road I'd highlighted didn't go anywhere. I was pretty sure it did, but we agreed to disagree and parked up for the night. While updating my journal and writing social media posts for the evening, I discovered a pretty important number: 1,500 miles covered so far. It was reason to raise a glass with Nads and Rich, and I looked forward to a future occasion when someone would ask me what my PB for the 1,500 was. 'Oh, about seven weeks ...'

Overnight, we'd come to no clear agreement about whose path was correct, so it seemed apt that on the morning of 8 November, US Election Day, we were faced with a divided camp and a decision to make. We elected to head our chosen ways separately, and I soon realised that I'd backed the loser. I was, however, excited about our endpoint, the whole reason for this route choice.

Rick wasn't as happy with my choice as the scenery wasn't quite as grand as his chosen route via Bisbee and its brewery, and he had to get used to the traffic. I'd become so accustomed to life on the road that when trucks roared by, a whisker from me, I no longer feared for my life. It was good to have him with us – and not just for me. Nads had been driving to my rest points, preparing food, doing laundry and generally being so tolerant of my myriad demands and requirements – the vast majority of the time, anyway – that having someone else around was equally welcome for both of us.

A wicked wind was forever in our favour and we were soon joined by a third traveller on the road. A tumbleweed led the way, and Rick and I tried our best to catch it. The tumbleweed

gamely kept the lead for a long time – a few miles, in fact. Rumours that the quality of our jokes hastened its progress are unsubstantiated.

The road into Tombstone was a long and winding one, passing High Lonesome and Wild West roads and countless election posters – there weren't too many for Hillary in these parts. I stopped for the day at the scene of the gunfight at the OK Corral in 1881, involving the Earp brothers, Doc Holliday and the naughty Clanton-McLaury gang. I don't know how I'd imagined it previously, but it certainly wasn't anything like the reality of a thirty-second shooting frenzy at a range of six feet. I wouldn't even want to be within six feet of a fistfight, thank you very much.

The big fight of the night was taking place in Washington DC, and our seats were in Doc Holliday's Saloon, where our barman was named Forrest. He told us he joined the army a few weeks after the film came out – and that it was darned appropriate his initials were FML. As we were telling him about the run and writing some details down for him on a card, a voice rumbled out to my right: 'I'd sure like one of those.' The voice belonged to Marlin, a retired horse trainer, musician and ringer for the bowling-alley cowboy played by Sam Elliott in *The Big Lebowski*. He told us he'd been born a 'hun'red-fidee years too late', and our meeting ended with my running out after him with the bag of dresses he'd just left behind having already told me he'd be in hot water with his wife if he left it in a bar somewhere …

The three of us were buzzing with election excitement, but our enthusiasm wasn't matched by Forrest. We had increasingly found on the road that voters on both sides were just disappointed with the choice. As the results came in and the winner became clearer and clearer, footage showed the shell-shocked Democrat staffers assembled at the Javits Centre in New York,

with its rapidly deflating balloons. The owner of the bar, whose allegiances were as obvious as his ten-gallon hat, offered everyone shots on the house.

Open your eyes. Waking up in the brave new world felt no different. The sun was still shining, my sore bits were still sore and I still struggled to raise enthusiasm for anything within an hour of turning off the snooze button. Eventually I headed out, past our neighbours, an RV bedecked in the Confederate flag and a 'Make America Great Again' placard, and set off from the OK Corral, albeit about two hours later than usual, in the direction of Tucson.

At the entrance to Tucson Mountain Park the next day, we were already surrounded by the giant saguaro cacti covering the hills and mountains like silhouettes of ancient Native American warriors. The saguaro – or giant, as you may know them – cacti grow to over forty feet tall and only start throwing out arms when they're about seventy years old and twelve feet tall. Those with five or so arms are usually around 200 years old and can easily weigh 10,000 kilos. Rick and I scaled an unrelenting hill on the hottest day since he'd arrived, with my constant stopping to take photos of our large pointy green friends a slight cause for consternation, as Rick is like a big diesel locomotive when he runs: steady and solid progress preferred, with inertia on restarting an issue.

I left Nads and Rick in the excellent museum to continue my run. A sign informed me not to give coyotes cookies and the sun was already well on its way. I was on one of my 'I don't think this road is really closed' tips, which allowed me a little cross-country to enjoy a more peaceful look at the Saguaro National Park. It was warm and dry, dusty and crisp, and the calm I felt being off the road among the saguaro was unbelievable. Surrounded by

these behemoths on the hills as the fading sunlight cast shadows on the road, the feeling of being somewhere very special was all-pervading.

I clocked up forty miles today and was pleasantly surprised to find it felt relatively easy – which wasn't the norm, trust me – while Rick offered another pleasant surprise by joining me for two runs today. While he was definitely feeling his second one, he still managed to keep pace – with a bit of prompting – and even delivered his customary burst of pace at the end, which he'd named 'Jenny Fever', a condition that came on as soon as we could see the RV parked up ahead.

Our reward was a drive into Phoenix, but I had neglected to consider that this meant Nads would have to drive in the dark through a huge city in a huge vehicle, which she was understandably not ecstatic about. I was feeling very guilty about it, but she got us to our RV park safe and sound, where the promised land of shower facilities lay. To conserve water, showers were a rarity in the RV.

The next day, we were going to see the Arizona Cardinals play the San Francisco 49ers in an NFL game. The wonderful owner of the RV park, Ang, said she'd drive us to the stadium, so, accompanied by her dog Loki and a handgun in the glovebox, we set off for the University of Phoenix Stadium and, more importantly, the parking lots, where the fantastic American phenomenon of 'tailgating' occurs. A mini-festival of barbecues, beer-drinking and games roared forth, with both sets of fans mingling together happily.

The stadium was colossal and laid on the full game experience, including long food queues, overpriced beer and lots of adverts. In between there was some good stuff – a bald eagle flying over a pitch-sized Stars and Stripes for the anthem, lots of tributes to

service people and a narrow home team victory. A full-on, fifty-man brawl erupted in the stands, which, while most unexpected, made interesting viewing, including for the security staff, who seemed happy to let it play out.

Feeling somewhat delicate in the morning, Rick and I sought some tranquillity and ran alongside the train tracks. Unfortunately, the gargantuan trains possessed the knack of stealthily approaching from the rear when you least expected it, only to roar like the end of the world just as they reached you. The road was good for running, albeit bad for the nerves, but eventually decided it didn't want to go on any more, so across the tracks we went, only to find a second obstacle to our serene progress in the form of a marsh deciding it had right of way over the road. That's right. A marsh, in southern Arizona, on a road. We took our chances with the busier highway that would run parallel to this until we got to the town of Maricopa.

By the time I reached Maricopa on a solo stint and saw an amazing California Zephyr locomotive called the Silver Horizon, the sun was setting, throwing shards of burnt red light onto the polished hull. I struggled, squinting in the half-light, until a peculiar sensation caused me to turn around and receive the shock of my life as a huge super moon rose from the eastern horizon, setting the fields ablaze with a golden glow.

I reached the RV to find Nads and Rick out front, just staring, in silence. I didn't say anything either, but put 'Moon', a beautiful, atmospheric opus by Foals, on my loudspeaker, and we listened while bathing in the light and the music, until a big bloody train went past for two solid minutes, blaring its horn and ruining the moment. Such is life.

* * *

Crossing the Sonoran Desert was my goal for day 58, so I gave myself an early start, as I have an aversion to death by exposure in most deserts. I planned to run a marathon, not as a deliberate test of strength, but out of necessity if I was to avoid an extra twenty-four miles by road. I felt it was doable and, okay, to be honest I was a tad excited about it, as if it were a race against such opponents as the terrain, the weather and my strength of will. Potentially insurmountable barriers and No Trespassing signs were just a couple of other factors thrown into the mix.

At a 'town' called Mobile I took a track at the foot of the Espanto Mountain, which hosted a grandstand of onlooking Saguaros placing bets on my demise. Electing not to have breaks so as to limit my time in the sun, I walked my refuelling stops. Three-and-a-half hours later, I worked out that the shimmer in the distance was, in fact, the 85, about three miles away. I managed to get there at a pleasing pace, even beating Nads and Rick, who'd gone rattlesnake hunting for the day. When they arrived with a jug of iced water, I was more than happy to do another six miles with Rick to a quiet off-road spot for the night, just south of the Gila River and from where it looked like there was a surprising flash of greenery in the distance. Nads pulled out a proper cowboy dinner of sausages, bacon and spaghetti in the desert.

My bubble of joy was popped the next morning when I learned that the greenery in the distance was merely from irrigated farmers' fields. The mighty Gila River was no more than two puddles of muddy water. I'd seen enough dry rivers in Arizona, New Mexico and Texas to last me a lifetime, but I still felt a mixture of sadness and anger.

It was a buoyant Dickie who lifted my mood, however, as he was lacing up his shoes in anticipation of breaking the hundred-mile barrier of his trip. He saluted his century on the road in

time-honoured cricketing style, raising his bat (shoe) to the assembled crowd (me and a fertiliser factory), before getting on with the run like a true professional.

The following day I reached my first meeting point. Just a few yards beyond stood a sign with an arrow pointing towards Los Angeles. It was beginning to feel very real. I was nearing Santa Monica and the Pacific. It was almost within reach.

After a long downhill stretch solo out of Salome, which was a lovely run, we ate breakfast in a town called Hope. The second leg, which Rick joined me on, would not be quite so easy, a thought confirmed by a road sign reading: '*Your* now beyond Hope'. That made three of us, if you included the sign writer's spelling. I'm now praying I don't misplace any apostrophes in this book ...

In fact, Rick finally gave up hope, after a couple of back-to-back runs, in a town called Brenda, which consisted of two RV parks, a store and a church. His boots were hung up for good and he announced, 'If anyone sees me near a pair of running shoes ever again, they have my permission to shoot me!' I promised I wouldn't hold him to that.

Post-lunch, my dirt track let me down and I somehow ended up off-roading on a ridge stuffed with the teddy bear cholla cacti I'd been warned about. These guys stick to anything, especially fleshy bits, and have barbs. They also throw off segments that I now know love running shoes and start their journey into your feet as soon as they touch base. The treacherous descent was punctuated with rockslides, my ankles plunging into the kind of holes rattlesnakes would enjoy. Nature was taking its spiky revenge for this act of trespass.

Eventually I found our venue for the evening in Quartzsite, a bar called Silly Al's – perhaps the slightly more restrained cousin

of Crazy Al's in Louisiana. I'd made it across most of Arizona in time to give us a shot at the border first thing tomorrow, which was a relief, though I'd been pushing myself to Quartzsite that evening for a surprise, which was arriving very soon. We meandered back to the truck stop, joking about the fact that RVs supposedly aren't overly welcomed by truckers and we'd doubtless get someone hammering on the door in the dead of night …

Cue said hammer and Nads's eyes widening in fright. Enter *my* surprise guests – Jamie Wignall (former bandmate, football teammate, eternal mate) and Luli Petersen, who met while they were both studying at LSU in Baton Rouge. They were also part-facilitators of my meeting with Khadevis Robinson. They'd travelled four hours from LA to spend the weekend with us and hopefully soften the blow of Rick's impending departure. It wasn't just Nads who could do surprise arrivals.

I'm sure Rick was enjoying a bit of schadenfreude when I got going less than five hours after the 2 a.m. end to the previous night's festivities, but having barely twenty miles to the California border was as good as any double espresso – as was the sight of a sign offering a choice between Phoenix and LA. One-way traffic only now, thank you.

Rick had handed the baton to Jamie, who joined me on the last run of the day and was instantly treated to some of my choice navigation when we realised we were about to enter the exit ramp of the interstate. We backtracked and were forced to go off-road and head for the hills. These were like nothing we've experienced before, with gradients of 20 per cent or more in places. All the best ultrarunners have walked hills before – or at least that's what I told Jamie as I happily walked them.

The culmination of this run was the biggie – our final state line before the ocean. I was filming a Facebook Live, using a GoPro

for the forward approach while Nads had the camcorder out in a three-pronged tribute to Silicon Valley. After crossing, I told everyone that we were done for the day. Rick dryly remarked that he never got any half days. We were glad to have our new guests, but it was with genuine sadness that we said goodbye to Rick. We had shared many an adventure, having run 610 miles cumulatively together during his stay. He could be my wingman any time.

Chapter 8

CALIFORNIA DREAMIN'

California
Days 62–73
318.14 miles

Injury watch: 1 taped-up Achilles tendon
Choice fuel: Flying Dog Double IPA (11.5%)

My emotions were hard to make sense of. I felt sad to be leaving Arizona behind, which had been so good to us, yet California felt so near to an ending, of sorts. I had a lot of questions to consider. I'd almost crossed the States, Atlantic to Pacific, after all. Would I turn around and start a second crossing when I reached Santa Monica or would I simply stop? I'd worked my way through injury thus far, but who was to say I wouldn't suffer worse? My three-month tourist visa was due to expire soon, and the good grace of US Customs might not be forthcoming. My money wouldn't last for ever, either. We'd spent around £25,000 of our £35,000 budget at this point, though we were considering credit cards, overdrafts and potential earnings in upcoming breaks when I'd have to go home to renew my visa. Was it worth it to be penniless afterwards when so many things were standing in the way of making five crossings?

However, once I start a job, I always want it to be done well, and I also felt the weight of an unspoken promise to my mum. Had I made a difference yet? I could always try harder and run further. So many questions and so few answers. I resolved to enjoy every minute – even the bits that were as big a pain in the ass as a teddy bear cholla would undoubtedly be.

I headed out for a hundred miles over the next three days, off-road or on dirt tracks, to the southern edge of the Joshua Tree National Park. I would spend evenings fretting about the upcoming routes, as even satellite images couldn't tell you what they were going to be like.

The road became so sandy that I was on and off it, testing out the surrounding ground, which contained far more holes – a couple of which I disappeared into. God knows what lived in them, but I didn't need to become acquainted with the local reptile population. My morning thoroughfare was the awesomely named Chuckwalla Valley Road, which was a road, in a valley, that should have been full of chuckwallas – large iguana-like lizards. The disappointments began immediately. First of all, it turned out to be a newly closed road – which obviously didn't stop me. Secondly, I didn't see a chuckwalla all day. I did, however, run past the town of Hell, which had been razed to make way for my old nemesis the I-10. To be fair, a town called Hell was never going to take off, was it?

On rough trails you're constantly looking down so a sharp stone doesn't hurt your feet or, even worse, a bigger one doesn't cause you to trip or roll your ankle. As a result, sight-seeing wasn't on the agenda. We parked up for the night at the site of a Second World War military hospital, facing down the seemingly infinite straight road towards the eastern mountains of Joshua Tree.

Our next morning start was delayed by an email from Jessica Taloney, the breakfast news anchor at WKRG, Mobile, with a

video of the story they did when I was in Mobile, which I still hadn't seen. We smiled at the number-24 high an' tight, clean-shaven Forrest running on day one. He looked nothing like this bearded sun-baked nomad (little was I to know how bearded and sun-baked I'd become).

After fifteen miles of more sand, dirt and hills, I saw Nads in the distance, holding a sign that she'd made, celebrating my 2,000th mile. The local services at Chiraco Summit were the last we'd see for about 60 miles, so we stuffed ourselves silly all the way through to the pumpkin and cherry pie climax.

I was hugging the park boundary on the trails at the base of the Joshua Tree mountains as the sun began its slow, slow, quick descent in the west, and in one of these wonderful pieces of fateful musical coincidence I encounter from time to time on the shuffle setting, a song from U2's *The Joshua Tree* – namely 'One Tree Hill' – came on. As with 'Born to Run' on Highway 9, there had to be some greater power at work. Maybe Bono *is* all-powerful. It brought me to a very important part of the run, for which I had to be properly prepared. I spent a solid five minutes getting the sand out of my trainers before I took matters out of the hands of the shuffle gods and pressed 'play' on *The Joshua Tree*.

I'd been looking forward to this moment since the start of the run, and my excitement had been running at dangerous levels for the last couple of days. I reached the park boundary with the atmospheric organ notes of 'Where the Streets Have No Name' acting as a stage for Edge's delay pedal guitar … slowly building … Adam Clayton's bass slide and BOOM! Full-on euphoria. It was hard to stop myself screaming out, 'Yesss!' My face said it all anyway.

This album has been called Bono's love letter to America, and I was feeling the love. The uphill continued, before a descent into

the Pinto Basin gave the feeling of being in a huge coliseum from where I was able to see Jenny, about four miles away.

Standing between Jenny and I was the small matter of a cholla garden. It seemed as though Joshua Tree was some sort of haven for the evil cacti from teddy bear mountain. There were thousands upon thousands of them, spread across the desert floor. I didn't know whether it was hyperventilating due to a flashback or the increasing altitude, as we'd left the Colorado desert and entered the cooler, higher Mojave desert, but once I reassured myself that I didn't have to wade through them again I felt much better.

A little thing called Thanksgiving was happening the next day, apparently, which meant many people had decided to come and thwart our peaceful Milky Way viewing. The campsites were full so we had to make do with an RV park some miles away, but it was still one of if not the best days of running I've had so far – maybe ever.

Nads and I would not be denied a Joshua Tree sunrise, which meant an early start. Nads told me she'd seen a coyote during the night. She had called for me to get out of bed and see it, but in my sleepy state I'd heard her whistle and shout, but concluded that the sound must have been a coyote in the distance and went back to sleep.

I didn't want today to be only about running – it was a national holiday, after all – so I took a bit of time to see some of the park at a slower pace. Joshua trees are quite remarkable organisms. They replace the saguaro cactus as the dominant large plant in this area – in fact I hadn't seen a single saguaro since leaving Arizona. Joshua trees can grow to about forty feet and can live for up to 500 years. Many of them give out the impression of a man throwing his arms to the heavens, which is why they were named after an Old Testament prophet. Joshua must have been a bit of a shaggy mess to have his name appropriated by them.

I off-roaded without a map, feeling that if I kept the sun at my back I'd have a decent chance of popping out on the road at the right place. This route allowed me to see a whole field of Joshua trees up close, as well as a couple of long-eared jackrabbits zig-zagging through the dust and a ground squirrel doing nothing of the sort.

The park boundary was approaching and I concentrated on keeping my head up and absorbing everything around me. You never know if you'll come back to a place, even one as special as this. On what must have been the eighth playback, 'Exit' came on, a song that I wish would go on longer and get bigger and bigger, but I think U2 realised that if it did, the world would probably explode. It was still long and beefy enough for me to get very excited, and I decided to put the hammer down increasingly to see what fast felt like again. I ran a 5.30-minute mile and held it there for half a mile or so, surprised that I didn't feel tired. I was still elated, and surveying this amazing landscape sent shivers down my spine.

We were brought down to normality with a bump when we arrived at a jam-packed Walmart parking lot, where we were staying overnight. We went in the store and, despite our phones and watches confirming that it was still Thanksgiving Thursday, we were informed by a store attendant that it was actually Black Friday. There was heavy security and a police presence, while the aisles were clogged with people who'd decided to abandon family time to come and get ten bucks off a teddy bear and have a fight over a new TV. We left with our food.

We stayed near the base of the San Bernardino Mountains, whose highest peak, San Gorgonio Mountain, is also the highest peak in Southern California. We were surrounded by hundreds of wind turbines towering all around us, swishing their applause. I

took a semi-off-road route through the wind farm, and it cast my mind back to Texas, where oil was king and there seemed to be a swell of local opposition to the turbines. I wondered if it was different in California. I did find it intriguing that many of these farms appeared to be on Native American land. I wondered what the people who lived there thought of these goliaths in the desert.

The trail was fun while it lasted, with the swoosh, swoosh of the turbines still audible over Leonard Cohen and a dust storm that forced me to wear my shades and pull my buff over my nose and mouth. Eventually, it ended near the I-10, where Nads wore an anxious expression as Jenny threatened to tip over, such was the strength of the wind. It turned out that the San Gorgonio pass is just about the windiest place in the USA. Those wind-farm planners were clearly smart cookies.

The next day the rain came down and I was soaked through and getting a little cold. My mood didn't exactly improve when I was stopped at a security barrier and informed that this was a Native American Reservation and I couldn't come through. My protestations that I was English and on a crazy adventure fell on deaf ears, and I was told I'd have to take my chances with the only road that was available to me, my old pal the I-10 – which, of course, I wasn't allowed on. My bacon was saved by finding a storm drain that went under the road and led to a service track on the other side. The rain was still pouring down, so the dry pass, filled with huge numbers of sheltering tumbleweeds, was fine by me, until I wondered where exactly the stormwater in the hills would be heading very soon.

The town of Banning signalled the start of the built-up sprawl of LA, and also afforded me the chance to change into some more suitable running gear. By nature I'm an incredibly sweaty man, so I hate running with jackets, but being happy and dry (at least on my top half) meant I could think straight. This burst of

weather had come just at the right time, serving as a timely reminder that if I carried on running after Santa Monica I'd need to improve my kit game, when winter would bare its teeth.

The San Timoteo Canyon was an olfactory delight of a road through orange groves and eucalyptus trees – no doubt a stark contrast to my own odour. I 'acquired' a couple of oranges that tasted otherworldly compared to those we get on supermarket shelves in the UK (I think America keeps the good ones for herself), and this seemed to spark some Californian magic as the clouds cleared to reveal the San Gabriel Mountains, which would shadow us all the way to LA.

This was it now. We were in the city. I ran alongside huge concrete channels that felt like the LA I recognised from *Terminator 2*. This led to San Bernardino Avenue, which was straight as an arrow. You'd think this should have made for easy running, but it was the start of an unwanted tango with traffic lights and crossing roads. Hardly anyone walks anywhere in LA, so if you catch yourself at a crossing and the lights have just changed, you'd best get ready for a long wait. I heard a kid, freshly saved by the school bell, shout, 'Run, Forrest! Run!' I tipped my red Bubba Gump cap to him. This kid must have been twelve, tops. I didn't think it was the sort of movie kids today would be interested in watching. I wouldn't underestimate its appeal again.

We were almost there. Day 72 was the penultimate day of the whole crossing. Tomorrow I would enter Santa Monica and touch the ocean. I could almost taste the Pacific breeze, and to add to the excitement our friend Alex, who had flown over from the UK for a neuromuscular disease conference, had joined us the night before. When Alex and Nads saw me off in the morning, the excitement was clearly getting to me, as I ignored Google

Maps' directions and skipped the RV Park road, heading directly down a steep hill through thorn bushes and prickly pear cacti. It was touch and go, but I managed not to crash.

I'd arranged to meet them at the end of the day at Weingart Stadium, not only the home of the East Los Angeles College Huskies, but more importantly the location for the scene in *Forrest Gump* where Forrest, playing football for the University of Alabama, scores a touchdown and keeps running out of the stadium. This happened so often in the film that the crowd mosaic needed to be changed from 'Run, Forrest! Run!' to 'Stop, Forrest! Stop!' After a friendly member of the security staff agreed to turn a blind eye, I managed to repeat the scene.

The LA skyline became more prominent as I moved the last few miles down Cesar Chavez Avenue and towards Union Station. I couldn't get over how surreal this all was. It felt a bit like what an Olympic marathoner must experience once they can see the stadium. I was the latest arrival to the City of Angels in pursuit of a dream.

I was struck by the number of homeless people, contrasting sharply against the background of the shiny, modern buildings and trappings of wealth. To my eyes, there seemed to be a much higher percentage of homeless people who were mentally ill than in the UK, all living in abject hardship. It made me think about the nature of the US healthcare system, and as much as Obamacare – the Affordable Care Act – had its critics, I was seeing first-hand what happened when the poorest in society were not helped by the state. It made me even more appreciative of the NHS and our welfare system in the UK. The slow, stealthy dismantling that appears to be underway with both of these institutions makes me shudder.

We checked into our hostel/hotel – Nads had gratefully swapped Jenny for a more manoeuvrable little hire car for a few

days – then headed out to a famous bar-restaurant called Cole's, self-proclaimed inventors of the French dip sandwich and also doubled – or even trebled – up for both the scene of Forrest and Lieutenant Dan's first meeting after Vietnam *and* the New Year's Eve party in 1972. It would have been rude not to partake in the dish that made it famous, which got a resounding two thumbs up from me. We went for a walk around downtown, taking in the Walt Disney Concert Hall and the Broad, as well as some more social establishments. It was a welcome late night. I had something on the next day, but I couldn't remember what …

Welcome to Tinseltown. Naturally I stopped by the Walk of Fame. Everyone's got a favourite. I love the fact that Muhammad Ali had his mounted on the wall of the Dolby Theatre as no one was going to walk all over him, but there were two in particular I was on the lookout for: Sally Field, who played Forrest's momma, and also Tom Hanks himself. Fittingly, I ran past another Zoltar machine.

The big finale was planned for sunset. It would be quite a welcoming party. We had a planned meeting with Kacey Montoya, KTLA 5 reporter and weather anchor, and her crew. I was also excited to see some old pals, including Jamie and Luli again, who had made the trek from Temecula, and Helen and Chris and their girls Emily, three, and Charlotte, who was only three weeks old. They'd all be waiting for me.

All I needed was one final twelve-mile push to Santa Monica. My route took me past Sunset Strip and through Beverley Hills. After being hemmed in by dry land for days, my heart skipped a beat when I finally saw the Pacific before me, immeasurably vast and blue. Eventually I spotted the sign whose image was burned into my consciousness: 'Santa Monica Yacht Harbor'. It marked the start of the pier, where everybody was waiting expectantly.

I had to wait, inevitably, at some traffic lights, so I prowled the kerbside before I was away, trying to avoid looking at the huge signs that Jamie and Luli had crafted until I reached the end of the pier, where the welcome party awaited me. The signs that read 'Run, Robla! Run!' were turned around to scream 'Stop, Robla! Stop! (For now …!)'. At the corner of the pier, where Forrest 'ran clear to the ocean' for the first time, I paused to close my eyes and allow myself a breath.

Did I think about stopping? You'll never know. Turning around, I set off once more and travelled about ten metres before I realised that I didn't have a clue what to do next. I gave a spontaneous jump for joy and fist pump, and that was it. I was done – for now.

Before I had time to think, Kacey was on me with the mic and began the interview: 'Why had I done it? What were my plans? How did I manage it?' A crowd was forming. Everyone was smiling, but no one more than me. I'd done what I'd wanted to do for years. I'd run across America. The only thing for it now – as I'd been told by Chris Finill, whom I could now stand beside as a fellow trans-continental runner – was to get in the Pacific and go right under. Despite warnings of hypothermia, I informed the KTLA guys that I'd cope. I was northern, after all. I stripped off as I ran to the sea and dived in after a few *Baywatch* strides into the water. It was bloody cold, but by now I didn't care.

I got half-dressed and we went for a meal at Bubba Gump, which was conveniently located at the top of the stairs to the beach. Standing outside I was still shoeless, my retro Nikes resting by the front desk. Nads nudged me and asked if I'd just put '*that* there'. She gestured towards the shoes, where a single pure-white feather had nestled by one of them – just like the feather in the movie that floats into and eventually out of Forrest's life, bookending his incredible story.

While the incredibly hard-working KTLA worked in their van at the end of the pier to get the piece ready for the news at ten, this ecstatic and equally bemused runner drifted with the rest of the team to the King's Head, an English pub in Santa Monica, where over a few beers we waited for the news at ten o'clock. The pub erupted in cheers as a group of new pals first recognised Santa Monica then me – I was still clad from head to toe in Forrest gear, of course. The whole bar chanted my name, which was a great feeling, but also a little weird as well, given that I'd only gone for a run, really.

Okay, it was a long one at over 2,229 miles, but I was right in thinking that it would be a long time before it all sank in. It was too much to process right then. I kept saying in my head as I went to sleep that night that I'd run clear to the ocean. And we still had the feather, so the story continued. The motivation to make a difference would persist long after my athletic itch had been scratched at the end of Santa Monica Pier, and I figured, since I'd come this far, I might as well turn around, just keep on going.

LEG 2

13 January – 28 April 2017

California, Nevada, Arizona, New Mexico, Texas,
Oklahoma, Arkansas, Tennessee, Virginia,
Washington DC, Maryland, Delaware,
Pennsylvania, New Jersey, Boston Marathon,
New York, New England, Connecticut,
Massachusetts, New Hampshire, Maine

3,759.3 miles

Chapter 9

NO EASY WAY OUT

California – Part 2
Days 74–83
331.83 Miles

Injury watch: troublesome right Achilles
Jenny watch: 2 tyres blown ($485)

You may have guessed by now that the run didn't continue immediately after a bowl of jambalaya on the pier. I have a couple of tips for you if you're ever planning a multiple transcontinental run across the United States:

1. Be American.
2. Be independently wealthy.

Forrest had that covered and I didn't, so we had to return to the UK to get an extended visa and earn some money. Now I'd proven that I could cross the continent, I wanted to go back and attempt it again. The thought of running Forrest's full five crossings was lingering in my mind, but for now I just wanted to run again and keep going for as long as my legs and my finances would carry me.

So, with a shiny new stamp in my passport and a ticket to LA in my pocket – not to mention an optimistic return from New York – I was back at Heathrow Airport on 12 January 2017 with a hefty sense of *déjà vu*. Olivia, whose surprise visit in Texas had been such a welcome part of the first crossing, awaited in LA with a 'Welcome Back!' banner, before the serious business began the next day.

Blue Benadum, one of Nike's best running coaches and a crack marathoner in his own right, accompanied by Olympic marathon hopeful Raul Arcos, was waiting for us at Santa Monica Pier for a 7 a.m. start. This jetlagged but well-insulated bag of nerves got out of the hire car and saw two smiling faces beaming down from the pier, ready to run at what was a much slower click than they were used to. My legs, now nicely detrained from sitting on my butt for a few weeks, had been a source of worry, but they seemed happy enough with the brisk trot the guys limited themselves to. Once they departed, I let my legs have a gentler time of it. Day 1 of this leg – or day 74 of the whole journey – was underway.

I've seen smaller walls for prisons than those guarding the mansions and villas of the rich and famous in the Hollywood Hills. I'd assumed that because we were still in LA I'd be able to pick snacks and drinks up en route, but it was all houses and not much else.

Not long after crossing Mulholland Drive, I finally found a gas station. The lady behind the counter, Magdalena, was an eight-time LA Marathon veteran and was so taken with my run that she gave me a CD of her music, which, along with a Camelbak water bottle I'd appropriated as 'road treasure' and the California licence plate I found on the road later, meant I had ten miles of carrying my booty to Santa Clarita. Here, finally, I was reunited with Jenny, freed from her storage by Nads and Olivia.

Nearly thirty miles had been ticked off and it felt good. Being back in Liverpool had felt like being in limbo. I had been desperate to return to the run, but plagued with the feeling that I should also be getting on with my life. I'd had worries about funding, trying (and failing) to get sponsors, planning routes to beat the winter weather and waiting on visas – but all of this had vanished. For now, at least. Bring on the madness, I thought. Run or bust, or maybe run till bust – we'd see. It was full steam ahead now. We'd reach another ocean and think about that other stuff when we got there.

It's remarkable how soon LA stops being LA when you head north. When approaching from the east, I spent four solid days seemingly being in the city. But now, within a day and especially once I'd left Santa Clarita, we were in the sticks. I took what turned out to be a masochistic short cut off-road, and found myself doing a forty-minute mile up what I guessed was a 50 per cent gradient – with an amazing view at the top, which looked even better once I'd caught my breath – followed by a proper lean back and pray job on the descent.

When I reached the RV park, Nads and Olivia were waiting for me behind a twelve-foot-high fence. There was no way round apart from a three-mile trek. I couldn't quite get under the fence, despite a rib-crushing attempt, so over was my only option. This wasn't done gracefully, though it was painful, thanks to my tight muscles – and it did seem to amuse a couple of passers-by.

I elected for an early start the next day, and the morning was the coldest yet, just at freezing point. I resembled a day-glo, reflective, bearded Michelin Man, thanks to the layers I was wearing, as I set off. I passed a sign that said Musical Road and wondered what events had transpired in Palmdale to give it its name. Maybe Johnny Cash put in a shift on the road crew? In the distance I heard a car coming down at a rate of knots, its

stereo audibly blaring from a quarter of a mile away. Wasn't it a bit early for a party? I tried to make out what tune it was until I realised that it was the road itself making the noise. Maybe I could make it play something?

As I should have known by now, Google Maps without satellite images can be a bit misleading as to the quality of the road. Take 35th Street, which sounded official enough but was barely a 4x4 track with huge puddles that forced you to go cross-country and jump across streams following the recent deluge. After the hills and this leg-sapping terrain, I was desperate for concrete to give my muscles, if not my joints, a rest. I'd even resolved to eschew any further shortcuts in favour of a safe bet.

The next day, however, was bliss. I headed north, still in the bright California sunshine, temperatures in the mid-teens Celsius with hardly any noticeable wind. Red Rock Canyon – a popular name for a state park in the US – provided a stunning backdrop to the mid part of the run, its different layers and shades of rock, ranging from orange through vermilion, visible on the hills stretching into the distance. It was idyllic, or at least it was until I barely avoided tripping on a three-litre bottle containing a dark yellow liquid. I'm pretty sure this was a trucker's toilet. Yuck. Unfortunately it wasn't a rare occurrence.

Almost all of the cars passing by seemed to have skis on their roof, no doubt thanks to the long weekend afforded by Martin Luther King Day. People were happy to return my greetings with waves, honks and 'Yeah!'s. It made the miles fly by.

But while my spirits were soaring, Nads was finding things a little tougher than last time. She missed her normal life, and while I was glad to have her with me, part of me thought it would be good for her to get back to some sense of normality. Back home, we'd looked at our meagre finances and worked out that she would only be able to stay until the end of March, though we'd

try to see if she could come back out later on. We had a solution in mind for when the time came. Once I got settled into a routine again, we were going to start a transition period for my possibly going solo, in the likely event that I couldn't find anyone else with the patience of a saint and deep pockets to take over.

I was excited about visiting a brewery, but Olivia was more interested in the roadrunner she had spied in the distance and went to investigate. We should have known. Roadrunners and Jenny equal one thing, and a tyre was duly blown. Jenny had two rear tyres on each side, and to rub salt into the wound our errant tyre took out its buddy and Jenny was stricken. All for the princely sum of $485 to rectify.

Even though I'd only planned on doing thirty-seven miles on day 78, taking us seven miles south of the RV park where we were going to stay, I decided to crack open a Red Bull, bash out the whole forty-four miles and take something positive from the day. As night fell, my new running lights ensured that my descent into Olancha was far less dangerous than some of my previous night-time excursions. As for the trouble with Jenny, what was done was done, and at least we could have a lie-in tomorrow.

Keeler was a once-thriving spa resort and is now a virtual ghost town, with a population of fifty and falling. I had a little look around, taking in the old gas station, which is now a junk art installation, where I saw a makeshift sign on a surfboard pointing out 'Keeler Beach'. Keeler took a big hit thanks to the California water wars in 1913, when the Owens River was diverted to provide water for the people of LA, drying out the lake over the next decade. Most people moved out due to the noxious dust storms that hit once the water exited stage-left, and today this is the biggest source of dust pollution across the whole of the United States.

My first rendezvous of the day was to be near the site of the actual U2 Joshua tree. Or at least I think it was. There are no signs as such, and I was getting bamboozled by conflicting information from maps and images, but with a bit of searching I finally saw it – high on a desert plain, just like the song. I knew that the actual tree had fallen down some years ago, as they tend to do after 200 years or so of life, but it has since been turned into a shrine to the band, with a new, very similar-looking tree standing guard just to the south. The lyrics spelled out on rocks as I approached signalled something special was on the way. That something took the form of a bronze plaque, set in place with an image of the original tree in its pomp, with the words 'Have You Found What You're Looking For?' inscribed. I had.

I left my own message in the ammo case near the trunk of the fallen icon, touched the tree and was suddenly overcome with an overwhelming sense of love – not just for the band, but in a way for anything and everything. It was a lightning bolt of emotion, and it took me back to the life-affirming time I'd spent in Joshua Tree, reminding me of what we'd achieved so far. I imagine this is what people call an epiphany, and I was glad I'd found it on my own, so I could let it all sink in without fear of emotional embarrassment or dilution.

I had another thousand feet to climb before I saw the mothership again, then it was into Death Valley National Park. Some 3,000 feet of descent awaited before Panamint Springs appeared in the glorious January sunshine, occasionally being buzzed by one of the F-18s training in the area. I could see Jenny at Father Crowley Overlook, and when I finally arrived the three of us headed to the rocky outcrop and stared in amazement at the wide, flat valley stretched out before us, encircled by ragged rocky mountains. I looked at the road to Panamint Springs, winding its way down the steep gradient like a stunt driver's wet

dream. I couldn't be bothered with that so I opted for the precip-
itous drop off the side. I managed not to die and cut three miles
off my journey with only a few scratches, though an official
protest to this act of recklessness would later be lodged by my
quads.

The evening was spent in a bar talking running with Mike, the
manager, a gregarious New Jersey native with a mission to
become a serious runner, and Bradford Lombardi, a local boy
and two-time Badwater* veteran who was heading to Phoenix
the next day for a hundred-miler. This was probably one of the
few locations in the world that I could have walked in with a tale
like mine and have people merely acknowledge it with a half-
smile. This was real lunatic runner territory.

In the morning, I wasn't looking forward to climbing from
1,500 to 5,000 feet in eight short miles. I was told it was going
to rain, which meant snow where I was going. I set off towards
an ominous-looking climb into cloud-shrouded mountains – very
Lord of the Rings – and before long I bumped into other runners
who told me they were heading back because of the change in
weather. That wasn't an option for me.

Jenny was struggling a bit with the gradient, which made two
of us, and the snow was stinging my face. It wasn't even blowing
horizontally in the wind – it was actually blowing *up* at times.
Snowploughs were whizzing past, kindly lifting their blades
whenever they went past me, and I got to the summit of Towne
Pass – the highest point, just shy of 5,000 feet – where Jenny was
supposed to be waiting, but there was no sign. It was a virtual
white-out briefly, and I hunkered down to wait for it to subside.

When visibility returned, I decided to keep moving, and I

* Maybe the hardest race on the planet – 135 miles of about 14,000 feet
of climbing in 125°F (almost 52°C) heat.

caught up with them three miles downhill – they'd headed safely down below the snow line. The clouds in the valley below looked incredibly imposing – and then it dawned on us that, within a couple of minutes, the advancing edge would envelop us. I was kitted out with a running light that made me resemble Iron Man as I ran headlong into the fog. Visibility was less than a few hundred feet and it was with a sense of foreboding that I made my way towards Death Valley proper – famed for being the hottest, driest place on earth. I half-expected the ghosts of pioneers to emerge from the gloom. The clouds finally started to clear and then I could see the stars sprawled across a tar-black sky.

I indulged in some anti-altitude training of sorts, with an easy descent to 200 feet *below* sea level and a place called Furnace Creek. So many place names in this area remind you that for most of the year you would cook in your own juices. Today, however, someone had definitely forgotten to stoke the boiler. When I glimpsed Furnace Creek in the distance, I was surprised to see a lush verdant landscape with palm trees, and was relieved to learn that it stemmed from a redesigned system for the local springs that actually enhances water retention in the area. All was well in my environmental moral bible.

Seventeen miles took me to Badwater, to see the lowest point in the USA at 282 feet below sea level. Pure salt rises from the ground here through cracks in the mud. I had a little taste, and I can confirm it was salty. When the first pioneers reached this point, even their donkeys refused to drink the water, and hence the name was born. The local guide said the only people stupid enough to come to Badwater in the summer were mad dogs and Englishmen. I told him I would be intrigued to come back, but I wasn't so sure about the Badwater race.*

* I am now wavering. Maybe watch this space?

A few more miles later, I met Krzysztof Jarzębski, a Polish athlete who was braving the hills and elements in a series of wheelchair marathons in the Valley and its surrounds. I feel a real kinship with fellow adventurers, and I was full of admiration for his plan and future dream of building a training centre for para-athletes in his homeland.

My route took me past Zabriskie Point, the place where U2 shot the front cover for *The Joshua Tree*. The Edge's main recollection of the shoot was that it was 'bloody cold'. I concurred. It was also now raining, making the already varied palette of colours of the different rock layers even more intense. I posed for a photo, trying to harness the Edge's inner cool. My inner was cool and it continued to be as I climbed to 5,000 feet again, into a howling gale that felt as though an invisible hand were pushing me back.

There was the surreal sight of the Amargosa Opera House – yes, an actual opera house – at Death Valley Junction, before a very unceremonious border with Nevada, where there was no sign, and so no Lean. We struggled to work out exactly where the border was, until we noticed the change in asphalt – each state maintains its own roads.

I'd just crossed the biggest national park in the contiguous states, as well as the Bear State of California. I wouldn't be back in a hurry – maybe the amount of time it would take to run 7,500 miles, but the idea of that sounded as ridiculous as it ever had.

Chapter 10

GETTING LUCKY

Nevada

Days 84–87

114.15 miles

Jenny watch: new carburettor ($700)

The road signs around Pahrump – another amazing name for a town – warned of wintry conditions and to take care. Soon enough, it was time to stop for the night. We huddled up and checked the overnight temperature of –2°C (28°F), wondering what that would mean for tomorrow.

What did it mean? More snow. Today we were going to climb to our highest point since the Guadalupe Mountains in Texas. There were reports of states of emergencies being declared in nearby mountain regions and people being stranded overnight. However, I was confident that the sun and the well-drilled road teams would ensure safe conditions for the RV, though Nads was obviously feeling a little trepidation. I layered up and, as the breakdown lanes were a bit cut up with rough snow from the ploughs, the central reservation seemed to be the safest place for me. The summit revealed the kind of Nevada vista I'd expected before we arrived in the state – no

snow, for starters, and on the horizon, Las Vegas, Sin City itself.

We had an exciting rendezvous lined up at the home of a long-time pal, Lenny, and his wife Laura. I'd last seen them in Vegas – at their wedding. They kindly let us park Jenny outside for a few days so me and the girls could taxi to the medieval-themed Excalibur Hotel and Casino. We slipped through the door to be confronted with lights, gambling, the smell of indoor smoke and bars galore. Vegas, baby! I've always wondered what Forrest would have made of Vegas. Maybe he bypassed the strip completely, as it might have made for a very different movie if he'd been sucked in by it all.

At the very start of the run, my ambition had been to cover a marathon or so a day, but that was becoming a comfortable distance by now. With the average creeping towards the high thirties, I'd arrived in Vegas a full day ahead of schedule, which gave me time to do some publicity for the run. Kacey Montoya had helped to arrange an interview with KLAS-TV, the CBS station in Vegas. I still didn't really know what I was doing in front of a camera, but I was becoming a little less wide-eyed and wooden – or so I hoped.

My miles for the day were taken down the Strip, taking in the Fountains of Bellagio, the Grand Canal at the Venetian, the Streets of New York and a few bars. I put a whole dollar in a slot machine and won 24 cents. I quit right there, while I was ahead. In Vegas, it can take you ten minutes just to walk past a single hotel, such is the enormity of things here. We took the tram to the Mandalay Bay, so we didn't have to walk far to the famous Las Vegas sign. It was just as it looks on the telly. There was the obligatory Elvis crooning away and also an 'official' photographer standing ten feet in front of the 'No photographers are licensed to operate in this area' sign. Sin City indeed.

We experienced some highs in Vegas. The Cirque du Soleil show *Love* at the Mirage, based on the music of the Beatles, was truly incredible. Tough Prints, a local print shop, pimped my kit by putting 'RUN ROBLA RUN' on the front of it, which would prove to be the best thirty-five bucks I spent on the whole run. It brought more encouragement from people I met and it meant I was called Robla by everyone now, not just Nadine, which I found kind of cute.

It being Vegas, of course, meant there came some lows too. The $700 cost of a new generator carburettor and service for Jenny might not have rivalled the biggest losses in this town, but we were also saying goodbye to Olivia, who was returning to London, so we were feeling pretty melancholy. The three amigos were two once more.

It was pitch black in the morning when I left the RV to head back to my starting point. Carl Frampton was fighting Léo Santa Cruz at the MGM Grand that night, and the Irish fight fans were still drinking from the night before. It was freezing, and the scantily clad ladies loitering in the shadows must have had a constitution of iron. I took the opportunity to run the length of the Strip, to the Mirage and back, and caught the sunrise perfectly. Night and day on the Strip. One more time, past the famous Vegas sign, before hanging a left past the airport from where Olivia had left us the night before. Despite everything that had tried to pull us down in the last few days, we left Vegas still lucky.

Chapter 11

ARIZONA SUNSETS WILL GET YOU EVERY TIME

Arizona

Days 88–100

489.72 miles

Injuries: wrist sprain – couldn't even open a
Dr Pepper with it

Jenny watch: Broken window mechanism fixed,
a new battery installed and the generator
sorted (again)

The Hoover Dam is stupefyingly colossal, though I had mixed feelings about it. It's had a huge environmental impact and is one of the reasons why the Colorado River doesn't reach the sea any more and fish populations, including rare species, have dwindled. But knocking it down wasn't going to help and there are ongoing efforts to minimise its impact, so I decided to keep an open mind and marvel at the feat of engineering. Apparently, if they'd poured all the concrete in one go, rather than block by block, it would still be setting today.

I crossed the state line and also from Pacific Time to Mountain Time Zone, which added an hour onto my watch and contributed to the frustration of a late start that day. I scrambled down

a rough rock face onto the road that would get me onto the highway and promptly slipped, landing awkwardly and painfully on my wrist. Would it cut short my fondness for breakneck downhill slaloms? What do you think?

It made a nice change to pass under a dedicated highway wildlife crossing, for bighorn sheep, after all the roadkill I'd seen on my first leg. The roads were as busy as you'd expect for the main route to the Grand Canyon from Vegas. I thought I caught a glimpse of a healthy chunk of the Colorado River at a scenic lookout, which was technically a thin sliver of Lake Mohave, another artificial lake created by further damming downstream.

In the morning, disappointed with the previous day's thirty miles and emboldened by a quiet overnighter and advice I'd received on the first leg of the trip from Chris Finill, I decided to introduce my 4–2–1 strategy. This was the miles run in a single effort, with a slow half-mile in between – so four miles, slow half mile, two miles, slow half mile, one mile – totalling eight miles. There would need to be some flexibility, but if I did that five times in a day I'd have forty in the bag. It also allowed me to run at a pace I felt was decent enough without prolonged, unabated trauma to the muscles and joints. I've seen trans-con runners adopt the strategy of a slow pace, nine minutes per mile or over, but this felt alien to me, and I figured if I were to alter my gait deliberately I would probably be more at risk of injury. I wanted to feel like I was running rather than ambling.

A successful 40 miles later – as well as passing the 500-mile marker on this leg – and our day ended in Kingman, a town famous for being on the junction of Route 66 where the road is still intact and hasn't been replaced by the Interstate Highway System. The only kicks we got to begin with were in the teeth when we pulled into our home for the night at a truck stop. It began with the generator, which was supposed to be in tip-top

condition, conking out again. Then we were woken up by a truck driver hammering on the door and scaring us out of our beds at 10.30 p.m. He demanded that we move and let him park where we were, even though we had permission to park there and there were plenty of other spaces left. The unwritten rule of parking in a truck stop is not to upset truckies, which was fair enough, and this was the first rude one we'd met so far. I admitted defeat, but not before winding him up to the point that I expected steam to come out from his ears. Hopefully there wouldn't be any repercussions.

Initially, Jenny wouldn't start. The emergency starter saved us our embarrassment and got us over the road. I then looked at the fuel gauge, which was reading empty, two hours after we'd filled up at that same truck stop. Nadine had heard a rattle around the side of the van earlier, which I'd dismissed as nothing, but it was clear to us that someone, possibly this guy, had stolen our fuel. I was straight onto the local police, who came out very promptly, took photos of the dashboard display and pledged to return in the morning to investigate further. We didn't get to bed until 1 a.m.

There was always a fine balancing act between what Nads wanted and what I wanted when things went wrong; I always had one eye on the mile count while Nads didn't want to be left with all the work to do. I knew that if I wasn't going to be filed under 'asshole' I would have to do the decent thing and take a drastically chopped distance for the day.

When the officers returned in the morning, Nadine had already shared some news with me. The tank was full and, rather than a gas rustler, the new diagnosis was a temporarily jammed dial. Crippled with embarrassment, I relayed the 'good' news to one of the officers. He raised an eyebrow, then smiled and flipped his notebook shut. I guessed that would save him some paperwork

– and the coffee and donuts over the road might help prevent any hard feelings.

The forecast was great for the following day, and after the first run I decided that it was time to break out the sun cream. Not bad for the first day of February. The 4–2–1 plan was back in play, and it was a good day. They often happen after rubbish days, which was fortunate, as the run, like Forrest's, would continue for as long as I was enjoying or 'feeling' it. I'd always said that if it became a burden beyond the physical and every day was a drag, I'd call it a day. I'd set myself a limit: seven consecutive bad days and I go home, unless I somehow manage to get to the fifth crossing of the country – then all bets were off. This certainly wasn't that day.

I was back in saguaro country by sunrise the next day, which left me in no doubt where I was. They seemed to be an Arizona preserve. Our next meeting point was a place called … Nothing. There was something at Nothing, but not much: a big sign saying Nothing; half-full litter bins surrounded by litter on the floor (don't get me started); a derelict hut and a telecoms mast; and a lot of people parked at the top of a big hill.

Leaving Nothing, we went looking for something – and found it, though it was completely unexpected: a Joshua tree. There'd always seemed to me to be an unwritten law that Joshuas and saguaros generally had their own patches and, like feuding Mafia families, they stick to their own, but there it was. Was he a scout, sent into hostile territory to make peace or carve out a new territory according to the laws of the time? I moved on, eventually coming to a sign that read Joshua Forest Parkway of Arizona. That explained that, then.

Things a Trans-Continental Runner Needs to Know but Never Thought About Before, entry number 16: the top three truck types in order of those most likely to take your cap off as they go past.

3. Car transporters

2. Trucks carrying pipes

1. Hay lorries. Hay lorries grip the air like a vice, and if I ever fall out of a plane without a parachute I hope there's hay on board. If I don't remember to grab my cap, it's gone, and I have to retreat twenty yards or more to retrieve it. Chin to chest is another good tactic for hay lorries, with the bonus of avoiding flying debris in your eyes. A combination of two trucks closely following each other is another sure-fire winner, the old one-two sucker punch.

Our town for the day was Wickenburg – a proper Western town, with a carefully preserved period town centre. As if to prove it, it's also the Team Roping Capital of the World! Wickenburg was built with an abundance of roundabouts – or traffic circles, in local parlance – and, whether they worked or not, these marvels of traffic management couldn't just exist, they needed to be celebrated with sculptures. *Big* sculptures.

When I reached Jenny later I was immediately told to be quiet by Nads, which wasn't that unusual, as I'm often booming of voice with my music still playing when I arrive at the mothership, but this time there was good reason. Nads had noticed some movement in the distance and then realised it was all around us. A group of ground squirrels popped up from their burrows, and Jenny's blacked-out windows meant we could watch them without needing to hide. Seeing *live* land-based wildlife was a real treat.

The second surprise of the day was the town called … Surprise. I wondered if anything unexpected would happen, just as I found a calendar called *Finding Jesus* on the ground, still in its wrapper and reduced to twenty cents, as it was the 2016 version. In actual

fact it was a *Where's Wally?* Messiah version. That cheeky Jesus was lurking in the crowd in twelve scenes such as music festivals and sporting events, and the aim of the game was to find him. I'd found Allah (the town) and Jesus within the space of a day. Who would be next?

I'll always remember my time in Arizona for the perfect weather conditions I experienced. In fact I delighted in telling locals how pleasant the weather was and watching their jaws drop. At this time of year it was like a gorgeous English summer's day. It was getting warmer, though, which wasn't a complete surprise seeing as we were almost in Phoenix, the hottest big city in the USA.

I was running through the heart of the city unsupported, as we'd found that cities weren't an RV's friend. I took my hydration pack, a few bars, a waist bag with a bottle of milk and my usual amount of porridge oats, in the hope that they would soak, and I set off. Three tiny little scrutlets – Nads's and my name for little scruffy dogs – were foraging for scraps of food on the street. Two ran away, as they were afraid, but the cutest one was very friendly and came right over. I genuinely thought of giving Nads the best surprise ever, as she'd said that if we found a stray it could well find itself in the UK next year. I couldn't bring myself to tear him away from his two pals, though, who were looking out from a nearby bush, hoping their friend would be okay.

I ran past the Tovrea Castle, a folly on a hill beloved of Phoenix, and soon I was at Tempe Bridge for an interview and photos with the *Arizona Republic*, the biggest newspaper in the state, which I was stoked about. I ran over the bridge into Tempe, a buzzing, hipster area, and all around the colossal Sun Devil Stadium. I thought for a moment how great it would be to live there, but then I remembered how hot it got around these parts in summer.

Nads had endured dozens of RV parks refusing us yesterday, as they only catered to over-55s. We had to beg to get a space in the KOA, which was full to the brim. We found a great little restaurant called Dirtwater Springs, where we bagged a prime spot to watch one of the best Super Bowls in recent history, though my heart broke for the poor Atlanta Falcons, who blew a huge lead as they lost to the New England Patriots, over the decent beer. We left to choruses of 'Bye, Forrest!' It was becoming the norm now.

The next morning I was on Highway 60 again, which would take us up into the mountains before dropping us onto the 70 for our re-entry into New Mexico. Rising from open desert and scrub, I climbed into the mountains and cast nervous glances at the weather forecasts and the Tonto National Forest. It's the largest national forest in Arizona and is reputedly named after a splinter group of Apaches who were deemed foolish for living in such a remote location, away from trading routes. The road wound through spectacular valleys flanking the peaks, dotted with saguaros and palo verdes.

Today we would pass the 3,000-mile mark. Nads was waiting and filming as I unfurled my banner, and while we were mucking about taking photos, a couple of cars pulled up to see if we were okay. The drivers were Kenny and Sheba, whose excitement was heart-warming, as was the offer of dinner and showers at theirs, water for now, a lift if we needed it – the moon on a stick, it seemed. For once, we were already as good as it got and thanked them, and they pledged to follow us online.

The next day, I had to negotiate a reportedly dangerous tunnel and a tough first few miles, with a 1,500-foot climb on the cards. On the approach to the tunnel, there was an unusual but poignant sign: 'The consequences of jumping from this bridge are FATAL AND TRAGIC'. Above it there was a number for a crisis hotline.

What sort of turmoil have people gone through to find themselves requiring the information from these signs? It made me realise that any of my worries were inconsequential. I looked over the edge. I started running again – quickly.

After that, the tunnel wasn't so bad and the hill felt easy enough. I met Nads at a place aptly named Top-of-the-World before heading onto Miami, which bore little resemblance to its Florida namesake but was in fact the Copper Capital of the World, apparently, complete with ugly scarred hillsides where mountains had been reduced bit by bit to nothing. It seemed like another unfortunate ghost town in waiting. I hoped that once the mining companies had finished here, they'd do something to help the town, but we all know how these things usually go once the money's gone.

Sheba from the day before had messaged me first thing, as she wanted to have her photo taken with me, and she was waiting in Globe where she treated us to lunch, regaling us with tales of the area. Before we parted ways she gave me two very kind gifts: a type of stone called an Apache tear and an amethyst, polished by her dad, who wasn't around any more. I found it hard to accept this, as it meant a lot to her, but she wanted me to have it, to help relieve stress. I made a return promise, that I'd take it with me the whole trip.

I then had the privilege of running through the San Carlos Apache Reservation. I'm not one for coming over all New Age, but I definitely felt some sort of connection with *something* – the history, the land, the people, I don't know. Alone on this desert highway, Aerosmith's 'Livin' on the Edge' drew my day to a close while I was in deep contemplation, a strange contented melancholy, wondering whether we can arrest the slide this world seems to be in. Thankfully, Nads was waiting further up the road

to take me back to the RV park and tip me back on to the sunny side.

Maybe I needed a musical rescue and Iggy Pop had heard the distress signal. The sun was shining, I'd had a good sleep. I had the lust for life and danced down the road to the first song of the morning. Running felt so easy all day long and I got lost in the music and surroundings, eloping with my mind.

Eloping wasn't an option for my body, however. I woke the following day with a crimson face, neck and shoulders, especially down the right side of my body, which had been having a stare-down with the blazing sun the previous day. When I saw that the weather was due to step up again, I knew I'd been lucky and couldn't get caught out again. I applied layers of factor 50 and set off down the Old West Highway, mostly through farm country, through Thatcher, home to one of the best 'welcome' signs I'd seen, a swooping eagle flanked by a mean old lizard with a Stetson, six-shooter and an eye for trouble. Soon, Thatcher merged into Safford, before this faded again into the open country that I'd grown so fond of, with snow-capped Mount Graham keeping watch.

I was wondering what emotional bribe I could give my psyche to help me with the last few miles when one came along in timely fashion. The blue sky suddenly changed into a mixture of reds, oranges and yellows as the best sunset of the trip so far descended on us. Two hundred metres from Jenny, a car pulled up beside me.

'Hey, where are you running to?' one of the occupants called out.

'Maine,' I said.

'Unbelievable! I'm walking across the country!'

I stopped and turned. The voice belonged to Chris Andrews, a cheery, fellow beardy from Suttons Bay, Michigan, who had

walked all the way from Washington DC, over the Appalachians in winter, self-supported and pulling a cart. He was crossing to fund his own initiative, Let's Talk, whose aim was to get America talking face-to-face again, instead of indulging an over-reliance on technology. And if recent world events had shown us anything, people needed to talk and listen more.

Chris had just crossed the New Mexico state line, which I was going to hit tomorrow. I was excited to talk to someone face to face about solo life on the road, in preparation for Nads's eventual return to the UK. Chris was smart and streetwise, and he gave me invaluable advice about knocking on strangers' doors, which I would come to rely upon some weeks down the line. It was such a welcome chance encounter. I couldn't help but think that the slightest change in my day – less time taking photos, running at a slightly quicker pace for a short while – and I'd have reached Jenny a few hundred metres ahead and been in the RV, each of us oblivious to the other's existence.

Before long I was descending to the town of Duncan, a cute little place of around 800 people that seemed a solid community. After a delicate chat about the recent election with the post office clerk, I went outside, where a lady advised us to take some of the green peppers at the side of the road – they were free from a local farm who donated their excess to the locals. They tasted as sweet as the gesture. As Duncan disappeared behind me, it was time to say adios to Arizona, possibly for the last time. I clung to the hope that I'd be back. Arizona held a special place in my heart already.

Chapter 12

THE NEW MEX FILES

New Mexico
Days 101–10
391.72 miles

Possible alien abductions: 1
Jenny watch: stuck in the mud

There was a mutual buzz between Nadine and me for New Mexico, as it was one of our favourite stretches last time. The initially barren-seeming landscape was in fact a ruse, revealing more and more subtle beauty the longer you looked. I wanted to avoid previously run roads if I could help it this time, and my plan for the next couple of days was to find whatever road or track that flanked the I-10 and try to stick to that, avoiding the interstate. In the absence of a reliable guide as to which roads were legitimate 'runways', I decided to employ a philosophy of seeking forgiveness rather than asking permission.

I eventually found an immaculate straight and flat gravel road on the other side of the train tracks that was okay, legally as well as physically, for me to run on, with no traffic apart from the occasional mile-long train. It was a strange combination of peaceful and lonely, and it was a pleasure to tear myself away

from my new surroundings to see Nads every now and then, especially at another old gas station with some great graffiti that reminded me of Melbourne.

I crossed the Continental Divide for the second time, now chasing the raindrops all the way to the Atlantic, which, for me, meant no turning back. A good day was followed by a rough night, thanks to the colossal volume of traffic, even in the early hours, from the I-10, which wasn't separated by any physical barriers from where we were, and a howling wind. Come the morning, the wind was still at it, as bad as anything I'd experienced so far. When I'm training for a race, I consider wind as free strength training, but it was all about getting to the end here as fresh as possible.

At one point I was sandwiched on my service road by a mile-long freight train on one side and a stream of trucks flying by to my right, which might not sound like much fun but it was how I'd imagined big stretches of the run. At an intersection a sign asked me if I wanted Truth or Consequences, or Elephant Butte. My already low mood dipped further when I heard that the wind was meant to get worse, but in a rare spot of meteorological good news, it didn't. Instead, it started to hammer down with rain. Memories of childhood holidays spent listening to the drumroll of raindrops tapping at the flimsy roof of a static caravan in North Wales flooded back to me as the fields around us seemed to become waterlogged.

We woke the next morning with a strange sense of foreboding. It was Jenny. Maybe our internal spirit levels had alerted us subconsciously to our lop-sidedness, as the overnight rains had turned our parking spot into a bog. We appeared to be stuck. We hastily gathered straw under the wheels in the freezing cold and tried reversing, but our efforts were fruitless. We were well and truly stuck – and then it began to pour down with cannonball

raindrops again. I ran to try to get help, eventually finding a friendly local farmer who offered to get a tractor over to us but offered no guarantees that it wouldn't pull something off the front of Jenny. Nads tried a more orthodox approach, calling our breakdown cover who agreed to sort it out.

Problem solved, I told Nads I should be on my way … which thankfully went down okay. It took me ten minutes to get my numb, swollen hands into my gloves and off I went, a headphone earbud lighter, which had somehow gotten lost in the mud. A short while later, someone passing by offered to tow us out – for $700. I don't think I need to explain how that was received by Nads.

I put down another eighteen miles in one go with minimal breaks. I saw some cows lying down – surely making that thing about rain and cows true – and also wild deer and jackrabbits, racing wide-eyed into the distance, away from this weird-looking potential predator. But the cherry on what was becoming a rapidly improving cake was the unexpected airing of 'It's a Long Way to the Top (If You Wanna Rock 'n' Roll)' by AC/DC for the first time on the whole run. I felt that this was an unofficial anthem for my adventure and was so sure it would materialise at the right time on shuffle, just like 'Born to Run' had on the way into New Mexico for the first time. I'd established a rule whereby I would not permit myself to walk if any AC/DC songs came on, and if I was on a walking break that would mean the end of it.

I had an eye on a big old mountain that would take me out of Las Cruces. It was a slog, but I seemed to fly up it, probably too quickly, and at the top I was informed that I was now in White Sands Missile Range, where I was not to take any photos and to keep my beak out of any areas not on the road. I kept to the

road, certainly not taking photos of the lovely snow-peaked mountains, vast plains and mock-ups of rockets.

I'd almost forgotten it was Valentine's Day, which I think is a bit of a sham, but it was an excuse to go out for the night. We enjoyed a few beers and a huge dinner at the High Desert Brewing Company, and Nads was presented with a heart-shaped cheese-cake on the house. Who said romance was dead?

The next day, we took in the White Sands National Park, a huge expanse of pure white sand dunes, made of gypsum, which have the peculiar quality of being so white that they reflect, rather than absorb, the sun's energy. It's possible to walk bare-foot on them in the height of summer. The closest I'd get, of course, was a glimpse of them at the side of the road.

It was nigh on a marathon of uphill grind to 'Tulie' – Tularosa. It wasn't particularly steep, just enough to let me know it was always there, eating away at my stamina. I passed Alamogordo first, which offered signs for the local Fighting Tigers sports team, a toy train museum, the second largest roadrunner I'd ever seen – Fort Stockton, TX was still in the lead – and the coup de grâce, the world's biggest pistachio, centrepiece of PistachioLand. Tularosa wasn't to be outdone, with two huge water tanks high-lighting the success of the town's 2005 national champions in team roping, and the state-conquering Wildcats, who were untouchable in the nineties. School sport here is awesome. I love it. An interesting footnote for the day was that Tularosa was less than fifty miles from the site of the first ever atomic-bomb deto-nation, at the Trinity Site in the White Sands Missile Range on 16 July 1945. They used one for real three weeks later.

The road started to curve upwards, and soon enough the mighty Sierra Blanca mountain was looming – eighty miles in the distance. While I didn't have to get to the 12,000-foot-high peak,

I did have to get over the range, which ran through the middle of the Mescalero Apache tribe. The Mescaleros are a proud people, with street art depicting famous warriors, messages imploring you to treasure your life, family and people, and tales of hope. Looking through the trees I'd occasionally catch a glimpse of snow, and these glimpses were becoming more frequent. I saw Jenny parked about half a mile away in the midst of a whole heap of snow, and I topped out at Apache Summit – 7,591 feet above sea level, beating my previous altitude record on this trip by about 1,700 feet. It was as good a place as any to stop for the day.

The main theme for day 107 was William H. Bonney, or Billy the Kid. The historic markers on Highway 70 told of his exploits in the now ghost towns along the route, as well as tales of conflicts between settlers and the Native American tribes. I passed through the settlements – often one-horse towns – of Glencoe (population: I'm not sure apart from a shop) and San Patricio – ransacked by a posse looking for that pesky Billy, and later home to artist Peter Hurd – before we got to Hondo, which was the biggest of these places, home of the Eagles and a Western curio shop with a great line in signs: 'Build the wall – where my wife can't go back'. And my absolute favourite, 'Bad decisions make great stories'. I identify heart and soul with that one.

The gloriously named Tinnie was next up, which had some decidedly ghostly looking buildings but was still very much alive and kicking, with a new post office, fancy-looking restaurant and fantastic metal sculptures created by a chap called William Goodman rising into the sky near the old gas station. In the fading light I reached Picacho, where we'd decided to stay in the post office parking lot, as it seemed the easiest option. I'd loved my day of descent through these little pieces of history, often in beautiful locations. Life ebbs and flows with the times in these

areas, and I had grown to have amazing respect for people who tough it out or make steps to improve things. Life adapts, as always.

Before we got to Roswell, we had lunch by the Atlas intercontinental ballistic missile silos, which apparently are empty, no longer pointing at Mr Putin and privately owned. Who buys these things? All types, apparently, from people looking for a secure marijuana farm to those building Doomsday condos. Whatever floats your nuclear submarine, I guess.

I had an interview about the run with the *Roswell Daily Record* – the same paper that publicised the infamous Roswell incident of 1947, when an unidentified object landed in farmland nearby and the remains were taken to a nearby airbase to be covered up, autopsied or acknowledged as a weather balloon, depending on what you believe. It happened to be the same year that David Bowie appeared on earth. I wonder ...

Roswell loves a good alien story. For the bargainous entry fee of five bucks, we were let in on the secrets behind them at the International UFO Museum and Research Center. As a scientist, I think that in this infinite universe the odds of there being life out there are fairly favourable. There certainly *could* theoretically be a life form capable of travelling the many light-years here. But why do they always seem to be drawn to a farmer's field in Idaho?

File me under sceptical, then. But the more you read the eye-witness accounts of a large number of seemingly responsible people, the more you start to wonder. And when you see the ridiculous explanations and evidence-switching of the US Air Force, including later statements that the alien bodies were crash test dummies that they used from 1954 to 1959 (wasn't the 'crash' in 1947?), you start to think that they could have been on to something.

My highlights of the exhibition included the fella who'd been 'abducted' before being arrested at the conclusion of a high-speed chase. He said that the alien had been in the passenger seat alongside him, egging him on, and disappeared just as the police walked up to his car. Priceless. A newspaper article highlighted the British reaction to all the furore, which was to compare it to the Loch Ness Monster and suggest that the whole thing would blow over if the 'Yanks took a stiff drink of soda'. To top it all was the discovery that 'Foo Fighters' was a term to describe UFOs during the Second World War, clearing up the origin of the band's name for me.

As Roswell began to fade into the distance, the Double Eagle Ranch, home of the 2009 Kentucky Derby winner Mine That Bird, passed by on my left and the ornate metalwork sign of LA Ranch on my right. I had the rare pleasure of seeing wild deer while the sun started to drop and my shadow lengthened, racing away from me to the finish.

A derelict gas station and store, with some of the ubiquitous graffiti, set against a stunning blue sky made for a spot of déjà vu and a good photo. As I took it, I noticed something watching me – a small herd of deer, about ten strong. When I started running, they ran towards me, but when I stopped to take a photo they scattered, leaving a straggler behind.

I saw Jenny in the distance, next to a store advertising home-made pies. Lunch was sorted, in my mind, before I got closer and saw it was shut, much to my disappointment. The local cattle on the other side of the farm gate undoubtedly didn't share my disappointment.

Two hours down the road, I came across what I initially thought was another herd of deer, but there were about ten of them again, and when they scattered there was always that same straggler, with whom I identified completely. Later, I caught a

local Roswell radio interview I'd done, sandwiched between an advert for handguns and a piece about pecan weevils, a combination that might have been a never-to-be-repeated radio first.

It was starting to look more agricultural and a lot less like New Mexico, as if I'd been picked up from the desert and mysteriously dropped hundreds of miles away. Surely that wasn't possible, but I seemed to have a blank spot in my memory after talking to that green fella with the big eyes ...

Remember, the truth is out there. *Believe.*

Chapter 13

TX2

Texas

Days 111–22

500.2 miles

Emergency toilet stops: 1

Toenail watch: second toenail on left foot sore
and probably a goner

Dead animal count: 3 coyotes, culled by farmer,
and a raccoon (God knows what the poor raccoon
did to deserve his fate)

We reached the Panhandle Plains. Texas has a lot of oil, but it's also great for farming cotton, which explained the surreal scene of ploughing patterns around oil derricks, with eau de petroleum and a cavalcade of noisy trucks for a backdrop. I stopped at a disused barn for a rest, and I was trying to work out what had made some of the unusual droppings in the corner, when a barn owl swooped past my head. There was another one in the corner. This magnificent bird flew out but kept coming back to look through a hole in the roof at me. I could hear sounds indicating that there might have been some babies, so I figured I was stressing them out and left. I notched the last miles of the day down

cotton-lined roads with the sun at my back. Things weren't so
bad. In a beautiful coincidence, we finished for the day in a place
called Plains and I was reminded by a news article that it would
have been Kurt Cobain's fiftieth birthday the day before.

Farmland as far as the eye could see on a dead straight road,
and there wasn't going to be any change for a long time yet. My
mind needed something to occupy it. The onset of explosive diar-
rhoea just before I reached Gomez was the unexpected and
unwelcome diversion. Shit was going down and it was on the
verge of becoming literal. There was no cover anywhere, just
harvested cotton fields. It was a choice between limping to the
houses I could see a mile away on my right or becoming the
worst scarecrow you'd ever seen. I now know that there are few
greater humiliations than asking a complete stranger if you can
use their toilet, then enquiring where the toilet paper is when you
can't find it, leaving them in no doubt as to your intentions. My
guardian angel was Gerald. I tried to skulk out with my head
down, mumbling a thank you, before he collared me: 'Si' down!
I wanna talk to you!'

There was no real option not to. It turned out that Gerald was
a seventy-three-year-old Gomez man, born and raised, who lived
next door to his daughter-in-law, granddaughter and grandson.
He had recently retired from his second job with a fertiliser
company, but he still farmed cotton and stayed active, having
been a good track runner in his youth. With his little chihuahua,
Kato, sitting on his knee, he told me that Gomez had once been
set to become the Metropolis of the Plains, losing out by three
votes to the appropriately named Brownfield, and all that
remained of Gomez was the cemetery, church and a few houses.
Gerald might, in fact, *be* Gomez. He'd watched *Forrest Gump*
for the first time the night before – to be fair, it was on TV a lot
in the US – and I worried that his family would return later that

evening, hear the story about the film character that came to visit Gramps the night after he watched it and decide it might be time for a care home. I couldn't imagine Gerald taking that lightly.

When I reached Lubbock, the birthplace of Buddy Holly, I turned off the highway onto 19th Street, which was something quite remarkable. I think you could live your whole life on this street, never leaving it, and have a full and rich life. You could be born at the hospital, which would hopefully keep an eye on you (if you had health insurance) as you progressed through the elementary school, high school and Texas Tech University, where you could get a job and live in one of the beautiful houses lining the road, buy an automobile at the local dealer, go to the theatre and have some great nights at the bars, coffee houses and restaurants. It was no detour at all to get christened, married and eventually eulogised over at your funeral at one of the churches. This street was so American Dream I'm amazed Bruce Springsteen hasn't written a song about it.

The Buddy Holly Museum and the Allison house next door, where Buddy wrote many of his hits, including 'That'll Be the Day', were fascinating, in a haunting way, and the original artefacts were something else. Sebastian, our guide, was also very knowledgeable about the Beatles, for whom Buddy was their major influence. No Buddy, no Beatles – they were named to be aligned with the Crickets, Buddy's band. Buddy was tragically killed in a plane crash at the age of twenty-two – unbelievable, when you consider his achievements – and the sight of his famous glasses, recovered from the wreck, was overwhelmingly poignant, providing a reminder of my own mortality.

The night-time temperatures got down to −3°C (26°F), which I classified as DEFCON 3 in terms of RV cold conditions. Extra blankets on the bed, long sleeves *and* a hat were called upon as

we settled near a huge phone mast on top of a hill looking down towards Dickens.

Our target for the next day was to get past Guthrie, passing the famous Pitchfork and 6666 ranches; the latter was once home to Dash for Cash – arguably the greatest quarter horse ever. I resisted the temptation to give in to 'Jenny Fever' and dash the last quarter of a mile.

Sundays often provided pleasant mornings to run on the roads. Maybe it was an American thing, or maybe just regional, but there seemed to be much more of a church-based respect for Sunday as a day of rest. I used it as an opportunity to run in the middle of the carriageway as a gift to my joints.

Liverpool were playing Leicester in the afternoon, their first game in a while, and I was looking forward to listening to the fantastically biased club website commentary. I'd been a little wobbly, emotionally speaking, for a few days now. The stress about lack of funding for the run beyond June, the enormity of the whole undertaking and how little I'd done as a proportion of the total, and tiredness were all getting to me, and when I felt a pain in the outside of my knee that got worse, I became very stressed indeed that this could be anything from iliotibial band friction syndrome to a cartilage issue, neither of which would be pleasant or conducive to forty-mile days. My feet were killing me too, and I was overdue a change of shoes.

I'd been noting signs for a place called Bowie along the way, and when the next song that came on shuffle was by the fella himself – 'Rock 'n' Roll Suicide' – I took it as a sign that the fates were helping me along and it lifted me out of yesterday's mental swamp.

When I'm in the mood for a particular artist it makes time fly, though I use these little boosts sparingly so as not to lessen their

impact. Today was the first day of spring and the animal and plant kingdom seemed to know it. I heard crickets for the first time in months, caterpillars were crawling across the road in their own inadvertent rock 'n' roll suicide, bluebirds flew between trees showing off their bright purple blossom (Oh! You pretty things) and the black vultures – those diamond dogs – had returned. I didn't know if that was a spring thing or if word of my fragile state of mind of late had reached Vulture HQ.

A couple of days later, it was time for a reunion with my great university mate Tex, or Alan, as people in Texas call him. We met his wife Suzie for the first time and his new baby Olive, which made for a slightly different meeting from the last time I'd seen him in Texas, when we shot guns at tin cans, watched ice hockey and drank a lot of beer. He arrived in time to intercept me on my penultimate run of the day and received a good sweaty man hug for his troubles. I set off on my last run with Tex coming to collect me at the end. Maybe I was showing off subconsciously, but I ran a bit quicker than usual and reached the centre of a lovely place called Whitesboro in no time.

Two kids rode past on their bike. 'Are you running like Forrest Gump?'

'Yeah, like the big man himself,' I said. I was wearing my Bubba Gump cap.

Their eyes widened and one turned to the other excitedly. 'That's *awesome*! How did I know? I knew!'

Our last full day in Texas. I'd hit the 4,000-mile mark the day before – Nads neatly adapted our 3,000-mile sign to celebrate the occasion and it got a huge response on social media – and I had a little surprise lined up for Nads later today, visiting the last town we'd hit in the Lone Star, the romantic hideaway of Paris, Texas. It even had its own Eiffel Tower, resplendent with a

Stetson on top. We finished our romantic night out with a trip to the local bar to see a Liverpool match. Nads is also a Liverpool fan, so that was fine by her. Not only did Liverpool win, but Robbie Fowler – aka God to Liverpool fans – retweeted one of my tweets about the 4,000 barrier. Cue my inbox going into meltdown …

I'd been thoroughly soaked on the run through Paris in a rainstorm that would have been in keeping with a wet November Monday in Paris, France, but my *joie de vivre* was undimmed. The north-east of the city was an unusual mix of country clubs and grand mansions, though I'm not sure how there was so much money in one place with no obvious big industries. Some of these houses were incredible, with curiously multi-layered roofs, but the gap between the haves and the have-nots of Paris was tragic. It seemed even more jarring in a place such as this.

It was raining when I set off in the morning on day 123 (the fiftieth day of this leg), and the first place I ran through was called Manchester, just before the border. It always rains in Manchester, of course.

The Lone Star had tested me to near breaking point, for different reasons, on both crossings, though maybe the shorter crossing this time helped me cope better on leg two. It certainly felt a lot quicker, for better or for worse. Would there be a third coming for comparison?

Chapter 14

SOONER THAN YOU'D THINK

Oklahoma
Days 123–4
83 miles

Oklahoma was originally meant to be for the exclusive use of the Native American people – the Choctaw Nation, whose language gave the state its name. In one of those lovely government U-turns, a 'land grab' was allowed in which people were held at the border until a starter's pistol was fired and they could basically race into the unclaimed land and plant a flag. There were strict penalties for people who tried to sneak in before the official start, hence people from Oklahoma are called 'Sooners', after these sneaky scoundrels.

My right Achilles had come back to the party as an uninvited guest for the last few days, so I reverted to my old tactic of waking the muscles up by walking the first mile. I amused myself by looking at some fun videos I'd received overnight of my friends re-enacting scenes from *Forrest Gump* and nominating two others to follow suit. I thought it was the greatest fundraising idea in history, but I could never quite harness the genius of it, to my eternal sadness. I caught the town of Idabel half-asleep, with the town centre relatively deserted. I got the

impression that this corner of Oklahoma didn't get many visitors, judging by the attention I drew from the few people who were about.

We'd been warned by a fellow camper earlier in the trip to take care in certain midwest towns, as they had been ravaged by drugs – crystal methamphetamine in particular. In New Mexico, Nads and I had joked about it being the perfect setting for our *Breaking Bad* binge, but here there was nothing funny about the decrepit buildings and overgrown front yards on the outskirts of town. I'd run past little communities like this many a time and not thought 'meth', so apologies to the people of Idabel – your town was no worse than any others where the streets weren't paved with gold. In fact, it was in Texas where I'd been the only one at the table not to realise that our waitress in a diner was most likely a meth statistic. It inspired me to get a bit more knowledgeable on the subject.

While not exactly reminiscent of an episode of *Breaking Bad*, America is in the grip of both the meth issue and an opioid epidemic, made worse by the dysfunctional private healthcare system that means people from low-income backgrounds cannot afford diagnostics and appropriate rehab, but are instead fed a diet of cheap painkillers by doctors who have their hands financially tied. Meth is relatively cheap and easy to make and buy, and has devastating consequences due to the high level of addictiveness and the lack of empathy it creates in those who are hooked. It has a huge impact on the poorest in society and leads to theft, prostitution and self-neglect. Tragedies also occur in the manufacture of it. Meth 'cooks', often strung out on the product, work with dangerous chemicals such as anti-freeze, battery acid and bleach in poor and potentially explosive conditions, which leads to many fatal accidents. And that's before we get to the problem that distribution and control creates.

I recalled a situation earlier in the run, when I'd chatted briefly with an apparently homeless guy, his strung-out lady friend looking on. He was wearing a hospital gown and showed me the ECG pads that were still stuck to his chest from his recent stay in the ER, following a presumed heart attack. I don't think he fancied hanging around for the 'admin' side of the endeavour, or maybe there was another reason for wanting to get back on the street? They were two unfortunate poster children for both the blight of drugs and the sad result of the healthcare divide in the States.

On closer inspection, Idabel seemed no different to a huge number of small towns. Not a bad place, full of hardworking folk rearing their families and doing the best they can, like the lady heading to work who bade me a cheery, 'Good Morning!' as I ran past, despite the pouring rain – which continued all day. The centre of town was immaculately well kept, and I felt a sense of welcome pushing against my initial unease. Regardless of Idabel's situation in the grand scheme of things, the problem was certainly real and a symptom of disconnection, industrialisation of community industries – such as farming in this area – and the forsaking of family units up and down the country. You could feel the desperate urge for change among America's blue-collar population, which made me realise that the election result was no surprise, but a cry for help. I just hoped it would be heard.

After just one night in Oklahoma, we were due to reach the Arkansas border by lunch. We sped through the larger town of Broken Bow and its restored steam railway engine, stopping for breakfast by an auto-glass repair shop that had an extensive classic auto graveyard behind. Here we met Jean, the owner of the shop who was enthralled by our adventure. She wanted to sell up, get an RV and see the country, which I heartily recommended,

though the running should be filed under optional, I added. She gave us a little something for Peace Direct, as she was happy to see 'someone doing something peaceful for a change', and when she learned we were heading in the same direction – De Queen, Arkansas – as we left, she jokingly offered me a ride.

The Achilles pain was still lingering, but I was monitoring it and had an instrument of torture called a Tiger Tail, a massage stick for my calves, which was going to get a lot more use. It was an evil mistress, but it got the job done.

At the border, we stopped at a bar for a celebratory beer. There wasn't much of a selection, so we had to go for a low-alcohol one, given the tough booze licensing laws in the state, where some counties had, until very recently, been completely dry. Then we crossed from Native America to the Nature State – did I tell you I was running for the WWF too? How appropriate.

Chapter 15

HOPE SPRINGS ETERNAL

Arkansas
Days 125–32
289.73 miles

Almost instantly, the sun came out and I loved Arkansas. Sorry, Oklahoma – you might get another chance. We reached De Queen, which seemed well put together, with a surprising number of hipster types apparent. After waving at Jean on her return journey, I met Nads and asked permission to do a few more miles. Permission granted, but it led to us driving back in rapidly fading light. Running east – away from the sunset – makes such a big difference to how late you can run in only a few days. 'How's your Achilles?' Nads asked. The fact that I needed to think about my answer made me realise it was fine.

On the road to Newhope, a lovely stretch with lots of greenery, I saw something ahead. My first instincts were that it was a coyote, but they're so sharp they'd see you a mile off and wouldn't stick around. It was a dog – a labrador/shar-pei I guessed – and she had decided I was worth investigating. I was initially a bit wary, but she came with a wagging tail and thankfully without rabies. I noticed that she was overly thin and

covered in bald patches of scaly skin – likely due to parasites of some sort, said the dermatologist in me.

There were a few houses around, so I knocked on some doors. She followed me closely, hanging back at a house that had another dog barking. I strolled up the driveway and noticed, just as I stepped onto the front porch, three cats were sleeping in the morning sun and my new companion was on my heels. Surprisingly, she didn't chase them. Good girl.

No one knew her, no one had seen her around. When I asked a mechanic labouring on a truck about the provisions for stray dogs in the area, he explained in the gentlest way he could that the local pounds didn't provide a service beyond the city limits and ill animals were often shot to prevent them suffering. He was at pains to stress that he wouldn't, 'but that dog gonna get shot by someone'. Of course, that couldn't happen on my watch.

I decided to lead the dog the few miles to Newhope, and maybe she'd head for home along the way. I walked the first half-mile and then decided I needed to be running. She didn't leave my side or miss a beat for the five miles to the local store, where Nads was waiting.

In the town, we tried to ring local animal shelters and the local sheriff. The answer everywhere was a firm 'no' and was maybe for the best, as I had a feeling that taking her to the local animal shelter could have been a fatal move. For the time being, we were clueless as to how to proceed.

Everything is better with some food in your belly, and our furry friend certainly agreed. We christened her Hope, in honour of the town and a brighter future. After eating her tin of food voraciously, she slept soundly on a blanket outside the RV, in the sun. I couldn't think straight, let alone make a decision. We were worried about taking her to another pound, in case they thought she wasn't suitable to be re-homed and euthanised her, while the

idea of turning her loose and living out her possibly short remaining time incredibly itchy, hungry and cold was unacceptable. We decided we'd take the risk of scabies and brought her on board the mothership overnight while we found a solution, whatever that was.

In the town of Kirby a local lady who rescued and re-homed a lot of animals was recommended to us. Through my work, I know a lot of people who do this regardless of their own financial situation. This can sometimes, despite the kindness of their hearts, not always be the best option. Not knowing what her circumstances were and growing rapidly attached to this stinky bundle of bones, I filed it under 'possible'.

I went into the local veterinary clinic, Wright's of Glenwood, and chatted to them about Hope. The local charity was unable to take her due to being at capacity, but the vets agreed to take her and look after her until the rescue centre could. This was an amazing gesture from the team, as vets generally just cannot do this – often to the frustration of the public. We felt Hope was special, there was a reason why she had found us, followed me and behaved so well. I think the team at Wright's sensed this and maybe our efforts persuaded them – or maybe they were just great people. We went on our way with reassurances of updates on her condition.

At Hot Springs, I rendezvoused with the Spa Pacers, the town's running club, who joined me for a run to our KOA campsite, before heading to dinner afterwards at one of the club's favourite watering holes. We passed a sign saying that this was President Bill Clinton's boyhood town, and we had a chat about Bill and Hillary. I got the impression that they weren't seen as hometown heroes any more.

I awoke to a lovely morning and I soon received a message that Hope had had a good night too. Later, as I walked out of a public

restroom, the screech and scrape of spinning tyres on loose asphalt alerted me to a car speeding away from the parking lot – away from a black labrador staring after them and wagging his tail. Not another one, surely? Was this my role in life now? At least this one had a collar. Had they forgotten their dog? The obvious alternative didn't bear thinking about. There was a work truck at the end of the lot, so I went down to see if it was their dog.

'Naw, that's "Beef". He lives on the other side of the highway.'

They told me he came down to the picnic area all the time to try his luck with passing motorists, hoping to separate them from their lunch. Classic labrador.

When I checked my messages in the warmth of the RV, I didn't need lights, just my beaming smile. I'd received a message from Dave McGillivray, race director of the Boston Marathon and fellow trans-con runner. His 3,452-mile run from Medford, Oregon, to Medford, Massachusetts, in 1978 (starting three days before I was born), all done sporting a great moustache, had clearly allowed him to feel a kinship with this fellow road warrior, and he had kindly accepted my request for a spot in the 2017 Boston Marathon in less than six weeks' time. I was pushing forty miles a day, but I now had a deadline that required almost a forty-five miles per day average to get there on time. It wouldn't be fun if it were too easy, would it?

Among her many other roles on the trip, Nads was a great press secretary. I got a message to be in Little Rock at the Statehouse Convention Centre for 10.20 to meet Mitch, a cameraman and reporter for both Fox and NBC. Little Rock seemed like a cool city, but there was no time to dwell these days, especially now that I'd put myself against the clock again.

In the distance, I saw a figure moving towards me. It was someone out for a run, and I wondered if I could persuade them to join me for a bit. It turned out no persuasion was needed, as

it was Adam, a pre-med student from the University of Central Arkansas, whom I had already been in contact with thanks to social media. He'd not been able to get hold of me, so had taken a chance, based on my route, and he caught me just a mile and a half before I took a back road. Perfect timing. He was another in the long line of good runners I seemed to bump into, so once again I moved out of my comfort zone for a good six or so miles with him. These mobile encounters were great for the soul.

I've only been to Carlisle in the UK once. It seemed nice enough, but it was freezing cold, wet and windy. How lovely of Carlisle, AR, to ensure I felt right at home as I passed through their version. Wrapped up warm, I strangely enjoyed it, and the cedar trees in the mangroves were enjoying the water too. There seemed to be a lot of water about generally in Arkansas and some impressive watercourses too. Passing through Hazen and De Valls Bluff, a very important port town in the civil war and now mostly famed for rice farming and a few great eateries, I crossed the White River, which was more chocolate brown if truth be told, with a huge amount of debris racing down to the Mississippi. The recent rains had obviously swollen the river, and I was quite glad to be high on a concrete bridge, snapping photos of the old elevating girder bridge, rather than the other way around. It was a treat to see the return of the herons that had been such a feature of the first half of leg one. They had retreated further up the bank than usual, but maybe it was a bit rough for fishing.

I felt a little stiff getting out of the RV the next morning into some bright Arkansas sunshine. My left quad was feeling tight, so I started off gently and did a bit of stretching, before easing into the normal routine. I had what I thought was a great idea – the Friday Follow. And I wasn't going to let the fact that it was a Sunday stop me from starting it that day. The crux of the Friday

Follow was to take a photo every four miles, regardless of where I was, to let people follow me virtually on a typical day. This was going to be anything but, and the pain levels in my leg rose to the point that I had to walk.

How had this happened? I'd slipped on some mud earlier yesterday and had got into the RV awkwardly earlier today. I reckoned it was the Jenny step. I rested up a bit and went out for my pre-lunch run, which lasted two miles before I had to walk. Two miles further of that and walking hurt too, so we called an unceremonious halt in a place called Forrest City, population 15,371, temporarily upgraded to 15,373, one of whom was trying to *be* Forrest. This was all documented in a staccato fashion on Instagram. High drama for the season opener of Friday Follow. Episode two would surely have more cheer.

It was another wet day, all day. The first song that came through my earphones was 'Rock or Bust' by AC/DC. You couldn't have been crueller, God of Shuffle. My non-negotiable rule of AC/DC = run was broken for the first time, and I decided to do without music for a while. When I felt ready to return, I took my fate in my own hands and selected Nick Cave, who was my constant companion for the whole day as I set foot on the Trail of Tears for the first time.

During the 1830s, the Choctaw people, removed from Mississippi by the US government, made their way along this trail to new lands in present-day Oklahoma. An estimated 15,000 Choctaw made their way by steamboat, wagon and on foot, and something like a quarter of them perished from cold, disease and starvation during the journey, so the route became known as the Choctaw Trail of Tears.

While I was trudging on, a couple of people, including a state trooper, stopped to see if I was okay, which provoked a smile and

some cheer. I decided to try a little running – only half a mile at first, with a mile of walking, then a mile, then a bit more. Somehow, by the end of the day I'd logged twenty-seven miles, with six of those spent running. Things were looking up.

We drove to our RV park, on the banks of the Mississippi, which I would cross for the second of hopefully five times tomorrow. We could see the huge tankers glide past from our spot, without a whisper, only visible by the lights on deck. Making progress, reaching their port, turning around and going again. It sounded familiar.

I got up after a nervous night with my leg feeling a lot better than it had the previous evening, and I decided to adopt a walk one mile, run three, walk one strategy, no big stints, decent rests. The first nine miles were a little tense, and I sensed a degree of upset when I got back into Jenny. I found out two miles into the next run that I had overstepped the mark. Some anxious thoughts swirled my mind. *If three out of ten pain was okay, where did that lie? Did I have a high pain threshold or not? Was my three really a six, or vice versa?*

I walked for a bit to mull this over and decided I'd set a limit of 'any more painful and that's it'. I set out for the Big River Crossing, a bridge across the Mississippi and into Tennessee that was only completed in October 2016. Sorry, Arkansas, through no fault of your own I had spent most of our time together injured and anxious. My moods were as volatile as my injuries, and despite having fun I found it unpredictable as to where my emotions were going to go on any given day.

None of this was helped by the fact that Nads would soon be heading back home. We had reached the limits of our finances and couldn't afford for her to be out here too. Running unsupported was going to change everything. I had been averaging thirty-five to forty miles a day when uninjured, but making it to

the Boston Marathon meant forty-five a day unsupported – a massive level up. I'd be pushing a stroller, doing all the work of feeding, laundry and arranging accommodation, including possibly taking longer routes to facilitate this. Things were only going to get more complicated from here on.

Chapter 16

A CHANGE IS GONNA COME

Tennessee
Days 132–4
75.7 miles

Not only is Memphis the city of Elvis, it is twinned with my home town of Liverpool. I was only passing through, so I pencilled it in for a future crossing. My medial quad, or *vastus medialis*, was always on my mind … and not in a good way. I was pretty sure I'd torn it, and I was trying to run through it. Four miles into a twelve-mile stint and that was it as far as running was concerned. That's right, I was walking in Memphis.

I love walking, but as with any idea, it's much better when it's done through choice. I would have found it unbearably frustrating if I wasn't so worried. I had to accept the fact that it wasn't about today, this week or even the next month. It was about the whole run, whatever that turned out to be, and my desire to do the very best I could for Peace Direct and the WWF. Pushing too hard now or throwing in the towel helped no one.

I woke the next day with little initial discomfort. Then I had a look at my left lower thigh, grotesquely swollen compared to my right. I poked it, causing a spike of pain to shoot up my leg, and I watched horrified as the impression I'd made took a couple of

seconds to return to normal. I told Nads, 'We're not going anywhere today.'

We didn't go anywhere the next day either, and walking in Memphis had become stuck inside a mobile home with the Memphis blues.

I took this as an opportunity to arrange my kit for the solo part of the run. I still hoped I'd set foot on the route again, but mostly I was desperate to avoid sitting around and moping. I like gadgets and kit. I always have, and I can be prone to getting something I think I need, only for it to sit in the back of a cupboard unused. During my time living in Australia, I'd purchased a second-hand Baby Jogger Performance, a running stroller designed for elite runners. You might prefer to call it a baby buggy. My Australia run never happened – or at least it hasn't yet – so into the garage it had gone, until it became a passenger on Jenny. I figured that this twenty-inch wheeled, lightweight flying machine would be sure to have low rolling resistance and be my friend on the hills. Setting it up for the first time, I started to panic that there wasn't the space to put all my stuff. Here's pretty much everything I could fit onto the stroller:

15kg army holdall bag, which would be the 'baby'
 2 orange short RUN ROBLA RUN charity logo shirts
 2 grey long-sleeve RUN ROBLA RUN shirts
 2 other running shirts
 4 pairs shorts
 2 pairs shoes
 1 pair khaki shorts
 1 check shirt
 1 pair Nike Cortez
 2 pairs running tights

Socks, including long white stripey ones (stripes drawn on)

2 waterproof jackets

Warm evening clothes

1 Bubba Gump cap, of course

Spare shoes

Tupperware boxes for food

Bike repair tools

Multitool (including knife)

Puncture repair kit, inner tube

Lights

10l water container on footrest

Coleman waist pack on handlebars for valuables

 phone

 headphones

 charging stuff

 wallet and money

 2 water bottles

Tent

Sleeping mat

Sleeping bag

Stove

Waterproof coat

Tiger Tail muscle massager

Pepper spray (for dog attacks, combined with Tiger Tail)

Portable camping seat

The dog defence kit was a new adaptation, after I'd been warned about the possibility of large roaming packs of strays in Tennessee. Apart from what I knew about Elvis, Johnny Cash and Dolly, this was the only real impression I'd been given of the place, so you could forgive me for not overly looking forward to

my time here. In fact, thanks to my injury and impending solitude, Tennessee was stressing me out already.

I affixed the rain cover over my water container and the body of the stroller, before inserting a 'Run Forrest Run' licence plate, a gift from Jamie and Luli in Santa Monica. It looked very professional, and if I ever got the chance to use it I'd need a name for my new wheels. As I was already on my way to looking like Chewbacca and I was soon to be alone with my stroller, I christened it, or rather him, 'Pramsolo'. I took him for a maiden voyage, delicately around a 200-metre perimeter road course. I was right about that rolling resistance – smooth as you like.

That St Patrick's Day morning, I didn't know whether it was the luck of the Irish, divine intervention or merely the magic of the oft-prescribed rest at work, but I walked back from the restroom with only a little bit of discomfort. I realised that I needed to see exactly how this would respond. I had a grade two tear of my *vastus medialis* and, if severe, it would take six to eight weeks to heal. I had to hope it was on the milder end of the spectrum and treat it like a Fabergé egg if I was going to avoid the kind of lay-off that would almost certainly mean returning to the UK and packing it in. It made sense to test it now, as Nadine was heading home in less than a week. If I saw no improvement, we could go home together with our heads held high, toasting the attempt at 30,000 feet together.

So I started to walk. I wouldn't even contemplate running for a few days. By removing the element of choice again, walking became more bearable, and I moved along at three miles per hour with pain levels staying below three out of ten. I picked up a car horn over my music and steeled myself to be cheerful as a man got out of his car.

'Hey, are you the guy from the news?' he said. 'We were sure we'd missed you! Would you like a donut?'

I never turn down a donut. He offered the bag to me and I took in the unmistakable scent of sweet sugary goodness. My day had been made already.

Big mileage walking takes time and that's something you just need to become accustomed to. After a night of thunderstorms, I left Jenny in the morning mist of Mason, Tipton County. I strolled down Highway 79 flanked by flooded fields reflected in the gloom. Ruined houses being reclaimed by that most ruthless of landlords, Mother Nature, were in a state of sinking – or maybe they were rising, zombie-like, from the fields. We were now desperately behind schedule. Nadine was leaving from Nashville in three days. The plan had been to get there on foot and carry on after seeing her off, but that was but a distant dream now. I'd decided to try my leg out for a few more days, so the goal for now was to reach the Greyhound station in Jackson. I would be able to return there from Nashville with Pramsolo.

On to Jackson, through the open spaces of Madison County. As the sun was setting I realised that my thigh was making its presence felt less and less. I came to a crossroads decorated with flashing lights. It seemed an appropriate place to wind up for the day, and I messaged Nadine to head to a layby just down the road, within a hop, skip and a jump of Jackson. Thirty-five miles for the day wasn't to be sniffed at, so as advised by a local church sign: why not smile?

I settled upon a less risky gait pattern to begin the half-marathon or so into town the next day, on a beautiful spring morning. Four miles in, I threw caution to the wind, electing to run for half a mile at around nine-minutes-per-mile pace. I did that twice again after breakfast, the pain staying on my side of the line in the sand.

Eventually I reached Jackson, which seemed frozen in time, in a good way, with retro Dr Pepper and Pepsi signs dotting the

streets and a Greyhound station plucked picture-perfect from a 1950s leaving-home movie. I stepped into Jenny for the last time, and we were soon heading to Nashville and my first meeting with some very important people.

Thaivi is our friend Luli's mum, and she was accompanied by her son Mischa and her partner Peter, a gentle, giant Brazilian-German hybrid. They had all thought nothing of driving four hours from Atlanta, Georgia, to meet us and take us out for dinner. They were also bringing the final pieces in my Pramsolo armoury – a microlight JetBoil stove, Marmot Phase 30 sleeping bag which would see me right to –1°C (I had little desire to camp in colder conditions than this) and a load of other kit from REI, including their Flashmat sleeping mat. I had designs on making these as light and as good at their job as possible, so I was happy paying for quality. If my kit was letting me down, I'd be more likely to let the mental demons in to do their worst. They also brought lots of other goodies, including something very special from Mischa, a recording of a song called '1,000 Miles to Go' that he'd written and set to a slideshow of my journey so far.

We had a wonderful time with them, and when they were set to leave they realised that they'd left my box of kit on their table at home. They insisted that they would drive back as soon as they got home – meaning a sixteen-hour round trip. My protestations were in vain, and this was the start of a very dear relationship I would have with both the town of Cookeville and Thaivi and her family.

Nads and I drove Jenny to Cookeville, a town eighty miles or so east of Nashville, and deposited Jenny into storage. We then took the shuttle to Nashville, where Nads and I would spend our last night together for a long while.

Money would be tight for me, which was now a constant source of worry. My budget would likely only get me as far as

Maine and the Atlantic, just that one time. Part of my strategy for proceeding was to seek sponsorship as much as I could. I'd prepared a glossy brochure about our aim and the trip so far, and sent it off to over a hundred of the Fortune 500 companies, with handwritten cover letters and envelopes so it didn't look like I was some sort of mail bot. Surely it was now just a case of sitting back and watching the offers roll in. We had to hope.

The next day was D-Day – Departure Day. I'll never forget watching Nads get into a taxi and drive away from the hotel reception. I was already missing her terribly, and neither of us knew how I'd cope on my own. Nads was returning to the UK to no fixed work. We had a mortgage to pay and I'd been left with barely enough money to get me to the nearest ocean, less than 600 miles away, let alone to Maine, which was up to a 1,000 miles further. The journey was going to be a challenge, and at that point I wasn't even sure if I'd last more than a few days.

There was also another worry for me. We knew that having Pramsolo would limit my agility on the road and make my over-all footprint wider. I remembered the I90 bridge in Baton Rouge and wished I didn't. I would almost certainly have caused an accident or been hit and likely killed if I'd tried to cross that bridge pushing a stroller. I just hoped it wasn't the sort of situa-tion that would develop suddenly once I was on an irreversible path.

I didn't discuss this with Nadine. I could already tell she was worried she might not see me again. Not a huge amount was spoken, except for warm 'good luck' messages, but she started to cry as she got into that taxi, and I felt wobbly too. In fact, I still do whenever I think about that scary, painful goodbye.

Chapter 17

GOING PRAMSOLO

Tennessee 2
Days 135–45
423.99 miles

I always imagined myself stepping into this scene holding a beat-up guitar case and the address of the girl I was going to marry when I'd made it big writing the song for her, but I had to make do with a stroller and a sad goodbye from my love as I walked out of Jackson Greyhound Station, feeling the warm Tennessee sun on my face.

I made a new friend almost immediately, while I was assembling Pramsolo. A middle-aged gentleman, softly spoken and shy, asked me politely what I was doing. His name was London and he was also fairly nomadic, having recently arrived in Jackson himself. He explained that he had no friends and was looking for work, living alone. I said he should come with me and I'd be his friend. I was joking about the first part, of course, though he did have some decent footwear. The second bit was true, however, and when I asked for a photo he told me that he didn't have a photo of himself and never had. Someone had once taken a photo of him and promised to send it, but the mail never came. I found this so poignant and pledged not to do the same. I duly

photographed him and shared his story on social media. It wouldn't be until after the run that I'd succeed in getting a printed photo to him, but I was as good as my word.

I looked at Pramsolo, packed and ready, Run Forrest licence plate in pride of place, and took a sharp intake of breath. I put some music on and we took our first steps together. We passed London and I wondered if he thought about joining. He looked like he wanted to. It made me think how different my journey would be if I were walking rather than running. It would certainly open up the range of potential candidates to accompany me.

For the last six months Nadine had been my rock. I might have been able to run for ever, I might not, but I would never have got this far, or even wanted to, if it wasn't for her. She'd not just taken care of food, water, laundry, driving, accommodation and navigation, but she'd been there to support me every day and put my needs above her own. It had been hard work for her, experiencing a high degree of confinement while I basically followed a dream. She had been finding things increasingly tough, and in a way it was probably for the best that our hands had been forced financially rather than waiting for something to break. We'd had a proper laugh, and I hoped she would come back out and rescue me some time in the future so we could continue laughing. It is with that in mind that I chose my 'tune of the day' to be 'Heaven for You, Prison for Me' by Marlon Williams. Nads was free now, but only on parole.

Navigating with Pramsolo was already proving a challenge. I rattled down Highway 70 through Spring Creek, doing my best to avoid the rumble strips at the side of the road, which I'm sure are a handy aid for tired drivers, but were anything but for me and Pramsolo. Throughout my breaks I searched online for a couchsurfing option or a motel without success, and as daylight faded my first night was likely to be underneath the stars. Land

appeared to be private around here and it certainly didn't seem like a good idea to try my luck. I saw an abandoned house that could have been the poster location for a slasher movie and debated it … briefly. My mind flicked back to Chris Andrews, who was doing a self-supported crossing when I bumped into him just before the border with New Mexico on leg 1, and his handy tip when you had nowhere to stay: 'I just knocked on people's doors and asked if I could camp in their yard.'

I tried my first house. Inquisitive children looked out of the window but the door remained closed. As I was leaving, their father, I presumed, answered and was the recipient of my sales pitch: 'Excuse me, sir, my name's Rob. I'm from England and I'm running across America for the World Wildlife Fund and Peace Direct. I'm looking for somewhere to pitch a small tent for the night. Would it be okay to camp in your front yard?'

'No.'

'Okay, thanks very much anyway!' I went past a few houses that fitted Chris's description of 'you'll know where *not* to call' and eventually saw a house that had a camping trailer parked next to it that looked perfect. The house was a little ramshackle, but I didn't see any signs warning of impending meetings with Jesus if I proceeded, so I rolled up the driveway. I left Pramsolo around ten metres back, stepped onto the front porch and knocked.

The blinds twitched. 'Who is it?' came a fairly indignant, grizzled voice.

'Er … Rob. From England.'

Nothing. I was just turning Pramsolo around when the door opened.

'Whaddya wan'?' Still gruff. More indignant. He wore jeans and a T-shirt, and he looked slim and fit, like he was able to handle himself.

I gave my spiel.

He looked at me suspiciously. 'Got any weapons on ya?'

'No, I'm British – just my razor-sharp wit!' Now, this was a slight fib, seeing as I had a can of pepper spray and a massage stick, but I figured he'd have better ones anyway.

'Good, cos I got plenty,' he replied, revealing a ten-inch butcher's knife from behind his back in the porch half-light. 'Anyone who hurts my daughter is gonna get hurt. Real bad.' The daughter in question must have been around two or three and was clinging to her father's right leg.

Please don't end like this, I didn't even get to see bloody Nashville properly, I thought. Was it too late to run?

'Hang on. I'm gonna call my wife. She works at the local store. Maybe you could camp round the back.'

Anywhere but here, I thought. *The further the better!*

A few seconds later and certainly not long enough to have completed any kind of phone call, he returned. 'It's okay. Come in. I trust you.'

God help me. Nervously, I chose to go in. Surely he wouldn't carve me up in front of his daughter? I don't think I'd have gambled on going in if I hadn't seen her first. I stepped through his door to be greeted by a scene that would be the same in any young family's house up and down the land. Kids' toys, TV on, comfy sofa. No padlocked trapdoor with muffled screams coming from below. I took the offered seat in the kitchen.

'You hungry? Thirsty?'

'Yeah, man!'

'Want some chilli? Noodles? Can of Coke?'

I went for the chilli and Coke and he started to take pans out of the cupboards. I didn't take my eyes off his left hand, which still had the knife gripped. I saw him look at it and realise, before he thankfully put it down.

We'd broken the ice now, and it turned out he was a genuinely lovely chap. He explained that 'people round here don't go round knocking on doors after dark, and if they do, they certainly don't tippy-tappy – they hammer on the door, as it usually means something ain't right'. G was a local builder who planned to build a new home on the same site for the family in the coming year. He cooked a mean chilli and his Coke was also of a decent vintage. He talked a lot about his little girl, and I could tell how proud he was to be able to build her a home. It was getting pretty late, so I made my excuses to go and put up my tent. I'd never set it up in the daylight, never mind the deep Tennessee night.

'Don't stay in your tent. I have a hunting trailer – stay there,' he said. He took me to it and removed his hunting rifle, which seemed sensible, even though I was clearly the benign type. Having said that, I still locked the door from the inside. I settled down, shaking my head at what had been a remarkable few hours, and slept like a baby.

My landlord for the night woke me the next morning at 6 a.m., on his way to a job. I called in to the shop where his wife worked to thank her for the hospitality. I picked up some goodies for breakfast to sustain me to Huntingdon, my intended destination yesterday, which I'd finished ten miles short of. That meant almost fifty miles today, which was going to be a struggle to complete in daylight hours. I didn't fancy a repeat of last night's antics, even though all had turned out well in the end, so I messaged Tequila Joe's, a Mexican restaurant and bar in New Johnsonville, asking if they could help me with something, anything.

I almost didn't need accommodation. On the Camden Speedway, seeing my lovely wide breakdown lane shrink to nothing, I heard the hiss and screech of brakes ahead. I looked up to

see a huge eighteen-wheel articulated truck jack-knife and contort like a snake across the road, screaming towards me. I froze. There was nowhere to leap out of the way. The driver's face was a mask of horror. The truck's wheels gouged into the grass verge, and mercifully it came to a stop less than thirty feet from Pramsolo's front wheel.

It happened too fast for me to react, but afterwards I was shaken up for a long time. I still don't know why he lost control so badly, as the road was quiet and the conditions were glorious. I suspect it was a phone-related incident and a moment of panic. We were both very lucky boys.

At 47.5 miles, just shy of my target of 50, I rolled into Tequila Joe's late in the evening, sat down in the corner and ordered my staple in these venues, a giant burrito and a Dos Perros beer. I'd received no word from the restaurant's Facebook account about accommodation and felt rude asking if they'd got my message, so I just asked for the bill.

'No charge. You're the running guy, right?'

I already felt a mixture of gratitude and guilt. 'That's me.'

'There'a few guys at the bar who wanna hear your story.'

I headed over and indeed they did. One of them, called Mason, got straight onto the local news channels, saying, 'No, you don't understand. This is what I want to see on the news, not all the depressing stuff!' When I told them of my encounter last night and that I was hoping to camp around the back of the restaurant tonight, they wouldn't hear a word of it. Cue a whip-round and a few generous donations that fixed me up with a comfortable bed in the nearby Deerfield Inn, a mile down the road. I wobbled my way there, already taking a bonus mile off tomorrow and grateful for the opportunity to relax.

The run today had been the first time I'd felt the quad for a while. Forty-eight miles wasn't a great idea considering all that

had happened recently. I'd built up to a pattern of run one mile, walk half, starting with a two-mile walk. By the end, buoyed by some serene progress, I'd upped the running to 75 per cent and felt good. There was always going to be a reaction. I just needed to be vigilant and ensure I didn't go too far.

I woke up a little concerned and put myself on yellow alert. A few miles down the road I was a lot happier, and with a restricted stride length I felt I could run at the 75 per cent proportion with which I'd finished the previous day. Even with the walking breaks, I was around nine minutes per mile or less. A local lady stopped and prayed for me at the side of the road. I'd take any help I could get right now.

It was a perfect sunny day and there was a fantastic surprise to come in the shape of Terry Bulger, host of the famed Nashville TV news slot *Bulger's Beat*, an irreverent look at the lighter side of the news – the news that Mason wanted to see. A fun interview ensued, accompanied by some excellent running shots that highlighted just how close the huge trucks that whizzed past my head actually were.

Bubba, one of the guys at Tequila Joe's who had helped me out, had got in touch with his cousin Keith. We were going to have dinner together in Dickson, and he also drove me to a very reasonably priced motel that was on my route. He expressed some reservations about my choice, but I had a basic rule of thumb for accommodation, inherited from my mother: as long as it has locks on the doors and clean sheets, I'm all good.

I opened the door to possibly the worst room I'd ever chosen to stay in. There were two holes punched in the wall, a sticky carpet, a dirty bath with a flickering fluorescent tube light, graffiti on the mirror, and I imagined turning around to see a hockey-masked man in a boiler suit bearing an axe. Fortunately, it was just Keith: 'Sure you want to stay, buddy?'

Keith was taking me out with his family to my first Applebee's. I'd seen *Talladega Nights* and I was very excited about this, though I couldn't have expected the welcome. One of the news pieces I'd featured in must have been played before I arrived, because when I walked through the door I sensed a strange lull. And then the cry went up: 'Forrest's HERE!'

Cue general uproar and applause. Fame at last. We enjoyed a great dinner – I could hardly move when I left – and the next stop was House of Brews and, at last, the chance to indulge that guilty pleasure of mine – karaoke. There was only one option in my mind and I duly set about slaughtering 'The Long and Winding Road' by the Beatles.

A very well-built fella and his friend on an adjacent table asked me what was next. 'Back in Black' by AC/DC was my go to and I had enough brewed confidence to give it a go.

'Don't mess it up – I like that song!' he retorted, with a sliver of menace in his voice.

I'd never been threatened over karaoke before, and wished I hadn't caught his eye. I squawked my way through it as usual, and afterwards he beckoned me over.

'Come with me,' he said, disappearing into the men's bathrooms. Now, I'm not for one instant speculating that this upstanding gentleman was involved in some of Dickson's 'alternative' industries, but his smile at least reassured me that he wasn't going to end my singing or, more importantly, running days. I did wonder what he had in store, though. He pulled out his wallet and handed over a very fresh banknote. As it wasn't folded, I could see that it was a hundred-dollar bill. My first ever Benjamin. I wasn't in a position to say no. I was broke and he was huge; argument over.

I returned to my motel later to find that my mum's rule held true – it was enough, though I didn't want to risk seeing what the

sheets looked like. I laid out my sleeping bag on top of the bed and got in.

Seeing Nashville on the horizon was bittersweet. I was supposed to have been here around four or five days previously, and despite a lot of my self-doubt disappearing over the last hundred miles and being taken into the heart of West Tennessee as I could never have imagined, I was still coming to terms with Nads not being here. I felt a bit lonely.

The people of Tennessee, however, refused to let me get down in the dumps. The friendliness and generosity continued, and it seemed I'd barely go a mile before someone new would stop to say hi, take photos and shake my hand – some of which contained a surreptitiously slipped bank note. I tried many times to gratefully decline, but everybody was so smilingly insistent. The Mayor of Pegram even slipped me a sly $50 note after another local had treated me to dinner in the Pegram Fish Fry.

In Nashville I had a big breakfast in Pinewood Social, a retro bowling alley and café, with some new friends. I went downtown to Third Man Records, owned by Jack White, an adopted son of the town, where I ended up *making* a record, because, well, Nashville. Their 1947 Voice-o-Gram record booth allows you to record two minutes of whatever you fancy and have it cut onto an old six-inch acetate for your listening pleasure. Neil Young made an album in the very same one I used. Borrowing an acoustic guitar that they had in store, and as an uninvited tribute to my absent host, I blitzed through a double-quick version of the White Stripes' 'Hotel Yorba'.

From the steamboat captain who promised me a trip next time I was in town to the head of marketing at Yazoo Brewing, Neil McCormick, putting me up in a decent hotel and bringing round some samples, I enjoyed an amazing stretch of hospitality, all of

which far exceeded my expectations. But, as I left Nashville, it was clear that I now had to think a few moves ahead. I would regularly contact bars, restaurants and other outlets to enquire about nearby camping options – hoping, but never asking, that they could offer something better than camping. The next few days were going to be a bit thin on the ground in terms of places to stay. At one rest point I got speaking to a police officer about rough camping and he strongly discouraged it, informing me that people were very protective of their land. When I mentioned my first solo night in Carroll County, he said, 'You were lucky you didn't get shot. I'm serious.'

The warm Tennessee spring afternoon started to get chillier as I cut through rolling fields where Al Gore's organic vegetables grow, with the trees just starting to show some interest in coming to life.

When a pedestrian or car driver gives you advice on upcoming hills, it's usually not as bad as it sounds, unless they're howling with laughter as you tell them where you're headed. But when a cyclist tells you something about gradients, you listen. I listened and I was worried about the warning of a steady climb with a climactic gradient to get me onto the Cumberland Plateau. I was back in the same pretty countryside as yesterday, which in parts very much reminded me of a more stretched-out England, with so much more space and room to breathe. I'd need that oxygen soon.

Up I went what I later deduced was a 14 per cent gradient for almost three-quarters of a mile. The sweat poured down my face and my lungs burst for the first time on the whole run. Sucking air at the top I enjoyed a brief respite before another climb got me on top of the plateau. I took a moment to collect myself and then crisscrossed the railroad winding through the huge maple,

oak and walnut trees of what is the world's longest hardwood forested plateau.

I passed through the town of Monterey, and at the end of the day's run, in the dark Tennessee night, my final meeting was with a police officer less pleased to see me than some of the other folk on the road had been.

'There a baby in there, sir?' he asked. 'We've had a few calls about a baby being pushed down the highway.'

I explained that there was no baby on board and that I only had half a mile to go before I'd be out of his hair anyway.

'Stay safe, son,' he said, and with a flick of the wrist, gave that pointing motion down the highway that they must teach in Police Academy.

The next day was something else, with undulations and sweeping corners reminiscent of a Formula 1 track. At the end of the day I got to the Brushy Mountain Pitstop – a bar/grill with a primitive campsite which was free of charge, and I pulled up a stool at the bar. I was in a famous part of the world for those who dare to go beyond the marathon distance. One barfly asked me if I'd been up Rat Jaw.

Rat Jaw was one of the notorious hills of the Barkley Marathons. I stepped outside and took a look down the road at a channel cut between trees to allow power lines to go over a mountain. This 'hill' made my route up to the Cumberland Plateau look like a speed hump. It would be just one of the slopes you would encounter multiple times in the Barkley Marathons through Frozen Head State Park. Started by Gary Cantrell – more commonly known as Lazarus Lake – in 1986, it took ten events before anyone even managed to finish the hundred-mile course, accumulating almost 17,000 metres (55,000 ft) of positive elevation, set over five laps. Its sixty-hour cut-off doesn't seem that hard until you hear about the gradients, briar-packed

undergrowth you have to bulldoze directly through and the brutal changes in weather that occur at this time of the year at the drop of a hat, meaning a set 'outfit' doesn't exist. It was inspired by the escape of James Earl Ray, the assassin of Martin Luther King Jr, from Brushy Mountain State Penitentiary. He was on the run for fifty-five hours before he was apprehended and, in that time, only managed to get eight miles. He was probably grateful to be recaptured. The race today often uses a tunnel that runs underneath the old prison buildings, in case you weren't cold and wet enough. At the time of writing, only fifteen people have ever finished.

Another chap joined us at the bar. 'You goin' up the mountain tomorrow?'

'Nah. I'm trying to avoid hills as much as possible at the moment,' I said, pointing to Pramsolo.

'Good, cos they'll kill ya.'

'The hills? They that tough?'

'No. The people. They'll kill ya. And keep a tight hold of your stuff, man.'

I heeded their advice. I set up my tent a little way back from the road, fending off some annoying biting flies and settled down on my sleeping mat. As I lay in the cool Tennessee night, I wondered if I was the only man on the planet to have run from Badwater to Barkley, the two totems of 'as tough as it gets'. I thought about heading out of my tent to take one last look at Rat Jaw and maybe tip my hat, but it was dark and I'd proven nothing yet. I'd have to come back one day and earn the 'nod' from the mountain properly.

A grey backdrop fell on Tennessee for pretty much the whole day. I enjoyed the sights of Knoxville, with its English-style mansions, the golden Sunsphere and the grand university

buildings with the giant 102,000 seater Neyland Stadium, home of the Volunteers, dominating the horizon to the west of downtown. The fine establishments lining Cumberland Avenue, including the Springsteen-referencing Tavern on Thunder Road, made it look like a great place to be a student, until I remembered the need to be twenty-one and how cruel, but very responsible, that was.

The next day I passed through some areas that had seen better days and turned onto Martin Luther King Jr Avenue. I'd been on a couple of streets by the same name in other cities and recalled a joke by Chris Rock: 'I don't give a f**k where you are in America, if you're on Martin Luther King Boulevard there's some violence going down.'

I'd had the same feeling. Not of being in danger necessarily, but rather that this street, wherever it was found, should be a beacon of hope for the local community. Depressingly, I'd found that they were often situated in the toughest parts of town and sadly neglected.

As I continued, I was watching a fella down the road taking a photo of what appeared to be a gas station sign, high in the air above him. It turned out he was taking a selfie, with me rapidly approaching in the background.

'What you doing here, man?' he said. 'You know where you are? You lost? You f***ing famous, man! I seen you on the TV last night. You're running round the world! You're gonna change the world, man!' He beamed, sporting a very impressive set of gold teeth.

'Nah, I just put in walking directions and follow it. I just go where the road takes me.'

'You for real, man? That shows you for f***ing real! Hey c'mere …' He gestured to a fella with long grey hair, a scruffy beard and few teeth of any composition to speak of, let alone

gold ones. 'You see this guy? He's Forrest Gump! He's famous, man!'

Meanwhile, a black Cadillac Escalade rolled up alongside and its tinted window went down slowly. A voice came out: 'Who you talkin' to, Holmes?'

'You see this guy? He was on the news, man! He's running round the world!'

I didn't have the heart to tell them that I was probably just going to stick to the USA for the time being. A multifaceted handshake, during which I was never quite sure what I was supposed to do, went on long enough for me to show appreciation and not too long so that I overcomplicated it and went down in his apparently considerable estimation.

Day 145. My last full day in Tennessee. There was only the small matter of my first fifty-miler to negotiate before I could contemplate getting nostalgic. I secured my Subway lunch properly underneath Pramsolo's main cargo bay. I'd lost a Subway from under Pramsolo on the way to Rat Jaw, but fool me once, Tennessee, shame on you. Fool me twice, shame on me.

I left Morristown, a pretty town with old department-store murals, and went on to a road that was made for Pramsolo. Despite not having a shoulder, it was quiet enough not to be an issue and it was smooth as a baby's bottom, with a heat haze shimmering in the distance as the needle crept up to a balmy 26°C. Turning off onto the shady McKinney Chapel Road, I suddenly felt I had company of the unwelcome kind. Haring up on me were the first pack of dogs I'd seen in Tennessee.

I stopped abruptly and gave a very firm 'NO!' That seemed to do the trick, and they backed off – until I took off again.

'No! G'wan, git!' This stopped them in their tracks again, but the main antagonist, a black crossbreed about the size of a collie,

was getting riled and was the only one not wagging its tail. The others were likely thinking it was a game, but it was time to be prepared. I unhooked my pepper spray and reached for my Tiger Tail, with which I could either lash out or at least offer something to bite instead of me. I set off slowly; this time they didn't follow and I relaxed just long enough to be off my guard. Suddenly, I heard the sound of paws thundering behind and I looked back to see the last-minute change of pace of a fully committed attack by my main antagonist. Having no deterrents primed any more, I sharply wheeled Pramsolo around to create a barrier, and he bounced off the side in a furious state. Did he have rabies? I backed off, not taking my eyes off him, while he decided that he had better things to do than get clobbered by a strange three-wheeled beast again. I ran the rest of that mile with my workhorse cum-bodyguard trailing behind me.

Spring was springing in the form of wildflowers either side of the road, and a lack of stress and general distraction apart from the scenery meant that my mileage seemed easy. I kept on the sunny side all day as I crossed the trail of the same name that runs all the way to Sevierville, the home town of Dolly Parton, the Queen of Country herself, and then I was on to Church Hill.

There was always something to look at while moving at this pace. I'd grown very fond of the roadside signs depicting specific pieces of history. I ran past Rice's Mill, where, in 1776, settlers were taking refuge from warring Cherokee. In a skirmish between nine pioneers and around thirty Cherokee, poor Frederick Calvatt was on the end of a scalping. Ouch.

As I peered through the pines on the approach to Mount Carmel, I saw my first glimpse of the Appalachian Mountains, which had been on my mind ever since I pushed Pramsolo onto the Cumberland Plateau. I had some slightly cheerier thoughts thanks to the signs for the local veterinary hospital: 'Your pets

will love us – we Shih Tzu not' and 'Whippet, Whippet good'. Red running cap off to you, doctors Calcote and Bonsor, for making me smile.

As I stopped for the night I'd run further than I'd ever managed in a day, with or without a stroller, and I'd effectively completed Tennessee. The state that I'd dreaded for a few reasons – its size, Nads's departure, the injury and, despite the presence of Memphis and Nashville on my itinerary, no real excitement about being here. More fool me. I now knew why I saw more of the state flag in Tennessee than any other state apart from Texas (of course). It's a pretty special place, but as well as being beautiful, what makes the Volunteer State so great is the people there. I was now ready for Virginia with a renewed sense of purpose, only two weeks from the Boston Marathon.

Chapter 18

MOSTLY SWEET VIRGINIA

Virginia
Days 146–53
367.39 miles

Typical shop stop: sachets of brown sugar and maple syrup porridge, fresh fruit (for a change), Twix multipacks, protein powder (strawberry, of course – never understood the obsession with bad-tasting fake chocolate stuff) and donuts

I wouldn't describe the feeling as I started Virginia trepidation, but I was quite worried in general about the East Coast. The cities were going to be tricky with Pramsolo and, despite there being more couch-surfing opportunities, it potentially meant more hotel stays and budgeting problems. But then the people couldn't be that different from Tennessee, there were some beautiful landscapes down the road and it was a stunning day, so I told myself to stop being so silly and just get on with it.

Bristol is known as the home of country music, so I'd run from the place where it was honed into an art form to its birthplace. There, in front of a gigantic 'LOVE' sign at the welcome centre – Virginia is for lovers, apparently – I did a piece with Maggie

Smolka of Channel 5 News. I had to repeatedly run up a steep hill, as it had the perfect background for filler scenes, but anything for a good shot …

The next day, the Virginian god of rain chided me for doubting the state's excellence. Pramsolo already wore a very natty rain cover, the main purpose of which was to keep things on board, but with some black trash bags lashed to the mast and some gaffer tape to cover up the breathing holes in the rain cover (nothing was going to suffocate in there, after all) the Pramsolo Precipitation Procedure had been enacted. Salvation came in the form of a Wendy's – my second of the trip – and an early $4 lunch was the perfect marriage of calories and cost.

When I got going again, rivers of rain ran over my feet and I could tell everything in the lower storage compartment of Pramsolo would be saturated. I sat in an underpass and contemplated my options. I was still seventeen miles from Wytheville. Surely there must be somewhere to stay. I looked at my daily mileage: barely 35, but that meant I was sitting at the 5,000-mile mark of my run. I looked again at the map and suddenly a hotel icon appeared. Was this some sort of negative mirage – an oasis of dryness in an ocean of saturated shoes? It was my salvation for the night.

Virginia was returned to spring by the morning. I had a free lane of traffic due to roadworks and the hotels of Wytheville were casually waved by as I sailed down the Smallville, USA, picture-book centre. I had thirty miles in my pocket by lunch and I set my sights on another fifty-miler to celebrate my landmark. As strange as it might seem, I felt like I was still finding my feet. Having little experience of ultrarunning before I started, I had no idea where my boundaries lay, and right now I was confident or naïve enough to call distances at will. The surreal sight of a big old teddy bear in a tree with Christmas decorations on greeted

me before a bridge took me over Claytor Lake and I started to climb towards the sleepy Blue Ridge Mountain town of Snowville.

Apparently, it was once a bustling iron-ore town – complete with a still-standing Masonic lodge – but you wouldn't know it if you were here today. This was the definition of a place you could come to 'get away from it all' – including campsites, it seemed. I would need to knock on someone's door again. When I knocked on a door, I didn't want it to be a woman who answered, in case she felt intimidated; I didn't want it to be a kid, as they'd have no say; and I didn't want it to be a man, in case they were scary and carrying weapons. I knocked. It was a guy – a ringer for Jack Nicholson, but thankfully he didn't open the door with an axe while shouting, 'Here's Johnny!' He was happy to let me camp.

Close your eyes. Imagine unzipping your tent in the morning to see mist gently sinking down a hillside, dew on the grass reflecting the rising sun's rays as a million twinkling diamonds and a breakfast box stand in front of you. I thought to myself, *Why don't I camp more often?*

Christiansburg was one of those historic-looking American towns that Virginia seemed to do so well. Founded in 1792, it had a genuine claim to being just that, with Daniel Boone, Davy Crockett and William Clark – a restless pioneering explorer whom I'd encounter many times later in the trip – having resided there at one time or another, which is probably the equivalent of Bear Grylls, Ray Mears and Sir Ranulph Fiennes living on the same street these days. I later reached Roanoke, where more Dr Pepper is drunk per head than anywhere in the world. I was not going to let the side down.

* * *

1. Need a 'high and tight'? Fluke's barbershop in Mobile, AL is the only place to go.

2. There's an awful lot you could tell about a person by their shoes.

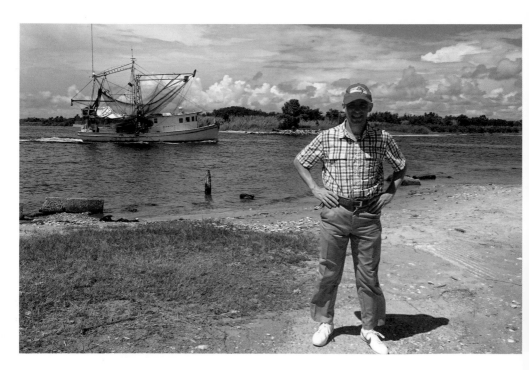

3. First view of the ocean and a shrimpin' boat. Bayou La Batre, AL. Bubba's hometown.

4. My boat, Jenny Jamboree; First Mate, Lt. Nads and our new best good friend, Bubba.

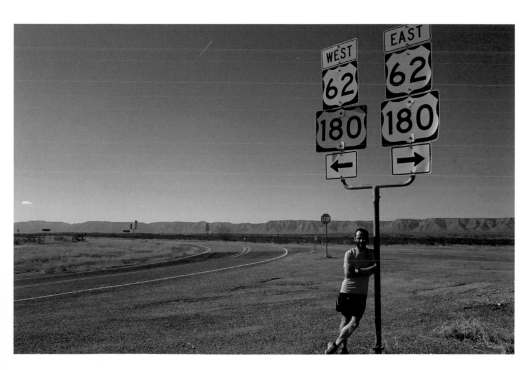

5. My signature pose: `The Lean.' Seen here in Texas, just south of New Mexico.

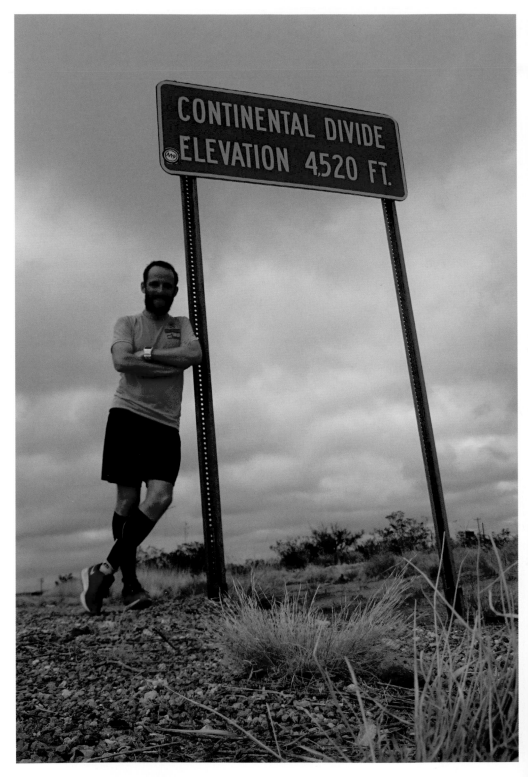

6. All downhill-ish from here. Until I'd turn around again at the edge of the continent.

7. You need to look behind you once in a while, so as not to miss the beauty...

8. Check watch. Check legs. Check resolve. Go. Again. Desert Center, CA

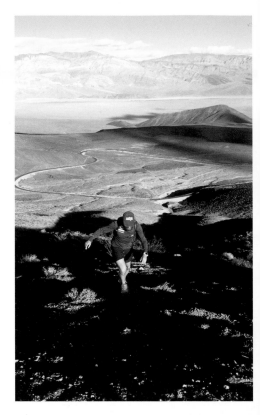

9. The culmination of a dream. I'd ran clear to the ocean. Once. Santa Monica, CA

10. Sometimes the road was too tame. Death Valley warranted a more exciting path.

11. I'd found what I was looking for. High on a desert plain. Near Keeler, CA

12. Well, Nevada does mean 'snow-covered.' I just never expected it.

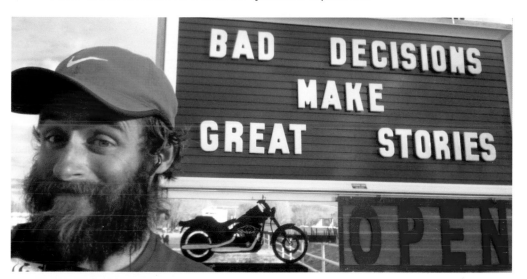

13. Non, je ne regrette rien. I can't wait for the next bad decision.

14. Progress. All about the progress. The Arizona–New Mexico border.

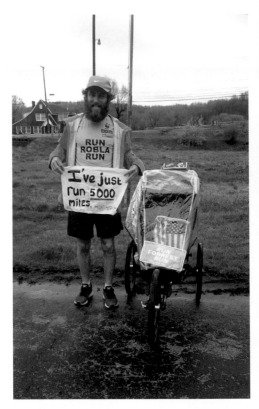

15. A busman's holiday, checking Hope over in Wright Veterinary Hospital, AR

16. Atkins, VA. Now I would run 5,000 miles and I would run 5,000 more. Twice.

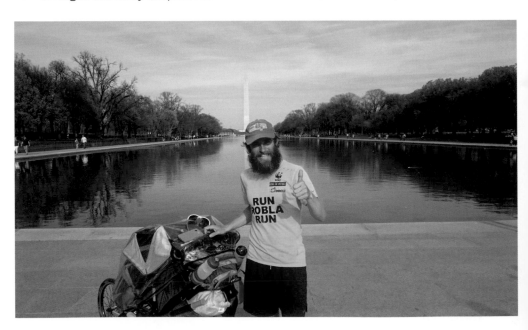

17. I half expected my Jenny to wade across the Reflecting Pool to me.

I crossed the Appalachian Trail for the first time at Troutville and, despite covering barely two metres of it, and laterally rather than longitudinally at that, I still felt entitled to a sense of kinship with those hiking it. At Buchanan I faced a choice. I could take the road, which was fully functional, quiet and sensible, or cross Buchanan's famous Swinging Bridge. Even looking across the bridge was terrifying, with a roll of about thirty degrees to the left in the first few steps. Made from wood and wire and 366 feet long, it was first built in the late 1800s, and the current version – previous incarnations had been burned in the civil war or taken by floods – was completed in 1938. I figured, given America's litigious society, that it wouldn't be allowed to be open if it were truly dangerous, so I went for it – though I still wimped out a little by putting my phone away and taking hold of my cap. The James River looked a bit chilly and fast flowing for me to save it if it came off. It was an exhilarating if not a little scary experience.

I passed farms and deserted shacks, through woodland and alongside streams, and as the sands ran out on my day I had a strange argument with a cyclist over my pedestrian status. A bearded MAMIL, he was indignant that I was running on the left-hand side of the road, facing traffic. I told him I was a pedestrian and had to do so, but he was insistent that I should be considered a cyclist and run on the other side. My protestations that I'd been told off elsewhere by police for doing so were met with, 'You're in Rockbridge County now, not anywhere else.'

Perhaps he was the county judge. I complied with a smile.

'You heading to the Bike House?' he asked chirpily, now that I was seemingly on message.

I had no idea what the Bike House was, and he sped off after we said our goodbyes. The road was so quiet I had no need to move back over to what I saw as the far safer side. It seemed silly

to be on the right. On the left hand, I'd at least be able to see whatever was about to wipe me out – assuming there would be no more jack-knifing big rigs like in Tennessee. I got my feet up and rested as best as I could in a motel that night, for the following morn there be mountains.

Climbing out of Augusta County towards Nelson, the rolling road of the previous few days gave way to the Appalachians proper. The reward for a long climb was an explosion of a vista as I topped out at the entrance to the famed Blue Ridge Parkway. To the east, as far as you could see, lay dark green forest, gentle hills and the odd column of smoke rising from a farmhouse. Somewhere thataway was the sea.

I wanted to know what the Bike House was, and I soon discovered that it was a very basic hostel set up by June Curry, who had devoted her life to taking care of touring cyclists crossing the Appalachians here. After she died in 2012, her will ensured that the Bike House would remain an active hostel. It was only twenty bucks a night, which ticked my boxes, especially as it was going to drop below freezing overnight in the higher country and this was not the time to be testing my sleeping bag to extremes.

It didn't look like a hostel. In fact, it wasn't too dissimilar to my own house back home. Apparently, only cyclists were allowed to stay, but seeing as my MAMIL had told me I was a cyclist, I'd blame him. I let myself in and stepped into another world.

There was not an inch of space on the walls and often the ceilings too. Everywhere you looked there were postcards, handwritten or sculpted mementoes, cycling jerseys – all with messages scrawled upon them – inner tubes, tyres, wheels and even some full bikes, including a tandem whose rolling days were over. Thousands of cyclists must have visited the place over the years – June estimated over 12,000 in 2005 – and many of them would

send postcards at the end of their journeys to let her know they were safe. Tonight I was the only one in residence.

Laying my sleeping bag down on a sofa, surrounded by so much love, I grabbed my toothbrush and headed to the kitchen. My eyes fell upon a Mr Happy T-shirt mounted on the wall, with a handwritten message from a cyclist who'd arrived hoping to meet June on his stay.

> **June Curry**: I cannot thank you enough for the couch to crash on this evening. I hope you recover and are able to read this. This basement has become a monument to you as a symbol of love + hospitality to thousands of weary bicyclists. I am in awe. You have made me Mr Happy. I wish I was able to meet you as a person.
> Sincerely, Andrew Pipkin
> July 11, 2012: VA Beach to Astoria

She died four days after he left. I was inconsolable, crying with a sadness for June, the kindness of Andrew's words, her actions and the beauty of the shrine that had been created.

The next morning, I left my calling card with the myriad others and pledged to send a postcard from Maine. The payment side of things was now handled by Airbnb, but I put a $20 bill in the cookie jar by the door, the way June would have liked it.

The theme of 'Love' was an apt one to start the day. I was loved up coming out of the mountains, but that didn't mean the end of the hills, and it was a day of undulations, approaching the town of Charlottesville to the north.

I was blissfully unaware of the debate raging over statues of Confederate generals in the wider area that would come to a head four months later when a white supremacist drove his vehicle into a crowd of protestors, injuring 35 and killing Heather Heyer, a

young woman who was involved in a peaceful protest against the far right, and injured thirty-five others. I'd seen Confederate flags all over the country and was well aware of its chequered history. I didn't know quite what to feel whenever I saw it.

Sometimes I like to apply 'Forrest logic' to these situations. Despite being from the hotbed of inequality that was the South of his youth, he didn't judge people unless they were deficient in good character and even then he tried to see the best in them. I'm sure he'd think that if the flag was making a lot of people unhappy and there was a need for a flag to show pride in where people came from, why not just make a new flag that doesn't have anything bad associated with it and didn't upset anyone? As I ran through this beautiful part of the world on that spring day, I dwelt on the wealth of love and kindness I'd received from people of all races and backgrounds during my time in the South, including one lady who wasn't even around to thank in person.

I reached town as it was just about fully dark, eyes darting left and right for a place to stay. I'd been given an unceremonious and repeated, 'No!' at the campsite I'd had in mind for the night, despite being told I was fine to just turn up. I suppose the love and kindness had to come to an end eventually.

I looked north down the road. No shoulder, busy, no lights. That would simply be playing Russian roulette, a game I'd already had my fill of. I went to the local police station. The telephone controllers were confident that the deputies would find me something and looked on aghast when one entered and told me I couldn't camp within the city limits. There was no local pub, just a restaurant, which made it a little harder to sit down and talk to people. The staff didn't know anywhere I could stay.

I went to the local church. It was too late to knock, and after twenty minutes spent sitting in some bushy cover I still had an

uneasy feeling. I went a mile down a farm road and miraculously found some woods that didn't have a 'POSTED', or no trespassing, sign. I started to unpack my tent. Dogs were barking, around 200 yards away, by the sound of it, surely too far away for me. Just in case I sat still for ten minutes, until all was quiet. I started again. Instantly the hounds bayed. I had no desire to be moved on at gunpoint or worse, and Pramsolo was subsequently loaded again. It was now just over an hour until midnight. I reckoned I could get to a hotel in Culpeper, the next town along, by 1 a.m. if I ran at full speed and didn't wind up in a ditch or hospital bed.

I set off down this fateful route when I saw a patch of scrubland behind a 7-Eleven store. It looked okay, ground wise, and the doorbell rang as I entered and approached the cashier.

'Excuse me, mate, do you know if I'd be able to camp behind the store?' Cue standard explanation of run, with added campsite rejection bonus story.

'I don't mind where you camp – there are no cameras there.'

Nice as it was that he didn't mind, I needed to make sure he had the authority to allow me to just in case there were any issues during the night.

'Nah, man, I just work here!'

That would have to do. I went to gather some late-night supplies, and when I returned to the till another deputy had entered. The cashier explained my situation to him.

'If I don't *know* about it, I can't do anything about it.' He looked at me. 'I'm certainly not gonna walk round the back of the store anytime in the next while.' What a champ.

I got my stuff unpacked and lay down. I wouldn't say I slept. The sound of car doors opening and closing, gas pumps whirring and the knowledge that I wasn't under the watchful eye of CCTV were not exactly conducive to a solid slumber. After some fitful spells in and out of sleep, I woke up at around 4 a.m. to watch

my breath condense above me for the next couple of hours, wondering how I was ever going to manage the longest run of my life that day. The gas station is always darkest before the dawn.

This was my first real disappointment since starting off alone, and I was glad of the early start to get moving once again. As I was making my way through the first few miles I received a message from an old university buddy, named Virginia, of course. She'd only just seen the social media post I'd put up last night about my accommodation status, and she told me she lived just ten miles down the road, in Culpeper, and if they'd known, they'd have come and picked me up. If only …

I needed to be in Manassas by the end of the day, and the miles seemed to fly by as I ticked off 3,000 miles on this leg of the trip, then 200 marathons run across America in total (5,243.8 miles) and finally a significant psychological milestone. As I ticked off 5,248 miles, it became less than 10,000 miles to go to the dream ending of completing the *Forrest Gump* run.

That night, in Manassas, Virginia and her husband Michael and son Collins joined me for a meal befitting of fifty-four miles and a Vienna lager from the Devil's Backbone brewery I'd run past coming out of Lexington. We, or maybe I, got sucked into the karaoke that was on offer too,* while a hotel room, very kindly courtesy of Virginia and family, awaited me. All of which made for a vast improvement on camping by a 7-Eleven.

* I know you want to know, so 'Get Back' by the Beatles and 'You Shook Me All Night Long' by AC/DC. A pattern was starting to emerge.

Chapter 19

MEETING GEORGE AND MARY, WHILE SAMPLING DELA'S WARES

Washington DC, Maryland, Delaware
Days 154–7
30.27, 84.65, 42.7 miles

I'd long since given up on running to Boston in time for the marathon, so my attentions turned to how to get there by other means. I sent a few feelers out on social media to see if anyone, most likely from the New Jersey and New York area, fancied a hitchhiker. I emailed running clubs as a more targeted tactic as well. I wasn't sad about not making it on foot, as it would have made the past few weeks a miserable affair, with no time to speak to people and take it all in. I was about to start a run of big cities too, and I wanted to experience them, at least a little, rather than get het up about having to stand at a crosswalk for 110 seconds *already*. I was thirty miles from Washington DC, a city I'd never visited, where I'd be staying with a good friend of mine from Ireland, Mike, with his wife Siobhan and daughter Fiona.

I passed the jumping-off point for the Wright brothers' first flight and was then into Arlington. The first monument I came across was the Marine Corps War Memorial, an image I'd seen a thousand times before of Marines struggling to raise the Stars

and Stripes on top of Mount Suribachi during the Battle of Iwo Jima during the Second World War. The sun was just at the right height to silhouette the statue when close up, giving it an ethereal glow. The Seabees Monument – for the US Naval Construction Battalions – carried a slogan: 'The difficult we do at once. The impossible takes a bit longer.' I decided I could adopt that.

To my right, I saw the rows and rows of over 400,000 men and women who are buried at Arlington National Cemetery. As well as military personnel – including the Tomb of the Unknown Soldier – President John F. Kennedy, his brothers Robert and Edward and his wife Jackie are also laid to rest there. Many tourists visit each year to pay their respects, but I didn't feel I was dressed for the occasion in fluorescent orange. Interestingly, General Robert E. Lee used to live within the grounds at Arlington House, which is now, ironically, considering his opposition to the glorification of conflict, a memorial to him. His statue in New Orleans is no more and the potential removal of the one in Charlottesville had its tragic consequences. Regardless of his views, I imagine he would have been horrified to learn of the consequences of a memorial he was opposed to. War loses still, 150-plus years on.

The Lincoln Memorial Reflecting Pool was of particular significance to my quest, as it's where Jenny splashed across to greet Forrest after his speech to the assembled anti-Vietnam War protestors was cut off by an over-zealous official. It wasn't going to be possible to recreate it without Nads there, but it brought a smile to my face imagining it.

I needed to make a stop at the infamous Watergate Hotel, where the scandal that brought down Nixon was discovered by none other than a well-meaning Forrest himself. I bet Tricky Dicky wished he hadn't invited him round for tea and a chat about ping-pong that day.

On the morning of day 155, I headed to the White House. I don't know if he was home, but the boss didn't invite me in for tea. More welcoming were two Secret Service agents, who apprehended this strange-looking visitor taking selfies by the North Lawn fence. In the interests of protecting their identities, I will call them Riggs and Murtaugh.

'Hello, sir, can I ask what you're doing, please?' Murtaugh asked in an alert, rather than threatening, manner.

I felt it was in my interests to be brief and to the point. 'You know *Forrest Gump*? Well, I'm running across America just like him.'

Murtaugh nodded and turned aside for a brief conversation with Riggs. They both turned back to me. Murtaugh looked me up and down again. Then his eyes lit up. 'Do you mind if we take a photo with you?'

I was hardly going to refuse – and, besides, it was potentially the coolest photo opportunity I'd ever been involved in. They gave me a special Secret Service pin, which still adorns Pramsolo's right flank to this day. I never asked if it was a tracking device, but once Murtaugh handed me his number and said to call if ever I needed it, I liked to think it was.

It felt like just as soon as I'd arrived, I was gone. I passed the offices of the *Washington Post*, and I seemed to find myself in Maryland before I'd had time to blink. I'd barely scratched the surface of Washington, so to be leaving so soon was jarring.

I enjoyed the solace of urban running down Highway 1 while it lasted. Passing a poster for the WWF as I emerged from one of the few areas where trees outnumbered buildings, I fell upon Daniel's Restaurant, a known biker haunt with rows of Harleys outside. I parked Pramsolo in the line and felt very amused with myself. You don't really want to piss off a gang of bikers, but

luckily for me they saw the funny side too. When I asked them for any hints on heading into Baltimore, 'Stay off 1 and get to where you need by dark!' was the general gist. I'd had that said to me about a large number of places I'd been to, so took it with the usual pinch of 'whatever', but I arranged to get picked up by Linda Kolodner, a friend of a friend who was hosting me at her place outside of the city. She worked in the local crime lab, so I got an insight into the crime and politics of the city. I knew of the rep and hoped for Baltimore's sake it wasn't true, but it made grim listening, especially for a Brit. I'd told her what the bikers had said and she confirmed that if I'd continued into town in search of a hotel that evening I'd have been passing through some risky areas.

Fearing the worst the next morning, I was pleasantly surprised when back on Highway 1 to discover that I wasn't passing through a virtual warzone. Instead the houses and stores and people with big smiles and encouraging comments all gave a positive impression. It might have been off the tourist drag, but it was just another working-class neighbourhood to me.

It didn't take long to escape the city, and I felt I could open my lungs up, relax in the reduced traffic and enjoy the Maryland countryside at last. Of course, I wasn't in the wide-open spaces of the West, so these moments never lasted. I came to Conowingo Dam, a Native American name meaning 'at the falls', which allowed Highway 1 to cross the Susquehanna River, alongside its day job of providing hydroelectric power. Sadly, it was collecting huge amounts of plastic and timber debris on its upstream edge. It was a fairly harrowing crossing via two narrow lanes with no shoulder, before heading onto Rising Sun, nearing the end of my Maryland route.

Three students whom I'd met over lunch back in Knoxville had promised to host me in Newark, Delaware, where they were

studying. Staying at my first 'frat house' was a fun experience, though due to the nature of the beast, beer pong and suchlike were off the menu. Pizza for dinner, a few Miller High Lifes and sleeping on a couch reminded me of everything that was great *and* awful about being a student.

In the morning, heading out into Newark, I chuckled at an old Trump campaign poster that someone had made themselves, stating: 'We Are the Basket of Deplorables'. A middle finger to the author of the name or remarkable self-awareness?

Newark was a self-proclaimed bicycle-friendly city and, in my experience, so was the whole state of Delaware, with no issues all the way to Wilmington, where I met another old pal, Bob Lawrie, for lunch. I thanked my lucky stars that the UK's veterinary schools had cast their graduates far and wide. I was sent east once more, with an aid package of Great British sugar, including shortbread, dolly mixtures, Sherbet Dib Dabs and, best of all, *British* Cadbury Creme Eggs. Until you've sampled the difference, America, you'll never know.

At the border with Pennsylvania the cycle paths promptly disappeared. And with that, I'd suddenly gone from grand houses and manicured lawns to an industrial railroad, which gave a very good impression as to what 'the wrong side of the tracks' looked like. I wondered if I should heed the bikers' advice once more: 'Get to where you need by dark.'

Chapter 20

THE GRITTY CITIES

Pennsylvania, New Jersey
Days 158–60
43.09, 50.07 miles

Punctures: 1, though fixing a Pramsolo puncture
was a less onerous task than a Jenny one

Being a huge Rocky fan, I was arguably more excited about reaching Philly than any other city, with the possible exception of Chicago. I aimed to take in all the sights – including the statue, Mick's Gym, Adrian's Restaurant – and, most of all, to run up those famous steps of the Philadelphia Museum of Art. I'd been enthusing over my impending title-fight arrival on my social channels, but when I received a message from my friend Dave, who worked for a Philly-based company, the referee called a no-contest: the NFL had apparently waved a huge amount of money at the town's authorities to allow them to hold the annual Draft on the steps. Rocky's steps. My steps. There would be no running up them and I feared it would be a metaphor for something not worth contemplating.

The road in was initially, for want of a better term, rocky, though thankfully bicycle lanes appeared. One lady went into a

flying rage at me for having the temerity not to have a baby in my stroller.

The centre of Philadelphia is extremely beautiful, if you like that sort of thing, which I do. The skyline rose above the predominantly low-storey neighbourhoods to the southwest, and I completed a half-marathon to the Museum of Art, the Schuylkill River running down its western side and the ugly stage scaffolding obscuring my steps. I wasn't bitter. Not at all. At least the bronze statue of Rocky was still accessible, in its new spot at the east side of the steps. If you're a fan of the films you may wonder why it's not where it used to be – at the top. After the release of *Rocky III*, city officials stated that it could not be considered as 'art', as it was only a movie prop, and it was moved in what seemed to be an awful case of art snobbery.

Benjamin Franklin Parkway's array of world flags lined its broad boundaries, making it look like an American version of the Mall, and I took in another famous statue – one of the versions of Auguste Rodin's *The Thinker*, in front of the Rodin Museum. This statue wasn't even cast until two years after Rodin's death, yet it seemed to take its place as an authentic piece of art, though I will be the first to admit that I'm hardly well versed in this area.

Exiting via Chinatown, I found myself in the inner-city hoods and saw a lot of my home town in those streets. While we don't have much in the way of weatherboard-style houses that I saw a lot of down Torresdale Avenue, the terracing and neat gardens reminded me of home, though maybe it was just the vibe of a city with a very similar spirit to what I was used to. After all, nothing gives a city more pride in itself than the feeling of having to prove something.

I was so used to seeing the weird and wonderful by now that the sight of a ten-year-old bearded Jesus carrying a cross that was

almost twice his size through the streets, flanked by a small regiment of centurions and a sizeable crowd of onlookers, barely registered a raised eyebrow, but it did remind me that it was Easter weekend, Good Friday, to be precise, something this lapsed Catholic perhaps should have been aware of.

I was lucky enough to be staying with another friend tonight, Pete and his wife Pilar and their brood. Their place was excellently named Norwegian Wood, just shy of the line with New Jersey. I also had a long-overdue chat with Nadine over the phone. She was doing okay at home, though finding it quite strange watching my life over the internet as an observer rather than being a participant.

My reaching out to make it to the Boston Marathon had been successful, and I had managed to arrange a Sunday morning pick-up from the town of Elizabeth so I could still participate. I'd need an early departure from Pete's and a good long day to get to my Elizabeth hotel in time.

A pretty decent runner himself, Pete escorted me out on Saturday morning and over the Calhoun Street Bridge, into New Jersey, with its very prominent sign informing horses that they were not welcome over its length. It must have been a significant issue at one point, I'm sure.

While Saturday morning was still stirring, we passed the state line and through a town that's had its fair share of bad raps, the state capital of Trenton, before we reached the opposite end of the spectrum by lunchtime in Princeton, home of the famed Ivy League University and touted as one of the best places to live in the whole country. Princeton wore its British architectural heritage on its sleeve, and it was hard not to feel slightly out of place among the preppy students mixed with the tourists snapping away.

One thing you would notice in my current line of work was how smooth the sidewalks were. Barely a mile would go by in a

blue-collar – if collars were worn at all – neighbourhood before something vibrated its way off Pramsolo, but Princeton was extremely smooth. In fact, the only mention of Princeton and Trenton in the same breath that I could find were monuments to two sneaky victories in battle by George Washington and his wily Continentals that, despite being small in stature, were grand in significance in turning the tide of the Revolutionary War.

I was happily trundling away, enjoying a top-quality sidewalk and approaching a junction with a road to my left. The pedestrian crosswalk signals told me to roll on, but in the US you can often turn right on a red light if no traffic is coming down the road you're turning on to. I'd learned to exhibit a degree of caution when crossing, especially when running. A car had approached the junction and stopped, so with one eye on the signal and another on the front fender, I proceeded to cross. I saw the car edging forward, but it didn't overly concern me, as cars often did to get a better view of the road. The problem was that it kept coming, and I could see the driver looking left repeatedly – but never right. I was fully in front of him when he decided to make a jump for it. I shouted out, but it was too late. The car hit Pramsolo and the wheels spat into the air and removed the barrier between the car's fender and my left hip, shunting us a couple of feet to the right. In my slightly shocked state, my main concern was for the welfare and integrity of Pramsolo. I saw that both of his wheels were sitting at an awkward angle.

The guy driving was smacking himself about the forehead in a frenzied manner and shaking his head. He looked up at me in dismay. 'The baby?'

'No baby, mate, but this is still serious.'

I could feel the relief flood out from him. He handed me twenty bucks.

'I don't want twenty dollars, mate.'

'That's all I have,' he said, before offering me another thirty.

I didn't want his money, even while thinking it was potentially going to cost a lot more, but I told him in no uncertain terms that he was sorting this out with me. I had to call the police, as I didn't want to get caught in some sort of 'leaving the scene' incident and have my visa withdrawn, which would also be a handy stick to wield if he decided that it wasn't his problem any more. I told him that I wasn't hurt and wasn't going to sue. All I wanted was to have the wheels fixed and to be on my way.

He agreed to stick around and help. Both pins that connected the wheels to the chassis were badly bent. He had some basic tools in his car and we set to work trying to straighten the pins, mostly by belting the living daylights out of them with something that looked like a spirit level. In the meantime, the police arrived. I discussed what had happened and said that the guy was a genuine enough fella and was trying to help, and the officer was happy not to fill out the paperwork. He did, however, say to call him if there were any issues.

We got the axles straighter, but not straight enough, so I needed some more professional help. With a badly right-tracking Pramsolo and twenty bucks of 'sorry' money, I headed north where first an auto-repair shop and then a cycle shop patched up Pramsolo. All in all, it was a lucky escape.

Pramsolo was rolling beautifully again and we still got in forty miles, but given that it was eight miles short of my target, it meant I hadn't arrived at a suitable destination. I stepped onto Highway 9, with darkness on the edge of town, in search of somewhere to stay for the night. One hotel advertised its rates by the hour, which I thought might be better to avoid, before I finally found what I thought was a suitable option. I slid the chain over the door and got my head down.

It was 2 a.m. when the phone rang. I'm not sure how long it was ringing for, as it morphed into my dream. I answered just as the line went dead. I turned over and had just about sunk back into sleep when there was a loud bang as the chain on the door snapped into action. A man and a woman were at the door, looking through the two-inch gap.

'There's someone in there! I think there's someone in there!'

'There is,' I replied firmly.

The door closed immediately. Heart racing for a good while and grateful for my door security, I tried to get to sleep. But all I was thinking about was how wrecked I'd be for the marathon if I didn't.

The phone rang again. I was awake this time so I managed to catch it early. 'Yes! There is someone in this room – stop calling!'

I should have also said, 'Don't send the cleaner in twenty minutes,' as my door slammed onto its leash once more. I guess that couple must have booked an hour.

Bleary of eye and heavy of foot, I walked my first half-mile on Sunday of what was a tiddler of a day's running, seeing as I had a 'proper' marathon the next day. I always taper off a bit later than most for marathons, but I never usually put nine miles in the day before. I got a ticking off from a police officer while I was singing along to 'Born to Run', who said that if I was stupid enough to be running on the 9, I should be concentrating, rather than singing. Some people just don't know talent when they see it.

I finished up in the parking lot of North Elizabeth Transit Station, close enough to smell the kerosene fumes from Newark Airport, where I waited for Salomon Vasquez of the Road Runners Club of Woodbury. He had volunteered to ferry this stranger all the way to Boston for the marathon. New Jersey

would have to wait for its grand finale, as I was off to Massachusetts for the weekend.

Sharing a journey with a fellow runner is a sure-fire way to get into the mood for a big event, and I think Salomon enjoyed the novelty of the situation. He asked if I was going to run in 'normal' running gear or as Forrest. What do you think?

Chapter 21

BOSTON STRONG

Boston Marathon
26.2 miles (or 24.2 miles followed by
2 miles of Party Time)

The resurgence of interest in running events is incredibly exciting to me, and the Boston Marathon is the granddaddy of them all, beyond question. Inspired by the marathon in the first modern Olympic Games of 1896 in Athens, a tribute to Pheidippides, who according to legend ran from the battle of Marathon to either Athens or Sparta (accounts differ, but it was still pretty far). Boston is the first and the longest-running annual marathon in the world. No surprises for guessing that it has a lot of history attached to it, encompassing the whole spectrum, from glory to tragedy. The 2017 edition was the 121st edition, and I'd already had the good fortune to run in the 110th in 2006, when I fell in love with the race.

This year, 27,222 people would line up at the start line in Hopkinton, Massachusetts, with around 15,000 men and 12,000 women – a fairly even split. One of these women in particular would raise a wry smile at this. Her second marathon was likely to be less incident-packed than her first. In 1967, Kathrine Switzer became the first 'numbered' female runner to complete

the course. Entered under the name K.V. Switzer, an official tried to rip off her number and pull her from the course in the finishing straight when they realised that her male credentials were open to serious question. Fortunately, her boyfriend tackled the guy to the ground and Kathrine was able to finish the race. Alongside Bobbi Gibb, who became the first woman to complete the course running as a 'bandit' or unnumbered runner, she was instrumental in having the rules changed to allow women to compete from 1972 onwards. This year, she was to run again, fifty years on, using the same number, 261, as she wore in her first.

Salomon and I talked about this and so much more on our four-hour journey north. It was his first Boston, having reached the qualifying time last year at the New Jersey Marathon in a sterling time of 3:06. Boston is fairly unique in that, barring a small number of charity places, you have to reach a tough age-graded qualifying time to be eligible to enter, so even getting to the start line is an achievement. The aspiration to Boston Qualify, or 'BQ', in the States is nothing short of a cult.

Salomon was hardly in need of any advice, having completed many triathlons too, but I had a few nuggets that I was happy to throw his way. Most people consider a marathon to be 26.2 miles long. I, however, consider it to be only twenty-four miles long, with the final two miles being a separate, completely unrelated event that I call Party Time. Now, I'm not being facetious or belittling anyone who thinks that these two miles are anything but Party Time. Trust me, I've found myself in some very dark places in those last couple of miles. The difference is that I tell myself that everyone around me, regardless of what they or I look like, feels worse, instantly making me stronger and able to run faster. Twenty-four miles is also near enough to the end that, unless something catastrophic happens, you're going to finish

and deserve to be proud of yourself. And whether you are or not, I promise you this – others will be. I tick down the miles from halfway, from where there are only a trifling eleven miles to go until you can have your party, as strange as that concept seems. You're galvanised by reminding yourself that you're only doing twenty-four miles, which you might already have done in training, and then, if you can convince yourself to, you can have some fun, even though that may require a sense of black humour.

We headed around the exhibition together before I collected my number 31249. Then I said goodbye to Salomon and reformed Pramsolo for a stroll down the finishing straight together, seeing as he wouldn't be able to ride along with me tomorrow. I saw a group of runners staring solemnly at something. During the 2013 event, around 200 metres from the finish line, two bombs were detonated, killing 3 spectators and injuring over 250. This was an unofficial memorial to the victims. But if those who commit such acts thought it would make them cower in fear, they had another thing coming, such is the spirit and attitude of the place. This is the city that threw contentiously taxed tea into the harbour and started a revolution. The hashtag BostonStrong has become a rallying point for the city to show it would not be dictated to by evil, and the marathon lives on not only as a symbol of the efforts of the athletic individuals who are lucky enough to participate, but as an emblem of a city's defiant spirit.

Early on the morning of the race, it was already getting warm. It would be warmer than any marathon I'd done before – even the Australian ones. I'd run through a desert not so long ago and I had no plans to push myself, so I wasn't that concerned. All I wanted was to get round and have a good time. In my khaki shorts, plaid shirt, long stripey socks and, of course, the red cap and Cortez, I cut an unusual figure among the lycra and racing shoes.

Being dressed the way I was meant that people would actively ask me about my story, and in turn I got to ask them about theirs. Chris Conlon towered over me with a radiant smile, and he had a remarkable story. Chris had a successful career as an engineer and was a member of the Screen Actors Guild. In 2012, Chris was out for a walk following knee surgery when a clot from the operation dislodged and caused him to have a severe stroke, which left him temporarily paralysed on his right side and struck with aphasia, a condition which dramatically affects your ability to speak and sometimes understand speech. Within a few weeks, he had driven himself to complete a 5k and finished his first marathon in 2014. He's put himself through 'Tough Mudder' events and even Ironman races, the thought of which terrifies me. Now it was time for his first Boston Marathon, raising awareness and funds for ARC Aphasia Recovery Centre. He struggled to find the words as quickly as he would like, but it didn't matter, as he had the full and undivided attention of the thirty or so people around us, as we waited in the rising temperatures for the bright yellow school buses to take us to the start, over twenty miles away. I'm glad we got the chance to connect and if ever I needed some inspiration to keep going, Chris was just that.

Bostonians turn out in force for this. Held on Patriot's Day, the civic holiday commemorating the first battle of the American Revolutionary War, half-a-million people line the streets and create an atmosphere second to none.

I started a good hour after the elites had headed off towards the horizon. The first few miles were painfully slow, due to the density of the runners. Resisting the temptation to weave as I was in no hurry, I stuck to the side of the road where I was able to fill my quota of high-fives. Gradually, the field thinned and my pace was able to rise as we snaked through the wooded communities around Ashland and on towards Natick. I felt strong enough and

gradually increased my pace from an 8.30 minute mile to some-
thing approaching 7 minutes. Just before the eleven-mile marker
I passed a sign advising that 'Toenails Are Overrated', and I saw
a fella in a Manchester United shirt light-heartedly heckling
whoever went past and offering them some beer. I drifted over to
his side of the road.

'Hey, Forrest, have some beer!' he said, brandishing a bottle of
Bud Light.

Without thinking, he was relieved of it, and I could hear him
shouting, 'Hey, he took the whole thing! Forrest Gump just took
a beer!'

In most situations I know what to do with a beer, though I'd
not factored this into being part of my hydration strategy.
Receiving an incredulous shake of the head from the runner next
to me after I offered him some, I proceeded to spend mile twelve
drinking and belching.

I'd not long finished by the time I reached the Scream Tunnel
– a mile-long section around halfway, near Wellesley College, the
women's liberal arts college, a notable alumnus of which had just
fallen short on becoming the first female President of the United
States. This was what it must have been like to be one of the
Beatles. Amidst deafening screams and signs offering kisses to
runners of various nationalities, I decided to say hello to a group
who appeared to be fond of those flying under the colours of the
Union Jack. Sporting several smackers on my cheek as I got back
into my stride, I heard one of my new fangirls scream to her
fellow college mates: 'Oh, my god! He sounded just like Prince
William!'

If I've ever had the pleasure of speaking to you, you'll know
that is a fair stretch of the imagination.

Around fifteen miles in, my mind began to make mischief.
What pace would I have to achieve to do a sub-three-hour

marathon? The answer, 6.08 minutes per mile, was a pace that I'd only flirted with crossing the Mississippi in Baton Rouge on the 190, the I-10 in Houston and that excited mile coming out of Joshua Tree. Well, that and a couple of occasions when I'd wished I'd connected the brakes on Pramsolo going down some of the Appalachian hills. I figured I'd give it a go for one mile and see how it felt. One mile later, I figured it felt alright, so I thought maybe I'd run to the end of town … and when I got there I figured I'd just run across Norfolk County. For no particular reason, I just kept on going, faster and faster until I saw the famed Citgo sign that sits high above the city, one mile from the finish.

The reception from the crowd was incredible, with thousands of cries of 'Run, Forrest! Run!', alongside a few 'Go, Jesus!', 'Go, Plaid Shirt Guy!' and even, 'Go, Grizzly Adams!' For that reason, I will give one last piece of marathon advice: if you don't dress up as Forrest Gump in a marathon, you're missing out on a lot of encouragement.

Turning onto Boylston Street, I was miling at around 5.40 pace. Sometimes the finish comes right at the appropriate moment, and it was barely 400 metres away. As I closed in, I ran past someone pushing a stroller and realised that this was not another cross-country runner, but another one of those amazing Boston Marathon stories. Bryan Lyons, a local dentist, was pushing a man called Rick Hoyt, part of the famed Team Hoyt dynasty. Bryan had recently taken over from Rick's father, Dick, who had been his running buddy ever since 1977, when Rick suggested taking part in a five-mile benefit run for a local athlete who had been paralysed in an accident. Rick has cerebral palsy, as a result of complications during his birth, and after his family resisted calls to have him taken into care, they realised that their son was an intelligent and passionate young man with a strong

desire to help others. Even though Dick wasn't a runner, they agreed to do what they could and struggled all the way home. That night, Rick said to his father, 'Dad, when I'm running it feels like I'm not disabled.'

I find that statement so profound and powerful. They took part in over thirty Boston Marathons together and completed Ironman Triathlons, with Dick pulling and pushing Rick around the courses in their specially adapted chair. I wished I could have shared something more profound than, 'Awesome work, guys' that I contributed as I went past, but I was now feeling the effects of my indulgence.

I crossed the finish line in 2.58.46, where I was interviewed by the live CBS broadcast. When they asked about the beer, I replied, 'It was only Bud Light – I think that counts as an isotonic sports drink.'

Chapter 22

AN APPLE A DAY

New York
Day 161
46.2 miles

Jamie Bishop, a friend and former housemate who sat alongside me in the Olympic Stadium at London 2012 to see the famous Super Saturday, when Greg, Jess and Mo brought home the gold for Team GB in a crazy few hours of track and field, had travelled out to Boston to accompany me for a few days on a bike. If I could make enough progress in the days following the marathon, we might be able to celebrate reaching an ocean together.

We were fortunate enough to have a lady on the inside in Manhattan. Lenore Muller hosted us at her apartment for a couple of days, which was a relief given the cost of hotels in the Big Apple. Forrest was in New York for a while and became re-acquainted with Lieutenant Dan after his appearance on *The Dick Cavett Show*. Dan and Forrest spend an ultimately ill-fated night with 'two sleazy women' (the words in the script, not mine) as the Times Square glitter ball descends. The name of Forrest's new friend? Lenore. The only two times I've ever come across the name.

I left Pramsolo in Lenore's apartment and took the train back down to North Elizabeth. It didn't take me long, running through Newark and on into Harrison, to be glad that I was running free, as I got into some serious industrial country. The sidewalks might have been built for pedestrians, but they certainly weren't maintained that way. Derelict and decrepit stores and warehouses appeared with greater frequency as I ran past a hand-painted sign informing me that I was at a 'Bus Stop Not a Drug Stop'.

Life went on around me. People went to work, kids were screeching and having fun in the schoolyards, and in the distance I would catch a glimpse of New York under leaden skies. I crunched my way over the Hackensack River on the shoulder of a bridge that would almost certainly have had me fixing a puncture or two on Pramsolo. The signs here forbade you from 'Jumping, diving, crabbing, fishing or loitering', but I wouldn't have thought any of those activities were particularly appealing in the Jersey docklands. I presumed the next billboard hadn't been erected by the authorities. Towering high over a warehouse, a cartoon of the then occupant of the White House made out to be the Joker, opening his Star-Spangled Banner-lined suit jacket containing three hand grenades, had the speech caption: 'Dare me.'

Hoboken was in stark contrast to this, benefiting as it did from the golden touch of regeneration. It appeared to be very smart indeed, and it also had one hell of a view that I was about to be part of – on the other side of the Hudson.

The last time I'd been in the Big Apple was almost nineteen years previously, for the New York City Marathon. My mum came to support me, and ended up having far more of an adventure than I did. As part of her fundraising efforts for the trip, she called the offices of Virgin and asked to speak to Richard Branson. I don't know how it happened, but she got put through to the man himself.

He politely informed her that Virgin couldn't sponsor me as an individual, due to their existing charitable commitments, which sounded like the standard big-business rejection, but, as a reward for pluck – and perhaps because he saw a bit of his own derring-do in my mum – he asked if she was coming to watch me. At that point I was the youngest Brit to run the NYC course, so it was a big deal for her.

She told him that she was unable to afford a ticket, and before you could say 'check-in', he'd arranged an Upper Class return ticket. He made an ongoing offer of help with the caveat that she call his PA next time because, as you might imagine, he was fairly busy.

She did try to find her own hotel in New York on the marathon weekend, but it was understandably tricky, so she made a last-ditch phone call to Virgin HQ. They put her in touch with a very polite hotelier to make the arrangements, to whom she said, 'As long as it has locks on the doors and clean sheets, I'm happy.'

The hotelier was taken aback. 'Excuse me, Ma'am, this is the *Sheraton* St Regis. The finest hotel in New York and possibly the world.'

Needless to say, Mum ended up with a majestic room, and you can bet I cancelled my pre-booked Travel Inn and moved there too. And that's why I've come to inherit her rule for sleeping arrangements.

Nineteen years on, the city didn't seem to have changed a bit. I remembered the organised chaos, the sheer speed at which people seemed to walk and the need to check it was safe to look up – a must here if you didn't want to miss half of the action – so you weren't trampled underfoot and on the wrong end of a steely gaze or sharp tongue. It was impossible not to feel as though you were in a movie when you stopped and turned around 360 degrees.

The musical meccas of the Radio City Music Hall and Carnegie Hall were on my list next as I headed north towards Central Park. I'd been listening to Interpol, my favourite New York band, and their music had created the perfect soundtrack for the day so far. At the boundary of the concrete and grass, at the corner of 7th Avenue and 59th Street, was the entrance to Central Park, which, if we're talking about soundtracks, has been featured in over 350 big-screen movies since 1908. I was heading to a particular area of the park, Strawberry Fields, to pay homage to one of my all-time heroes, and I needed a change of musical pace. I reached the focal point, a circular pathway mosaic of inlaid stones with a single word, the title of John Lennon's song 'Imagine' at its centre. I had myself a little moment, which is quite hard to do when there are thirty other people around trying to have theirs. I was glad of the need not to speak to anyone at the nearby Dakota building, where Lennon was taken away from us on 8 December 1980. It's a strange situation to feel like you've grown up with someone who was never actually around by the time you were able to be aware of their existence, but we'll always have his and his three pals' music, the likes of which we'll probably never see again.

It was straight as an arrow up Frederick Douglass in Harlem. I felt more at home here than I did among the bright lights behind me. There was a 'Police Line – Do Not Cross' barrier straight out of *Ghostbusters*, and I passed fantastic murals of Martin Luther King and Barack Obama with their respective messages of hope – 'Dreams Do Come True' and 'Yes We Can' – before a field of dreams in Yankee Stadium.

Even before the state line, the vibe was changing firmly from New York to New England. I'd eaten the Big Apple in a day, and it couldn't help but feel like a bit of an anti-climax to be over so soon. At my Greenwich finish point, I headed back into the city

for the night, for one last shot at Times Square and a Bubba Gump restaurant, which I thought would serve as a fine location to début my new threads: a bright red track top hand-embroidered with a blue and white stripe by Nads, very similar to the one a certain Mr Gump wore in the film.

Chapter 23

A NEW ENGLAND

Connecticut, Massachusetts, New Hampshire
Days 162–7
145.8, 83.1, 40.8 miles

New York's concrete summits were shrouded in a cold April mist as Pramsolo and I boarded a northbound train. Jamie was going to spend some time in the city for a few days before re-joining in Boston, so I waved an early goodbye to both him and Lenore and headed to my Greenwich staring point, where I had the pleasure of being interviewed by *Runner's World*. Did that mean I'd 'made it'? It certainly meant a lot of people in the running community would hear about the run and that had to be good for the charities.

Chris Finill's rule about crossing the country was that 'it doesn't count unless you get in the ocean', but he hadn't warned me about the call of the sea. I'd been skirting the ocean ever since Washington DC, so if I'd grown tired of the whole mission I could easily have found somewhere to dip my feet within a day or two. Now that we were running through towns with names like Bridgeport, Southport and St Mary's by the Sea, the waves were whispering in my ear to call it a day here, have some chowder and a Sam Adams and be home in time for the London Marathon. The clos-

183

est I got was in West Haven, where I was effectively running on the promenade of a small beach that led directly into Long Island Sound. Some people may argue it was a bay, rather than the open ocean, but I was careful not to stray onto the shore, just in case the tide suddenly came in and the Atlantic got me.

Grey skies looked set to be the backdrop for the entirety of my stay in Connecticut. With a big effort today I could reach Massachusetts and maybe even re-run the Boston Marathon tomorrow, seeing as I was in the area. Close enough to smell Rhode Island but not pound the pavement there, I forged ahead for the day. As the light robbed me of my weatherboard houses, bright red Dutch barns and the sight of a rock painted to resemble the head of a bald eagle, my confidence ebbed away and I decided to call it a day, but only after my signature Lean at the Massachusetts border.

The road to Hopkinton was a beautiful prospect in the morning light. Hopkinton is justifiably proud of its location as the start of the Boston Marathon, and I was privileged to get a good, unhindered look at the start line painted on the road. I re-ran the whole marathon course, and it was one of the more surreal runs I've enjoyed in my life. I became the only participant in the nation's best-loved race. I recognised the 'old fire station', looking naked without its people and party mood, and marvelled at just how green a route it is, especially in the first half. There were no young ladies of the Wellesley Scream Tunnel, which was more library than the cauldron of Patriot's Day. The opportunity to take lunch en route was a useful modification to standard marathon protocol and ensured that when I ran up Heartbreak Hill (which isn't that bad, honestly) and saw the Citgo sign, it was without the usual desperation in my legs and lungs. I could get used to doing marathons in this style. I braved the traffic on

Boylston Street to cross the line one final time. The painted markers were a little worse for wear compared to last weekend – and I'm sure a lot of the runners still felt that way too.

I reunited with Jamie, who'd made it back from New York, ready to hit the road the next day on his two-wheeled steed, which we named Chew-bike-a.

We headed back to the fading finish line of the marathon to find that, improbably, it had been restored completely, which defied all logic considering the business of the road. Was it like this all year round? Now five, not three wheels glided towards the Mystic River.

I fed off Jamie's excitement throughout the morning. It felt like an extended lap of honour with a good friend to share it. Even though he wasn't running, I enjoyed passing on my road knowledge, waving at cars and looking over my shoulder to check he was doing okay, like a concerned father. Beyond the city, every second town betrayed its heritage with English-sounding names, and the weather was in keeping with the best of our spring.

We had breakfast in Massachusetts and second breakfast in New Hampshire, after we'd passed a life-sized model of a giant great white shark that had been caught just off the coast here in 1957. *Jaws* was filmed just down the road. Suddenly I wasn't so sure about my post-crossing dip in a few days.

My enduring memory of my sixteen miles through beautiful, beautiful New Hampshire was a parade of shops seemingly tailor-made for a teenager starting his first job at the car wash, which was the first building of a block that also featured a comic book store, a place selling fireworks, a pawnbroker, tattoo parlour, smoke shop and finally an adult emporium. I don't imagine that first paycheck would go very far.

Lunch was going to be in Maine, my final state of this leg and third state of the day. Not bad for a morning's work. Our reward

for such wonderful progress was incessant rain as soon as the clock struck two. There was no let-up through York and into the seaside town of Ogunquit, which means 'beautiful place by the sea' in the native Abenaki language. It resembled a wet weekend in Blackpool to me, though the buildings were a little more 'Hamptons' and there were no fairground rides in sight.

I wasn't bumping into as many people as I had in the South, but the world wasn't too different in terms of the hospitality of the people. I'd not been disappointed in New York and the other big cities per se, as everyone I'd had the pleasure of speaking to seemed genuine, interested in the run and kind. The issue was getting people to engage. Being the sort of guy who rushes around everywhere at home with work and a hectic social life, rarely sitting still and taking things in, I did wonder whether life would just be better if you cut 20 per cent of *whatever* out. People here seemed to be so much more relaxed.

There was nothing like a little bit of rain to make me miss home. Nads would have loved to be here in this part of the world with me. I was acutely aware of the importance of finishing at least this leg. The first leg had been a personal challenge, while completing a second leg felt just as important for WWF and Peace Direct fundraising. I couldn't stop thinking about her incredible empathy and selflessness to let me go on this lonely and potentially dangerous path in the hope of making a difference. Here I was, a couple of days from reaching the Atlantic Ocean, having crossed the States twice. I couldn't have done it without her. I missed her and wished she were here instead of back in Old England.

Chapter 24

THE MAINE EVENT

Maine

Days 168–70

125.19 miles

I don't know if I'd ever imagined Maine in the rain in my pre-run daydreams, but it wasn't all bad. Every now and again you would lift your head enough to appreciate the giant conifers lining the road and listen to the sound of new life in the woods. Having company was as good a reason as any to turn the music off for a while, and the lack of heavy traffic meant we could commune with nature a little, until it was time to hand Jamie a nutrition lesson. This was primarily an excuse to get out of the rain for a while. Dunkin' Donuts had proven to be a solid alternative whenever I couldn't find a local concern, and I came back to our table with six donuts and a couple of large sodas.

'We saving some for later?' asked Jamie.

'Of course not.'

Jamie stared at me in disbelief. Then at the donuts. Then back at me. He had so much to learn about life on the road.

Buzzing from the caffeine and dough-based goodness, we struck gold on almost nine miles of traffic-free 'rail trail', which took us through Scarborough Marsh, which is Maine's largest

salt marsh and home to a huge number of waterfowl on their way to Canada via the Atlantic Flyway. Herons, geese and even seals were everywhere. We were concerned that our narrow path would become submerged, and it was mighty close by the end, though our luck held out.

Flooding out our lunch joint with our hastily hung, dripping outer garments, the feeling returned to my extremities, and with it various painful chafing wounds came to light, including some in regions that you don't want to know about. Twenty-four hours of running in the rain had given me something bordering on trench foot. Changing into some dry socks, I placed plastic bags around my feet and put them back into shoes that weighed around four times what they should. I figured that I was too cold to sweat and make my feet soggy via internal humidification.

For those of you who have been enjoying the snippets of local geographical and cultural information and were looking forward to a Portland nugget or two, here goes. Nicknamed Forest City (almost perfect), it's the nearest transatlantic port to Europe, is Stephen King's home town and, despite its former mayor being regarded as the father of prohibition, its population of 60,000 get to enjoy seventeen microbreweries – the most per head anywhere in the States. Best of all, it's got a Sasquatch museum. But we were on a mission to find a laundromat and a good heater, so we only viewed Portland in passing, from underneath a dripping hood.

The plastic bags on my feet lasted all of five miles before the dam broke. Jamie had no lights or reflective gear, so he went on ahead to get to our hotel before night fell. I was left to navigate from one last long look at the map, clinging on to the last percentage of phone battery life until I got to Yarmouth. The narrow tree-lined road brought me back to the nature I'd left in a donut shop that morning. This was Peak Maine.

I was glad that I was able to share full and interesting days with Jamie, with all the emotions that came with them. I'd grown accustomed to dealing with negative twists that could add an illusion of misery to the whole picture, despite their being a veritable drop in the ocean. I was close enough to my finish point in Port Clyde now, with no more worries about accommodation, as the previous week I'd been contacted by James Morris, a Port Clyde lobsterman and second mate on boats all around the world. He lived barely a mile from my finish point and informed me that the area was quite abuzz for my arrival.

As the sun began to make an appearance, the smells of the forest, awakened by the recent downpour, added to our sensory experience. Balsam Fir and Eastern White pines applauded our steady progress through the town of Bath, over the Woolwich Bridge and onto that most important of times, lunchtime, in the pretty town of Wiscasset, famous for its seafood, especially the lobster rolls at an unassuming-looking shack called Red's Eats, which always has a queue stretching round the block.

Even struggling up a hill through some roadworks the next day could not dent my buoyant mood and our approach to the ocean. We'd enjoyed some fantastic hospitality in Maine, with plenty of meals on the house, so over a celebratory lunchtime beer in Thomaston, Jamie was shocked that we received a bill. We didn't *really* mind paying, but it had been good while it lasted.

The cute little town of St George was on the final straight, along with lots of encouraging messages from locals. I made time for a quick costume change, bringing out the Nike Cortez and the rest of the outfit from the famous scene at Marshall Point Lighthouse, including the red track top Nads had embroidered. I knew it would come in handy. There was no escaping the ocean once on the peninsula, with inlets and bays visible through the

spruce trees and lobster boats bobbing gently on the brine as a mist began to roll in.

Jamie rode on ahead to the lighthouse, leaving me alone for the final ten minutes, a growing tumult of emotions coursing through my body. I'd planned my music for this moment, 'The Lighthouse' by Interpol, who'd already accompanied me through their home town of New York, but it wasn't just the name of the song that made it the soundtrack for such an important moment. It was the bleak yet beautiful feel of the rattling sparseness within and the hint at an infinite expanse, rising and swelling, like the waves at the end of a rocky peninsula.

The mist faded in, stage right. I ran past Jamie with a couple of hundred metres to go and caught his eye.

'You okay, mate?' he asked.

'No. Not really, mate.' I didn't really know what I was, but okay wasn't exactly the word. Fighting back tears, I tried to avoid eye contact with the press and numerous smiling onlookers. I crossed the grass and onto the wooden runway, up to the door, stopped, paused … and seeing as I'd got to another ocean, I figured since I'd gone this far, I might as well just turn back, keep right on going.

Of course, it would have been a little rude of me to just leave my welcoming party, so instead I made my way to the ocean's edge. The razor-sharp slippery rocks prevented me from taking the plunge as robustly as I had in the Pacific, but I figured fully submerged feet would do. It was freezing cold, if you hadn't guessed.

Jamie and I were treated to an off-season tour of the lighthouse museum, which detailed the history of the local fishing and maritime industry and, as of 1993, contained an exhibit dedicated to the filming of *Forrest Gump*. Tom Hanks would be pleased to hear that he was considered a delight to have in the area during his brief stay.

Picking up four postcards of the lighthouse, I had the recipients already in mind. One for Olivia, who had been there at the start of this leg; one for the Bike House in Virginia, as promised; one for Tom Hanks (of course); and one for my Jenny. The human one. I was still heartbroken that Nads couldn't be here. I wondered what she was doing at that exact moment. I'd never know. What I did have was the confidence that she believed in me. Whenever I was at my worst, her voice would ring in my ears: 'You'll do it. I just know you will.'

As we departed, the lighthouse was almost entirely shrouded in fog. I'd had a $50 note burning a hole in my pocket ever since it was handed to me at the Pegram Fish Fry, back in Tennessee, by the mayor himself. With the local bar, the Black Harpoon – a pirate's den if ever there was one – selling wood-fired pizza and excellent ales, I thought it was a fitting way to remember a gesture that was one of many, without which I would not have got anywhere near this far.

LEG 3

29 April–30 September 2017

Maine, New York, Pennsylvania, Ohio, Michigan,
Indiana, Chicago, Illinois, Wisconsin, Minnesota,
North Dakota, Montana, Idaho, Washington,
Oregon, California

4,163.05 miles

Chapter 25

BECOMING A TRIPOD

Maine 2, New Hampshire 2, Vermont
Days 171–8
99.1, 112.4, 64.47 miles

Punctures: 2
Food watch: 'Italian Sandwiches' that Maine,
and Portland in particular, was famous for. The
granddaddy of all subs, containing ham, cheese,
tomato, green peppers, olives, salt, pepper and oil
(hold the cheese and olives, please)

Back to the lighthouse. The Zemeckis in me loved the still shots we'd taken yesterday, but to recreate *that* scene required the improved visibility that this morning afforded. So, before I headed up and outward once more, our host James, budding cinematographer Jamie and I had to go back to the edge of a continent.

I ran a totemic first mile from the door of the lighthouse to take a peek at James's lobster boat and the particular orange and white buoys used to mark his patch, one of which adorned the ceiling on the Black Harpoon, among many others. His boat was named the *Cindy C*, and it used to be owned by Cindy, the wonderful manager and part-owner of Red's Eats. Small world.

It was time to say goodbye to Jamie, who would be missed. We'd forged a strong connection over the last few days and couple of hundred miles. I was already steeling myself for a further effort. Having completed two crossings, I felt I had decent odds of being able to run the full five crossings that Forrest had. In the meantime, I had over a month before I was due to fly home to reset that pesky visa. I'd always wanted to visit Chicago and it was a trifling 1,200 miles away. *Let's give that a shot*, I thought.

I took one last long look at the ocean, then I went big and managed the longest uninterrupted run of the entire trip, a twenty-nine miler, straight off the bat. I reached my rendezvous with my hosts Dan and Katie's waiting truck, where Pramsolo was strapped in after another good day's work. We were cheered into town by a large environmental protest on the Damariscotta River bridge. If ever I needed motivation to continue, this was it. The third leg had begun in earnest.

A wave of sadness washed over me when I saw the sign telling me I was leaving the Pine Tree State and crossing back into New Hampshire. Maine had got under my skin. Pramsolo and I glided down the almost deserted and absolutely beautiful Ossipee Lake Road, after Loon Lake, which sounds like the setting for a teen slasher movie but is actually named for the birds of the same name that migrate over a thousand kilometres in a single day. Oh, for that rate of progress.

The next day, something inside must have been telling me to take it easy, as there was no explanation for my being as drained as I was. Pausing for an emergency hot dog, banana – I was worried that my lack of fruit and vitamin intake could be contributing to my fatigue – and Red Bull – I was *convinced* a lack of caffeine was involved – I walked past the home of the Plymouth Panthers, the sporting arm of Plymouth State University. A ball

rolled to my feet. Softball and lacrosse teams were playing either side of me behind tall fences. Whose ball was this? I guessed lacrosse, and the disappointed faces of the softball players as I launched it in the opposite direction told me I needed to rest. I'd been dwelling on the challenges of the journey today, from my desperate rescue of Hope to my various injury crises, losing Nads, the New Jersey car accident and the euphoria of Boston. I'd obviously been on an emotional knife-edge for a while, and my tears at the lighthouse had confirmed it. I rested up in a hotel for the night. Some Chips Ahoy cookies and milk took me back to the days of Jenny and Nads before I melted into a deep sleep.

I didn't stir until my alarm went off. I got my money's worth from the complimentary breakfast – extensively filling my pockets in the process – and stepped into the New Hampshire sun a new man.

I would almost close out New Hampshire by the end of the day and I was only just getting into being here. Gentle hills and valleys, getting greener by the hour, warnings of crossing moose and the sweeping curves of the roads on the approach to another brush with the Appalachians dominated my day. They were welcome to do just that if they stayed this pretty all the way to Connecticut River in West Lebanon.

I enjoyed a wonderful couch-surfing night with Ed and Betsy Warren, who introduced me to the delights of Panera Bread sandwiches, but I hoped I didn't wake them when I was up at 3 a.m. for a live interview with Sky News back in the UK. Not having a stylist or make-up artist currently on the staff, I wasn't looking my best, whatever that is, and my appearance was referred to by one wag well known to me as 'looking like Saddam just after they found him in the hole'. Hopefully it didn't spoil too many UK breakfasts.

* * *

I crossed the Maple Street Bridge and set foot in Vermont, towards a date with the mountains once more. The honeymoon period was excruciatingly brief, thanks to the driving rain, which automatically engaged my head-down, push-forward gear, despite the natural splendour offered by the Ottauquechee River. Wet, cold and indulging in an increasing sense of nihilism, I called a temporary halt at the Long Trail Brewery to enjoy its open fire and excellent line in hot dogs and blackberry wheat ale.

I knew I needed to drag myself back to the road, as I'd only covered a little over twenty miles and wasn't in the mood for feeling soggy for myself. One of the bartenders mentioned that there were camping lean-tos just up the road in Coolidge State Park that would be free and likely empty this time of year, so I elected to save my money and indulge in a gamble.

The lean-tos were raised three-sided log platforms with tin roofs that looked out into the forest beyond. My shelter was named Sapling. I pitched my tent in the confines, hung clothes to dry and even managed to fish out my stove to make a feast of noodles. Delving deep into my kitbag to retrieve all manner of rarely used items of clothing to get my core temperature back to something approaching tepid, I was quite proud of the little home I'd created for the evening. The pitter-patter of rain on the tin roof turned out to be remarkably soothing and was no hindrance to a decent night's sleep.

Being in an internet blackspot and having no idea whether the weather was due to change any time soon, I made my way into Plymouth, stealing some Wi-Fi from the hotel that I could have stayed in last night if my finances were better. I plotted my day's route over the Appalachians and memorised some key land-marks, just in case.

I was electronically directed up Round Top Road, which turned out to be every bit as bad as my Cumberland Plateau

lung-buster back in Tennessee. A local slowed down as if he were going to say something to me as I laboured up the hill, but he must have thought better of it and drove on. Strange. The road eventually seemed to give up, becoming a muddy single track increasingly punctuated with tree roots and puddles. It was becoming a bit wild. I had to push Pramsolo across a fast-flowing stream where the water was halfway up my calves and threatening to pull Pramsolo down the mountainside. I had to move quickly and I forced his wheels up the bank at the other side.

I'd slowed to barely a walk, but I seemed to have reached the summit. A huge puddle lay in my way and I feared for the conditions underfoot, as the ones I was moving through now were at least shoe deep and slippy. Initial toe dabbles indicated that this could be a more serious proposition, but as is occasionally my wont, I favoured the quick fix of a blitz through rather than disassembling the components of my mobile belongings and carrying them around.

Lining up Pramsolo like a one-man bobsled crew, I unleashed the full power of my tired stick legs with the fury of a gentle breeze and achieved splashdown at a decent enough speed. The pace began to ebb away as the narrow wheels and heavy payload began to bite into the mud, and I could feel a dangerous lean to the right. Mustering up all I had, quads burning and hopefully not tearing, I managed to move a few yards forward before coming to a halt. The water level was just reaching the main storage compartment, and I pulled the right wheel out of its sticky situation and got a couple more feet before the wheels seemed to gain more purchase and we rose like a salvaged wreck from the mire. I saw a sign to my left: 'Road Not Maintained in Winter Months. Pass at Own Risk.' To top it off, Pramsolo had another puncture.

* * *

The sun came out. I began to dream of a holiday home in Vermont. I had been warned about the bear population by a few notices in the last mile. My fatigue level was such that I would have had no problem playing dead if one appeared. I carbed up my shaky legs in the village of Wells on the steps of the Town Clerk, happy that the hills on my right were far bigger than the ones down the road. As I did my signature Lean on the 'Welcome to New York State' sign, it dawned on me that it would be a long time before I crossed another state line.

Chapter 26

HOW I LEARNED TO STOP WORRYING AND LOVE BRUSSELS SPROUTS

New York 2
Days 179–89
419.22 miles

A typical day's intake: oatmeal breakfast, some cereal bars, a burrito, Coke and a bag of Caramel M&M's, a hot dog and Dr Pepper, microwaveable rib sandwich, big bag of onion rings, some Arizona tea and a beer

Pramsolo finally got to roll in New York, and it was a pleasant introduction to life for both of us as the most testing day of the run so far, physically and mentally, petered out in the fading light. The sight of Granville and the Pine Grove budget motel next to What's Up Dawg, a hotdog-heavy diner, had this Pavlovian dawg's bell a-ringing like a royal wedding. Prising myself up from my face-down position on a bed that had surely descended from heaven – it could have been made of nails for all I cared – I went next door and hoovered up just shy of 2,500 calories.

In the morning it was time to see what the *other* New York had for me. Free-roaming goats and chickens with a strangely

strong sense not to leave unfenced yards seemed to be one thing. I crossed the Hudson for a second time. I didn't even know it came this way. Last time, it was to arrive at the hallowed columns of the House that Ruth Built, aka Yankee Stadium. This time, the congregation were there for a wedding on the banks of the river and the falls that gave the town its name. Despite some leverage being applied from the matriarch, a platinum-curled nanna who came over as the party processed past my lunchtime park bench in the vividly blooming village green, I couldn't hang around for the festivities.

Taking off to get onto Highway 9, which seemed a lot greener than its Jersey cousin, with fewer knocking shops and the inspiring message of 'Love Trumps Hate' spray-painted on the shoulder, my own party was just fine. I had a bed for the night in the very swish Saratoga Springs, a horsey town with a famous race course that they're rather proud of, with statues of horses on every corner and grand mansions belonging to those who got rich from that, I presumed. Or maybe they came with fortunes made, in search of the natural waters of the town that reputedly have healing powers.

My host Jacob assured me that the smell of flatus coming from the water was quite normal and didn't affect the taste, so I followed his lead and took the plunge – though I stopped short of emptying my water bottles to have some Saratoga healing for the road ahead. Later, I bonded with a very curious beaver on the banks of one of the Mohawk River tributaries. We stared at each other for a while, before something shiny in the water became of interest and he was gone in a slinky brown blur, barely making a splash.

The roads opened up from the quiet farm lanes with their white weatherboard houses and nonchalant grazing cattle to ... more of the same, but with bigger roads, until I reached the

Riverside Motel in Fultonville. I washed my kit in the truckers' laundromat and met some fellow road warriors, who had a lot of respect and concern in equal measures for what I was doing.

Farms passed me by on either shoulder and signs started to warn of horse-drawn carts. A few fields away, two shire horses stood out, pulling a plough through the ground. At the helm was a teenage boy dressed in the Amish style. He waved at me, so I went over to him. His name was Enos and he asked me where I was headed.

'Chicago.'

'That's very far,' he said. No need for superlatives, just facts.

'Is it hard to plough with the horses?' I asked.

'Not for me.'

I loved his straight answers. 'Could I take a photo of you with your team?'

'You can take one of the horses, but not of me,' he replied with a smile.

I saw a few more carts in the area and said hello to one passing in the opposite direction, my greeting returned with gusto. For some reason I was surprised at the Amish friendliness. I don't know what I expected to happen – maybe that I would be ignored or they'd be irked that an outsider was being nosey by talking to them? But I learned that in reality they're just people with a different way of living to most of us, and they might be on to something in terms of a lifestyle that would allow us to live a little more in harmony with the planet.

I crossed the Mohawk River into the town of Frankfort, where I'd convinced a local to break his couch-surfing duck and host me for the night. His name was Billy Ganey, a postman, who was no stranger to helping people, having founded a popular Facebook group called Man Tip of the Day, where fellas help

other fellas and the community out, wherever they could. Each year at Christmas, they organised the Man Tip of the Day Christmas Break-in, where they raised a large sum of money and, identifying a few families in need in the area, bought whatever it was they needed, such as a new washing machine or fridge, and 'break in' to leave it for the unsuspecting beneficiary to find when they returned home.

Billy offered some venison fillet from a deer that he had caught recently on a hunt. I felt uneasy about this, which Billy picked up on, so he only cooked a little and said I didn't have to eat it if I didn't want. This was a minor concern to the abomination he offered next: Brussels sprouts, the green balls of eggy misery that your nanna would cook for you and then watch out of the corner of her eye to check that you hadn't dropped them under the table at Christmas. I had no intention of eating them, but out of politeness, explaining my sentiments very clearly, I tried one. How wrong I was. Billy made me a believer – and one day I might even share his recipe.

Billy filled me in about the Amish. They're known for their craftsmanship, making everything from hand and using only generators for power, if they use power tools at all, preferring to be off-grid. They might have a phone, but not in their pocket – instead in a separate building to the house only to be used for emergencies. They have no cars, just horse-drawn vehicles, and most intriguing was hearing of a particular custom called Rumspringa, which is derived from a Pennsylvanian German word meaning 'run around'. Amish of an age not dissimilar to Enos have the rules relaxed and might even leave the communities to live among the 'English' (as we outsiders are known). They might even go off the rails enough to have a drink or a medicinal cigarette or two. A year or two of varying levels of rebelliousness under their hats, they need to decide whether to leave the faith

or return full-time to the community. Maybe surprisingly, or maybe not so, 90 per cent or so will choose to return to their former lifestyle, most likely once they've seen how crazy the outside world can be.

In the morning I hooked up with a local runner, Michael Polidori, who was in the middle of his battle to BQ for next year's marathon. Having some local knowledge onboard was handy for avoiding the hills around Higby Road on the way out of town that Billy had warned me about. As we ran down the wonderfully named Mucky Run Road, on a thankfully dry but cold day, I told him about Party Time and hoped it would help him out in his quest.*

Chittenango just happens to be the birthplace of L. Frank Baum, author of *The Wizard of Oz*, so I was desperately disappointed that I wasn't wearing a pair of sparkly red Pegasus, favouring a nice teal colour that morning while I carried on running down the yellow brick road.

I camped behind a barn opposite a chicken farm that night. Mark, whose land I was on, gave me a little tour after dinner. His little boy, not long turned eight, had recently shot his first turkey on a hunt, and the tail-feather fan mount was on display above the hearth. Mark sensed I didn't share his enthusiasm, which was true, but I genuinely did respect the pride he had for his son. I just find this custom so strange and hard to accept, but they were good people and who was I to claim any moral high ground? I was staying opposite a mass production chicken farm and had just finished eating chicken wings, which, ignoring the fact that they were very tasty and given out of the kindness of people's

* It did. He partied hard in his last two miles a few weeks later and got his qualifier by over five minutes. Boston-bound at last ...

hearts, probably originated from a bird that had a far lower quality of life than the turkey above the mantelpiece in that front room. I was in no position to judge, regardless of my gut feelings.

Another rusted Cadillac, another story I wanted to hear. Another girder bridge and I'd crossed Black Lake and was into the Montezuma Wildlife Refuge, with ospreys nesting on three generations of electricity pylons. Then it was Seneca Falls, famous not only for being the inspiration for the town of Bedford Falls in *It's A Wonderful Life*, but also for hosting the first women's rights convention in 1848. Among its achievements was the blistering Declaration of Sentiments, which was central to the suffrage movement and the gaining of the right to vote following the 19th Amendment in 1920. The convention and the Declaration were incredibly brave for the time, with local newspapers either neglecting to cover it or stating that it was a dereliction of a woman's duty. The *Oneida Whig* called it 'the most shocking and unnatural event ever recorded in the history of womanity'. As women's rights were one of the reasons why I was running, it was an honour to be here, despite it being a shame that 'women's rights' even need to be talked about as a separate entity in this day and age.

My couch-surfing host Liz was just what the doctor ordered – a massage therapist. My incredibly inelastic muscles and reluctance to stretch adequately meant I was already starting to feel the effects of gradually tightening limbs, and the massage offer was tabled. My greatest areas of need were both of my gluteals – or, as Forrest would say, 'butt-tocks' – but, feeling a little ashamed of my forefathers in nineteenth-century Seneca Falls, I couldn't bring myself to mention them, so my calves, who were next in the queue, benefited.

* * *

It was Mother's Day in the US and a full-scale party had been going for quite some time in Dadio's Central, a bar in the town of Corfu. As such, enthusiasm levels were ripe for the entrance of a prodigal son. The place took me all the way back to Louisiana's Crazy Al's, especially when a young man in a wheelchair rolled up to me as I took my place at the bar.

'Hello,' he said. 'I'm Lieutenant Dan!' He offered to become my first mate as soon as I got my first shrimping boat.

I skirted to the south of Buffalo, taking in the New Era Field, home of the Buffalo Bills, and despite not being able to run the length of this field, I wasn't too glum as I approached the shores of Lake Erie and enjoyed the wide roads and wider smiles.

I took advantage of the weather to push on past the last of the motels and stopped at a pub for dinner and to find a potential camping spot. Tonight, fortune came in the form of a giant of a fella by the name of Craig. He had me at, 'Don't eat noodles, come back to mine and I'll cook you some Walleye.' I didn't know what Walleye was and I didn't want to look an idiot by asking.

The Walleye was, in fact, a fish, which was duly blackened in butter and garlic and accompanied by his mother's apple sauce, Brussels sprouts that were every bit as good as my favourite postman's, and some prosciutto made by a ninety-two-year-old fella Craig knew. I talked about my acquired love for the area and how I'd love to see it in the winter, and his housemate Dan told me that in the winter when the lake freezes, it groans, creaks and crunches. I was assured that it was completely safe and more people drowned in the summer. The 'more' wasn't much of a reassurance, to be honest.

* * *

I had lunch at the end of Dunkirk Pier, which was every inch the childhood seaside experience, minus a seagull swooping and stealing my food. I'd gaze out between the trees and see the sun flicker off the still water as it moved westwards. This was a New York I'd never seen before, and I cursed the fact that those 'I Heart NY' T-shirts only seem to get sold in Manhattan. I even got to finish at a lighthouse on the shores of Lake Erie, at a place called Barcelona, no less, during an incredible sunset, with just under fifty miles on the odometer.

In recent weeks I'd noticed changes coming over my legs and posture. Whether it was leaning over Pramsolo or reaching fifty miles in a day more frequently, my glutes were becoming tighter, weaker and generally upset with the monotony they were subjected to. I'd been using a Triggerpoint massage ball to inflict torture sessions on them, but it had gone the way of my Subway sandwich and so much other cargo, to live a new life in the weeds at the side of a road or under a motel bed somewhere. My last New York host had just the thing for me, a firm racketball, manufactured by Wilson, as if it could have been anyone else for this situation. I spent my final night before crossing into Pennsylvania inflicting torture upon myself.

Chapter 27

THE FLATTEST OF ROLLERCOASTERS

Pennsylvania
Day 190
25.44 miles

By the time I hit the road, summer had not only arrived, it had set up camp. Temperatures were to hit 30°C (90°F) in the shade, and my eyes darted from one tall tree to the next to anticipate when I'd be out of the direct sun. Then I saw a peculiar sight.

It was a straight road with crops on either side and the occasional farmhouse. A man who must have weighed double your average, shirtless, covered in black tattoos and with a shaven head, threw what appeared to be a black trash bag six feet across his front yard. Now, while I do my best not to profile people, my instant thought was, *Scary neo-Nazi guy.* The trash bag hit the floor and the momentum caused it to roll a little, and on closer inspection I realised that this 'bag' had legs. It was a dog. And that throw was not part of some playful rough and tumble.

What do I do? Say something? He's just abused an animal in front of me. He might have a gun! As I was almost dead level with the front of his property, he strode over and delivered a

vicious kick straight to the poor dog's guts. At that point my anger took over. 'Oi! Leave him alone, you f***ing tw*t! Don't kick your f***ing dog!'

Please don't let him have a voice like an ogre, I thought. His furious gaze snapped to me. 'What did you say?' bellowed the ogre.

'You 'eard!' I replied in my loudest and scariest Scouse accent. 'Don't kick yer f***ing dog!'

He gave no reply this time, instead striding purposefully towards me, eating into the thirty-metre distance between us.

'You take one more step, mate, and I'm calling the police,' I yelled.

He didn't just take one more step. He decided to take numerous steps. I had about eight seconds, if I was lucky, before we would be having this conversation face to face.

I hightailed it with Pramsolo, thanking my lucky stars that the road was flat. I glanced over my shoulder to see him still advancing, his belly wobbling in the breeze and the dog running behind him, wagging its tail. I was happy the dog was up again, as the force of that kick was enough to have scored a forty-yard field goal, but this poor creature was showing unconditional love to the brute who might have been about to kill him – and for all I knew was still going to.

Glancing behind again, I saw that he was not built for stamina and had stopped. But he then turned around and jogged back to his house. Why would he *run* back? Oh …

Don't get in your truck, don't get in your truck … I instantly took a screenshot of a pin placed on his house on Google Maps and sent it to Nads with the following message: 'If *anything* weird happens to me in the next few days or if you don't hear from me …' I directed her to the likely spot where the trail of evidence would begin.

It's not exactly a nice thing to receive when you're 4,000 miles away and powerless to intervene, and she didn't get the message for a while, but I reassured her that I was staying in a house that evening and would be able to let her know how I got on.

For the rest of the day I was on high alert. I watched for the face of everyone who drove past me in either direction, which involved a lot of head-turning and stress. When I stopped for second breakfast, I debated whether to call the police or local SPCA. The latter didn't exist and I wondered what would actually happen if I called the police. They'd go round to the house, see a dog running around, wagging its tail, and listen to the guy's denial of guilt – case closed, most likely. I was still worried he'd track me down, though – I wasn't that hard to find on the road, after all.

I entered the city limits of Erie, where I made a call to the local police department. I don't think it was high on their priority list. I had to remain hopeful that I'd caught the man at a bad moment.

I hadn't even got going the next morning before my heart was broken in two. One of my heroes of the run, Chris Cornell of Soundgarden and Audioslave, had passed away. One of music's ultimate men of the highway, a loner *and* a team player, this eternal wanderer had either reached a place to rest or to roam freely, depending on how you wanted to imagine him.

Chris Cornell and his music had taken a prominent role in the fabric of my journey. While I'd always had my goals and motivations, which were as strong as ever, I was always aware that a moment might come when it felt like it was the end. Sitting by the roadside, I'd never felt closer to the end, and I even got as far as looking at the cost of flights home. I was crying, and it made me think of the dog and then I thought to myself, *Have I done enough?*

I wasn't sure. I needed to retreat into the comfort of something that I'd always found cleared my head – running. I didn't even bother with a warm-up. The city was strangely quiet, despite it being mid-morning. Erie was a former industrial port, and street art replaced the queues of factory and dock workers these days as the city continued a steady regeneration after being one of the hardest-hit Rust Belt areas. Philly's houses had reminded me of home, and the warehouses here reminded me of the docks in Liverpool. I was glad that this induced a sense of pride rather than longing, which would not have been in my best interests at that point.

A sign outside a local community organisation quoted Jean Vanier, the philosopher and humanitarian: 'The belly laugh is the best way to evacuate anguish.' I pulled the plug, at nothing in particular. It wasn't the worst piece of advice I'd taken.

Later, weighing up my options at a cute roadside shack called Dairy Oasis, which emerged out of the sun shimmer as all good oases should, I still felt heavy inside. I tried to assemble the spider's web of thoughts I'd created on my runs so far today. *Start a new state on a clean slate tomorrow. Get to Chicago. If you want to finish then, finish. Don't give up. Not now.*

Lying on the bed in my motel room that night, I focused on tomorrow and beyond, to Ohio, and I hummed the tune of the same name by the Low Anthem. It was the first music to penetrate my mental fog – besides the haunting sound of the man on my shoulder – and it was a song that hinted at a chance of hope after loss, a message that I was now more open to. But for the moment, I'd close my eyes and return to thinking of a friend who never knew me.

Chapter 28

THE OCEANS BETWEEN THE WAVES

Ohio, Michigan

Days 191–201

225.89, 187.87 miles

Best second breakfast winner: Red, white and blue
donut on Memorial Day Weekend from Sweetwater
Donuts, Michigan

Punctures: 1

No clouds in the sky and none in my mind as I greeted Ohio with a decent Lean. This being America, the extraordinary was always expected around the next bend. This corner was the junction of West and 84, just after Geneva, where I bore witness to the First Amendment being as colourfully and sadly employed as I could imagine it to be. Adorning almost every inch of a house and station wagon were brightly coloured, hand-painted signs by artist Jeff Elersic, grieving his brother's death, which he believes to have been carried out and subsequently covered up by the police and the local judicial system. I didn't know if he'd ever be seen as anything more than a noise-maker by the powers that be, regardless of their complicity, while all the time Jeff would paint on in a state of frustrated and angry limbo. I continued towards

Madison, keeping my fingers crossed for Jeff so that whatever peace he might be able to achieve would arrive soon.

I'd heard from the touring cycling communities that it was sometimes possible to camp out back at the local fire station in town, so I tried my luck. Following a pint or two to toast the birthday of one of the fire crew, I pitched my tent behind the station. They warned me that if a call came in, it would be broadcast over the tannoy so everyone could hear, and I wasn't to panic. The alarm inevitably sounded at around 3 a.m., with the engine pulling out barely a minute later. It turned out to be for a guy suspected to have died in his car, though it turned out he was only asleep. I enjoyed the schadenfreude of someone else getting woken up as well as me, though I'd have preferred neither of us to have left our Ohioan dreamlands.

The next morning, I set off towards Cleveland, a city I'd been intrigued to reach. The East Cleveland streets were as gritty as anything I'd been down so far, but it wasn't long before I was surrounded by gleaming buildings on all sides as I entered the medical district. Martin Luther King Drive meandered away from me on my right past the stunning Museum of Art and the Rockefeller Greenhouse on its way to the shores of Lake Erie.

Cassandra, my gracious host, took me for dinner on the banks of the Cuyahoga River, maybe Cleveland's most infamous feature, having been so polluted that it regularly caught on fire. In 1969 it was described as a river where a person would 'not drown, but decay'. The outrage in the sixties was one of the first steps in the realisation of the environmental movement in the USA, and the river, once devoid of all aquatic life, is now home to forty-four species of fish.

My first conversation of Sunday morning was with a lady watching the runners of the Cleveland Marathon stream by. My route took me past the centrepiece of Cleveland, the grand public

square housing the Soldiers and Sailors Monument, to the big race finish where I caught the 10k winner Edwin Rotich zoom by in under twenty-nine minutes.

I returned to Cassandra's place to pick up Pramsolo, having been grateful for some unhindered urban running, and was on my way. A sign in Amherst – the sandstone centre of the world, according to Amherst – told me 'Life was too short to have bad hair', which is a motto I resolved not to live by as my ragged locks bobbed along Highway 6, the coastal road. I'd have lingered at my lunch stop to admire the gorgeous horizon over the lake, were I not beset by huge mosquito 'thingies', which drove me on.

Over a sunset beer in Sandusky with my hosts for the night, looking out at the bay into Lake Erie and the twinkling roller-coaster in the distance – the second-largest in the world, apparently – I learned that my lunchtime pursuers were 'muffle-heads' and not mosquitoes. They could serve as body doubles for their cousins, but thankfully they didn't bite and only served to annoy as a result of their sheer numbers for a brief bloom, each summer.

Sandusky wasn't always a place of pleasure for many. The Underground Railroad wasn't underground, nor a railroad as you would imagine, but a network of safe havens and a lifeline for those escaping the brutality of slavery. They were sheltered, fed, clothed and instructed in their difficult journey to Canada and freedom. This movement was one of America's greatest social, moral and humanitarian endeavours, but was clothed in secrecy to protect itself. I was surprised I'd never heard of it and felt poorer for my ignorance. It wasn't hard to feel unbelievably privileged as I pointed my wheels west once more and embraced a freedom I'd never had to lift a finger to achieve.

My host in Albion was Roger Albertson, an interested and interesting insect neurobiologist who, when he wasn't determining

the effects of psilocybin on the behaviour of fruit flies, would run like the wind blows as well, having completed over fifty marathons himself. He'd moved from the big city to Albion only recently and was finding adjusting to the slower pace and different way of life somewhat jarring, leading to regular trips to Ann Arbor to 'surface for air', as he put it. I loved the way his brain worked. A scientific meeting of minds that often spilt into bilateral streams of consciousness ensued, over excellent pizza in Gina's, a joint which seemed slightly out of keeping with its place in one of the old industrial buildings of a town on the turn. Roger would be packing his bags for a trip to Peru the next day to meet a shaman in the middle of the Amazon. And I thought my life was interesting.

In Bell's Brewery in Kalamazoo, Michigan, I was commandeered to give a team talk to a high-school soccer team who were in town for a tournament. When the coach heard I was from Liverpool, he bestowed mystical motivational properties upon me, and told his charges that I should discount what he told them if it disagreed with anything I said, as here was a guy who 'really knows soccer' and should be taken as the final word on the subject.

I'd crossed the state in four days, effectively, from Lake Erie to Benton Harbour at Lake Michigan. Across this particular body of water lay Chicago. Excited didn't cut it, with a hundred miles to go.

How are you supposed to feel on Memorial Day? People seemed to be celebrating it, rather than merely observing it. Memorial Day marks the unofficial start of the summer holidays in the States, but it's a commemoration of the United States service men and women who have died while serving, so it seemed peculiar to me to be upbeat for the occasion, but I guess

in a nation that is overwhelmingly proud of its military it was the equivalent of a minute's applause in contrast to a minute's silence.

I would make superb time on my way to Michigan City, just over the border in Indiana, where I finished my day with a cover of John Lennon's 'Imagine' by Chris Cornell, as two more souls were commemorated in my thoughts.

It felt like the beginning of an ending, and although I was nowhere near the Pacific or the Atlantic I stepped onto the squeaky white sand on the shore of Lake Michigan to dip my toes into the chilly waters, the sun setting somewhere over Chicago. I was only a few days away from flying out of here and seeing Nads again. I couldn't wait to see her, but I had to admit, this beautiful vista didn't seem the worst place to be right now.

Chapter 29

IF YOU LEAVE ME NOW

Indiana, Chicago
Day 202
41.48 miles

It was just before noon when I heard a voice that sounded familiar: 'I'll follow you anywhere, Mr Gump.'

Chris Conlon, my Boston Marathon inspiration, had found me on the Red Arrow Highway, having been tracking my progress over the last few days on his way to Chicago. I was slightly surprised he hadn't cycled from Baltimore, swum across Lake Erie and ran the rest of the way in the fine pair of Nike Cortez he was wearing. It's a shame he had his truck, as I had no doubt he would have been good company for the next fifty-plus miles.

It was good to see a friendly face. Despite having run through the serene surroundings of the Indiana Dunes State Park along Highway 12, all towering oak, maple and gum trees and an air of peace, followed by the mile-wide flat shoulder flanking a bayou straight outta Cataouatche, it had only been a few miles before that I'd passed the Indiana State Prison that once famously housed the bank robber and arch escape artist John Dillinger. I had the uncomfortable air of a voyeur looking through the outer perimeter fence, knowing that there were men inside the walls

waiting to be put to death, though it had been eight years since the last execution. I just don't see what benefit the death penalty offers apart from satisfying a primal urge for quick revenge (which isn't the reality in the US). In a country that places far more emphasis on its Christian beliefs than I'm used to, this seems to be a paradox, since all major church leaders reject the death penalty. If you want tough justice, it's worth remembering that no one in the US sentenced to life without parole has ever been released, and if you're looking for bang for your buck, maybe I'd point out the fact that the cost to the taxpayer for a death sentence is, contrary to belief, more expensive than full-term life imprisonment. With the death penalty, everyone's a loser.

Chris's intervention came at the right time to lift me out of this #TuesdayThoughts trip, and I moved on towards Gary, once dubbed City of the Century and the birthplace of the Jackson Five, but now one of the more troubled cities in the country. In 1993 it was given the unwanted moniker of the 'murder capital of the US'. Its population has more than halved in the last fifty years to around 80,000 now, with the decline of the steel industry causing mass unemployment and the subsequent exodus leading to around a third of the city's buildings being unoccupied. I later read of a resident saying that murder and drugs were now so much rarer as there was 'no one left to kill or sell drugs to'.

I felt like I was running through the biggest ghost town yet, even in the residential parts, as the wide avenues and well-built apartment buildings stood silent, with seemingly no people around save for the odd parked or passing car. I only passed one person on foot, who looked like they might not be lucky enough to have an apartment. Despite not voting for Trump, perhaps people hoped the recent election results would turn the city's

fortunes around. Until then, Gary's residents would do what they have done for years: stick it out, make the best of it, and hope the next guy would be different.

I reached my end point for the day, at South Chicago Metra station. I rode from there to the red line of the 'L', Chicago's famed overhead or elevated railway, disembarking at Sheridan, a few blocks away from Wrigley Field, one of the great ballparks and home to the Chicago Cubs, the 2016 Major League World Series Champions and, conveniently, my team.

For Pramsolo, this was the end of the line for a while. I was staying with Dan and Michael Reichart, who were the cousins of Lenore, my adopted Liverpudlian New Yorker who'd put Jamie and me up. Dan met me at the station, which was a stone's throw away from Byron's Hot Dogs, reportedly President Obama's venue of choice when he was in the market for the iconic Chicago dog.

For my final run of this trip, I returned to South Chicago the next morning, hands-free, with only a waist pack added to my outfit of khaki shorts, blue plaid shirt, long double-striped socks and, of course, the red cap and Cortez. I was definitely a bit wild in hair and beard, by now, and pretty tanned too. But I felt fresh as a daisy and pumped to be visiting a city that had been in my sights for over thirty years. The occasion was of enough importance to warrant full regalia, I thought.

I'd attracted a few raised eyebrows when telling people I was heading to 93rd Street in such attire, with the phrase 'Chi-raq' being mentioned. Yeah, yeah, I'd heard that before.

Closer packed than north Gary, the dereliction was still a blight on the neighbourhood, but the residents of South Chicago were out and about in the sunshine. I headed up Baltimore Avenue, and heard a shout somewhere over to my left. I pulled

out my earphone and looked over, pretty sure that the shout was directed at me. It was a group of guys near a convenience store in baseball shirts, bandanas and jeans that showed more than a hint of underwear above the low waistband. Nervously, I smiled as I turned.

'You run, Forrest! Yeah, man!'

I crossed the road to say hi to them, and we had a great laugh for a few minutes. Suitably emboldened, I thought I'd broach the subject of the bad rap their neighbourhood had in the media.

'We write those things in the paper to keep the hood nice. We don't want no trouble. It keeps the real bad guys away.'

'I'm alright though, yeah?'

'As long as you don't tell 'em it ain't true!' said B, wearing a Muhammad Ali shirt. Everyone folded up with laughter. Seeing as I'm not an investigative journalist, I left it at that piece of comic perfection. For all I knew it was true.

I left Baltimore, onto Commercial and then Exchange, racing the Metra and onto South Shore, before sidestepping onto the Lakefront Trail to the corner of 67th and *then*, in a fountain and a burst of skyscrapers, it was Chicago. Chi-town. The Windy City, without a hint of a breeze. The second city. The real Gotham. Home of the Bears, the Cubs, the Sox, Bulls and Blackhawks. A city I'd wanted to visit ever since a seven-year-old boy heard there was a man called 'The Fridge' living there and watched him dance the Super Bowl Shuffle to join Walter 'Sweetness' Payton and Jim McMahon in becoming World Champions at Super Bowl XX. I'd had this city in my thoughts for 7,175 miles and seven months. I knew I belonged here, on these streets, which offered up another piece of my hidden America, while someone etched the words 'more love' into some setting concrete.

The Lakefront Trail will forever be one of my favourite places to run on earth, and a completely unexpected aspect of my

approach, with towering sculptures to my left and expanses of white sand that slipped into Lake Michigan on my right. Barely containing myself as Soldier Field, the colossal home of my team the Chicago Bears, passed me by, I continued towards the end zone, thinking that maybe this could be a fitting place to 'touch-down' for good on the run, to finish on a high before a low finished me.

Next morning, I made my way downtown for an appointment with *Today Show* anchor Terrel Brown outside the ABC studios and the world-famous Chicago Theatre. When he asked what I was planning to do with the seven days of downtime I had before I flew back home, I said I somehow wanted to find a ticket for the sold-out U2 show at Soldier Field in three days.

'Ask and you shall receive,' said Terrel, briefly raising my hopes that the station had some free passes. The call, perhaps unsurprisingly, didn't come, but a message appeared in my inbox from a guy called Randy, who said he had a spare ticket. 'There was a reason why I turned on the TV and you instantly came on,' he said.

That morning President Trump had declared that the USA was to pull out of the Paris Agreement for Climate Change – the biggest piece of multilateral action the world has ever taken to try to avert an environmental and ecological meltdown. While this was as disappointing as you could imagine for someone who had tried to champion these causes, it made me more determined to ensure I reached my goal.

Randy contacted me to tell me that tonight was not going to be your average concert. He had upgraded the tickets so that we would be immediately next to the stage runway – in all aspects a VIP experience. In the evening, I met up with him, his girlfriend Amber and buddy Steve. Randy could have been one of the cool guys from *Sons of Anarchy*. He would have been able to handle a linebacker or two.

The gig started with Larry Mullen Jr hammering out the iconic and instantly recognisable drumbeat of 'Sunday Bloody Sunday', as he was joined by the Edge, Bono and Adam Clayton in musical sequence on a small stage in the middle of the audience, less than twenty feet from where we stood. A volcanic performance of 'Pride (In the Name of Love)' in the city where Dr Martin Luther King Jr led the Chicago Freedom Movement preceded the recreation of *The Joshua Tree* album in full, something which had never happened before this tour.

This all took place in front of the largest concert video wall ever seen – the width of a football pitch – initially bathed in red, with the huge black silhouette of the Joshua Tree jutting out. It cut to a black-and-white scene tracking along a highway, being walked by migrants – a road I knew because I had run it, high on a desert plain – all while the build-up to 'Where the Streets Have No Name' started to set off goosebumps along every arm in the house.

Randy turned around, maybe to see if I was okay. I was more than that, but you wouldn't have thought so to look at me. Tears were streaming down my face as I sang along with 80,000 other people to the beginning of the band's love letter to America. Next came 'I Still Haven't Found What I'm Looking For' – my song of Joshua Tree National Park – and 'With or Without You'. The song 'Exit', which hadn't been played live for years and had accompanied me out of Joshua Tree National Park during my fastest mile until Boston, was battered out with absolute venom and proved a corker of a prelude to Bono telling us that politicians are petrified of the people being organised. 'They should be afraid of us,' he said, 'not the other way round.'

All of which brought me back to my choices about continuing the run. All the problems I had were still there: lack of funds, logistical problems, missing Nads, visa concerns. But my mum

wanted me to make a difference. Bono had just told me and thousands of other people to do just that. I didn't begrudge being reminded.

We all want to run and hide sometimes, but in the bowels of Soldier Field I resolved to lay down as much effort as I could, to do everything in my power to make sure that I went on. Whether I was running solo or not, the friendliness and hospitality that greeted me on the road meant that I rarely felt alone. So yes, I'm still (going to be) running.

Chapter 30

ONE VISION

Illinois

Days 203–6

122.14 miles

Several hours into my flight back to the US, heads started to peep over the seats. A few rows in front, a commotion had broken out. Appeals for a doctor were aired, and when no one came forward I tentatively took a look. I expected a heart attack and I am trained in human CPR.

It turned out to be a teenager having an epileptic seizure in front of his distraught family. I had experience of managing these in animals, so I cleared the area of interfering fingers trying to prevent him swallowing his tongue, informing the person involved that they'd be likely to lose a digit. Glancing at my watch, I laid him on his side. I asked for a list of on-board drugs in case the kid didn't stop fitting in the next few minutes, and began to reassure his mum and parents. I learned that it was his first seizure and confidently stated that it would be over in a couple of minutes, desperately hoping he followed the typical pattern. I explained that there was nothing we should be doing apart from preventing harm.

When a freshly graduated doctor arrived on the scene, I deferred to him, but he deferred straight back, having never dealt

with a fitting patient before. I asked him what the dose for diaz-epam was in humans; he didn't know. The list of drugs arrived and, scanning its contents, I noted adrenaline/epinephrine, pain-killers, asthma medication, but no anti-epileptic drugs. I was afraid of getting myself into a legal nightmare by administering a speculative dose of drugs to a human. Fortunately, the lad's signs reduced, and we were only an hour away from the airport. When the paramedics came on board, the poor family were told that they would not be boarding their connecting flight to Disneyland. I'd had my share of excitement before I'd even got to the immigration line.

'Purpose of visit?'

'Running across the country. Like Forrest Gump.' I smiled, pointing at my cap. In fact, I was wearing the full Forrest regalia.

The thirty-something immigration officer wore a blank expression.

'You know, Forrest Gump? Like the film.'

'I don't know it. Tell me about it.'

I couldn't believe he didn't know the film – and once I'd finished explaining, I don't think he cared. He waved me through with a six-month stamp, much to my relief, given that I'd only been home for six weeks. I had no Lieutenant Nads by my side this time – she needed to work a little longer before she'd be able to up sticks and join me once more – and I was heading towards territory far more remote than I'd ventured to alone thus far. What if something were to go wrong?

I had a return flight from New York on 17 December. My connection to Chicago allowed the excitement to build, now the pressure was off. Thirty-thousand feet below lay a thousand miles of my journey so far, with the Finger Lakes, the Walleye and sprouts in Hamburg, and the pier in Dunkirk looking out

over Lake Erie, which even from the air resembled a never-ending ocean.

My goal was to reach the Pacific in San Francisco by 2 p.m. PT on 15 September, in about ten weeks, and complete three trans-continental crossings in one year, which, as far as I could determine, would be a record. America looked quite small from the plane. If I kept telling myself that, maybe I'd even start to believe it.

After first indulging in the Fourth of July celebrations with the Reichart boys and being reunited with Pramsolo (and replacing his tyres), it was time to begin the push north, to the strains of Queen's 'One Vision'. My handbrake was soon applied by the oppressive heat. I'd heard that the Midwest summers were something to behold and, having just spent six weeks in rainy Britain, I still needed some acclimatising.

I felt like I'd raced a marathon rather than ambled a restart. You might think I'd be glad of the rest during these enforced gaps, but my experience thus far was that they served as a mighty reset button on any rhythm and physiological adaptations I'd acquired over the course of a few thousand miles. At home, I spent the time frustrated, trying to guess how soon I could go back, working pretty much the whole time to top up the cash reserves and hardly doing any running at all. In fact, I struggled to scrape a fifty-mile week, and I gained fifteen to twenty pounds, operating as I did on run hunger levels.

At least I was sweating it all out now. It was 38°C, which meant it was the first time the mercury had hit 100°F since the Deep South last autumn. I was glad I was heading north. An Illinois traffic cop stopped me to express friendly but firm concern that I was out in this heat and checked if I had enough water.

Another white feather caught my eye, blowing across the road and under my feet – pretty apt, considering it was the twenty-third anniversary of the nationwide release of *Forrest Gump* in the USA. I took this as an auspicious start to a brand-new trip.

Chapter 31

TOO KWIK A TRIP

Wisconsin

Days 207–12

198.34 miles

Injury watch: advanced nipple maceration

I'd become a devotee of gas-station nutrition as a matter of necessity, but I would look forward to some more than others. Race Trac, Speedway, Love's, Stewart's Shops were all firm favourites – but then there was Kwik Trip. Not only did they usually have cherry Dr Pepper and a solid donut selection, but they possessed such exotic delights as fresh fruit, an extensive selection of hot dog condiments and, best of all, they introduced me to F'real frozen milkshakes and their protein-rich berry yoghurt in particular.

My destination was Milton, a lovely little town with more pubs than you would expect. I was in search of a 'stealth' camping option, and Mud Lake recreation area seemed a decent bet. Struggling with Pramsolo down the sort of paths you'd find up a mountain in Vermont, I gave up in a small clearing, which seemed the best option. It was a muggy night, and the sky was full of fireflies, initially glowing orange before switching to a

neon green once they'd warmed up. I should have realised, given the name of this spot, that muddy lakes often attract other insects. Taking a few warning shots to the legs, I set the tent up in record time and made sure the zip of the tent was as tightly done up as it could be. Then the buzzing began.

Proboscis after proboscis poked through the mesh of my tent as I opened my eyes, a few inches out of range of my new friends, prompting a liberal coating of DEET and long sleeves for the quickest tent packing you've ever seen. It seemed everyone was in a rush this morning, with a deer failing to look both ways as it crossed the road, missing the front fender of a swerving truck by a matter of inches. Even the rabbits seemed to be in a frenzy, tumbling around in the fields, probably to fend off unwanted attention from the mozzies.

The morning temperature was nigh on perfect for running, and even the highs today were going to be bearable as I headed to the state capital, Madison. The roads were quiet and the corn was growing high, so there were few better places for me to be on earth right then – as long as I kept moving. I couldn't really rest before noon as the local insect population were keen to accompany me. My shins and neck were peppered with red bites as soon as I'd sweated away the DEET.

Madison, Wisconsin, was a beautiful city, coming into view as I curved around Lake Monona – my new favourite way to approach a city – with its domed Wisconsin State Capitol building the biggest deal in town on the skyline. The Capitol was stunning up close, fringed by vibrant red blooms and an art market, as well as the Wisconsin Brewery, where the Badger Club Amber came highly recommended.

The weariness hit early the next day. The next few days were going to be a slog. My red forehead, courtesy of the local biting insect population, might have invited trouble from the swooping

scarlet tanagers trying to warn me off their nests, so I didn't begrudge them their intervention. In fact, they raised the first smile of the morning's running. Cornflowers merged into the near-cloudless sky seamlessly at the horizon, separating me from the green fields in a primary-colour morning. The bald eagle soaring overhead made it look so easy, but I bet even she had tough days.

Taking the roads designated with a letter rather than a number, I knew I was in for a quiet and peaceful time. I passed the most picture-perfect barn with a huge Stars and Stripes adorning the front wall. This was the sort of stuff you could get patriotic about, for sure.

A warm mist hugged the sides of the road out of Richland Center on my path to Viroqua, almost shielding some deer from my view as they hid underneath the wooden swinging bridge. Despite it being a little cooler today, that humidity would stick around for the whole day, and by the time I'd crested the first hill that looked to be the first of many, I was soaked through. Juiced up on eye-watering levels of Dr Pepper there was no surprise in my getting to Viroqua in hardly any time at all.

Viroqua seemed a special place and very hippyish, with a farmer's cooperative, rainbow-coloured houses and apparently the biggest concentration of organic farms in the country. My couch-surfing hosts David and Davina fitted right in. Their house was old in style but run with a lot of attention to treading lightly on the world, with water from the spring and natural home-wares. Nearby, David's brother Josh had fashioned his own house, workshop and a yurt, weaving the latter by hand from willow found by the creek where the boys played as youngsters and in which we now dipped our feet. Josh talked of his time living in Stourbridge, back in the UK, while German Davina,

who worked in the local Waldorf school teaching the therapeutic performance art of eurythmy, started our meal with a few lines of her native language. While I didn't think it was a prayer of grace, it seemed like something I should get my head down for and not query. I quite liked the mystery behind it. Their minds operated on a gloriously different plane to the norm, and they planned to open their own school, where of course eurythmics would take a prominent place. I asked if Annie Lennox was a fan, and apparently she was, having been involved as a child. That would teach me to be flippant.

Hearing rain lashing against the window and booming thunderclaps while lying in a comfortable bed wasn't high on the list of drivers for an early start, so it was with great happiness that I heard the last few drops come and go before I needed to make headway on my last full day in Wisconsin. Sometimes a storm is the break in the weather, but today was not that day. It was going to be a roaster, with two huge hills lying in wait.

I ran into some more smiling Amish and waved at a group of girls who ran off giggling in their cotton dresses, looking over their shoulders at this strange yet familiarly bearded sight. Temperatures were touching 43°C at their worst, and beads of sweat visibly formed on my heavily sun-screened arm before they got big enough to run off onto Pramsolo's frame. I thought I might have been broken – it sure wasn't normal.

The gas-station slush machines were churning out little more than cold juice by the time I reached LaCrosse. Incidentally, it *is* named after the sport, which was played by the Native American tribes in the area. The road that took me there swept, wound and dipped through the greenest of forest land, though with space to breathe before the autonomic gasp when I saw the Mississippi for the third time and flanked it and the railway tracks all the way into town.

Nads had finally got her ducks in a row and was able to come out again. I couldn't wait to be with her again, so I promptly booked flights to meet her in Nashville. It was for the good of the run that temptation was kept at arm's length as I raced on a four-day clock to reach Minneapolis to make my flight.

Running upstream, the Mississippi to my left, and through the town of Onalaska, I stumbled across the Great River State Park Trail, which, for eighteen blissful miles, took me to within a couple of miles of Minnesota. For a decent part of this I had company – a local runner named Tate joined me with a jogging stroller, so we were an eight-wheel outfit, with his daughter Lucia taking the best seat in the house and his son Owen adding a further two wheels with his bike. We covered just over six miles together in an hour before they needed to turn back, Owen having ridden his longest ride yet.

Who needed music while I had the opportunity to listen to the nature that sensed it had no need to hide as soon as the sun had crept above the treetops? Birds, frogs, God-knows-whats and sometimes just the sound of my feet and the wind provided the rhythm and melody through swamps, bluebells and daisies, until the Great River Road told me it was time to take a turn to the left.

And so I crossed the great Mississippi once more. Baton Rouge and near-death, Memphis and near-catastrophic injury, and now a third crossing in Winona. I left the Badger State behind me and had to improvise my Lean by a spray-painted concrete wall, as the official state line was on a bridge with no railings and a hundred-foot drop straight into the Mississippi.

Chapter 32

HIGHWAY 61 REVISITED

Minnesota
Days 213–15
117.03 miles

I didn't see Bob Dylan's 'Howard' when I reached the corner of 72nd and Martina, but I knew from the song that there was adventure to be had down Highway 61, which connected his hometown of Duluth, Minnesota, to St Louis, Memphis and New Orleans all the way to the Mississippi Delta and the home of the blues. Now that would be a road trip to consider.

Happy to see Kwik Trip would be coming along for the ride, I popped in for breakfast and saw that I was front-page news, being the big splash on the cover of the *Winona Daily News*. Thank goodness nobody recognised me, which might have had something to do with the fact that my left eye had swollen almost completely shut after taking an insect bite to my eyelid at some point yesterday.

Lake City, fifty miles away, was my goal set in stone. This took me northwest alongside the Mississippi the whole way. The scenery – perfect weather and roads with smooth, wide shoulders – barely changed, but that was no hardship, as the Mississippi morphed into Lake Pepin, a stunning body of water.

* * *

It was a day for wearing white, with nowhere to hide from the sun. I was bubbling over with a sense of effortlessness and fun, which was probably a bit of heatstroke kicking in, and my mental state became detached from the physical. I was aware I was hot, but a silliness had set in and I would race through roadside speed traps to see what I could register on the digital display and encourage big rig drivers to sound their horn as they went past. It all culminated in a tribal-cum-*Saturday Night Fever* dance under the jets of a sprinkler that some unknown angel had set loose by the side of the road. I stayed under the jets for a good ten minutes before I started to feel a little more normal.

The first hotel I tried in Hastings that evening was cheap and available and importantly had air-con in the rooms. The issue was at my end. My card didn't work. Refused three times, I checked my balance: $36 remained, circling the drain. I'd known my funds were running low, but the recent spate of couch-surfing and camping had made me stop thinking about it. It was a complete shock.

Humiliated, I begged for an act of mercy at both of the local hotels, and my desperate pleas were turned down at both. The local police had recommended against camping in a random spot so it was time to wheel out the old failsafe – the first bar with an open door.

I sat with an IPA in the Draft House and took stock of the money situation. I'd been trying to obtain sponsorship with no success, despite my many news appearances, social media presence and the generosity that so many locals had given me on the way. I could gamble on an encounter with a health-conscious, tech-rich San Francisco fairy godmother, but who was I kidding?

At least I wasn't paying for my beer. The good folk of Hastings were keeping me stocked for tonight. When Jen, one of the bartenders, asked where I was staying, she shook her head in

disbelief at my reply and said, 'Stay at our place – we have a couch.' She was finishing her shift soon. It was the most welcome couch I'd ever slept on.

There were reasons to be cheerful the next day. I had a wire transfer from the UK to tide me over financially, and more importantly today was the last day of running for a few days, as I would reach Minneapolis and head south, to pick up Nads in Nashville.

Pramsolo and I had a good last day together. We'd shared eighty days on the road as part of this team, but nothing had seriously threatened to stop me running – even the impending financial disaster had stayed off the radar until the last and best possible moment. In recent days, I'd had the wonderful people of America to host and help me along the way. Running with Pramsolo had been an almost overwhelmingly daunting prospect but had grown into an incredible learning experience. I wasn't just a runner any longer – I was an adventurer. Cheers, Pramsolo.

I'd never made a name sign to greet someone at an airport before, so I got out my crayons and did my best to make it look good, and waited at the arrivals gate at Nashville. She looked absolutely gorgeous – and the sign went down a treat. We headed for the Cookeville bus in much better spirits than the last time we boarded it, in the opposite direction, and went to collect Jenny. It felt like coming home.

Chapter 33

US

Injury watch: Foot pain. Dr Google diagnosis: either
a fracture of the fifth metatarsal or peroneal
tendinopathy.

I'd been in contact with the WWF and told them that because of
my dwindling budget I'd likely have to stop once I got to San
Francisco. They replied to tell me they'd arranged a bake sale at
the Living Planet Centre – the WWF UK headquarters – to send
me a new pair of shoes. Four days after hanging up Pramsolo's
wheels, the WWF had sent not one, but five new pairs of Nike
Vomero.

With Pramsolo, I'd carried three pairs of shoes, in constant
rotation, each pair lasting about six weeks before being retired,
saluted and duly shipped off to spend their dotage in Georgia,
with Thaivi, our friend Luli's mum. Now, thanks to Jenny's
return and the generosity of the WWF, I could rotate five pairs in
one go. I'd typically wear a pair for one run, then change out for
a fresh and dry pair after every break, to keep my feet as clean

and dry as possible. Even the Minnesota heat couldn't leave me with a complete set of soggy trainers now.

First things first, before running. I went on a sightseeing trip past Fifth Element Records, the spiritual home of Brother Ali, the hip-hop king of the Twin Cities and a personal favourite of mine. It was perfect symmetry that I'd finished one phase of the run following the lyrical path of Robert Zimmerman down Highway 61 of his home state, and I would be closing out Minnesota and starting anew with Nads from where it was at for the Brother. I listened to his album *Us*, which would only get more relevant as time went on.

Being with Nads again made everything ten times better. Firstly, it meant having my best friend with me to share the stories in person. Not only that, but first time around I'd been too tired to recognise everything she did logistically. This time I understood how much work it took for her to support me, to be there for me and put her whole focus on keeping me safe and well. I made sure to feel and show my appreciation as much as possible. It was all a reason to love her even more.

Minneapolis in the summer looked like a lovely place to live, especially if you had a ton of cash. The houses around the Sculpture Garden were palatial, and apparently some of them had heated driveways, which seemed ecologically questionable.

I reached the halfway point of the whole Forrest run – 7,624 miles done, 7,624 to go, though I still doubted it would happen without the help of further benefactors. By the end of the day my quads and feet were complaining. It was likely to do with the lack of Pramsolo's support. I had become prone to leaning my body weight onto the handlebars, which had inevitably affected my form. I must have been underworking certain muscles, because running unsupported and upright took a couple of days to adjust to.

We broke in our first night on the road together in the most traditional way possible – in a Walmart parking lot, as if we'd never parted. All three of us.

Minnesota is known as the land of Ten Thousand Lakes, though it is also seemingly as abundant in trails, with the Wobegon Trail providing over thirty miles and almost a whole day's worth of flat, traffic-free running. *Maybe one day there would be a paved trail that spanned America*, I thought. *Wouldn't that be something?* By the end of the run I'd have a decent opinion on what would be the best route for it. The trail itself was named after the fictional town of Lake Wobegon, from the imagination of author Garrison Keillor. When he was asked where it was, he initially told his readers that it was a mere fabrication, but as this proved disappointing to many, he decided to tell them it was in central Minnesota, as pretty much no one outside of the area knew much about it. He created it as an ideal, to make people think of their home town and reminisce about the great times they had there. I can think of a similar trail in Liverpool, and I hope you have yours too. If not, move, for they are wonderful places indeed. Maybe even come here? You'd even go past the model town of Memoryville on your way.

If I needed a lift, I'd find it at every mile, with messages of encouragement and advice attached to every mile marker on the grass verges that lined the trail.

'Be kind.'

'Just one more mile.'

'Be a good friend.'

'Exercise does the body good.'

'Be positive.'

I also had the benefit of my own positive-thinking coach, parked in another supermarket parking lot cooking a veggie

Bolognese. Seeing her smile and smelling dinner meant I was unlikely to be on a downer any time soon.

The next morning we made a significant change to our routine. As a stress-avoidance measure for Nads, all route planning for the day would be done and dusted in Jenny in the morning, before I set off. I had been happy to wing it, especially during my Pramsolo days, when I'd often just work out my running segments at each rest stop and my sleeping arrangements pretty much in a bar at the end of the day. But I understood her need for clarity and good planning. Driving Jenny was a subject that I would always tread delicately around with Nads. I had never driven her, mostly due to being scared stiff of her size, and every passing day would make it more difficult not only for me to drive her, but to question the decisions made by the boss.

I was listening to Johnny Rocket on Cool 94.3 FM, and hearing the delivery of a *Forrest Gump* quote segue into Tom Petty's 'Runnin' Down a Dream' meant I had to get in touch. It was requests hour and I fired one in for 'Purple Rain', in honour of my passage through Minneapolis, the home of the artist known as, then formerly known as, then known once again as Prince. Johnny Rocket read my message out and duly played Purple Rain, to my immense joy. I had a lot of Johnny's music on my own playlists, but there was a certain frisson in hearing a radio station choose these songs independently.

Day three of the Wobegon and now Central Lakes Trail, and the wildlife was straight out of a Grimm fairytale. A big fat toad in the middle of the trail was shifted to prevent a less watchful traveller making a more lasting impression on it; there were the most beautiful of butterflies chowing down on whatever faeces they could find (I'd never look at them the same way again) and, as I was putting on my sun cream, I saw a tick making its way up my leg towards the darker recesses of my shorts. Cue hurried

internet searches about Lyme disease. I managed to pick up a second tick on my next run, prompting Nads to say that if she got one on her she'd be going home. When we bumped into Jake, a State Parks worker, he reassured me that these were larger wood ticks and were Lyme free. He could have stopped there, but he continued with the story of how his sister and her husband once came back from a run with about thirty ticks on each leg. This was not exactly helping my efforts to convince Nadine not to worry.

Only the sounds of my footsteps announced my progress through Ashby and Dalton. Johnny Rocket began to crackle and fizz and then disappeared into a wave of static as I moved further away from Minneapolis. I wasn't ready to move on yet. He was my first American radio love and I regretted not getting into this medium much sooner on the run.

I'd been on this trail for ninety-five miles, but it came to an end in a truck stop in the town of Fergus Falls. I spotted Jenny and made my way over. As she often did, Nads waited to greet me at the doorway. She gave me a moment to catch my breath and then hesitantly spoke: 'I've got some news for you that I don't really want to tell you and I don't think you want to hear.'

I looked at her, confused for a moment. Another puncture? Was the truck stop unsuitable? Maybe we'd run out of strawberry protein powder, requiring a switch to vanilla. Then the moment of insight hit me.

'Baby?' I asked.

'Baby.'

Nadine's first concern was me and the run. She'd already had a few hours to digest the news, and wanted to sit down with me and work out some logistics. It was the end of July. She'd be due towards the end of March, so if I somehow managed to make the full Forrest run, that was my hard limit on finishing. Since she

wouldn't be able to fly late in the pregnancy, it meant she wouldn't be able to see me at the end. This was a crushing realisation for both of us. Not only did I rely on her support massively, but I missed the hell out of her when she wasn't here. Being on this adventure together meant the world to me.

The rest of the evening was surreal. We had discussed having children, and I'd gone from being dead against to more like 70:30 in favour, whereas Nads had wavered in the middle ground and was more against than for before this point. For now, it was our secret and we hoped nothing would change in the immediate future, though Nads's glasses of red wine in the evening were now a thing of the past.

We tried to settle back into business as usual the next morning, but thoughts were filling my head and it was difficult to concentrate on the road. I made an annoying wrong turn after Carlisle. Except for the odd ground squirrel and nesting eagle, I truly was alone with my thoughts when I was out on the road. I figured I'd best get used to it, as North Dakota wasn't far off, followed by Montana – both states that were hardly teeming with folk.

I was increasingly worried about Nads's welfare. It had seemed strange when she had declared she would go home after a tick bite. Just this time yesterday, I'd have chuckled and told her she was being daft. But now if she so much as hinted at feeling vulnerable or even just said, 'I think I'd feel better off being at home,' I was ready to cancel everything and drive her to the airport myself. She reassured me she was fine to continue for now, and that we'd work everything out as we went along. I started to see if we had any wriggle room in our plans.

My sweet spot for daily running was being able to hit the fifty-mile range. The days where tiredness struck never seemed to relate to the previous day's mileage, apart from when I strung many days in the high forties or above together. I knew I had a

good chance of sustaining this to achieve the full Forrest on time. However, the one thing that wouldn't change was the number of hours in the day, and more miles meant less time to chat to people, take photographs and sit and watch the world go by, which would be a missed opportunity. It wasn't just about covering the distance; it was about the experience too.

As it stood, we were only set to get to the Pacific by about the end of September and wrap it all up there. It still didn't stop me looking up all kinds of contingencies, such as specialised health insurance to allow Nads to be covered up until thirty-six weeks, which was the latest safe date to fly.

Amidst all this administrative problem solving, we both had to process what it meant for us as a couple and as individuals. Life was going to be very different come next April, and likely more difficult. I'd been feeling for a while that it would be a good thing to shift my immediate focus away from *me* and maybe the run. It was all about me at the moment, which not only meant the pressure I put myself under was considerable, but it also pulled Nadine away from her own needs. I wanted to get my mindset more into a greater awareness of the world and my place in it. That was one of the things I loved about being a vet, after all. So this news was potentially the best piece of scheduling we could have wished for, in terms of my being as ready for fatherhood as I could be. Despite the challenges it would bring, I was excited by the new adventure it promised.

I would run into North Dakota properly the next day, but that evening we sneaked across the border in Jenny for a bit of a celebration. We went to the cinema in Fargo to see *Dunkirk*, starring the great Mark Rylance, a fellow Peace Direct patron. I think we deserved a bit of a treat. But it wasn't just about us these days, so when we bumped into Ciarán, an Irish travelling cyclist from New York City bound for Washington State, we

took him along for the ride. He was staying in the same campsite and we couldn't let him cook noodles and get bitten by mosquitoes while we were elbow-deep in popcorn. This crew was growing by the hour.

Chapter 34

FAR-GO

North Dakota

Days 222–32

411.94 miles

Dog chases: 1 chihuahua

Pain watch: 2 feet giving me grief, 1 ankle, 1 back

issue, 1 stomach-muscle issue

Fargo, the biggest city in North Dakota, is known as the Gateway to the West, and to me sounded like a primitive command, with the mile marker telling me it was 321 miles to Montana via the shortest route, which seemed less interesting than my planned 400. My day began in Minnesota with a daisy growing through the cracked tarmac, straining towards the sun at a six-way cross-roads with an added train line for good measure.

This was a fitting place to tick off my 300th marathon in 222 days, and I crossed the Red River from the twin city of Moorhead on the Minnesota side and, with no sign of a North Dakota sign, I did a Lean of sorts on one of the central columns of the Veterans Memorial Bridge on the state line.

Global Tiger Day meant a welcome return for my Tiger Vest with the slogan 'The Tiger Made Me Do It'. Maybe my mum

'made' me do it, but the tiger was crucial to why I did it. The WWF Tx2 campaign's ambitious goal of doubling tiger numbers by 2022 could be possible, as long as the threat from poaching and habitat loss could be addressed – they are *cats* after all, and all cats will breed prolifically if they get the chance. We lost over 95 per cent of the world's tiger population in the last century, but we were now seeing encouraging signs and their recent population increase, albeit small, is an encouraging sign about our environment.

Trawling through the airwaves, I came across The Fox 105.3 – Minot's Rock Station. If you ever fancy a snippet of my North Dakota life and you're not in the area, just put the heating up to full in your house, put on The Fox and close your eyes. Bliss. Wish You Were Here? Well, that was the first song that came over the airwaves, as the farmland opened to a golden stripe of sunflowers to my left. Beyond a copse of trees, they extended as far as the eye could see. Luminescent and stunningly beautiful.

The lack of shade and the heat turned Jenny into an oven by lunchtime. Despite Nads not being one to complain, we now had an increased responsibility for her wellbeing. Whenever I could, I would send her ahead to our resting stop for the night, such as the one nestled by the Jamestown Reservoir, with ample shade and a clubhouse to escape.

The afternoon shift was tough with the heat. I made it to Jamestown and was met with a familiar shout I hadn't heard in a while: 'Run, Forrest! Run!' The owner of the voice was also brandishing a hosepipe, and offered me a soaking. A sudden moment of British reserve almost stopped me, but I went over and he offered to buy us dinner at the clubhouse. 'Eat as much as you want,' he said. He might not have known what he was getting into there.

The next day played out true to form as I baked under a relentless fireball, grateful for every second of shade and the

breath of wind that a passing truck would send my way. My thoughts were focused on one thing – the municipal swimming pool next to our city RV park in Carrington that evening. City parks were designed to entice those in transit into the town with basic but usually very inexpensive facilities. This one was only ten bucks, with the pool costing another five. Cooler air was starting to come in from the north and Jenny was a nicer place to be once again.

Farmers rejoice! The patter of rain on the roof signalled at least some relief from the drought that had hit the US from North Dakota to the Rockies. With it came perfect temperatures, though it soon rained so much that the road took on the appearance of a shoreline, with white waves breaking across the surface due to the longstanding dust and the salt on the road that had been spread during the previous winter – a measure of just how dry it had been. It came with a new, unforgettable smell. Now, this wasn't the 'farmyard' smell of the surrounding landscape, but one of baked earth being coaxed back to life, almost smoky in nature but fresh at the same time. It smelt of hope. Unfortunately, it also meant trucks speeding by, kicking up muddy, salty spray into my face.

I paralleled the Soo Line Railroad, where I would overtake parked trains containing over a hundred carriages or watch as one would take a few minutes to pass. They were comfortably a mile long, being dragged by five locomotives, with some needing a little push from one at the rear. I caught up with Nads having a long stop, cut off by one of these haulage behemoths at the railroad crossing in Drake.

Traffic was getting sparser by the day, with almost nobody to be seen on the roads in the morning. That was, until an entire house came down the road, blocking the entire carriageway and requiring me to exit stage left and sharply with it. Large loads

were usually accompanied by a lead and tail car, with flags marking the height of the soon-to-be-passing object to avoid becoming one of those videos on 'America's Craziest Things That Get Stuck Under Bridges'. I'd been passed by helicopters, tanks, air turbine blades, mysterious things under tarpaulins as well as a lot of farm machinery, but this was the first and probably most impressive literal house move I'd seen. I'd seen a sign back in Gainesville, Texas, that read, 'Don't like your neighbor? Don't like your view? Tired of high city taxes? Let us move your house.' It didn't occur to me at the time that it meant literally.

At one of our rest stops, we made a new four-legged friend, encountering an example of *Ambystoma mavortium*, or the western tiger salamander, who seemed a little bemused by the presence of a thirty-foot RV. He was emboldened to leave his hiding place by the rains, which I imagined went down swimmingly among the local amphibian population, and I marvelled at the fact that he could exist somewhere that had been hit by such a severe drought. It seemed that wherever you were in America, life would find a way, like the sunflower that trumped my Minnesotan daisy by growing a good few feet through a hole in the tarmac no bigger than your thumbnail. Triumph through adversity.

Pain was a way of life now. My now throbbing left foot did not let up. I'd decided that my injury was peroneal tendinitis, a troublesome condition of the foot that meant a significant lay-off from running. My previous success stories with tendon rehabilitation made me hopeful it wasn't a fracture, and was something I could bounce back from by minimising stress on the foot. Searching online, I'd no means to properly diagnose or treat until the town of Williston, 200 miles away, so for now I had to bite my bottom lip and suck it up.

Over dinner we heard wild tales of Arctic winds that would rip off your truck door and temperatures of 40 below, and a

liquor store straddling the Canadian border with different doors and different rules depending on which side you entered. It also sounded more like the rules could be filed under 'guidelines' at best.

A disturbing piece of news came in on one of the last bits of internet my phone would receive for a while. A fellow trans-con runner, Nick Ashill, had been involved in a hit-and-run incident in Ohio. A driver, seemingly deliberately, changed firstly to the inside lane and then speeded up and veered onto the shoulder where Nick was pushing his stroller, giving him no time to react and pinning him onto the road barrier. He shattered his pelvis and broke his leg, as well as receiving severe internal injuries. In total, he spent almost four months in hospital and his doctors told him he would never run again, though I had no doubt that he'd complete his crossing at some point. The authorities were never able to locate the person at the wheel.

My heart went out to Nick and his loved ones, and the shock hit me hard. My life was no longer only my own to worry about. I had responsibilities now, and I worried about Nads being left a single mother. I needed to keep my eyes open for more than beautiful scenery, wildlife and interesting curios on the road.

Chapter 35

BIG SKIES

East Montana
Days 233–44
469.55 miles

This would be our second single largest state crossing, after Texas, with 667 miles or thereabouts of Montana's finest awaiting me before I would reach my sliver of Idaho. Montana is known as the Big Sky and it truly needs to be experienced first-hand to comprehend the vastness of the panorama. I would experience a few occasions when a 360-degree turn would make you think you could slice off the sky like the top of an egg. I passed a disturbing number of white crosses on the side of the road. They were placed by the American Legion in Montana and marked the places where somebody had died in a road traffic accident, to encourage motorists to drive with care. I passed them from my vulnerable roadside position, hoping that passing drivers would take heed.

Another hot day was taking its toll on all of us, but more so on poor Nads. By the time lunch rolled around, most passive attempts at keeping Jenny cool would be defeated and the mercury would climb to 100°F-plus. I would tell her to use the air-conditioning, but she was reluctant to have it on all the time

and would tough it out. She was also toughing out some severe morning sickness, which for her would persist through the bulk of the day before peaking, conveniently, around mealtimes. She would violently retch passing my lunch across the RV or placing the night-time burritos and sweetcorn on the dinner table. I don't know how she coped during this period.

I moved a freshly squished hognose snake to the side of the road for the crows and to await its own snake-sized white cross to be placed in the grass. I'd almost stood on a live garter snake a couple of days previously, and panicked for a moment because prairie rattlesnakes did roam these plains and had caused fatalities in Montana. Fortunately, garter snakes are harmless, but this place was sounding more like Texas by the second.

I was now deep in reservation country, in the lands of both the Assiniboine and the Sioux tribes. Reaching the town of Brockton in the Fort Peck Reservation, I met a Sioux family led by William Boyd. Wife Bird, son Bear and grandma Grabel, who didn't say much but flashed a warm toothy grin as I was introduced, were all in the car. They returned a short while later to shower us with gifts of a handmade piece of jewellery in the form of a Native headdress, mounted on our rear-view mirror, about three kilograms of frozen local cherries (which were a bit like cranberries) and some of their sacred white sage, which I hoped would live up to its reputation as a healing herb by bringing the body into balance and dispelling negativity. William signed off with a rib-crushing hug that would have squeezed any remaining negativity from my bones, while whispering in my ear, 'Never lose anyone.'

I don't think I have enough profundity in my soul to grasp the entirety of what it meant, but it seemed more of a command than advice. As such, I could only agree and thank him. These lands were, as with many of the reservations I'd been through,

indicative of a life on the breadline, which would perhaps always have been the way. Shorn of good land and the ability to roam and cultivate both crops and livestock, the nature of 'getting by' was for many a hard and desperate existence.

This was particularly evident when we entered the outskirts of Poplar, one of the larger towns, where yards were overrun, buildings had seen better days and billboards told of the need to 'Chase Your Dreams, Not Meth'. I was advised that it was not a good idea to park up overnight in some areas of town, though all the people I came across were of good grace. I met three firemen from Santa Barbara in California, who had come to help out with the droughts and the increasing fire danger. Local manpower was not what it should have been. The drought had made Montana very yellow.

As per advice, we didn't stay in town, and drove on to a defunct rest area with a lone tree for company. I didn't even know what type it was, but there was something mystical about that tree. It stood, alone in a cornfield, drawing my gaze wherever I stood. I went outside at night. The almost full moon had come up and I stared awhile, as it cast its shadow and hid a few thousand stars in the distance, before going back to bed. I didn't know why I felt that way about the tree, but I bet William Boyd could have told me. I gave his sage a rub on the way back in.

As the local mosquito population zeroed in and the sun beat down on Wolf Point, I thought about having to trace this route as a pioneer, without any real idea of where you were headed, let alone being Google and DEET assisted. I would have to downgrade my self-classification of 'adventurer' a tad, or at least separate that category from 'explorer', which was a different level.

Wyatt and Zander, two local high school students who needed to do their daily training for their cross-country team, came with

me for four miles after they asked their mum to stop as they drove past. Their outdoor sports season was very short here, only lasting from August to October before they went inside and played basketball. In those three short months the small schools in the area packed in cross-country, football and baseball before the big freeze hit.

The last three miles were spent fending off the dusk squadrons of winged probosciscs. These guys were as big as those back in Wisconsin, and seemed to have the ability to attach at full running speed. Buddhist principles of 'live and let live' were abandoned as multiple fatalities occurred up and down my legs, with the final execution witnessed in the breached sanctuary of Jenny's fibreglass walls. By rights, each would have to be marked with a white cross.

The mosquito population were causing me constant stress. Their presence was probably down to the thick sliver of green that flanked Highway 2 for a good stretch in these parts, where the slow-moving, winding Milk River fed the corn industry and nursed the bloodsuckers. I know people have to make a living, but I'm not sure I'd want that living if it came with the need for a monthly blood transfusion. That lush strip of misery would continue for another 160 miles or so, and I prayed that it wasn't as mosquito-ridden the whole way.

Kitted out in homemade hazmat despite the early evening heat, I spied a gentleman mowing the lawn of the United Methodist Church. I walked over to ask if we would be able to park up for the night. He seemed carefree in his short sleeves and was more than happy for us to stay the night.

'Are you not being eaten alive?' I asked.

He gave me a wink. 'Not me, son. They prefer new blood. We only let tourists come to draw their fire. Don't kill 'em or it'll get too busy around here.'

There is a scene in *Forrest Gump* where you see the main man running down a road that breaks the expanse of corn in northern Montana. It was a moment I wanted to reproduce, but the harvest had been going on for some time to try to save what they could from the ravages of drought. If I waited much longer to find the right spot I'd risk missing the corn entirely. My eyes had been peeled for a few days, and on the way into Saco I settled on our set and returned with Nadine first thing. It was a one-take shot thanks to the presence of the bloodsuckers. That evening I did some online research and discovered that a recent study had shown a quarter of the mosquitoes of the Milk River harboured West Nile Virus, which caused a flu-like disease that could progress to seizures and death. Was it sensible to share this with Nads? Too late.

We were supposedly in buffalo country, and Nads and I were extremely excited about the prospect of seeing wild buffalo. Sadly, they didn't appear to be popular in these parts. A shop in town at the start of the day had a sign saying, 'No to free-ranging bison'. It seemed a pretty selfish attitude, but considering my mood of the last two days thanks to the mozzies, I could see why they were grouchy.

I made progress towards the far edge of Havre, where we stayed at a campsite with donkeys and ducks to help soothe our road-weary souls. The road beyond saw the onset of a slight upwards gradient, which, alongside a brisk headwind, signalled the start of hill training. The Rockies lurked somewhere over the limitless Montana horizon.

Three hundred miles of Montana had disappeared in my wake and local deer stared apathetically at me as I approached Kremlin (USA STYLE – the sign reminded me). The town, if you could call this railway siding, a few silos and fifty or fewer houses a

town, earned its name when a mirage formed by the distant Bears Paw Mountains reminded one of the railway pioneers of his Russian homeland.

I left Rudyard, 'home to 596 nice people and one old sore head', on a day trip through Inverness, Chester and Devon. I think the person who made the town signs realised he or she had a duty to give the traveller something to take with them from the area. Elaborate wrought-iron signs gave each settlement its own work of art, with the odd unusual sculpture of, for example, a triceratops appearing in a field when towns were already covered. The local history signs were a cut above too, informing me that Butch Cassidy and the Sundance Kid pulled off Montana's Great Northern Train Robbery in these parts.

I was informed by locals in Shelby that a fair amount of forty-rod went down in the past, so named for being so strong it could kill at that distance – about an eighth of a mile. The exact recipe is the stuff of legend, but one version that sounded 'interesting' included grain alcohol, a twist of tobacco, red chillies, a bar of soap, a rattlesnake's head and a little water. Mixed in a barrel, when the gnarled mixologists thought it was ready, they'd drop a horseshoe in it. If the iron sank, they'd stir in some more alcohol until it rose to the top. I'd stick with beer and hopefully retain my vision, thanks.

My target was the town of Cut Bank, the coldest place in the lower forty-eight states – though I was fortunate to be experiencing it at the hottest part of the year. If I was growing dulled to both the beauty and the danger that existed on every mile on the run, a reminder was served by a bunch of blooming yellow sunflowers soon followed by another white cross.

The history signwriter told of more tragedy, detailing the Baker Massacre of 173 Piegan Blackfeet people, mostly women, the elderly and children, but also their chief Heavy Runner. He

welcomed a vengeful US Army brigade with his good conduct papers as a gesture of peace, but to no avail. Over a hundred prisoners were made to fend for themselves, with no clothes or supplies, causing many more deaths.

The Rockies were no longer hidden by the horizon and loomed ever larger with each mile. We would have to adapt our support approach as we headed to Glacier National Park. Jenny was too big to navigate through the pines and over the passes of the famous Going-to-the-Sun Road, so we found a place for her to 'couch-surf' while we hired the cheapest car we could find.

We picked up our car and headed out to Browning for one last long look at 590 miles of Highway 2, under the widest blue yonder. Never change, 2. You never did and I was fine with that.

Chapter 36

BIGGER SKIES

West Montana
Days 245–52
257.96 miles

The mountain lake that Forrest ran past in Montana had been a totemic vision for me for many years. It influenced my route planning and it provided a focus for dreaming of progress when none seemed possible during the darkest times of the run. Now it was less than a day away, somewhere over those mountain peaks and under the same sky.

Our base camp was just outside the Glacier National Park, where Nads was set for a taste of my solo life. At the end of my only run of the day, to our campsite from the town of Browning, chased by wild horses while I in turn chased the sun disappearing over Glacier National Park, it felt like a perfect postcard from the Montana tourism office. We'd borrowed a slightly larger tent than the green coffin that had served me well on the east of the continent, and taking two of Jenny's mattresses ensured a little more camping luxury than I'd been used to.

We rose before dawn to the cold mountain temperatures, despite it being August. It sent a shiver down my spine thinking about camping during the autumn and maybe even winter

months – if I was able to continue running that long. Nads would certainly have returned to the UK by then.

An early mist conjured the notion of Blackfeet ghosts that I'd felt the presence of. Suddenly, from out of the mist came a shadow and I froze to the spot. A large black animal had just stepped onto the road – in country where both grizzly and black bears roam. My heart pounded as I wondered what on earth to do. The mists parted, and it came into focus …

It was nothing more than a wandering cow. I exhaled again and my heart rate settled. A false alarm this time, though it signalled the start of a long period of edginess for me. A bear could appear at any point, and I had to keep my wits about me, which probably meant no headphones today.

If Arizona had stolen my heart in the sunset department, Montana was making a strong case to rule sunrise. Today I would climb to 6,000 feet, overseen by a total solar eclipse just before noon. Though we wouldn't experience totality here, it was still a big draw for people in the area, and two lads kindly gave me a couple of pairs of viewing glasses so we could look without risking permanent damage.

I transitioned from trailblazer to awestruck movie tourist as soon as I crossed the boundary to the Park. I ran across the bridge at St Mary, the three-arched stone viaduct that Forrest crosses to the strains of Jackson Browne. To my left, the first view of Glacier's 'Grand March of Mountains' took my breath away.

We decamped to Dog Run Flats, the very same place that Forrest ran by his mountain lake. His description of it was as accurate as I'd hoped, and as we looked across the water through our glorious eclipse-viewing goggles, reminiscent of 1980s 3D glasses, the moon passed between us and the sun and an eerie hush descended across the park. The birds stopped singing and a noticeable chill fell upon the air.

A natural phenomenon to which the Park is no stranger is fire, and on an afternoon hike with Nads to the Baring and St Mary Falls we saw the aftermath of the 2015 Reynolds Creek fire, which nearly did for the Going-to-the-Sun Road that snakes through the most beautiful areas of the park. Despite the sadness of seeing so many burnt trees, not to mention six additional miles my legs could have done without, this was filed under mental rehabilitation for us. This was the territory Nads had waited the whole trip for, an all-too-rare reward for the hours of driving and putting up with my crap.

Seeing the majesty and power of nature so intensely is an obligation of existing in Glacier and it was one of the reasons why I was here in the first place. At the Glacier Visitor Center we read a forecast that by around 2030 there would be no more glaciers in the whole Park if the current rate of global temperature increase continued. If you stand in the beautiful surrounds of this National Park, you can see the effects of climate change in the continual shift of the tree line, climbing up the sides of the mountains.

After a night camping among bear-proof bins – we would have to wait and see if our tent was bear-proof – the first run of the day was any runner or cyclist's dream, heading up to Logan Pass, which marked the Continental Divide. It was all downhill to the Pacific, for those raindrops and me, from now on. One mountain in Glacier is geographically unique: a drop of water falling on one of Triple Divide Peak's three slopes will either drain into the Atlantic, Pacific or Arctic Ocean, via the Mississippi, Columbia or Hudson Rivers, which is one humdinger of a piece of pre-determination.

My cross-country route via Gunsight Pass was ruled out due to another large fire that was starting to spread dangerously out of control. At least staying on the Going-to-the-Sun road reduced

my chances of becoming lost, incinerated or eaten. I ascended into the alpine landscape, a thousand-foot drop immediately to my left, and wound my way around mountains and through tunnels. Tourists rode past in the vintage red buses of the Park, waving and taking photos, but I swear that I had the best way of seeing it.

The first twelve miles delivered a 2,500 feet increase in altitude, and I was more than a match for many a cyclist who joined me this Monday morning. Nads's morning nature walk had yielded ground squirrels, bighorn sheep and the excellently named hoary marmots. Neither of us had seen a biggie yet, although bear, moose and elk were apparently in the vicinity. Mountain lions were also present in decent numbers, but if you see one of those you're usually already being eaten, as they prefer to sneak up on unsuspecting prey from behind. I wondered if, somewhere nearby, the greatest selfie *and* photobomb ever was about to be taken.

Having reached Logan, I'd effectively crossed the Rockies again, though this time I'd chosen its narrowest point, at around sixty miles across. From here it was twenty miles of glorious descent, with my pace quickening by ninety seconds per mile and this magnificent road never failing to deliver. I did cast slightly envious glances up at the Highline Trail, a narrow traverse far above the Going-to-the-Sun that would give you a real insight into the life of a mountain goat, but for once I'd opted for the safer route. The photograph Nads took of me in the area around the Weeping Wall would remain my favourite of the entire journey.

I would see Nads on her bear hunt a few times along the route, where a group of people were looking through the trees. According to a member of the gathered throng, a mother and her cub, which can be a dangerous combination, had been sighted

minutes previously in this area. I progressed for another mile when I saw a man walking to the edge of the river and peering around a tree at something in the water. And there, in the shallows less than fifty metres ahead of me, was around 200 kilograms of black bear. It definitely wasn't a cow. I was torn between watching him and realising that I could be running into a conflict situation very shortly. I couldn't tear myself away, though, until he'd crossed the river and was out of sight in the trees, and only then did I turn on the afterburners and hightail it for the next forty-rod to take me clear of any potential danger.

I felt disappointed for Nads that she'd missed out on a bear sighting, and she had to take consolation from the sunset on the shores of Lake McDonald. It was another from the postcard factory, with the sun, just before it went to bed, casting a million sparkles on the water. A man in lederhosen played the alpine horn in front of the wooden chalets and a haze flowed over the mountain tops.

I turned and remarked to another camper at the edge of the water, 'I've never seen light so beautiful before.'

'That's the Park burning,' he replied.

My Glacier hangover was rough. No manner of kind words, great bicycle paths and clement skies would help. We picked up Jenny and eventually made our way on a quiet lakeside jaunt to the town of Elmo and the refreshingly affluent Flathead Reservation. This was the rolling landscape that would take me to Idaho, a hybrid of Glacier and the far east of the state, with parched grasslands leading into pine forests.

The town of Plains – née Wildhorse Plains, which sounded much more adventurous – looked every inch a frontier town, sitting on the banks of the Clark Fork River which meandered to my left. It had enough charm for Nads to hanker after looking

in the windows of real-estate agents, until an ear-splitting train horn ruined the moment and any promise of a quiet life here.

'Beware of Bears' signs heralded my route through Thompson Falls, where the overwhelming feedback from locals was that I would need to be prepared for close encounters of the bear kind.

'You got a gun? You got bear spray?' said one. 'You'll need one. I'd take both.'

One of the group, maybe spotting my expression, reached over and gave me ten bucks: 'Buy yourself a beer, try not to worry.'

'Good luck on the bear super-highway, Forrest!'

I'd pass on the gun, but perhaps some bear spray might be in order. To my immense concern, Thompson seemed to have sold out completely. I was at a loss until a lady overheard me talking and offered to sell me one.

Tooled up with bear spray and a six-pack of Moose Drool, it was time to thank Montana for its many wonders. Sage on the dash, cherries in the freezer, West Nile Virus still in a mosquito, my favourite photo of the trip and seeing *that* mountain lake amongst the glaciers – thank goodness I'd plotted such a northerly route.

Chapter 37

SUNSHINE ON LEITH

Idaho
Days 253–55
157.67 miles

Mostly, I dreamt of trains. Trains of different lengths and types, but all of them noisy. My advice to the President on his over-blown quest to make America great again would have been to stop the trains sounding their horns every time they approached a junction, invest in some railroad-crossing barriers and let America's workers and schoolchildren get some sleep. An example of the rich–poor divide I noted was that when you were in well-heeled areas the trains would conveniently be stopped from blaring away, with signs at junctions telling you that train horns would not be sounded. They were almost apologetic in their nature: 'Hey, guys, wealthy people are sleeping, so is there any chance you can just keep a watch out for those pesky trains instead? Thanks, the Rail Company.'

There is nothing like lack of a decent sleep to make you a bit edgy, and bear country was the worst place to feel edgy. While untold terrors lurked in the shadows either side of my trail, I focused on just how special it was to run on these quiet, narrow tree-lined roads. I had my bear spray on the waistband of my

pack, like an Old West gunslinger. The theory behind bear spray is that most of the time bears do not want to fight, but they may bellow and charge to intimidate you. If a bear gets within twenty-five feet, it's time to deploy a Hail Mary of hot pepper, aiming a five-second burst just above its eyes, so by the time it reaches you, you may only get knocked off your feet rather than torn apart. Hopefully, by staying calm, talking calmly and firmly, and moving gradually away while maintaining eye contact, you won't need your deterrent. Incidentally, you shouldn't use this stuff in advance – bears will detect it and salivate like you've covered yourself in a spicy Tex-Mex rub.

The next phase of dealing with a bear depends on which type of bear you're dealing with. If it is a grizzly or a surprised black bear that has made physical contact with you, you should play dead, lying face down, protect the back of your head and neck with your hands, legs and elbows spread wide, so the bear can't flip you and get at the good stuff. My favourite piece of advice was this: 'If an attack is prolonged, or the bear starts eating you, it is no longer being defensive and it is time to fight back.' You don't say, Sherlock.

The US National Park Service recommends fighting any black bear that you can't escape from, concentrating your blows and kicks on its face and muzzle, because I'm sure it's that easy to focus on your jab range rather than making like a drunk hooligan and 'windmilling' for your life. We all know that only Chuck Norris could fight a bear, and he wasn't on the trail that day. It was just me.

Ultimately, the safest encounter with a bear is one that doesn't happen, so the advice was to try to avoid their territory or scare them off by making yourself heard in the distance. It sounded a perfect time for a spot of karaoke, so I tried singing to Paul McCartney down the bear super-highway of Cooper Pass. I was

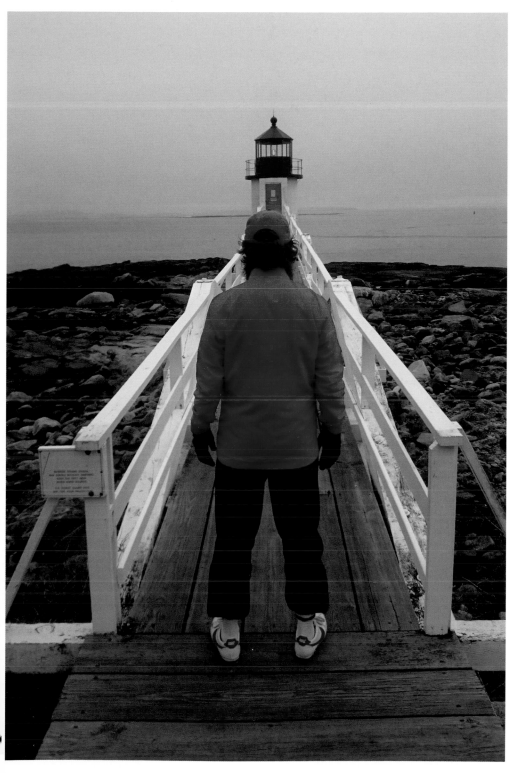

18. When I got to another ocean, I figured since I'd gone this far... Marshall Point, ME

19. As beautiful as it gets. The Weeping Wall in Glacier National Park.

20. Fifteen of the thirty-three pairs of Nikes - including the Cortez, naturally.

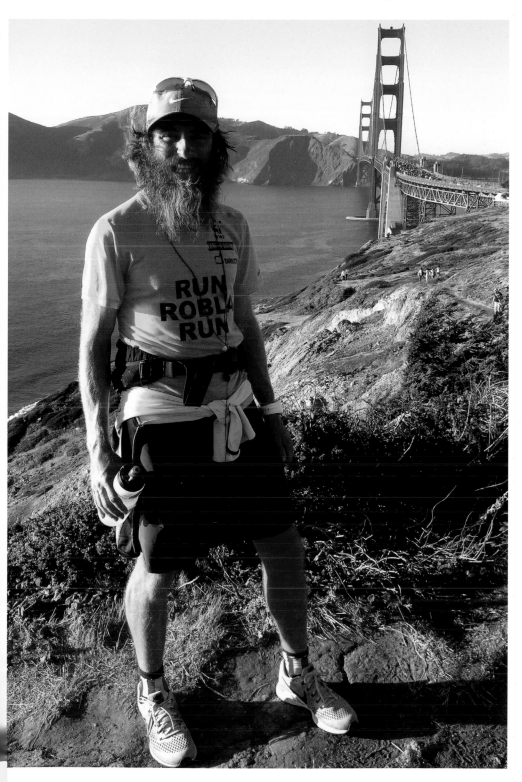

21. If you're going to San Francisco, be sure to wear some flowers in your beard.

22. Lining up my land speed record attempt on the Utah Salt Flats.

23. I learned the hard way in Wyoming that beard freeze was a thing.

24. My final ocean, SC

25. A necessary pit-stop.

26. Closing in on something special.

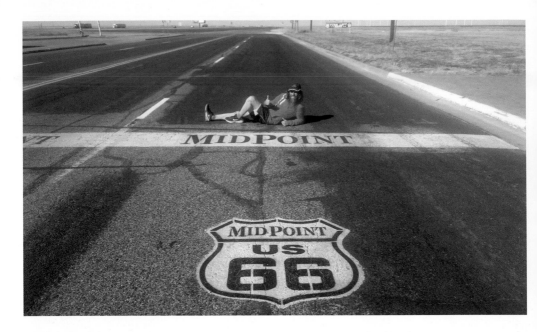

27. The exact midpoint of Route 66. An iconic place to be laid up for five days.

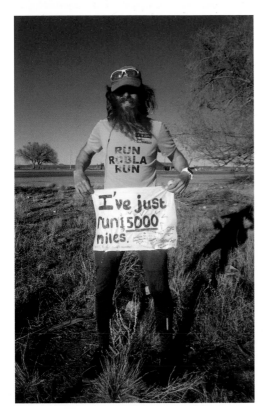

28. The final `thousand-up' marker. Wagon Wheel, NM

29. Grandfather Mountain and `Forrest Gump Curve.'

30. The most beautiful thing I've ever seen.

31. \`I'm pretty tired. I think I'll go home now.' Forrest Gump Point, Highway 163, Utah.

32. The happiest ending.

dressed all in black so as not to provide an interesting flash of colour through the low branches, and it was close to an hour of terror. I worried how I would ever see a bear coming from the side to give me the requisite time and range for the spray to be effective and resigned myself to playing dead and praying for Chuck to show.

I saw no bears, though I spotted deer, wild turkeys and an angry bar owner annoyed at Jenny parking in his lot.

While I did an improvised Lean on a broken waypost to herald my arrival in Idaho, a local informed that the Idaho side was a lot busier and thus, where bears were concerned, safer. I availed myself of the state fruit and a known bear delicacy – the huckle-berry – and took some back for Nadine to celebrate my immortality. I hoped they were huckleberries – I'd seen *Into the Wild* and the results of shoddy botanical knowledge.

Purple of finger and sweaty of beard, I wouldn't have looked out of place a hundred years ago as I made my way through the ghost mine town of Burke. From a population of 2,278, it had now dwindled to 10, and there was no sign remaining of the Tiger Hotel that was built over a stream and had two railroads and a street running through its lobby, such was the demand for space. Now only a couple of trailers and a few shacks remained, and I was already down the road towards the historic town of Wallace.

Wallace was saved from the bulldozers after the townspeople won the fight to make the I-90 freeway fly over rather than through their quaint downtown. They held a funeral for the traf-fic light the bypass made redundant, before exhuming it and pressing it into service elsewhere in the town. Have I told you yet that Wallace is actually the centre of the Universe? Not only is the whole of downtown now on the National Register of Historic

Places and the setting for the film *Dante's Peak*, but in 2004 the mayor made a declaration: 'I, Ron Garitone, Mayor of Wallace, Idaho, and all of its subjects, and being of sound body and mind, do hereby solemnly declare and proclaim Wallace to be the Center of the Universe.'

If you keep your eyes peeled on the way back from the Bordello Museum, you may see the commemorative manhole that designates the spot the rest of the cosmos revolves around. Nads and I liked Wallace a lot and it is right up there in our Small Town USA Hall of Fame. We toasted life with the North-Western Blood Orange IPA and Wallace Brewing's IPL and saluted the town who had proclaimed, 'You may take away our traffic signal, but you'll never take our freedom!'

The Coeur d'Alenes Trail is a glorious seventy-three-mile-long flat tarmac trail that was to become my Idaho. It was no wonder I ended up loving the place. The miles ticked away on my trouble-free trail, to our campsite on the shores of Medicine Lake, where ospreys stood guard from their telegraph-pole high-rise nests.

An early start saw the Montanan sunrise finally climb over the Rockies to greet me and added to the sense of peace that hung around on the trail, with the morning mist drifting in from the river. The spruce and fir flowing up the sides of the valley and the crisp morning air transported me to the Scottish Highlands. The only appropriate thing to do was to engage the Proclaimers to colour my morning.

Ahead of me on the trail was an animal, walking slightly awkwardly, like a horse with a limp. Was it a deer? It was a big one if it was. In the Grampians this would have been a proud stag, but as I got closer I realised it was a bull moose with a mighty set of antlers. Often these guys have a bad temper to match, especially in the company of a female, so I slowed to a

walk and remained a couple of hundred metres to its rear as he loped slowly along. He paused every twenty or so steps to look back and check on this strange potential predator. Silently, I debated whether there was any way around the big fella, until a cyclist came steaming around a blind corner in the other direction. He slammed his brakes on, just in front of the danger end.

Instead of tackling the cyclist, the moose turned round in blind panic and stampeded towards me. Moose are known to have bad eyesight and the best thing you can do in this situation is to hide behind a substantial tree, but the only one nearby was completely blocked off by Rob-proof thorn bushes. I reached for the bear spray, which worked equally well on anything with eyes and a nose, but realised I'd left it in the cabin that morning. By now he'd eaten up three-quarters of the distance between us in ten seconds, showing no sign of stopping. I leapt to the front of the tree, the least thorny side, and reverse hugged it, screwing up my face in anticipation …

I don't remember closing my eyes and certainly don't know what purpose it would have served, but I remember opening one when I heard a crash of branches and leaves to see the rear end of half a ton of moose exit, trail left, to the safety of the banks of the stream. I heard another sound to my right, and realised I was barely ten metres from his female friend, who was looking at me with soft, unconcerned eyes. No wonder he'd panicked. I don't think I'd ever felt so alive.

As my nerves returned to normal that morning, I thought about my near miss and how important it was for me to be there for Nadine and our baby, who was now the size of a kidney bean. I didn't feel I would be the best judge of a girl's name so had suggested that side of the job would be Nadine's, but I'd claimed responsibility for the naming if Bean was a boy. Maybe inspired by the Scottish-esque scenery or by my Scottish-born

granddad, I thought Alexander Douglas sounded very noble indeed and steeled myself for the inevitable battle of wills with Nadine. She'd staked her claim to naming Bean regardless of gender.

Meanwhile, the Proclaimers continued their serenade on the Coeur d'Alenes with 'Sunshine on Leith'. I'd heard this song before in passing without paying too much attention, but right now, in this place, I thought it was the greatest thing I'd ever heard in my life and played it several times in a row. As if some higher power were watching and wanted to emphasise the fact, a bald eagle swooped over Springston Bridge to my right. Okay, Idaho, I got it. You were special.

When I was reunited with Nadine later, I asked her, 'Do you know "Sunshine on Leith" by the Proclaimers? I was listening to it when I was on the trail and it just did something to me. I listened to it on repeat for about half an hour.'

She looked at me in surprise. 'That's so strange. I've been thinking that if we have a boy, that's what I want to name him. Leith.'

I loved it and mentioned that this had all transpired while I was thinking of names. 'I'd been thinking of Alexander Douglas,' I said, bracing for the response.

'No.' Her expression was clear this time. Then she tried to meet me halfway. 'Maybe Douglas as a middle name.'

Douglas was my granddad's name. I was fine with Leith Douglas. 'Right-o. And if it's a girl?'

She gave a one-word answer: 'Bee.'

'Riiiiiight.'

Chapter 38

BURNING

Oregon and Washington
Days 256–63
318.87 miles

We were now in a state where the ocean formed a border, and thoughts began to focus on where exactly I would finish a third crossing. No one knows where Forrest made turn number three, as it's not addressed in the movie, but, judging by our map that we already had to deviate from to get to Glacier, it was probably somewhere in South Oregon, after which he stayed on or near the coast, to roughly San Francisco. As I made my way west, I could at least entertain myself by checking out beach locations between here and there like an excited holidaymaker thumbing through the brochures.

The sun rose around the back of a corn silo, with the light reflecting off the tracks giving the appearance of the train to end all trains coming around the corner. No trains, or anything else for that matter, came past for what seemed an age, as I wondered if I'd missed some sort of apocalypse overnight. It seemed as though the whole county were having a siesta.

The town of Washtucna was deserted, with one bar still open and all the stores closed, which made my heart sink in the usual

manner. The Evergreen State appeared to be playing tricks with me, as it looked more like a remake of *Lawrence of Arabia*, the harvested fields on the hills aping the giant dunes of the Sahara. It was certainly more Tatooine than the Endor I'd expected.

I was starting to become encouraged by the fact that I wasn't fazed by what might seem monotonous to some. I'm happy to be on a treadmill for a few hours at home, as long as I have something to listen to, and I'd survived the plains of North Dakota and Montana, so a few days of this was just fine.

It was 3 September, a special day for us – our seventh anniversary. It was also the fifteenth anniversary of my mum's passing, which always makes it a bittersweet celebration. We decided on a romantic dinner that evening when we reached Oregon Trail RV Park, overlooking the Columbia River. To earn it, I had some solid climbing awaiting, once we'd left the town of Pasco, which housed a truly incredible men's boutique where the gold lamé shirts, paint-speckled trousers and rawhide boots in the window told me that when Pasco partied for real, it would be a sight to behold. I made a mental note to return for the Cinco de Mayo with a credit card and a lack of self-awareness.

Up a stiff gradient, I sweated my way to Oregon, which was just as parched looking as Washington. We readied ourselves for our romantic dinner, but it transpired that the local restaurant with the best reviews doubled as a strip joint. A candlelit dinner there might not have been overly appreciated, so dinner was microwave burritos and instant mash Chez Jenny, which was still as romantic as we needed it to be.

Oregon is one of those sensible states that allow pedestrians and bicycles on the interstate system outside of the big cities, and I planned to take another day and a half to the Dalles, where I'd

switch to the more scenic Historic Columbia River Highway and into Portland.

I had steep banks to my left, obscuring my view south into Oregon, so most of the day's viewing was across the Columbia River over to Washington. The unusual calm was enhanced by the return of a familiar ominous haze in the air. Two days previously, a fifteen-year-old had let off some fireworks further down the river in Cascade Locks, not far from Portland, and started a forest fire covering 50,000 acres. The fire was eighty miles ahead of us, yet there was so much smoke I could stare at the sun directly without the aid of sunglasses. Eventually, it was a struggle to make out the far bank, which was only a hundred metres away.

There was an immediate danger that my original route would head straight into a wildfire. We held a hushed, urgent conference in a McDonald's. I couldn't yet detect the smell of the smoke, but the air quality had to be a worry, especially as I was sucking more gallons in per hour than the average bear. My only real option was to proceed until told otherwise, though it looked as though the Columbia Highway was going to be out of the question. Surely they wouldn't close the interstate, though? The decider was likely going to be if we could breathe or not, so we called it a day and decided to make a call on it in the morning.

As we progressed through the morning, the sun over my shoulder looked more like the moon than its usual self, and with every mile the smell of smoke was more noticeable. By lunchtime we had reached the Dalles and had a big decision to make about my route. I presumed the fire would be under control, but Nads and I read reports that it was stepping up a gear and some areas of the interstate had been closed due to heavy smoke. I'd already been running with a Buff (a sort of fabric snood) over my face, soaked with water to try to filter out the worst of the smoke. I'd

been okay, but there was no way I could expected Nadine to be fine with us heading towards an active forest fire.

It seemed the small volume of traffic that was still out on the road was crossing the Dalles Bridge over to Washington, so we decided to follow. The bridge sign said 'Oregon Thanks You. Please Come Again' and I had a lump in my throat as I crossed my fingers. Nineteenth-century explorers Lewis and Clark appeared on another sign, pointing that the ocean was leftwards, so left it was on a road that banned big trucks and, seeing as they seemed to be the only people wanting to drive today, it made for a quiet afternoon.

The river seemed to be a handy barrier for the smoke, with the air being a lot cleaner to my nose, though the Buff was still required and the smoke was so thick, Oregon may as well have not been there on the other side. By the end of my first run on 6 September I'd passed the area of the smoke, which was an incredible relief. Not only that, but towards the end of yesterday we'd started a transition to the forest lands, even though this had almost been unnoticed as the uneasy feeling of the previous few days was all-pervading. Being in the Pacific North West was a huge thing for me and even more so for Nadine, so where was the elation? I couldn't shake the feeling that we were trespassing in someone's grief, and to be 'going for a run', whatever my motives, felt flippant, even ignorant.

Nowhere was the impotence of man in the face of nature as evident as when I reached the Bridge of the Gods back over into Cascade Locks, where the fire had started. The fire had spread many miles to the east and the smoke was being blown east too, so the air was clear enough here to see the rising smoke flumes and the odd lick of flame visible in the trees beyond the far bank. Chinook helicopters dumped thousands of gallons of water from the river into the forest over and over again. From this distance,

it looked as though it may as well have been a teaspoon's worth, and it was clear that the name of the game was not extinguishing the blaze, but desperately trying to stop it getting worse. I was glad that I'd seen it during the day, as I imagine at night it would have been terrifying.

Having recently been so wonderfully exposed to the wildlife of the north, my heart hurt for the animals affected by the calamity. I wished I didn't give a shit. My emotions were normally on a swinging scale of extremes, with the middle ground being visited less frequently as I went on. It's going to be harder and harder for people to ignore wildfires such as this, despite claims from the most ardent deniers of climate change. To not make our own changes would be a dereliction of duty to ourselves, our children and the world's animals. I told myself that having faith in the ability to shape the future is paramount, whether that was solving the greatest of all problems or just getting to the end of the day safely. The latter was something that I could control, so I set about doing just that.

Within a few miles I'd climbed the Cape Horn overlook, where the tree-lined river valley looked as green as ever. Nads gave me a huge hug. Maybe she realised how torn up I was inside. I slowly rehabilitated my mood on the way into Washougal, on the outskirts of Portland. I'd cross the Columbia for the final time tomorrow and head south, across Oregon and towards the ocean in California. With a bit of luck, perhaps I'd pass some rain clouds on their way east to save the day in the Cascades.

Chapter 39

THE PREFONTAINE PILGRIMAGE

Oregon, California
Days 264–83
335.77, 425.64 miles

Jenny watch: 2 days in a repair centre (thanks for
the loan of the sporty red convertible, Jay!)
Injury watch: Piriformis syndrome, a troublesome
condition caused by overly tense muscles in the
gluteal area – literally a pain in the arse

It was a bittersweet re-entry into Oregon. It would have been my mum's sixty-fourth birthday today. I thought every day about her advice – 'do one thing in your life that makes a difference' – and I would celebrate her birthday by trying to do what she'd asked.

Over the Glenn L. Jackson Memorial Bridge and I was into the city of Portland. It was a place that had changed from a vicious old port city to a melting pot of cultures and counter-culture, known for its indie music scene, healthy sporting lifestyle yet multitude of breweries, and for being one of the most environmentally conscious areas in the United States. It was my kind of town. At the end of a brief and leisurely running day, Nadine and I took a rare side trip to stroll around the Nike Campus and

make a pilgrimage to one of America's athletic greats, Steve Roland Prefontaine, or 'Pre' for short. Tragically killed in 1975, only a year after his Olympic début, he held all of the US distance track records at one point and had a charisma that would have elevated him alongside the likes of Usain Bolt today.

My exodus from Portland sadly showed me again that nowhere is perfect. I was flanked by tents and makeshift shelters, and I saw the extent of the homelessness problem in the city. It was as bad as anything I'd seen, barring Los Angeles. Averting my eyes as I passed a gothic-looking lady, naked apart from her lower-half underwear, a pair of leather boots and a thousand-mile stare, it appeared that the demographic was a little different, with many of them the victim of Portland's own post-recession success. There were a lot of initiatives underway to alleviate the problem, and many people were building 'tiny houses' in their yards for a hopefully mutually beneficial and rewarding experience, but it was feared that such generosity might take pressure away from city authorities to provide affordable housing.

'Where Am I?' was scrawled in chalk on the path near a house whose front yard resembled a hobbit's, with used-tyre plant pots and satellite-dish flower beds. Four brightly coloured Buddha figures on the huge mural nearby cheered my passing, and as my exit from Portland was all but complete, a broken wooden sign, now laid out on the floor, read: 'We're so glad you're here'.

I got re-acquainted with the freeways of Oregon after Gervais, with the I-5 taking me south towards Salem and a diversion I couldn't pass up, to Forrest Gump Lane Southeast, the only road in the world named after the man himself.

The next stop in the footsteps of a legend was Eugene, home of the University of Oregon and so famed for the exploits of its runners and coaches, it's also known as Tracktown, USA. I found my way onto 'Pre's Trail' – winding through the woods outside

Eugene, with a few speedy runners haring round in the light of the sunset, before I'd complete an 800 in tribute to the great man on the famed Hayward Field track.

In the morning I headed to Skyline Boulevard for the most poignant moment of the day. Pre's Rock was the spot where he crashed his car and lost his life. It was a beautiful granite memorial adorned with running vests, medals, running shoes and other tributes, my favourite of which was a chain of Buddhist prayer flags, which I imagined fluttering on some mountain top in Tibet and seemed to capture his free spirit perfectly. 'Pre. For your dedication and loyalty to your principles and beliefs. For your love, warmth and friendship. For your family and friends. You are missed by so many and you will never be forgotten.'

Forrest's threepeat seemed to end in southern Oregon/northern California, so I had my eye on a little place south of Coos Bay, called Bandon, that was within range of an arrival before 2 p.m. on the 15th, which would be three crossings of the USA in a single year. I hoped Forrest would approve of my choice. Forrest appeared to head down to the Bay area too, so that route would give me a week or two to think about the future of the run, our finances and how the pregnancy would affect our plans.

Financially, only the upcoming finish in San Francisco was guaranteed. After that, everything was still up in the air. I'd created a GoFundMe page after Nadine first went home through lack of money, and friends had asked me how they could personally help me. But I had been loath to promote or mention it on social media – until I was up against it, and only then with a feeling of immense guilt. Appealing for money might have made my life easier, but it just wasn't me.

Steam was rising from the Siuslaw River, whose dark surface reflected the bushes overhanging the banks, the trees on the nearby hillside and the near-cloudless sky, making it look more

like an infinity pool snaking into the distance than a river. When I began to smell the salt on the wind, my heart rate went through the roof with excitement. I now found myself in Florence, an 'official Coast Guard City', complete with sculptures of seals, and this time the bridge over the Siuslaw afforded a view of sand dunes that just about masked the big blue beyond. There, I reached the junction with Highway 101, the road that would take me to my ocean point at Coos Bay and then pretty much all the way south to the Golden Gate Bridge.

A truly sublime day of running was capped off when I opened an email from the staff of Peace Direct to see that they'd sent a video from their patron, Mark Rylance, not only the star of *Dunkirk*, which we'd seen in Fargo, but also an Oscar winner for his role in *Bridge of Spies* alongside none other than Tom Hanks. His personal message of support was the sort of thing that made it all feel worthwhile. My reasons for continuing were to create something special for Peace Direct and the WWF, and this helped me move my focus away from the personal, athletic nature of the challenge and redouble my efforts as a charity campaigner.

It was September, but in this area the fallout from last year's November election showed no sign of abating over the news networks. Certainly, one RV park owner was a Trump fan, as made evident by the intricate carving of his name in a fallen log at the entrance to his establishment. If he'd lived a little further south, the size of the trees there would probably have allowed him to carve the whole Second Amendment in place. I wondered if weary Democrats were prepared to bite their tongue as they handed over their cash in return for a 30 amp hook-up and a hot shower on the way to North Bend.

My entrance to the town of Coos Bay came towards the end of a beautiful day on the Oregon Coastal Highway flanked by forest to my left and sand dunes to the right. It was also part of

my Pre Pilgrimage, being Steve's birthplace and where he first started to show his incredible talent. Every year, there was a huge open memorial race and it just happened to be scheduled for the day after I planned to complete my third crossing. I'd emailed the committee about attending and the fact that, although I was seeking coverage, I didn't want to draw any fanfare away from the event. I received a rapid reply from Steve Delgado, head coach of the Prefontaine Track Club and the Marshfield High Cross-Country team, aka the Pirates: 'No problem at all with you speaking to the press. Would you like to run in the race?'

I wasn't sure if running a 10k would be in my best interests. I wouldn't be able to stop myself from making it a race, as I have a nasty case of start gun fever, and such things usually led to injuries. Naturally, my response to him was, 'I'd love to!'

Steve Delgado's hospitality didn't end there. He arranged for the Mill Casino to give us what turned out to be the best hotel room we'd stay in for the whole trip, for a local garage to fit Jenny in for a service and, most excitingly of all, he invited us to the dedication of a huge and incredible mural depicting Pre, taking up the side of two buildings on South Broadway. Here, I also had the honour of meeting Jay Farr, a childhood friend and teammate of Pre, and owner of a wondrously well-kept moustache, and Linda Prefontaine, Pre's sister. I found it humbling that they were so excited to have me attend, but I think it's just a runner's thing. Pre was famous for a lot of things, but his never-say-die attitude ensured that he probably transcended even his own mighty talent. This quote sums that up: 'To give anything less than your best is to sacrifice the gift.'

The final introduction was with Johnny 'Wildhorse' Truax. He had earned his nickname by designing the Wildhorse trail shoe as part of his role in the technical department of Nike. And lo and behold, Johnny had brought me two shoeboxes: one contain-

ing a pair of very sexy silver Pegasus and the other a pair of his own Wildhorse babies. The former would get pressed into service immediately, while there would be muckier paths ahead to tread in the Wildhorses.

'Why haven't we heard of you at HQ?' he asked.

'You know how it goes,' I replied with a wry smile. I'd written a couple of messages to people at Nike, asking about sponsorship before and during the run, especially when money got tight and replacement shoes were starting to make a serious dent in the budget. Somehow, I'd managed to blag my way into a meeting before the run and received a very kind donation of kit from Ruth Hooper of Nike UK. Since then, my ability to attract any attention from Nike – from anyone – had been unsuccessful.

'Don't worry,' he said. 'I'll speak to someone.'

It was some day. Unbelievably, there was still room for it to get better. When Nadine and I relaxed in luxury in our casino hotel room, my total mileage read 9,563 miles. Divided by 365, it gave a figure of 26.2 – the marathon distance – which meant that in less than a year I'd managed to run 365 marathons. With the enforced lay-off to dance the visa tango twice, it meant I'd done it in just 269 days of running.

I stepped out into the September sunshine to finish my third leg in Southwest Oregon. Today I would reach the ocean once more. I'd chosen 'Nothing's Gonna Stop Us Now' by Starship as my Tune of the Day. Having survived the northern extremes of the country, running through blistering heat, charging moose, indifferent bears, carnivorous mosquitoes and noxious forest fires, what could stop me now? Roll on, Pacific Ocean.

Any semblance of cool evaporated into the morning mist as I tripped on an uneven kerbstone and went down hard on my

right hip. As if that wasn't enough, a few minutes later I was flagged down by an Oregon State Trooper, who looked all business and no pleasure. I'd heard tales of the officious West Coast highway patrols, so I was expecting the worst. I put on my most smiley of faces and greeted him as if running down a busy highway was the most regular thing going.

'Are you the guy who's been running all over the state?' he asked, looking me up and down.

I put on my best, most friendly, innocent British accent. 'That's probably me, I'd guess …'

He broke out into a smile. 'Do you mind if I grab a photo for our Facebook page?'

And so through the beautiful Bandon Marshes Wildlife Refuge into Bandon itself, the entrance marked by an arch not dissimilar to the one that greets your first steps onto Santa Monica Pier. I realised something remarkable was a matter of minutes away.

I didn't enjoy the 139 steps of the wooden staircase down to the beach, with my recent fall and general hip niggles lingering, but I made my way down to the sand, past a smiling Nadine and over a driftwood bridge to the ocean. There was the Pacific once more.

Grinning from ear to ear, I took off the Cortez and ran into the surf with Nadine following closely behind. I hadn't been brave enough to immerse myself 4,000 miles previously in Maine, but I did it here. I felt exhausted and elated all at once, and not even the freezing-cold water could dampen my spirits. I dipped the amulet containing water from the California Pacific and the Northern Atlantic into the brine and turned around, to face east, once more, brandishing a new sign made by Nadine: 'I ran clear to the ocean, again … and again. Three crossings in one year – how many more times?'

All the finishes had been great: a mini-party at the end of the first, the magical lighthouse moment in the fog with Jamie in

Maine, but it felt extra special to experience a finish with just Nadine, particularly after our recent news. I found it hard to fathom how I'd managed to get to this point. It was a year to the day of putting rubber to pavement and, as far as I could work out, I had become the first person to cross this vast land on foot three times in a year. Nads and I shared the end of a road. She deserved an exclusive.

I had one final thing left to do before I said goodbye to Oregon: complete that memorial 10k, and with it the Pre Pilgrimage. My fellow competitors included local hotshots, regular townsfolk, fellow pilgrims, serving soldiers and high school runners. At the front of the field I talked to a shirtless Sawyer Heckard, devoid of body fat and fast as a viper. He was aiming for the win and to break thirty-two minutes. Ambitious. I started maybe fifty or so rows back and on the gun gradually got into turning my legs over. I made encouraging progress through the field, cheered on by the crowd as I struggled with the pace and the gradient. The heat was on. I put the hammer down, reaching 4:44 pace and, to my astonishment, crossed the line first. As Linda Prefontaine handed me a hand-carved plaque I discovered I was State Champion. I'd become Australian Champion without being Australian, and now I was the Oregon Champion without being from the state. A running cuckoo.

Now I needed to get the 700 or so miles to San Francisco, past the 10,000 mile marker and through the giant redwoods, where the shade would hopefully give me a cool head to decide just exactly what to do when I got there. I was flat broke, starting to hurt pretty bad and now, I was an expectant father. Nadine was heading home. Maybe it was time for me to hang up my shoes for a while, maybe for good.

LEG 4

1 October–17 December 2017

California, Nevada, Utah, Wyoming, Colorado,
Nebraska, Kansas, Missouri, Illinois, Kentucky,
Tennessee, North Carolina, South Carolina

3,140.77 miles

Chapter 40

INSPIRATION POINT

California
Days 284–89
213.14 miles

The fourth leg. The middle child of the run. I'd viewed this leg with
a degree of trepidation and not planned it in much detail, as I had
no idea whether I'd make it this far or at what time of the year. I
wanted to make sure that this leg took me up Grandfather Mountain
in North Carolina, but the rest of the route was not governed by
Forrest Gump landmarks, so I had only a vague route to the
Mississippi and would be making it during the onset of winter.

Nads was heading home. It was tempting to think I'd had a
decent run and that I could call time then and there and go back
with her, even as I started to pack for the trip ahead. We said a
ceremonial goodbye to San Francisco at Jack London Square,
which we'd chosen for its resemblance to the Santa Monica Pier
area. Jack London was the San Franciscan author and animal
activist who had scribed two of my favourite childhood books,
The Call of the Wild and *White Fang*. He had provided me with
my first experiences of the American wilderness and was respon-
sible in part for instilling that sense of wonder and magic in me
about the great land.

Nads promised me that she'd be just fine for the time being, and I told her that if she weren't, I'd be on the first plane back. There was no question I'd be heading home for the birth, but if she needed me during her pregnancy I was ready to cancel everything and come back to her at the drop of a hat. She kept telling me she'd hate to be the reason for doing that, but I didn't care – she came first. It was a traumatic goodbye for both of us. Running away from the love of my life the first time had been hard. This time she was several months' pregnant and refusing to let it get in the way of my goal. I would worry about her every day until I saw her again.

An amazing piece of luck was coming my way. Olivia had come to town – our friend who had accompanied us through California last time. She'd been completing her PhD and had offered to take over from Nads. I don't think Nads would be shy in admitting that she was glad to see the back of her driving responsibilities, and I was ecstatic that somebody else was willing to fill the position.

The city streets of Oakland gave way to Skyline Boulevard, where I questioned the decision-making process of the presumably highly intelligent mega-rich who had elected to build their multi-million dollar homes on stilts on the precipitously sloped hills of this notoriously earthquake-prone region. This area was also where Tom Hanks went to school, but my flat-lander legs had cried 'No more!' in the heat and harsh gradients of the San Francisco hills, vetoing any sight-seeing detours.

At the top of the ascent, I took one last look at the ocean, probably for a long time, and a magnificent three-bridge view of the bay. Somewhere down there, Nadine was heading home to a huge challenge on her own.

An excessive number of signs warned that the road ahead was closed. I'll be the judge of that, was my verdict. And even when

three cyclists drew level with me and told me the road had gone, I pushed on. Road cyclists aren't prone to hyperbole, whether it was gradients or distances, and when they'd told me the road had 'gone', it had: the bridge across the Moraga Creek had been demolished.

I reached the end of my run for the day to see Jenny parked near Isleton Bridge, some forty miles east of San Francisco. For someone who used to break in wild Mustang horses as well as drive a huge horse trailer, driving Jenny wasn't going to be a problem for Olivia. She had sailed serenely through the day, making my ham and Catalina dressing sandwiches to perfection and having the recovery shake chilled and ready as I headed in the door.

Things weren't as smooth in Rancho Murieta, where first we were moved on from our spot for the night by a security guard, before being tailgated by a guy for a couple of miles, who eventually informed us that we had broken brake lights.

I set off down a serenely quiet dirt road towards Kingsville and down Memory Lane – the name of the road, though memories of my time in Australia were rekindled by the already baking heat, the dust kicking up from my heels and the presence of a real-life emu in someone's oversized front yard.

I started along the remnants of the Pony Express through Eldorado County, and received immediate warmth from the locals of Sacramento at a daytime rest stop, who refused to let me leave before they'd badgered everybody in their bar to throw in a dollar or two. I passed the pretty goldrush town of Placerville, aka Old Dry Diggins and, more gruesomely, Hangtown, due to the number of hangings that took place at the Hangman's Tree, where Willie, a controversial mannequin, still swings from the hangman's noose to this day.

One of my key inspirations for starting this whole crazy journey was the account of his own trans-con by Nick Baldock. Of

all the awe-inspiring sights he'd written about, the one I remembered most was coming up – the incredible light in the Eldorado National Forest area. I set out on what would prove to be a day of almost constant climbing on the sharp inclines of the Sierra Nevada, which I'd inflated to Himalayan proportions in my dreams. We rose from 3,000 to over 7,000 feet in the space of around twenty miles. Our bags of chips swelled into taut balloons as the air got thinner. I followed the curves of the mountains before climbing to the peak of Echo Summit to see Lake Tahoe, straddling the border with Nevada, less than ten miles away. Right then, I understood exactly what Nick was talking about. The deep blue waters were framed by the high peaks in the distance and an endless expanse of pines before the nearest shore. The light was incredibly intense but soft at the same time, and so blue. Everything had an air of freshness about it.

The state line intersects Tahoe, so I continued around the lake to enter Nevada. Whereas on the Californian side of the line you would find understated log-built and decidedly low-fi Californian dwellings, crossing over into the Silver State led you to the glass high-rises of what appeared to be a mini-Vegas. A particularly palatial mansion on the lakeshore had the biggest Halloween display I'd ever seen, with fifty huge inflatables flanking the gates and a sign for the Bates Motel hung askew on the wall. I know Americans love their Halloween, but it was only 5 October.

All good things come to an end, though. I turned off from the lake up to Spooner Summit at 7,129ft and the zenith of my Sierra. I looked behind me to see the lake was long gone. Soon, the trees became thinner on the ground and the air less crisp and forgiving. The earth took on a dusty hue and the mountains in the distance looked bare. My final gift was unwrapped over an hour-long, eight-mile, thousand-metre descent. I was back in the desert. My new spiritual home.

Chapter 41

ONLY THE LONELY

Nevada
Days 290–300
444.79 miles

I entered a state in mourning. Five days before, fifty-nine people had been killed and hundreds injured by a gunman in Las Vegas, and every flag was flying at half-mast from Stateline through to Carson City, the state capital. A few hundred miles away in Vegas, apparently, it was business as usual for most of the Entertainment Capital of the World. Never had the nickname Sin City seemed so appropriate, with billboards still advertising the opportunity to shoot a fifty-calibre machine gun for twenty-nine bucks.

I would have plenty of time to debate that on Highway 50 again, dubbed 'The Loneliest Road in America'. Despite the splendour of the alpine paradise we'd left behind, it felt more 'real' in the desert to me, more closely aligned to the image I had in my mind of running across the States. The signs on the road warned of wild mustangs roaming the desert. The mercury rose on what was probably going to be the hottest day remaining until deep into next year. I put on my sunglasses, turned up the volume on some Jerry Lee Lewis and pushed down on the

throttle, *Top Gun* style. Highway 50 was indeed the highway to the danger zone, as the US Navy's elite fighter academy made famous by Tom Cruise and Val Kilmer had moved from Miramar air base to Fallon, not far from here.

My legs were having one of those leaden days and my new requirement for a forty-five-mile average seemed daunting right now. Liv was coming down with a cold and was in a very prickly mood. Though very firm friends, we're known in our circle as the pair most likely to start an argument in an empty room. The two of us rubbing each other up the wrong way was a low-grade source of anxiety for me, and I'm sure it was the same for Liv.

I was surprised it took eight days for the first argument, sparked inevitably by Jenny, who was arguably in the worst health of all, as her batteries were dead again this morning. We got her started again, but this power drain would be an ongoing problem. This was going to be a headache. I could feel it. A misinterpretation of time scales for the day and the urgency of finding an auto electrician led to a fairly one-sided argument over lunch. We'd had tons of arguments not dissimilar to this before and they were never an issue, but Liv's distress weighed heavily on me. I was already in a tough place, and I was concerned about a bad atmosphere in the van making it worse.

A sunset that highlighted the magic of the surroundings intervened later. Salt flats stretched into the distance in the Mad Max landscape on the approach to Sand Mountain, which, perhaps unsurprisingly, is a huge sand dune some two miles long and 200 metres high. The wind whistles here as it blows through the only home of the critically endangered sand mountain blue butterfly. Unfortunately, it was also playing host to numerous dune buggies rampaging across its surface, creating general havoc and drowning out the singing of the sand dunes with their whining engines. Mad Max it was, then.

Peace had broken out within Jenny's all too thin walls. Liv (who had now adopted the radio callsign 'Blue Butterfly') and I agreed that it was too risky to carry on to the next smaller town, so we drove back to Fallon in the morning to sort Jenny's electrical issues.

In a fast-food restaurant, a group of older gents, wrinkled and deeply tanned under their trucker caps and moustaches, sat nearby over morning coffee in a manner that suggested they'd been here every day since they first clocked on at work. They heard my accent, started up a conversation and recommended a local garage. Then one of them asked: 'Hey, whaddya think of Trump?'

'Erm … he's a pretty interesting character,' I replied, never sure how to answer this supremely loaded question. Of course, no matter what you thought about him, he'd just be happy that you were thinking about him. He was often the biggest show in town on whatever news channels Jenny could pick up.

'He is THE MAN,' he replied.

'He's an idiot,' interjected one of his companions.

The whole conversation was very civil, in contrast to the way the media portrayed the divide, and I was sure they'd be back the next day to debate the latest developments over another brew.

Two hours, three garages and a painful $200 dollars later, Liv and I were on the road. Nads later sent a message to me: 'I'm just surprised it took you all of eight days to have your first fight!' She obviously knew us too well. Olivia and I had to laugh.

A sign to my right, peppered with gunshot, showed the way to Rawhide, while to the left the sign to the sinister-sounding Navy Centroid Facility had taken similar punishment. It was quite difficult to find a road sign that no one had shot at.

It was another fantastic day on the trail of the Pony Express, where I learned that despite being so well-known it had only existed for eighteen months before the telegraph wires made it at once redundant and romantically immortalised. There were tales of fearless young riders including Buffalo Bill Cody, racing station to station, crossing the country in less than eight days on a good run, battling against brutal weather and the danger of ambush.

My original plan had been to head more or less directly east through central Nevada, Utah, Colorado and over the Coloradan Rockies into Denver. But with heavy snow forecast for the next three weeks, I didn't fancy Jenny's chances on the high mountain roads in the Rockies (nor mine, to be honest). That meant making a hundred-mile diversion north to find an easier path and lower altitude via northern Utah into Wyoming, skipping Denver altogether. It made sense to make that diversion here in Nevada, on better terrain.

It was damn cold, expected to get as low as −10°C overnight. I didn't think I'd ever run in temperatures as cold as the −6°C of the morning. Since my first injury way back in Texas, I'd been walking the first mile of every day to practise a bit of self-care, but the cold meant I was desperate to get running as soon as possible. As soon as the sun got its act into gear, my spirits rose with the temperature.

I saw in the distance that Liv had found a good spot and, what's more, she had some company. But as I approached I could see she was wearing a pained expression and standing with her arms folded, talking to two strangers, by a car that was parked at a strange angle. The car's right front wheel was massively buckled and the wheel arch was in tatters.

'Is everyone okay?' I asked.

Liv nodded.

'Jenny?'

I approached Jenny on the right side and she looked fine to me. But when I walked round to the front, where a second car was parked, I could see Jenny was missing her fender and there was extensive damage to the left wheel arch and driver's door. I peered underneath and saw that the steering rod was snapped and, though the inner workings of vehicles aren't my strong suit, I was pretty sure that 'things' were bent underneath.

I took a deep breath, composed myself and returned to Liv and her two new companions, who had got out of the second car. It was then that I realised the driver of the first was still in the driver's seat. 'Oh my God, is he okay?'

The guy in question was a very elderly gentleman bleeding slightly from a forehead wound and mumbling incomprehensibly, clearly hugely shaken up. But he was conscious, his breathing was okay and he wasn't trapped. A 911 call had been made so it was time for the inquest.

Liv had travelled a good fifteen miles down the road and reached this dirt road turning – a good place to park up and prepare breakfast. She'd noticed a car approaching at a rate of knots behind, so got the blinkers on to let the driver know in no uncertain terms that there would be a turn coming up on this nigh-on deserted road. Soon, he was tailgating and out of sight from all of Jenny's mirrors. Assuming that he'd got the message by not overtaking, Liv slowed down to prepare to take the turn. It was at this moment that he decided to overtake, and slammed into Jenny's front left corner, careening off into a ditch. Somehow, Liv had managed to prevent Jenny from flipping over and had incredibly regained control, with one wheel blowing in the wind, and come to a stop in a perfect parking spot.

The police, fire truck and ambulance arrived and tended to the driver, who was going to be okay, thankfully, and they took our stories. Later, they'd tell us that he had been rushing to get to

Vegas for the week. His son would tell the breakdown truck driver later that he'd begged his nonagenarian father to give up driving recently, but his pleas had fallen on deaf ears, with the desire for one last Vegas blowout almost proving to be one gamble too far.

Jenny was not going to be okay. The breakdown drivers weren't sure she could be repaired, and certainly not in Ely. Vegas or Salt Lake City were the only possible destinations for such heavy lifting work, so in the meantime, while we waited on the insurance verdict, we would be heading back to Ely and maybe an opportunity to put everything on red at the Nevada Hotel. That was before Liv intervened.

'You should carry on,' she said.

I couldn't do that. It wasn't fair. I'd been involved in a couple of road accidents before, so I knew that they were real pains to deal with. I couldn't leave Olivia to do that on her own. She, however, was having none of it.

'There's nothing you won't be able to do over the phone, and to be honest, Rob, I'm not sure I fancy being holed up in a hotel with you for a week, bouncing off the walls, because you want to be out running. It'll work itself out.'

I was massively conflicted. If I went back to Ely with her, I'd have no chance of getting to the ocean in time, plus a higher chance of getting nailed up north with bad weather. On the other hand, I felt terrible abandoning my friend to handle this alone. I was also completely unprepared for a solo stint – Pramsolo was stowed away and I had no solo supplies for what would be the most challenging logistical months of the whole trip. I'd expected Liv to be providing my support for the next month or so, until the middle of November.

Two hours later, Jenny was hanging off the back of a tow truck. With Liv's reassurances that the situation was in hand, I

assembled Pramsolo and loaded a hastily put-together bag, including much more in the way of hats, gloves and long-sleeves, as well as a pair of Bubba Gump baby booties, with a pea pod on one and a carrot on the other. They went well together. They would be my totem for whenever I thought of home.

I couldn't help but feel incredibly guilty about Liv's staggeringly selfless gesture. The beautiful weather, scenery and even road conditions did their best to cheer me up and tell me I'd done, if not the 'right' thing, then the *permitted* thing, with a noble aim.

I ran until sunset, and then sat by the side of the road with noodles and chilli, surrounded by desert mountains and wearing a new long-sleeved top I'd just found at the side of the road, which was a perfect fit and perfectly clean. As the temperature fell sharply, it would come in handy. I pitched my tent and, after what seemed like an age, I was able to stop my mind racing for long enough to fall into some sort of a sleep, until I was woken by the sound of a car door closing. It was a quarter to five in the morning and still dark. Surely someone couldn't have seen my green tent from the road? But then I was hardly in deep cover.

Footsteps became audible and grew louder. I fumbled around in the dark for my knife, just in case, but found only a couple of tent pegs, which I gripped tightly in my hands while I quietly unzipped my sleeping bag. The footsteps stopped. After a moment they resumed, and this time they got quieter. A minute later the car door opened and shut. I heard the engine start and the crackle of stones under rubber, and then they were gone.

Nadine texted me to report that the baby was healthy, as far as they could tell, and due to the wonders of genetic technology we were now 100 per cent certain that we were having a baby girl. A little Bee. After my initial surprise at Nadine's suggested name, I'd quickly come round to it. We were going to have a

baby Bee. Nobody was there to see my beaming smile, but it could have lit up the whole Nevada desert.

I started very early, to continue the good work of yesterday's near-double marathon, despite the huge chunk of time lost. The rising sun cast a perfect shadow of my running form, which was looking a little crooked these days, and Pramsolo, rising from the beautiful salt flats that hinted at what was to come over the border. A short day brought me finally to Wendover, a city that straddled the Nevada–Utah border. Frank, the guy who'd stopped by the crash site to help Olivia, had messaged me to say he'd arranged and paid for a room at the Wendover Nugget, the glitzy casino that afforded a last spin of the roulette wheel before the slightly more sober state of Utah.

When I visited the post office, the clerk reached for two items before I'd even spoken. 'I guessed these would be for you,' she said with a smile. The first was extremely welcome, a diverse winter-weather running pack from Nike, courtesy of Johnny 'Wildhorse' Truax, my Oregon fairy godfather, including an extra coat, leggings, warm socks and some shirts. The second was Jenny's registration, all the way from Aubrey, Texas, as requested by the insurance company, which brought my mind back to Liv and Jenny in Ely. Liv was shaken up and nursing a bad back and the developing bruises, both physical and psychological, from the accident, as well as having to deal with the administrative fallout from it.

I would be in Utah in the morning. Nevada had been a rough couple of weeks, and I was glad to be moving on. I stocked up at the hotel's buffet, as this next stretch was going to be barren.

Chapter 42

UTAH SAINTS

Utah
Days 301–6
208.27 miles

I headed out of Wendover to the Bonneville Salt Flats, the dried-up remnants of ancient Lake Bonneville, which is so flat that not only can you see the curvature of the earth on the horizon, it is also used for many of the world's land-speed record attempts. A huge billboard celebrated the achievement of the all-electric Venturi car, which broke the speed record for an electric vehicle, hitting 341.1mph a week after I'd set off from Mobile. It had the speed, but at this point I still had the range advantage.

I doubt it would have managed the sixty-six miles from the truck stop out of town to the next sign of civilisation, another gas station, with almost certainly no charging points until you got to Salt Lake City. The warnings were there – a 'No Services Ahead' sign begged me to reconsider but I was prepared with a foot-long sub sandwich, the swag from the hotel buffet raid and twelve litres of water. I set off on the frontage road that flanked the I-80, with no intersections for another thirty-seven miles. This was not the place to miss your turning as you gazed out at the mirages. I encountered four vehicles on the frontage road,

and two of those were the same telecoms van, containing the only souls I'd see all day.

At the end of a good day's running the snow-white surface turned a milky blue as the horizon was ablaze. I pitched my tent behind some sand piles. The roadside signs warned of snakes and scorpions – a surefire recipe for unsweet dreams.

Liv messaged to let me know that the insurance company had decided to fully assess Jenny and would ferry both Jenny and Liv all the way from Ely to Salt Lake City the next day. It was quite a long way, as I recalled. In the morning I headed straight up the side of the Wasatch Mountains that cuddled Salt Lake City's eastern edge. By the time I reached Parley's Summit, there was snow on the ground. These bitter, freezing temperatures were now all the more frequent.

Jenny arrived at the repair shop. I was happy to see Liv again, considering the week she'd had. She was still struggling with a sore back. When I'd set off into the desert and left her with Jenny, I never anticipated that it would be me who'd have the easier time. With Jenny out of the picture, it meant Liv was going home some two or three weeks earlier than she'd planned, so the mood was muted between us. She was also clearly still upset by the whole experience.

I boarded Jenny. It was clear that she'd be in this repair shop for quite some time, so it was time for some proper organisation. I began the task of putting things I'd need to see again into boxes and bags. My chest tightened as I picked up item after item that took me back to a time and place – back to when Nads was here. The road atlas we'd use to tell each other the flower of the state we were in, or the population density of another (it was a wild ride on the road). Magdalena's album on CD. Bubba, the panda we rescued in Texas. I stuffed some clothes into black trash bags

and broke off. It felt eerily similar to when I was going through my mum's stuff after she died, and I couldn't handle it. I went to the bathroom, sat down on the toilet and cried. At first a little, then a whole river – enough to fill the Great Salt Lake. Who knows how awkward Olivia felt as she waited in the main living space. I pulled myself together and told her I'd have to deal with it later.

A night out was needed, to say goodbye to Liv before she headed back to Indiana and then the UK. By the time dinner was over any lingering tension seemed to have cleared. She was flying in the morning, and when I walked her back to her hotel room before her morning flight, I thanked her for everything and we wished each other well.

Forrest had served with distinction in Vietnam, and I'd heard on many occasions that this fictional character holds a special place in the heart of American servicepeople, especially those who served in Vietnam. So it was a special moment when I was flagged down by Jim Daley. He had been in the 9th Infantry Division in Vietnam, the same regiment that Forrest served in. He told me how much meaning the film had for him and his military friends, and that he had a whole heap of respect for what I was doing. He asked if I needed anything, to which I gave my stock reply of, 'Ah, I'm doing great. Thanks, though.' I should have asked if he had an RV and fancied an adventure. He refused to let me leave empty-handed, however, and he joined the small but very appreciated Benjamin Club. As with the other members who'd parted with a $100 bill, he refused to let me talk him out of it. I stopped short of giving him a salute and instead offered my heartfelt thanks and headed up the trail.

The idea of Wyoming, up next, was scaring the living daylights out of me and had for a while. I'd been so glad to have Liv for

this part – on my last crossing, North Dakota through Washington would have been unbearable without Nadine's support – but now winter was on its way, Liv was already on her way home and I was on my own. A gentle first run brought me up the 11,000-mile mark and a high five for anyone who was around – which was precisely nobody. Perhaps I was congratulated by the ghosts of those manning the fortifications of the Echo Canyon Breastworks, built by the Mormons in preparation for a war that never came – the best sort. I was truly solo now, and I found my rhythm on the beat of the interstate, from here until Laramie, over 300 miles away. At least I wouldn't get lost.

Chapter 43

WYNTER IS COMING

Wyoming
Days 307–14
359.09 miles

Wyoming. For the first time, it didn't get much warmer once the sun was up and my running tights stayed on for the whole day. Snow was expected in a few days and I imagined I'd be using that shirt I picked up from the Nevada desert floor more often than not. Terrain-wise, it was benevolent, ignoring the three big hills on the way out of Evanston, which, to their credit, went a long way to warming me up.

News from the repair shop came that Jenny was able to be fixed, which was wonderful, even if there was nobody to drive her at the moment. I had two spells running alongside a herd of wild deer, who eagerly tagged along through the scrub, with the snow-capped Uinta Mountains and huge fields of wind turbines to the north, thumping along in the westerly wind. Wyoming's wide-open spaces at least meant there was hardly any traffic on a road that seemed too good to be true, and when I travelled the last eighteen miles on a completely closed carriageway I could hardly tell the difference, save for the lack of waves from my trucker pals.

Putting off the inevitable for as long as I could, I pitched my tent a couple of hundred yards from the freeway, down a dirt road, in a huge cloud of the mosquito-like insects that had been following me, despite the cold. They were hardly the company I hankered for right now. I was lonely and missed Nads terribly. I went out briefly to watch the lights of the cars on the freeway in the distance, joined by the twinkling of the red lights on top of the windmills and the billion stars in a moonless sky. Nadine sent me news that baby Bee was now as big as a pepper and moving around a lot. She probably had more room than I did in this tent.

In the night, I got too warm and took off a few of my multiple layers. Waking up cold an hour or so later, I found that these sweat-soaked discards were now frozen stiff and unwearable. My breath steamed up my less-than-desirable residence, before freezing on the tent walls. I reached for my water bottle, the contents of which were frozen solid. I needed to move to stay warm and ran around in the frost, almost busting my ankle as my right foot slid into a rabbit hole. That would have been one disappointing way to end. My fingers were so stiff I could barely manipulate them into my gloves, let alone pack my bag. *Screw this*, I thought. The polar expedition could wait. I wasn't sure I was cut out to be the outdoors type, and I'd have to find an alternative for tonight's accommodation.

Civilisation, of sorts, lay in the form of Little America, a hotel that grew so big and beyond its original remit that it's now an official census-designated place with a permanent population of fifty-six. I was only there for a meal, rather than a place to lay my head, but I reached this island of comfort at exactly 11,111 miles, without anyone to celebrate with. My gluteals had tightened dramatically in the cold over the last couple of days, and somewhere along the way I'd lost Wilson the Racketball, who

had been doing such a good job of kneading out my muscle knots. I set my bearings for Green River, where I had set up a couch-surf night.

The first two small snow flurries hit the next day. It wasn't just the weather forecast or the time of year that had me braced for the big freeze; it was the sight of huge roadside barricades to stop the tidal wave of snowdrifts that had already started to cover Canada and Montana. Looking to the southeast, where the Rockies looked to be getting smashed, I felt certain I was going to get caught in the middle of it all. A vicious headwind with a bite in the tail made itself a very unwelcome party guest and, coupled with the backdraught from passing trucks, it would frequently bring me to a complete standstill. It would have helped if I wasn't pushing what was effectively a fifty-kilogram sail into a gale. I swore into the maelstrom, but the wind just laughed back. It was probably better to be in on the joke rather than the subject of it, so I embraced the absurdity of my situation whenever I appeared to be pushing water uphill or I had to retreat the length of a football field to retrieve my blown-off cap. If I didn't laugh, I'd cry.

I would also have nowhere to stay this evening, with my day's endpoint being the very uncomfortable sounding Point of Rocks. I was beyond grateful when the Varleys, Mark and Meaghan, whose family had run the gas station there for a long time, let me in and fed me, then gave me my very own trailer for the evening. The heating was on and beers were shared. I looked down at the Coors bottle cap: 'A Hard Day's Work Deserves a Beer'. By the time I hunkered down under the blankets, I rubbed my feet together cosily and fell into a deep sleep.

It was the coldest start yet. My nan used to say to me, 'Don't put your coat on indoors, or you won't feel the benefit of it.' But here, if you went outside to put your coat on, you might die. The

cold air soon burned deep into my chest and I contemplated the misery I'd endure if I camped again.

By the end of my first run, huge icicles had formed on my moustache and beard and pulled at my skin, as they were buffeted by the −8°C wind. Seeing no shelter on the horizon after a couple of hours, I tried to take a break. Curling myself up tightly, leaning against Pramsolo's wheel and using him as a windbreak, I tried to stop shivering. I continued on. Just two miles later, infuriatingly, I came across a heated rest area and spent ten minutes warming my hands and arms up under the hand dryers, attracting many a confused look from visiting motorists.

After my first run I took an early break at the Sinclair gas station, in the town of Sinclair, named after the Sinclair Oil Company – famed for the green dinosaur named Dino it uses as its logo, which was parodied in Pixar's *Toy Story* and *Cars* movies. I was reading the local history while eating my brownie and refilling my tanks with cola.

'What gas miles do you get for that thing?' asked a grizzly old trucker, nodding at Pramsolo with a grin.

'Twenty miles per 32oz Dr Pepper, forty with a Red Bull,' I quipped cheerily, despite over 11,000 miles on my own clock.

He chuckled on the way back to his rig.

I reached the town of Elk Mountain, and saw the peak after which it was named jutting up from the stunning plains. My host was none other than the town's mayor, Morgan Irene, who was all smiles and solid handshake. He definitely had my vote – though I was careful not to ask what his actual politics were, as in these times it was best not to go down that road.

Pictures and certainly not words cannot do justice to the feeling of freedom and space Wyoming has to offer, and I felt truly fortunate as I headed relentlessly east. I left the interstate and

travelled along the snow barrier-lined farm road to town, observed by a herd of mustangs and past a line of cottonwoods, pointing the way onwards, always east, having been shaped by the wind to do so over the last fifty years.

A big day was required. Laramie, the third biggest city in Wyoming, yet with only 30,000 people, was two-and-a-quarter marathons away, but I planned to get there tonight, come what may. A dusting of snow lay on the ground and had frozen solid, ensuring a skittish start underfoot to the morning. By the time I reached the interstate my beard was glassy white with four-inch icicles getting longer and thicker, and I'd resorted to wearing my sunglasses to try to keep my eyes from freezing over.

I fought my way there, one stage at a time, hat down over ears, three base layers and a windproof jacket, hood pulled tight. At least the road was nigh-on deserted, as anyone with any sense had elected to stay indoors.

By the afternoon the sun had melted my beard and I had a surprisingly pleasant lunch under the I-80, looking up at the abandoned swallow nests clinging to the underpass concrete, the occupants having long fled south. They might have been onto something here.

I edged painfully slowly towards my destination. I was scheduled to meet Mel and Craig, my couch-surfing contacts, in town. As I ran on, I could feel the warmth and energy leaving my body with every breath. I was so cold and worn out when I arrived, I had to give myself a pep talk on the front step to be sociable. Craig got me a local beer from the fridge, which made things a bit easier, though the beer hailed not from Wyoming, but Fort Collins, Colorado, prompting Craig to ask if I was heading that way. He mentioned how warm Denver was. Warm? How

perspective changes everything. I had already diverted my course much further north than Denver to avoid the cold. The next stop for me was Cheyenne, then onto Nebraska, which rhymed with Alaska, a very cold place indeed.

Chapter 44

ALL DOWNHILL FROM HERE

Colorado

Days 315–19

211.31 miles

Aid packages: 1, courtesy of Johnny Wildhorse,
containing three pairs of new running shoes,
including a beautiful white pair of Pegasus, five pairs
of socks, one set of thermals
Pramsolo: new inner tubes containing 'slime' to
avert punctures

All set to do the fifty miles to Cheyenne, Wyoming, and then keep rolling east into Nebraska, I paused at the junction and looked south down the road towards Colorado. Why exactly wasn't I going to Colorado? It was a good question. I rechecked the route. It would add a grand total of precisely one half-marathon to take a more southerly route via Fort Collins, which would factor in two new states, Colorado and Kansas, and still allow me to loop back up into Nebraska and on.

I looked again towards Colorado. It was a road that rose to bridge the railway tracks. Beyond that, who knew? I decided to take a little look. My eyes lay fixed on the Rockies to my front

and right, watching huge white-capped peaks emerge from around every corner and over each crest. I entered and did a Lean on the 'Colorful Colorado' sign, which I hoped wasn't a dig at Wyoming, though it did look more colourful than the Cowboy State, with the medieval-looking snow barricades replaced by conifers, which were far less intimidating.

I'd felt a lot like Indiana Jones being chased by a boulder in *Raiders of the Lost Ark* with the imminent winter always close on my heels. When Jenny was totalled and I made my huge diversion northwards in Nevada, I had been trying to stick to one constant objective, to be over the Rockies by the end of October. That objective had now been achieved on 31 October. Happy Halloween!

Colorful Colorado didn't disappoint. The dropping sun gave the blue sky a completely new palette and a bright yellow school bus passed me by, looking very *South Park*. Once again, I was the beneficiary of some divine hospitality, with an offer to stay in a local church forthcoming. I took my shoes off before I entered, not because I had my religious etiquettes mixed up, but because I'd stood in something soft, squishy and definitely organic on the quarter-mile stroll to the Livermore Community Church. Warm, safe and dry, the kindergarten floor had an inch-thick carpet, which, with my sleeping mat, was almost as good as a bed. Sleep in heavenly peace.

I wasn't prepared for how cold my shoes would be when I retrieved them from their overnight airing. I'd done the right thing leaving them outside: last night's squelch was the rotting corpse of a skunk. The sign above the approach read 'Go and make disciples', which reminded me to take care of my social media duties.

The brutal westerly crosswind was so severe, the 287 was closed to all, which is what I think the sign said, though I kept

eyes down most of the time. I coped well with the gale, though my pace would frequently drop by three or four minutes per mile, at the force of the gusts.

The Poudre River Trail delivered me downtown, past copious breweries on the pretty Main Street. I was staying with a university pal of mine, Laura Halpin, just outside FOCO, which is what the cool kids call Fort Collins. Before I met her I stopped at a gas station, where a couple of bicycling locals asked me if I wanted to go and get high with them. A kind offer I felt obliged to decline.

In the morning the freezing wind had abated. My target was the small town of New Raymer, over sixty miles away, which would make it the longest day I'd done so far. My reroute meant I'd done no homework on the area, so I had nothing lined up in terms of accommodation but had a gamble at the post office's 24-hour lobby as a failsafe. I was pretty keen to stay in one. The westerly wind cajoled me along Highway 14, through the Pawnee National Grasslands to Briggsdale. Running seemed easy today, which was fortunate as it got later and later. The road was nigh-on deserted, so the lack of light was rarely a concern, though the eventual sight of lights on the horizon was a very welcome one indeed. I arrived in New Raymer forty minutes too late for the local café Pawnee Station to be open, but I decided to check, just in case. I'm glad that I did.

'Oh, my Lord Jesus, it's Forrest Gump! Hey, Forrest, did you run here? Get Forrest a beer!'

This was Jeff Stelter, possibly the loudest man I've ever met, and he was coming at me with a hurricane of enthusiasm. It turned out that Pawnee Station was a saloon as well as a café, and would be staying open until Jeff wanted it not to be. New Raymer was a town built on the cattle and oil industries, and Jeff was a driver for one of the pipeline companies. I was surrounded

by cattle- and oil-men, a mixture of Stetsons and cowboy hats, with big smiles and warm handshakes.

When he learned about my sleeping arrangements for the night, Jeff boomed at me, 'No way, you're staying at my place! Forrest Gump ain't sleeping in the post office!' It had become a fortuitous day.

I approached an area of traffic control. As I ran past the queue of waiting cars, an angry-looking man huffed and hollered after me. 'You can't go that way,' he shouted. 'The road is closed!'

'Where are these cars going, then?'

'It's not closed to them, but pedestrians aren't allowed. You'll have to go another way!'

'Where's the sign that says that?'

'I'm the sign. You can't go there.'

'Can bicycles go there?'

He thought about it for a second. 'Yeah.'

'I'm going, then.'

He stood in front of me and thrust his hand into my chest. I said nothing but looked at his hand and then at his face, before walking past.

'If you step on the pavement, I'm calling the police,' he warned me.

'Good luck with that, mate. I'm going off-road. Have a great day!'

Off-road it was, then. For the next three miles I pushed Pramsolo through thick grass at an awkward angle, putting a terrible strain on the frame. At least the decision to fly south for the winter had paid off, with the temperature reaching the low 20s, or 70s, depending on your preferred currency. Out came the shorts in one of my last acts of defiance in the face of the inevitable march of winter.

I was halfway down the forty-mile stretch of straight road to Holyoke when a chap called Phil flagged me down and asked me out of the blue, 'Got a place to stay? I'm the owner of the Burge Hotel. We can give you a cheap room.'

He said he'd see me later, and I carried on towards the Burge. By the time I arrived it was dark. Holyoke was a small town, but still bustling with activity at this hour. The late corn harvest meant the grain elevators, of which I had run past many today, were still humming away, flanked by trucks waiting patiently to drop off their loads.

Phil's hotel was a very quaint, historic building, built in 1887, which was positively ancient in these parts. After a delicious home-cooked meal courtesy of his wife Carolyn, it was time for dreams, but only once I'd hung my britches over the back of the chair like an old gunslinger and readied myself for tomorrow. It would be another state crossing, so the only right way was by listening to Bruce Springsteen's *Nebraska* with my eyes closed. Colora-done.

Chapter 45

THE CENTER OF THE UNIVERSE

Nebraska, Kansas

Days 320–30

90.87, 377.32 miles

Pramsolo watch: cracked rain cover, patched
up with duct tape

'NEBRASKA – the good life!' declared the sign. I remembered Nick Baldock's book and his descriptions of cooking in the Nebraskan summer heat surrounded by endless fields of corn and little else. I reclined in the cold, damp wintery grass by the state line, trying to stay out of the wind while I ate my Danish and drank a protein shake. I struggled to imagine breaking a sweat ever again. I didn't encounter a soul until the end of my day, when I reached my motel in Imperial, Nebraska – one of those towns that sounds unbelievably cool when suffixed by its home state.

Next morning, bags packed in the motel, I threw back the sheets to see a bug, a little smaller than your fingernail scuttle away. Trapping it with a glass, the internet confirmed my suspicion that it was a bed bug. The Good Life. Not wanting to give an unwelcome alarm call to the owner, I rang around ten-thirty.

'You must have brought that in with you, son.'

I reckon he'd have guessed by my flabbergasted tone that I was not of the same opinion.

'Hey man, I just thought you should know. I got rid of that one, so if I brought it in, you've nothing to worry about. It's up to you what you do now, but if you see one, I guess it proves my point.'

'Oh well... OK. Thank you.'

The cornfields of Nebraska had now given birth to huge corn mountains and grain elevators, which lined the route to Culbertson. Out on Highway 83, I changed my watch to Central Time, while I lay on my back, trying to recover some length in my gluteal muscles, contorting myself through a variety of stretches on my back. Through gaps in the clouds, rays of sunshine poured down and warmed my face, and for the briefest of moments I saw the form of a smiling angel. I reached hurriedly for my camera, but by the time I had it ready my angel had flown. A lesson that some things are worth remembering and you don't always need the photo. It might only have been two days, but thanks for the good life, Nebraska.

The sunflower state welcomed me by taking away the shoulder, and there wasn't a bloom in sight. I felt terribly lonely. Seeing people together in the town of Oberlin had me imagining how I would cope if I didn't have home, friends and family to look forward to. I'd already met people on the road who were in that situation. At least I had the occasional text and photo update from Nadine to lift my spirits. She sent me a photo of her ultrasound scan and it broke my heart in the best possible way. It kept me going.

Fortunately, my loneliness would soon be lifted by the arrival of Ben Twiston-Davies, a filmmaker from the UK, who would accom-

pany me for three days. Ben was engaged to my old friend Helen, who had run the New York Marathon a couple of days ago – twenty years after I'd done the same. That made me feel a little old.

When we met up over a burger, Ben already had tales of endless plains, the scent of skunks everywhere and deer whose luck had run out when crossing roads. We had so much in common already. Given my glute issues, Pramsolo would be taking a much-needed break and going in the back of his hire car, and Ben was happy to take on a support role alongside his filming. Today we would reach Smith Center, the geographic centre of the forty-eight lower states. The sign marking the spot was worthy of a Lean.

The novelty of moving my arms while running certainly boosted my mood, but the biggest difference was the presence of a friendly face, just when my loneliness was starting to crush me. At one of my breaks I saw him in a town called Portis, taking photos of walls. It's sort of his thing, don't judge him. Portis had some great walls, apparently. The next time we rendezvoused, he was happily driving down the wrong side of the road in Osborne County.

Finding a hotel for the night had been nigh on impossible, as everywhere was inexplicably booked. The last time I'd checked, the Super Bowl wasn't happening in the middle of Kansas. Maybe the gravitational pull of Smith Center was bigger than I imagined? Our luck finally changed when we contacted the West Lake Inn, and after checking in we went looking for dinner.

'Hey, wanker!'

I looked around, incredulously, for the source of the voice. Was he shouting at me?

'Yeah, you. Tosser!'

Ah, I thought. *Someone's trying to show off the fact that they know a few British swear words.*

His name was Raimey. He was staying next door to us in the hotel. 'How'd you get a room here?' he asked. 'There's a ten-year wait list!'

When we asked why it was so busy, he explained that tomorrow was the first day of the pheasant hunting season, and people travelled from all over to come to the Downs area to take part. Raimey introduced me to his friend Kirk. They'd driven up from Alabama.

They accepted us into their group, and over a forecourt beer, just like a football tailgating session, we learned that despite this hotel being the hottest ticket in the Midwest, Raimey's two dogs both had their own rooms and a bed each.

This was a transient but close-knit community, with once-a-year friendships being rekindled and everyone on first-name terms. Clearly, we were quite the novelty, so I was tactful and discreet about hunting not really being my or Ben's thing. If you've ever drunk in the home pub as an away football supporter, you'll appreciate the awkwardness that hung over us until beer warmed us all up. Behind the camouflage gear, the smiles and warmness were as genuine as I'd hoped.

Before the end of the night, Raimey said, 'You comin' back to Alabama?'

'Of course.' At this point, 10 November, I knew my exact route, barring minimal detours. Hitting Alabama during the fifth leg seemed feasible.

'Well, if you're ever in the Decatur area, let me know.'

The first stop the next day, a rainy one, was Cawker City, in Mitchell County, home to an achingly tragic Cadillac graveyard next to a thankfully restored old gas station and, more joyously, the biggest ball of twine in the world. You might be surprised to hear that this is a hotly contested category. I was able to identify the end of the sisal string and considered tying it to my waist to

set a new record for the longest ever unravelling of a ball of twine, but to do so would desecrate a monument to sixty-five years of America at its quirky, competitive best. I would have had to run all the way to the ocean and then swim fifteen miles out to sea before I'd feel the tug of Cawker City's residents reeling me back in, over 1,400 miles away.

To my right I saw a line of men with guns, fanning out across the fields, resplendent in hi-vis tangerine. I wondered if anyone from the night was present, which was confirmed when I heard a call of, 'Run, Forrest! Run!' floating across the heathland.

Tonight was Ben's introduction to couch-surfing. We were hosted by Peggy and Josiah, two ethical farmers who'd built their decidedly and beautifully out-of-place home with views to die for. Despite our issue with shooting wildlife, we were more than game to fire a few rounds off against inanimate objects. A few beers and a disagreement later on as to who had actually hit the beer can with the handgun from twelve yards (it was definitely me), Ben asked, 'Is this what couch-surfing is always like? It's the greatest thing ever.'

Miltonvale, whose cobbled streets carried the echoes of a more affluent past, was a pretty town which provided Ben with some excellent walls to photograph. Having someone to share in the wonderment of places like this gave me a real boost.

The time was already approaching for Ben to leave the place he'd labelled the 'greyest place he'd ever seen'. Clearly he'd never been to Manchester. We owed it to Kansas to return at the height of the sunflower bloom for a more representative experience. Ben's project was an ongoing exploration of 'what it means to be a man', so he wanted to grasp what the real driving force behind me was. I sensed he had wanted more jeopardy in the storytelling and was a little disappointed with how routine the previous few days had been. I *was* struggling internally, even if it wasn't translating in a visual sense.

Ben wanted to get behind the man, exploring my reasons for undertaking such a huge task. There seemed to be something lacking for him in the way I spoke of doing something special for my mum, for the charities and for myself too. For him, perhaps I might as well have been answering him with, 'I just felt like running.' Perhaps I did.

Pramsolo and I hit the road once again, on our way to Topeka in the grey drizzle. The Westboro Baptist Church was in town. I had a feeling they wouldn't be anywhere near as friendly as the Livermore Community Church in Colorado, given that they were so obsessed with who God hates that they felt the need to put it on billboards.

For every Westboro, there was a *Brown vs Board of Education*, where the US Supreme Court in Topeka in 1954 ruled that segregation in public schools based on race was unconstitutional. This paved the way for the Little Rock Nine in Arkansas, but the decision was still being resisted in Alabama in the early 1960s by Governor George Wallace, who physically tried to block the path of black students Vivian Malone and James Hood through the schoolhouse door at the University of Alabama. You may recall that Forrest thought it was a great idea that non-white students wanted to come to study with his fellow students and walked right through the door alongside them.

On my last morning in Kansas, a bald eagle glided along the Kansas River before landing on a branch reaching from the deep. A red wooden barn, with a huge Stars and Stripes painted the whole length of its wall, caught the first rays of the Kansas morning sunlight, whose absence had been giving the lie to the Sunflower State moniker. I'd even been treated to a sunset last night. Ben was missing out.

Chapter 46

BREAKING POINT

Missouri
Days 331–36
266.83 miles

I was just about clinging onto my schedule, and I had a goal to hit. In one week it would be Thanksgiving, and while last year I'd both enjoyed and despaired at the Black Friday frenzy unfolding in the Joshua Tree Walmart with Nadine, this year there was a seat at a table with my name on it. The only problem was that it lay in Marietta, Georgia, with Thaivi, Peter and Mischa, plus Jamie and Luli, among others. To get there on time, I would travel east through Jefferson City and along the northern banks of the Missouri right to St Louis, from where I'd fly down to Atlanta. It was a bit of a diversion and I seriously doubted my ability to do 350 miles in a week, given my glute issues, but the promise of the company of good friends gave me a surge of motivation to go for it regardless.

The Missouri side of Kansas City seemed far rougher around the edges than the shiny, groomed suburbs of Overland Park in Kansas proper. But people seemed just as pleasant and news of Forrest sightings travelled faster than I did, from my donut stops to my hotel at Lee's Summit. The first-day friendliness made me

think I'd grow partial to Missouri, providing the road shoulders got bigger.

There's a debate as to whether Missouri is a southern state or part of the Midwest. Some say that the Missouri River itself is the dividing line, and for the moment I was to the south, which might have explained the sad sight of the change in roadkill to include my beloved armadillos. One day I'd see a live one, but for now I mourned every one of those erased lives on my journey.

It was a tired runner who stepped into the Knob Noster morning rain. You couldn't help but laugh at a name like Knob Noster. I posed for a photo between two sasquatch statues, noting that I was probably the hairiest of the three of us now, and during my first break I looked up in vain for a gap in the clouds as I sat on the floor. I was in the Eagle Stop forecourt, knees to my chest, feet tucked up close to my butt, so only my toes were getting wet.

I was pulled out of a state of deep contemplation by a pair of soft brown eyes and a kind voice. 'Here you go, buddy. Good luck.' He handed me a note.

'Thanks, man,' I replied on autopilot, before my brain conducted an inquest. He'd given me two dollars but he hadn't asked about the run. 'Hey, dude, I'm not homeless, I'm –'

He just gave a thumbs-up as he got in his car and closed the door, waving with his companion as they drove off.

On the approach into Sedalia, the shoulder vanished. A sidewalk started up, but one so rutted it wasn't conducive to stroller running. It was time to look apologetic and face the gauntlet of mid-town traffic. I soon became nervous and frustrated about being in the way, just waiting for someone to complain, as rain fell and cars splashed me as they zoomed by. There was only one honk from a disgruntled driver, but it flipped my switch and I let

fly with a volley of invective and a few hand signals thrown in for good measure. I was furious with myself for losing my cool. Perhaps I was shivering not just from the cold, but maybe a little emotional fragility too.

I stopped for lunch and went to the bathroom to change my clothes. It was a pleasant surprise to hear 'Highway to Hell' by AC/DC over the roar of the dryer. Then the DJ started speaking: 'Saying goodbye to Malcolm Young, who left us last night. There'll be some party in the sky with Bon Scott tonight. Rock in peace, Mal.' To quote the great man, I'd been kicked in the teeth again. For me, Mal *was* Acca Dacca: the driving force, the creative force and the boss. He was the guy I imagined raising an eyebrow, or more likely a snarl, when Phil Rudd's drums kicked in at the start of 'Back in Black'. It seemed a feeble gesture to raise my Coke to him when I returned to my table, but it was all I had.

Second breakfast at a McDonald's in California, Missouri, was enhanced by two ladies giving me twenty dollars to buy some 'decent food'. The only downer was my inability to wash my clothes, as the town laundromat had perished in a fire. This was probably my last chance to do a proper laundry run before Thanksgiving. I hoped Thaivi would still open the door to me.

I crossed the Missouri on the Jefferson City Skywalk and was soon on the Katy Trail, the biggest rail-to-trail project in the US at 240 miles. If my experience on the Coeur d'Alenes in Idaho was anything to go by, I was headed for a hundred miles of stress-free rolling. I ran into the dark with my headlamp on, and the accompanying hoot of owls and scurries of possums, betrayed by their reflecting eyes, provided a welcome return to living nature.

The goal was the village of Tebbets and the Turner Katy Trail Shelter, which was a bunkhouse just off the trail with echoes of

the Bike House in Virginia. It's now run by volunteers and supported by a meagre $10 donation per stay, so I gave thanks to the late Leone Turner for her generous bequest. It was a treasure hunt of sorts to find the key to the door, but I was rewarded by having the place to myself and a hot shower. I added a couple of pieces to the huge jigsaw left out on the table and cast a rueful glance at the ping-pong table, wishing I had Lieutenant Nads around to play a game with.

The next day offered perfect conditions in which to run and view the trail. I followed the banks of the Missouri at a place where nineteenth-century explorers Lewis and Clark had camped with their men. Signs along the way told of the history of their expedition in this area and the roles in the touring party, including the sergeant-at-arms in charge of issuing 'spirituous liquor'. I would make do with a protein shake.

Pushing, always pushing – or so it felt today – on my way to Marthasville. I got a degree of tunnel vision going, becoming an ever-smaller ball of running, but suddenly I felt taller, towering over Pramsolo. It wasn't an out-of-body experience – something was wrong with my friend. Six-thousand miles of pushing over all manner of ground was bound to exact a toll eventually, and I saw that the frame was cracked.

Although we'd survived being hit by a car in New Jersey, it seemed the game was most likely up for Pramsolo. There were fifteen miles to go to Marthasville and a now unachievable twenty-three to Washington, so my accommodation plans for the night were suddenly scuppered. The fabric sling attached to the frame that held my holdall somehow managed to hold things together until I got to the bar area of the Twin Gables in Marthasville.

'Hey, man. What you doing? You want a beer?' said a local with a beard to rival my own sitting at the bar. He introduced himself as Nick, and we got talking.

'You're not a welder by any chance, are you?' I asked. In my experience, Americans were just generally handier than us Brits, a thought first planted by Liv when she told me about her renovating an old farmhouse and doing all her own car maintenance. If I rewire a plug or change a tyre, I tell everyone as if I've just invented fire.

'Well, I build houses for a living. Why do you ask?'

I pointed at the junction of the now completely severed handlebars and the mainframe. 'That.'

Nick nodded confidently. 'Where are you staying tonight?'

I explained that I'd cancelled my Washington plans, so I was thinking about the post office lobby.

'Stay at my place. We'll fix it tonight and you can get where you're going tomorrow.'

I couldn't believe my luck. When I gratefully accepted all of his help, Nick asked me one final question: 'Fancy that beer?'

And just like that, my dark mood had lifted.

A good few beers later at the bar and then at Nick's (very well constructed) house, we attended to Pramsolo's wounds. Half an inch of copper pipe was fitted snugly down the lower part of the frame and the handlebar section could slip over the six inches or so that protruded out, restoring a good amount of integrity. Welding wasn't an option, due to the positioning of some of the plastic parts, so this would be our limit for now and I'd review the situation if I got to St Louis. There was a sliver of hope that Pramsolo wasn't done yet.

Nick had an early start the next day, so I found myself standing at the Marthasville trailhead parking lot in the daylight, but way before seven in the morning. A tame wild turkey, who was the town's pet and would not be destined for any table in two days' time, showed up as I tentatively re-packed Pramsolo. He pottered around my feet, tilting his head and looking at me quiz-

zically. He stuck around until a roaming bull terrier going about his business spooked him, whereupon he exited stage left into the bushes. I hoped his street smarts would continue to serve him well, especially where any hunters in the area were concerned.

Nick's repair job was spot on, and a beautiful morning drifted into a warm afternoon in Augusta. The Katy Trail was serene, taking me all the way to St Louis through 150 miles of the best running I'd experienced on the trip. The dappled sunlight shone through the trees and there was even a mile of the trail dedicated to The Dude. It might have been meant for Jeff Lebowski, but on this day I chose to dedicate my mile to Nick.

For two days over Thanksgiving, the heady mix of friends, family, good food and drink, Thanksgiving NFL games, and most of all smiles and laughter, was just the reset I needed. I ran only to keep my muscles moving, but it got me itching to get back to the road as soon as possible.

Something else happened over Thanksgiving. My best good friend Simon knew that money problems were a constant issue now. Nadine and I had no money in our accounts, and I was largely living day to day, without much certainty about the future of the trip. The occasional withdrawal from my GoFundMe page and the amazing but unpredictable donations I received from kind American souls I met on the road were my lifeline. I felt so uncomfortable asking for money – it's just never been in my nature – that I just couldn't bring myself to promote my GoFundMe page. I didn't want to be that guy constantly flooding people's news feeds with requests for handouts.

Simon innocently asked me to make him an admin on my Facebook page, to help out with updates and moderation while I was busy on the road. I agreed, and then, while I was asleep, he wrote a post, linked to the GoFundMe page, explaining that I

was flat broke and the trip was in danger of falling through. I awoke to a cluster of new messages and donations from far and wide.

I was mortified at first, but I quickly came round to feeling gratitude. It was emotional rescue of the sort only a best friend can provide. I was overwhelmed by the response. I feel awkward about naming names, but you know who you are and how much your kindness means to me. Thank you all so much.

It meant I finally had enough security to budget for the rest of the leg and not have to stress about money for the coming weeks. For that, I was immensely grateful. Lingering money concerns can eat away at you in unmeasurable ways. If Simon hadn't spilt the beans, I've no idea if I'd have gotten my feet wet in the Atlantic one last time. As it happened, I'd even begun to think that I might, with the help of an emergency credit card, be able to turn around once I'd done that.

YOU CAN GO YOUR OWN WAY

Chapter 47

YOU CAN GO YOUR OWN WAY

Illinois, Kentucky
Days 337–42
160.66, 86.53 miles

When Forrest crosses the Mississippi for the fourth time, we have the famous scene in which Jenny, serving coffee in a diner, sees him on television, being pursued by reporters across a cantilever bridge asking him why he is running. The map that appears behind the newscaster was the one that I'd followed as closely as possible to make this run as faithful a recreation of Forrest's as possible. It appeared that he crossed the Mississippi around the St Louis area, so I did likewise – and stepped into unchartered territory. The unmapped last legs of Forrest's journey meant that, while I still just felt like running, from here on out I'd be designing the rest of the course myself.

In Illinois now, I ran through what appeared to be a desperately run-down area of East St Louis, a place that appeared to be so deprived even the pawnbrokers were closed. I hardly saw a soul and it felt like Gary, Indiana, in resembling a ghost city.

Beyond the Mississippi, I was now a pioneer myself. Save for a few landmarks, I had a greater degree of flexibility in my route – though I'd have been happier to have such power over time. It

made sense to take a pretty direct route to the ocean, so if Forrest hadn't decided to run up Grandfather Mountain in North Carolina I'd be saving 150 miles and three to four days of running – but it would be a shame to miss such a beautiful state. I had Illinois and Kentucky to pass through before I made any major decisions, though.

The next day I passed 12,430 miles – the distance from the North Pole to the South Pole along the prime meridian. And if you don't think that's cool, you're deep into the wrong book, my friend.

A seemingly lifeless bird of prey lay at the side of the road – until I went past, at which point it feebly raised its head. It was a Cooper's hawk. I examined it for injuries, praying I didn't find any that required me to dispatch it there and then. It had an old leg break but it wasn't infected, and I guessed he just couldn't hunt as well as he should have been able to and was extremely weak. He maybe had a chance, if there was a rehab centre nearby. As I was doing this, someone pulled alongside to see if I needed a ride.

'I don't, but if there is any way you can get this little guy to a veterinarian it would be appreciated.'

I felt some anxiety when my legs raised objections to the variety of the landscape, including some unexpectedly hilly roads, which left me a little stressed about the impending Appalachians. This tension was heightened by an unexpectedly busy route on a road with no shoulder and some less-than-welcoming drivers. The first thought it was a good idea to blare his horn at me for a good hundred metres before and after unnecessarily passing me far too closely, while another pulled off a ridiculous overtaking manoeuvre from behind and whizzed so close past me that my cap was pulled from my head.

My hosts Tony and Berna served me Filipino pork, potato, kale and rice, with everything apart from the rice having been grown or raised on their land. They'd just had twin boys, when Tony was fifty-two, and he was just about keeping up, despite recently breaking his leg. Perhaps I needn't worry about becoming a parent at the ripe old age of thirty-nine.

A fractured leg and a snake bite had given Tony and his family their fair share of health-related grief, with the latter generating a huge bill that anyone would struggle to pay, let alone a public servant such as Tony. Even though his employer took care of the majority of it, he was still lumbered with a $2,500 bill. I could only begin to imagine the kind of nightmare it would be to exist in the state of limbo between those who could afford decent insurance and those who were eligible for whatever level of care was deemed to be 'bare bones'. Health-related costs are the biggest cause of bankruptcy in the US, which I'm sure does wonders for people's recovery.

I waved goodbye to Tony with his warning ringing in my ears to take care on Highway 45, as there was no shoulder to speak of and some bad drivers around. Sure enough, an old guy in a red pick-up with whom I had full eye-contact sped towards me and flicked his wheel to make the hood of his truck come out towards me, missing me by about an inch or two at the most. It made me shudder, thinking back to Nick Ashill's near-fatal hit-and-run in Ohio during his trans-con attempt. The way this guy had looked straight at me and swerved deliberately made me wonder if the guy who hit Nick had tried to scare him in the same way, but with tragic consequences.

A town called Metropolis, which I thought would provide no more than an amusing footnote or a photo opportunity by a sign, turned out to be the self-styled home of Superman, complete with the world's largest statue of the Last Son of Krypton, on

American Way, naturally. It so happened that he was getting into the spirit of Christmas and sported a very fetching Santa hat. On the way into town, there was a sign with emblems of the various community organisations and a sign telling you to 'Attend the Church of your Choice'. Whether they had a Raoist church for the man himself, I do not know.

After an interview with the town's newspaper – the *Daily Planet*, though Lois Lane and Clark Kent were sadly not in attendance – I left town pushing the Pram of Steel (and copper) to Fort Massac State Park, towards the Unbridled Spirit of Kentucky over the Ohio River.

A mile-long narrow-lane bridge with no shoulder awaited. It had a metal grate for a surface, allowing me a view of the hundred-foot drop below. The oncoming motorists were seemingly unable to compute the sight coming towards them in the fading light, requiring me to wave them by as they crawled past at walking pace. This might have been the first and only time I felt genuinely guilty about being on the road, even though Google had told me it was fine for bikes.

I composed myself by the Kentucky sign that told me I'd entered my forty-first state, while the sun was sinking fast. An officer of the law, wearing a simply excellent moustache, approached me. 'Tell me you're not going to cross that bridge, sir,' he said.

'Already done it, mate. It was awful.'

I'd only be in Kentucky over two days in total, before I hit Tennessee, though it would prove enough to experience some fine hospitality from the good folk of the state. Winter must have stopped rolling east in Kansas, as Illinois and Kentucky seemed to be experiencing a perpetual Indian Summer. On the road, someone hollered, 'Run, Forrest!' from his car window. He then

swung around, stopped and apologised for his rush of blood to the head when I was clearly just a guy out for a run and not deserving of such disrespect. Nope, I explained, he had it right first time. My body was in its usual state of discomfort, so I decided to comfort eat, starting with a KFC. When in Rome ...

Chapter 48

BACK TO WHERE I BELONGED

Tennessee 2
Days 343–51
368.42 miles

As I reached Tennessee once more, I received a Forrest shout-out from a guy who'd seen me on the news last time I was in the state. He was incredulous that I'd made it back – almost at the end of my fourth crossing, over a year later.

You never know when you're going to receive good advice. In the Tennessee countryside, a sign on the fence of a front yard told me to 'Keep an Eye on Jesus'. I wasn't sure if that referred to the chihuahua that was shrieking and snapping at me as it tried to wriggle through a gap in the fence or the bull terrier that had just jumped onto his kennel roof, which was higher than the fence. I thought it prudent to keep an eye on both of them, as, no matter which was Jesus, the other one looked like trouble too.

I'd been dancing a complicated routine with the shoulder for most of the day. Sometimes it was lovely and wide, sometimes narrow, with the dreaded rumble strips. And sometimes, like now, at the end of my shift, it was completely in the dark and blocked by a huge fallen branch that I just managed to stop in time for. It became a hair-raising mile from hell, during which I

feared being hit every step of the way. My heart was in my mouth the whole time, and when it was finally over and I reached my room for the night, I decided that I was done with night running. I'd taken the odd risk over the past year, but I hadn't felt as though my life would end at any second like tonight. I had just four months to go until Bee arrived and I was suddenly extremely full of a sense of my own mortality. I had no wish for her to only know me through stories and photos. From now on, any days over forty-three miles would start in the morning dark, before the roads were busy. I decided to rejoin Highway 70 just to the east of Nashville, for a hefty dose of déja-vu from leg 2. The availability of revisiting friendly faces overruled the disappointment of failing to break new ground.

I caught up with Neil McCormick of Yazoo Brewing again, who put me up at his home. His philosophy on life resonated with the idea of 'being more Forrest', though sometimes his choice of language differed from Forrest's. 'There are two kinds of people in this world,' he said. 'Those who make sure everyone gets their fair share and those who make sure they don't get f***ed out of what they've decided is their fair share.'

In Lebanon, first thing in the morning, I moved through the still snoring town. The movie theatre advertised a screening of *It's a Wonderful Life* in nine days' time. Christmas was getting close, and soon I'd need to depart before immigration collared me. Only 600 or so miles to go.

Back to Rome, back to Rock City. I'd seen a barn in Kentucky with the words 'See Beautiful Rock City' painted on the side. I'd thought it was unlikely that it referred to this little cluster of houses I now came upon, especially as it was so far away, but it turned out that the real Rock City was even further away. Its creator, Garnet Carter, had painted over 900 of these signs in seventeen states, as far away as Michigan and Texas, luring them

to his mini-golf course on top of Lookout Mountain and a view of seven different states if luck and nature were on your side. Air pollution today meant you'd be very lucky indeed to get the full set. This was one of the great pieces of opportunist advertising, with barn owners in the 1930s Great Depression desperate for free paint for their grain and animal stores, regardless of the 'finish' they received. Did any of these farmers ever get to see what all the fuss was about?

There wasn't much fuss going on in the Rock City I found myself in, until I ran past an autoglass shop where I'd previously stopped to chat and reluctantly declined a moonshine offer. The guys recognised me and came running out. There was no moon-shine offer this time, though they were amazed by the whale-shaped trace that mapped my route thus far. The photo of this Fab Four on that Sunday will be forever how I imagine Tennessee man: hardworking, straight-up and a lot of fun.

I climbed further into the trees of the Cumberland Plateau. I passed over the graffiti-strewn Crazy George Bridge, where poor George had a fateful argument with a train many moons prior. Rumour had it that he still roamed these parts.

I was certain I didn't want to see the inside of a tent again between the months of November and February. I was put in touch with a truly unique individual called Bob who, along with a few other like-minded individuals, had formed a loose commu-nity in their log cabins around a lake in the Tennessee backwoods. I heard about their community's recent ecological battle against a local sand quarry, which threatened bird life and the very exist-ence of a crayfish species found only in the area. I was pleased to hear that the WWF was one of the main supporters of their fight.

I took a steaming-hot outdoor shower as the temperature approached freezing point and retired to my own little cabin. I

lay in bed, listening to the wind howl, under a clear sheeting roof illuminated by the retreating supermoon. The wind chimes eventually sang me to sleep as I wondered what the wind was going to bring me.

Over Daddy's Creek, over Mammy's Creek, into Roane County and into the Eastern Time Zone, the final one until the ocean. I reached the city streets of Kingston ahead of schedule, which would come in handy for my upcoming Appalachian crossing, given the bad weather forecasts.

On the approach to the Appalachian foothills, I passed the birthplace of Davy Crockett, which brought to mind the moment in the film when Forrest said that Bubba Gump had 'more money than Davy Crockett'. The heavy rain made me contemplate an early halt to the day in Johnson City, before again getting a grip on myself.

The Braemar Castle Hostel has been a beacon for hikers on the trail since 1976, offering inexpensive dorm beds and good food, but there would be no other guests apart from me that night, this not being the most hospitable country in the winter months. While I had regularly taken advantage of kind offers from couch-surfers to pick me up from the spot where I would call it a day (and return me in the morning), I hadn't expected it of a hotel owner, but Sutton wasn't your average proprietor. Not only did he provide transport, a feed of chilli and Yeehaw Pale Ale with his son, Benjamin, and a warm place to drop, he also showed me how to pick a padlock, which might come in handy one day. I already knew all too well how to fix a puncture, so I retired to do just that.

I was a few miles from North Carolina now. It had started to snow again. My ambition was to get up and over the Appalachians in a day, which would mean a day of steady climbing. My major

concern was the fact that any cars coming towards me would be braking on roads that were coated in a veneer of early morning ice.

A gun shop displayed a billboard with a semi-automatic rifle propped up, decorated to look like a Christmas tree. It seemed jarring that, in an area where Christianity was such a huge aspect of society, a symbol of Christmas had been hijacked in such a manner. Did anyone else in the area think it was a little weird? I could already hear the protesting arguments as to why it was perfectly acceptable in my head.

As I climbed towards the state line, the snow lay thicker on the ground, yet it was turning out to be a beautiful day, with the Cherokee National Forest looking magnificent in her winter livery. Eating and watching the world go by from a closed antiques store, which provided a rocking chair (perfect for life contemplation), it struck me how lucky I was to see so many parts of the country outside of the usual tourist season.

Chapter 49

SUMMIT TO SEA

North Carolina, South Carolina 1
Days 352–59
231.68 miles

Roadkill count: 1 chihuahua

North Carolina offered all the visual benefits of a winter wonderland. I passed a billboard for the WWF titled Polar Opposites, showing the plight of the polar bear in the Arctic, which is being worryingly plundered for its oil and natural gas, with seemingly little regard for the environment. The Eastern Continental Divide was reached at a height of 3,860 feet, and the Appalachians were, in principle, conquered. A sigh of relief clouded in the cold air on the outskirts of Linville, a small town at the base of Grandfather Mountain.

I had more climbing scheduled, but Pramsolo, whom I never thought would get this far, would stay behind on this trip, at the home of Cobbie Palmer, the self-proclaimed 'coolest guy in Linville', which, considering he was a former race-car driver as well as an incredible guitarist and drummer, might very well be true. We travelled together towards Grandfather Mountain and the famous Forrest Gump Curve, the reason for my diversion

and the setting for one of the most iconic scenes of the *Forrest Gump* run. Things were about to get very disappointing: the mountain was closed.

The snow and ice meant visitors weren't allowed for health and safety reasons, and despite my protestations that I had little regard for such things and zero appetite for litigation, the security guard was unmoved. My wail of having run almost 13,000 miles did little for my chances or my dignity, but I was willing to try anything. Cobbie and I retreated to hatch a plan to do it another way, but decided it might not be wise to get in any trouble, given my impending visa expiration.

Instead I set out with Pramsolo in the morning, diverting onto a still-picturesque route I felt too melancholic to appreciate. Frozen lakes and huge icicles hanging from outcrops were my only company, as sensible drivers stayed home until lunchtime.

Almost too late, I yanked Pramsolo to a stop, as an extremely furry caterpillar made his way into our path. Called 'woolly worms' by the locals, according to folklore they were a reliable barometer of how severe the upcoming winter would be. If this year's crop were black you were headed for a cold one. I was pleased to see that this one was a reassuring brown as I escorted him into the grass.

I eventually closed out a reluctantly disciplined day in Kings Mountain, a place I was surprised hadn't been renamed, since it was the scene of a battle that effectively ended the involvement of the King in American affairs. I'd be heading along the trail of some key Revolutionary victories tomorrow as I finally reached South Carolina, the state where I'd reach the ocean.

Over the border, the conifers of the highlands were now giving way to the cypress trees that so defined the Carolinas in my mind. But in one of their last strongholds, as I was floating gently

down Highway 321 lined either side by these giants, a couple purred by in a perfectly restored 1970s sky-blue Buick coupé, the scene identical to how it would have been in Forrest's time. I imagined the driver in brown slacks and a patterned shirt, smoking a cigarette and listening to country music, while his wife, wearing a matching headscarf and sunglasses, gazed out of the window, dreaming of Kenny Rogers taking her away from it all. From the car, the mood would be one of complete relaxation, but it was the opposite for me, with the road only deeming it fit to provide a shoulder when there was just enough room to fill it with wide rumble strips too broad to straddle with Pramsolo's rear wheels, which was worse than no off-road space at all. I was surprised only to receive one horn blare, but I was rapidly becoming too tired to care if it were a hundred.

With the aid of beautiful weather, quiet roads and a continual downhill, I got to the edge of Columbia, the state capital, before it was dark. When rush hour struck, however, my peace and quiet was ruined. The drivers were close and aggressive, and on the internet in my hotel that evening I learned that I was ten times more likely to die on the road as a cyclist in South Carolina than in Oregon.

The TV in the breakfast room told me about the efforts to repeal Obamacare. I looked at the receptionist, who'd just filled up the coffee pots. 'Awful what they're trying to do there, isn't it?'

'I haven't been to the doctor in thirty-seven years,' he said, smiling.

'That a good thing?'

'Nah, man. I'm dying. Falling apart.'

'Do you not get healthcare working here?' I asked. The hotel was part of a very well-known chain.

'We don't get nothin' but a paycheck, and that ain't all that.'

'Sorry to hear that.' What else could I say? I was sorry. There was no way that the world's biggest economy shouldn't provide free healthcare to its population unless the welfare of the entirety of its population wasn't its main priority, which was a worrying thought indeed.

The centre of Columbia is very grand these days, considering it was burned to the ground at the end of the Civil War, with both sides, of course, blaming the other. It sounded like modern politics wasn't so different from the olden days. The South Carolina State House was refreshingly different to the identikit white domes I'd seen dotted around the country and every bit as beautiful, fringed by palms and plaques detailing the grand and complex history encompassing civil war and civil rights.

The stressful roads were one way to keep my mind off injury. Complaining about injury was akin to polar explorers moaning about the cold, I told myself, but there was no escaping the feeling creeping into me that this adventure was no longer quite as fun and exciting as it had been a year ago, with Nads, Jenny, and the wide open road stretching ahead of me.

The Force was with me today. I hit some kinder roads and started to enjoy just *being* in South Carolina. I put in a strong fifty miles down the road to Ireland Creek Cinema in Walterboro, where I bought myself a ticket to the latest *Star Wars* film, a giant bucket of popcorn and a vat of soda. I don't think I'd been as excited about something for a long time, perhaps not since Christmas as a child when an X-wing and TIE Fighter lay under the tree for me. On the way back to my motel, I noticed that a STOP sign on Mount Carmel Road had been amended to include the words 'Hammer Time' below the instruction. I took my red cap off to the author of that. Tomorrow, I would see the ocean.

* * *

The near-deserted 303, with Spanish moss dripping from the cypresses that lined the road, ferried me onto some beautiful wide-shouldered roads. South Carolina was looking up. I made it to the Spanish Moss Trail on Port Royal Island, the last fifteen miles of my run. Water was on all sides, leading me to wonder if they were rivers or if I had already seen the ocean, but I elected to finish at Port Royal itself, where the hurricane scenes were filmed in *Forrest Gump*. In the movie, only *Jenny* returned to port, sparking the upturn in fortunes for Bubba Gump. It seemed as good a place as anywhere to finish.

And at ten after five, and ten before sunset, I just happened to be there against all odds. My first finish had been a parade, my second a magical lighthouse in the fog, and my third a poignant, private one to one with Nadine. The fourth proved to be just as special, even though it was a silent, reflective and solitary affair.

It was a picture-perfect sunset, with a sky of lavender and gold. I walked along the boardwalk, which led out over one of the river inlets, its calm and flat water below, and climbed the observation tower, like Lieutenant Dan atop his mast. I was king of the castle. I saw a dolphin frolicking in the bay as an extra reward. If ever there was any doubt about my being the first person to cross the USA on foot three times in a year – my first crossing was a little short – this one settled that issue and made it three times in a calendar year to boot. Eleven months, if we're counting.

I stared out at the ocean, strangely emotional but happier than anything.

'Hey, man, what are you doing?' came a voice.

I turned to see a lad of about fifteen under a baseball cap, with a very fancy camera around his neck.

'I've just run across America four times. Like Forrest Gump.'

'Mind if I take your picture?'

This was Mathew Nans, a photography student from Beaufort always looking for the perfect shot. The setting sun left just enough light to allow him to do his thing. I'd see more of Mathew later, once I'd worked out what the world had in store for me regarding visas, finances and fatherhood.

Some old friends arrived in the form of the Kane family, James the chiropractor and Corinne, the nomads from the RV park all the way back in Austin on leg one of the trip. They had finally put roots down, as far from California as you could pretty much get, up the road in Charleston. I packed down my trusty steed, battered but unbroken, into the back of the Kanes' truck, and we went out to celebrate. Pramsolo would couch-surf for a couple of weeks before normal service resumed. Or at least I hoped it would, but it wasn't only my call to make any more.

LEG 5

5 January–29 April 2018

South Carolina, Georgia, Alabama, Mississippi,
Arkansas, Oklahoma, Texas, New Mexico,
Arizona, Utah

2,266.9 miles

Chapter 50

RE-BECOMING FORREST

JFK, New York

This was why I hated breaks. The potential for things to break existed at every point. I was delayed at London Heathrow for two hours, then my initial flight was cancelled, rearranged for twelve hours later and then, as I learned from an email that I very nearly didn't check, for four hours after that. Instead of heading to Atlanta, it was rerouted to JFK and stuck there in a snowstorm. I was given a domestic connection but an impossibly narrow window of time to make my way across JFK and through passport control. How big was this place? I easily ran a mile, from gate to immigration. Now, as you may have gathered by now, I'm reasonably well-acquainted with running and might even have been known to enjoy it on occasion. But this was sprinting – veins popping out of my forehead, dodging slow-moving passengers and their badly steered baggage.

I'd been rehearsing my arguments to be let back into the country. Since I'd only been home for fifteen days, I'd likely be flagged on the system more vividly than the Christmas lights that still decked the halls. The check-in staff had already slapped an ominous red sticker on my boarding pass after scrutinising my passport for an age.

'Purpose of your visit?' asked the immigration official at passport control.

'Running across America,' I replied, red-faced, breathless and dripping with sweat already. It wasn't a look that would inspire confidence. 'Like Forrest Gump.' I pointed at my cap, which I'd worn especially for this occasion, once again.

He barely even looked at me. 'Duration of your stay?'

'Eighteenth of March,' I uttered between gasps, looking around for the signs that would tell me where to go.

He stamped my passport. 'Good luck,' he said, returning it with a smile.

And with that, Forrest was back in the States.

There must have been a processing delay on good-luck applications at JFK, as I reached my gate five minutes after departure. What made it worse was that the snow was the wintry manifestation of a 'bomb cyclone' that was hammering the East Coast, meaning every useful destination to the south of New York would be unreachable via a direct route the following day, and there would be no more flights at this hour.

I pleaded my case to the lady on the Delta counter, but in the face of an 'act of God' the best they could do was either a 6.10 dawn flight, which they predicted would be cancelled anyway, or a hotel, forty minutes away during ideal traffic conditions – which a bomb cyclone was not. It was now getting on for midnight so I elected to stay put and hope for better news. I went to a quiet part of the airport, got out my sleeping mat and bag, and closed my eyes under a bench. It was a truly disheartening way to start the fifth leg.

I'd returned home to Nadine at the end of an incredibly tough stretch. The fourth leg of the journey had brought me real hardship with the weather, the loss of Liv and Jenny, the near-loss of Pramsolo and my seat-of-the-pants finances. I'd been running

defensively to protect myself from my injuries and also from the traffic on roads that were never designed to be what I wanted them to be.

But having come this far, I had to finish the run. My plan was not to reach the Pacific again, but simply to reach the same point where Forrest stopped – that spot, on Highway 163, Monument Valley, Utah, where he finally decided to head home. I would mirror that moment, so come what may, this would be the final push. It was just a *measly* 2,000 miles – the shortest crossing of them all.

I'd accepted the fact long ago that the run was no longer about me. It was primarily for the charities, who were still sending me support and gratitude. Of course, I had personal pride too, but pride alone would never have got me past those bleak wintery days in Wyoming. Luckily, I still sort of felt like running. Not as much as I had on the first leg, of course, but I hoped that I would be refreshed after a little break and able to get back on the road in good form.

There were still mixed feelings, though. I didn't want to leave home, where a heavily pregnant Nadine and the feel of a kicking baby Bee were sources of wonder. I'd enjoyed eating good food (it's not all hotdogs and donuts when I'm at home), catching up with friends and even going to work. Leaving all that behind to finish in the dead of winter was inconvenient at best.

Twelve hours previously, while waiting for my transatlantic airline food, I flicked through the movies and came across *Stronger* – a film following the story of Jeff Bauman, one of the victims of the 2013 Boston Marathon bombing. I'd experienced the resilience of the city first-hand when I ran the 2017 edition, but seeing the dramatisation of the tragedy brought home just how horrendously cruel man can be to others when ideologies

are twisted in such an evil way. It was impossible to watch the news at home or in the US without it being dominated by conflict. We tut and sigh when we watch it unfold from our comfortable lives, but very few of us could ever imagine or feel the true plight of the children in Syria or Yemen who experience terror daily, or that of Jeff, who lost both of his legs in the blast. To see Jeff, having been laissez-faire to the point of distraction pre-2013, turn his life around, shaped by the impending arrival of a baby girl, hit me hard.

The film made me think of so many small incidents that had happened to help me out along the road so far. Seeing how someone could change other people's lives for the better, just by doing the right thing, by putting in a little effort, had already changed mine.

I knew I was helping people by being out on the road, which was both tremendously humbling and something I found uncomfortable to own up to. I was just a guy from Liverpool who happened to put myself in front of the microphone for a bit, but the gratitude I received via email, social media and most importantly in person was a powerful thing and something I still couldn't fully comprehend.

I also watched Al Gore's second film on climate change, *An Inconvenient Sequel*, set against the backdrop of the Paris Climate Conference and its unprecedented consensus that drastic change was needed immediately.

I'd been the closest yet to a complete motivation failure (apart from the odd moment spent shivering under an overpass waiting for the rain to go away), but when I stepped off the plane, having reluctantly left the convenient life behind, I was itching to get going again.

Finally, some good luck came my way. At 2 a.m. one of the women at the Delta counter gently woke me from a deep sleep,

handing me a confirmed ticket for the 06.10. 'You deserve this,' she said with a cheery grin. 'Don't oversleep, now!'

I was so happy and relieved I didn't sleep another wink.

Chapter 51

ONE. LAST. PUSH.

South Carolina 2
Days 360–62
98.55 miles

Even the low Carolinas were cloaked in snow, the first time in Beaufort for twenty-eight years. After twenty-four hours of travelling and a bed for the night that was a vast improvement on the floor of JFK courtesy of Nancy and Tim, Pramsolo's couch-surfing hosts, I decided to ease myself in gently. I decided to meet Mathew, my new photographer friend, first thing to see the lay of the land. He was joined by two local track stars, Eli and Nash, plus Howard, the team coach, and my plans for an easy day were suddenly looking a little mean-spirited. The miles ahead of me still needed running, so I figured I might as well get on with it.

With Howard providing support the whole day long, the four of us set a course for Hunting Island, the location for the Vietnam scenes in *Forrest Gump*, which offered an uninterrupted view out across the Atlantic. This area had seen more than its fair share of bad weather in recent times, with the beaches having taken heavy hits from Hurricanes Matthew and Irma, though I never expected to emerge from the ravaged maritime forest trying to see where the snow ended and the sand begun. It still

looked beautiful to me, but I knew that the local people and especially the park rangers were still heartbroken at a landscape changed forever – unrecognisable from the scenes filmed in 1994.

I looked out to sea in the vague direction of home, where Nads and Bee waited for me some 4,000 miles away, and a dolphin slipped in and out of the water. Had it followed me from Port Royal? Climbing the lighthouse, which miraculously survived the full force of the terrible twosome, Matthew and Irma, it was time to put some distance in.

I was feeling the pull from having sprinted through JFK yesterday, and the conditions weren't exactly conducive to speed. I ran faster than I would have liked to, probably thanks to trying to look less of a plodder and more like a serious athlete in the company of three decent young runners. On a mixture of snow, ice, slush and, where we could take it, normal road, I managed just over thirty miles, with the boys keeping me company for twenty-two of those. Slipping a few times during the course of the day aggravated the strain in my groin. I was still in driving range of Nancy and Tim's place, so they introduced me to the delights of Frogmore stew – a kind of jambalaya with corn and potatoes, the size of which was fit for a king. One thing I would never grow tired of in the South was the home-cooked food.

It was time for life to imitate art when I crossed the Woods Memorial Bridge, used in the film as one of Forrest's Mississippi crossings but which really runs over the Harbor River in Beaufort. When Forrest crossed his bridge, he was asked if he was running for world peace, the homeless, women's rights, environment or animals. These five noble causes were the driver for the selection for my two charities, the World Wildlife Fund and Peace Direct, and I'd dreamed of recreating this scene if I ever got this far.

Mathew, with the little help of some high-up folks in City Hall, had arranged permission of sorts to film the occasion, so I had around twenty runners in tow, plus a film crew, all of whom Mathew marshalled so well that despite his tender years he looked every inch a budding Zemeckis under his beanie. I owed it to him to and to the run to put in a decent performance. Does Mr Hanks ever suffer from on-set nerves? I wondered. If I ever got the chance to meet him I would have to ask.

Stripping down to the appropriate outfit of Nike Cortez, knee-high white socks, red shorts and a yellow polo shirt, topped off with the Bubba Gump cap, I set off in the 'right' direction across the bridge. Meanwhile, a man with a screwdriver who will remain anonymous (just in case) held the traffic signals on red, and we filmed a somewhat different version of Forrest's interview.

'For the fourth time on his journey across America, Robert Pope, a veterinarian from Liverpool, England, is about to cross the Mississippi River again today. Sir! Why are you running?'

I think you know the answer to that by now.

The timber-framed Yemassee train station was the kind of place you could imagine walking into and purchasing a ticket to anywhere; the tree-lined track unfurled into the distance, suggesting at untold opportunity beyond the county line. My adventure had already taken me here, past the church that refused to fall, having been burned by both the British, in the Revolutionary War, and General Sherman as he scorched the earth on his March to the Sea that broke the back of the Confederates during the Civil War. I was worried the retracing of this route would be the breaking of me. It would take me less than a week, by which time I'd know a lot more about my ability to carry on, and I also had a date with a chiropractor/sports masseur that I was anticipating and dreading in equal measure.

My final day of running in the Carolinas was perfectly set up. Pramsolo's holiday was over and I got him ready for one last big roll, while Mathew's mum Lorene wheeled out her speciality smokehouse ribs, and from here, armed with the fortitude that only the love of a proxy family can provide, I felt I had it in the tank to get to the heart of Georgia. First up was a trip to the church in McPhersonville, where Forrest sings his little heart out with the gospel choir in the film. The church was locked up and thick snow lay all around, but peering through the windows I was transported back to the film.

I stopped outside the office of a chiropractor's clinic in Varnville and asked someone passing if she could take my photograph. Gods Glory church was directly across the street. The latter doubled as Gilmer's Drug Store and the chiropractor was the barbershop that Forrest ran past in the first mile of his run, where we learned of Jimmy Carter's collapse from heat exhaustion.

'Welcome to Greenbow, Alabama!'

The voice came from Ment Nelson, a local artist who was waiting at the lights in his red pick-up truck. He'd called it right. Greenbow might not exist in real life, but if any place on earth had a claim to it, it was here. Ment would later list his painting of President Trump and Kanye West for a million dollars, explaining that if he couldn't value himself at a million dollars, who would? He had a particular piece of advice that could be filed under 'Be More Forrest': 'Don't let small-minded people discourage you from attempting what they can't imagine.' With those words I was off, but not before he filmed me taking that right-hand turn by Gilmer's Drug Store. Who knows, maybe that will be worth a million one day?

I called into the local Dollar General in Allendale for some chocolate that evening and realised I'd left my wallet in

the motel. The cashier heard my accent and said, 'You from Scotland?'

'I –'

'Man, I love Scotland! Fish and chips and lager!' he said, and promptly covered the chocolate for me.

Like the random act of generosity, this accent guess wasn't a first. Many people I met thought I was Scottish, Irish or Australian. When people guessed, it was often linked to the place that they hoped I was from.

The next morning I ached, after a night of being unable to find any sort of position where my hip, groin or abdominal muscles didn't hurt, so I would usually settle on a position where only one of them did. I'd not been able to put my shoes on without sitting down first for a while, but now I couldn't raise my knee off the floor to get my shoe on without using my hands to physically pick it up. I had a chiropractor's appointment in six days, which couldn't come too soon.

Swallowing a few ibuprofen, I headed out the door and walked for the first seven miles on an almost deserted four-lane highway with a beautiful morning that made just the act of being outdoors pleasant. My hair swished across my face in the crosswinds – I was one ungroomed individual these days, but it came with the territory. Half a marathon later, I crossed into new territory, Screven County, Georgia, where I did my last ever Lean on a state I'd not visited before.

Chapter 52

PEACHES AND SCREAMS

Georgia

Days 363–70

292.03 miles

Aid packages: Three new pairs of Pegasus, courtesy of Johnny Wildhorse

Welcome to Georgia, the Peach State, and state number forty-three for me. I expected a bit of a fevered atmosphere, as the Georgia Bulldogs were facing off against the Crimson Tide of the University of Alabama – Forrest's old team – in the NCAA National Football Championship game tonight. I once got to the final of the University of London second-tier football cup competition, and I think there was a grand total of a hundred people there, including both teams and substitutes. College sport in the US, however, is an entirely different beast to anywhere in the world. I'd seen how big high school games could be in Texas, and the colossal stadia of the Louisiana State University Tigers and Tennessee Volunteers. The whole country would be watching in their millions later tonight.

My aim was to find somewhere to check the game out, but my reduced speed and shortened run sacked that idea before the

snap. I got as far as Sardis, a very small town around thirteen miles short of where I'd banked on staying. The town was mostly shut, and I didn't have much of a clue as to what I was going to do for accommodation. There was always the post office as a failsafe, but first I called in at the police station, who directed me to the fire station, who called the mayor of the town. Carol was the most un-mayoral person I'd ever met, with no grand robes of office, but she was a hard worker who cared passionately about her home town, despaired of previous administrations and was happy to talk of her plans for the future.

She arranged for me to stay in a small cabin building owned by her sister, a single-room structure with a concrete floor and bare walls, with a space heater and a huge tool cabinet, the likes of which you'd see in a professional garage. 'Sorry about the roaches – we bombed it last week,' she said.

My roommates were a few hundred dead cockroaches and other insects that littered the floor. Hoping that more weren't lurking in the shadows waiting to reclaim their dead and take revenge on the new guy in town, I folded the blanket out on top of the tool chest and pushed it in close to the wall, so I'd only be able to fall four feet onto concrete from one side, and inflated my sleeping mat for the first time since JFK airport. At least this time I didn't have to put up with passenger announcements and the fear of a missed flight. My mind was cast back to my mum telling a bemused Richard Branson that as long as her room had 'a lock on the door and clean sheets' she'd be happy. Well, I had a lock on the door and the heater was quiet, so I called that a win.

The following morning I was treated to the jarring sight of a young black boy holding the hands of his two younger sisters at the bus stop, which happened to be outside a house flying the Confederate flag in the yard. I hoped for all the world that they were still too young to know or care. Though sadly, it seemed

unlikely that the times would have a'changed enough by the time they did.

Whether I needed faith, fortune or just my spirit animal David Bowie, whose birthday it was the previous day, to make me feel better, I didn't know. But I controlled what I could and elected to listen to nothing but Ziggy and co all day, remembering the time he dug me out of a deep hole in Texas on the second leg.

Apparently 35 per cent of people in Sparta are below the poverty line, rising to 50 per cent for those under eighteen, though there were grand buildings on the main street and some very pretty houses. I learned here that Sparta was home to the Grant twins, Harvey and Horace, both of whom went to the NBA; Horace won four titles, playing alongside Michael Jordan and Scottie Pippen, for my team, the Bulls. My motel room was a bargain – my cheapest ever at $37 – but despite checking carefully for the presence of insect life, I still woke up with a perfect line of itchy bites across my abdomen.

My daily mileage was back up in the mid-thirties, but with my accumulation of countless injuries over the miles, I was beginning to realise that my resources were finite. A pelvic issue, massive blisters, tib-ant and Achilles tendinitis, and a quad tear had all been issues at some time or another, and I was getting pretty depleted by now. Hitting a daily mileage in the high-forties and fifties several days in a row had been a casual thing on the fourth leg. Now even hitting forty in a day seemed too much for me. The cracks were beginning to show.

Today, my fuse ran out just after lunch on the 441, which was a full-blown nightmare, with plenty of traffic and rumble strips on the shoulder that would normally have forced me to run in the main lane. This was out of the question thanks to the torrential rain and the number of cars that would fly past and soak me, so it was a bone-shaking, potentially frame-breaking slog

towards Madison. My hip flared up massively from my altered gait to cope with the rumble strips and my inherent urge to curl into a small ball against the lashing rain. It was rare that I would wildly celebrate the end of the day, but as I rounded the final curve and saw the hotel sign, I punched the air and checked in with such joy, the poor reception lady didn't know quite what to make of it. My thoughts turned to home, and I called Nads who told me that Bee was as big as a pineapple now. I went to bed feeling calm and grateful.

I had a few days in store traversing Atlanta, one of America's great crossroads, made evident by the seemingly endless list of city nicknames, one almost for every letter of the alphabet: The A, Big Peach, Chicago of the South, Dogwood City, Empire City of the South, Forest City, Gate City, Hot'lanta (I could go on).

It was an opportunity to give Pramsolo a city break and run with my arms free, which instantly relieved the tension that coursed through my body, anchored in my butt and groin. It eased so much that after my morning run I half thought about cancelling my chiropractor appointment tomorrow, though the fact that I'd elected to take the shortest route Google had given me to Marietta rather than a more scenic tour through central Atlanta still hinted at a more deep-lying fear that I was no longer fit for purpose. My main worry, however, was that the chiropractor Steven Saul would be a sadist.

I sadly wasn't going to see Momma Thaivi, who was away with work for a few days, but Peter reprised his incredible Brazilian culinary skills with a Feijoada, the black bean stew that invariably looks awful but whose looks are inversely proportional to how good it tastes, in my experience. This was as good as it got.

In the morning, Peter dropped me off at the office of Steven Saul. I felt like a child going to the dentist. Steve seemed a friendly

chap as he watched me walk up and down and checked the alignment of my spine. He concluded that I was pretty decent in this department. I did, however, have extremely reduced hip mobility and weak gluteal, adductor and abductor muscles, to the point that they were barely straps of tendons with the muscles having gone on holiday for the last year. Pramsolo and a slouched posture had not helped, and simply trying to run more upright had expired as a useful tactic a long time ago.

'I wouldn't normally go as intensively as this,' he said as he got me to lie on the rack. 'I'm going to try to loosen your left hip and gluteals, with some myofascial release, and that will help for a while, but for a few days you're going to be pretty sore in that area.'

I knew he would be a sadist.

He was a good man – and thorough. As I ran the remaining seventeen miles of the day, my hip felt incredible. The chronic pain and murky grey of self-pity and negativity had now been returned to full Technicolor. I felt I could now experience emotions with more clarity than I had for the last week. I rejoiced in the opportunity to chat with a young lad called Jordan and his friends and parents, after he told me I looked like 'you know who'. Then I swung to extreme sadness when I saw a local guitar store had closed. On the front door, next to murals of Animal and the Electric Mayhem Band and Angus Young, read a sad note: 'For every $100 spent at an independent store, $48 returns to the community through taxes, payroll and other expenditures. Spend the same in a national chain and $14 stays. Spend online? NOTHING! Support your local businesses.'

I imagined a sad long-haired dude wearing a Metallica shirt who'd spent the best years of his life pointing at the 'NO Stairway to Heaven' sign above the guitar amps turning that sign around to 'Closed' for the last time.

In the morning, the discomfort that was foretold yesterday had kicked in, but I could handle this different kind of pain. I spent my day steadily climbing over a thousand feet on the Silver Comet Trail. I'd run on three of the longest rail-trails in the country now, and I read with interest that there was a project that one day *would* link many of these together to provide a traffic-free route across the whole of the continent. Body willing, perhaps I'd experience this joy one day.

Huge icicles hung from the jutting precipices of the rock that the tracks of the Silver Comet were once carved from. There were rare but welcome encounters with fellow travellers, whether they were voyaging near or far. I heard about the joy of experiencing the changes of the season on the trail as the months advanced, and I was at once jealous and appreciative of getting this chance to be here.

I made it to Cedartown for an unexpected reunion with not just Peter, but Thaivi, who had made it back home and insisted on driving out a long way to take care of me one last time. The next day was my last in Georgia, and Alabama and the Trail of Tears awaited once again.

Chapter 53

SWEET HOME ALABAMA

Alabama
Days 371–78
206.07 miles

Alabama's gift to me as I came 'home' was a trio of state-line signs, including one that said, 'Welcome to Sweet Home Alabama'. I was never happy to leave a state – not even Vermont, where the weather had tried in vain to poison my mind against the green mountains – but I was excited about this homecoming of sorts. Did Forrest ever run back to Alabama? I couldn't see him deliberately avoiding it, but what would have driven him to continue after this point rather than heading home? Maybe the Jenny heartbreak hadn't mended, or maybe he still just felt like running. He must have started to have his doubts by now. Maybe, just like me, he wanted one last look at the desert.

Centre was a town that appeared to be in the centre of precisely nowhere and had the claim to fame of being 'The Crappie Capital of the World'. Paris, Rome and New York it was not, but it wasn't *that* bad, so I put it down to the fish of the same name on the town welcome sign. I was warned of an incoming cold snap and to expect snow. Temperatures could drop, with wind chill, to below zero – in *Fahrenheit* – or –18°C, the coldest I'd ever experienced.

I had no accommodation lined up, except a possible motel in the town of Arab, which was sixty miles away in the snow. That just wasn't happening, and the only other option was a motel fifteen miles away. Disappointing though it was to let the weather get the better of me, it was a surreal pleasure to see the time on the alarm clock read 8 a.m. and be able to turn over and go back to sleep.

When I finally left, I was wearing two pairs of socks, my gloves, a pair of running tights under my track pants, a short-sleeved and two long-sleeved tops, my classic Forrest track top, my bobble hat and, to try to cover as much of my face as possible, I wore my Buff over my mouth and nose and my sunglasses to try to stop my eyelids from sticking together. The sunglasses came in handy in the face of the brilliant blue skies and frosted earth.

An hour in and by now a positively balmy −10°C, I was brave enough to try to de-layer, starting with the Buff. The problem was that it had frozen solid to my moustache and beard, and preliminary attempts to separate them warned of a complete face waxing in prospect. I spent the next twenty minutes breathing with my hand held tightly over my mouth to steam the ice away.

I'd barely freed up my mouth when a siren blare went up twenty metres in front of me in the lay-by.

'Hello, Officer!' I was quite well-versed by now. 'You get a call about a lady pushing a baby down the highway?'

'Sure did!'

'Why's it always a lady?' I said, laughing.

'Son, you ain't getting no men pushing strollers round here,' replied Officer Brent. 'I drove past you and thought you looked like one pretty hairy lady!'

Brent wished me and my icebrows safe passage through Cherokee County and beyond. It seemed the whole county was

concerned for me today, as lots of people stopped, asking if I needed a ride.

I had a lot of time to think when I made the fifteen miles to my hotel. I'd always had a sense of a 'seven-day rule' since I last turned my back on the Atlantic – that if I had seven bad days in a row it was time to hang up the Nikes and the cap and wing my way back home to Nadine. I'd taken this rule with a pinch of salt because I'd anticipated the emotional turmoil, and I'd already had more bad days than I knew what to do with. I knew I wouldn't be able to trust my own judgement this deep into the run, and I had come so far and was so close to my goal. But I missed Nads and everything about home terribly. I was barely a fortnight into a three-month stint, with extreme cold and injuries wearing me down. What I needed right now was certainty. I needed to regain control and cast aside the rule. I would not stop this fight. No matter what. The fight would have to stop me.

The battle to keep the fists clenched and upper-lip stiff was aided by a perfectly still morning on an idyllic deserted country road. It was another beard-freeze day, but that didn't matter, I told myself. It was going to get warmer soon. My legs felt okay – maybe I was holding myself taller – and though tightness would set in later, what did I expect? I was running across America – it's what happens.

One thing that did not give up on me was the generosity of Americans. My 'fellow' Alabamans continued to make me feel like the home-town hero. I would never forget any of these warm people, and I only wish I could acknowledge them all. They were the juice in my engine over these days in particular. I was so far from friends and family, but the kindness of strangers did so much to keep me going.

Icicles on the embankment, steam in the air. Hope in my heart, agony in my butt. Braced for a day of physical misery, I was at

least bolstered by the positivity. From the morning, when I walked then ran past the initial discomfort of stiff tendons and ligaments lengthening and warming up, through the middle bit, when I would cruise and try not to think about it, to the afternoon, when tiredness in my big muscles would lead to them giving my injured ones more and more work to do until they surrendered. When that happened, I'd stretch or otherwise placate them until I got to where I needed to be and promised them it would be so much better tomorrow.

I was on my way to Decatur, Alabama – home of Raimey, my verbal jousting partner last seen in Downs, Kansas, who had offered to throw open his doors if ever I was in the area. Four miles from Raimey's place, white-hot daggers shot down my left leg, causing it to collapse at the knee. I didn't even have four yards left in me.

Raimey picked up the phone on the second ring. 'Hello, Pope. Where you at?'

'By the junction with ... Brown?'

'You're right outside my house.'

I'd been making my way to Raimey's new farm, but unknowingly had broken down outside his old place. His Anglophilia didn't only extend to his preferred cuss words, but also to his vehicle, a classic Land Rover, which he picked me up in. He introduced me to his wife Charlotte and his two awesome kids, Owen and Benjamin.

His boys were star multisport athletes at their schools and excited about running with me in the morning. But when I began the opening mile with a walk, as was my tradition, it was clear that I wasn't going to progress to running today. I found myself apologising profusely and feeling a terrible fraud, and I told the boys that we'd be back in business tomorrow, though it sounded more like I was trying to convince myself. The following day I

ventured out again, but it was the same problem all over. I was back on their couch before the hour was out.

If they were disappointed, they didn't show it, and they looked after me and fed me like a king. In the three days and three nights I spent there in Danville, I attended my first high-school basketball game – missing my honorary free-throw attempts in front of an expectant crowd – ate a lot of donuts, imparted the phrase 'wheelie bin' (as well as some others) unto the Ellenburg vocabulary, watched the NFL playoffs and fixed a constipated goldfish. Even though it was probably never their intention, they soothed the emotional pain I was going through and soon we were to roll the dice one last time to solve my physical discomfort.

Raimey's friend Kirk, whom I also met in Downs, KS, lived next door to a Dr John Irle, who came to my aid with ketoprofen in my left butt cheek and two types of steroid in my right. There is a last-ditch play in American Football named the Hail Mary. I said one of these as the second needle was being prepared, just in case that helped.

The next morning, it seemed it had a little, and I prepared to leave home. To inspire me, Raimey took me to the birthplace of Jesse Owens, the Alabaman Olympian who once set three world records and tied another in the space of forty-five minutes at a college track meet and most famously went on to win four gold medals at the 1936 Berlin Olympics, which was a matter of great consternation for the Nazi regime.

Jesse Owens felt more shunned in his own country than in Germany, and the head of state he was most snubbed by was his own President, Franklin D. Roosevelt, who never sent any word of congratulations. He returned home to a country where black college athletes were still forced to live off campus and were forced to eat at 'black-only' restaurants when travelling with their teams.

I felt fully re-invigorated as I strode into Danville Middle School, hoping no one remembered my free-throw humiliation, to give a talk to Benjamin's fifth-grade class and answer the kind of questions I'd never get asked by adults. They were surprisingly well-versed in the movie, and my favourite question came from young Willy Wilson, the simple but direct: 'Where's Jenny?'

'She's back home in England and I miss her very much.'

I resolved to do two days of walking before I would reintroduce running gradually, as I'd successfully done with my quad tear around Memphis. Progress was slow, but it was progress nonetheless, and it was accompanied by a mini-playlist of songs that were recorded at the nearby Muscle Shoals Sound Studio – one of the most iconic hit factories in America's history. From their walls sprang 'When a Man Loves A Woman' by Percy Sledge; the Rolling Stones' 'Brown Sugar' and 'Wild Horses'; 'I'll Take You There' by the Staple Singers; and perhaps the most surprising for me was to hear that Rod Stewart had recorded 'Sailing' there. It was part of his *Atlantic Crossing* album, so this crosser chose it as my tune of the day as I sailed slowly on my course.

The naughty runner in me was growing noisier and badgered me to let him out some time during the day. It didn't take much persuasion, with pain levels the lowest they'd been in a long time, so five miles in, my steroid-numbed and double-leggings-warmed muscles were startled from their slumbers into a trot. Half a mile on, half a mile off, until I forgot myself and did a couple of miles.

When I wasn't worrying about seizing up, the only thing on my mind now was the finish. It got me dreaming about Nads, now almost seven months pregnant with a butternut squash-sized baby Bee. I had an epiphany. When I'd talked about the run back in the UK with my best good friend Simon, he'd asked if I genuinely wanted to run one final time. I'd said no with a half-

laugh, and I'd sort of meant it, though I'd had no real idea why – apart from the death by twenty million cuts. But five miles from the Mississippi state line, it hit me why I'd not wanted to come back: I wanted Nads to be there at the end.

Her absence meant the finish could never be what I'd hoped for. Of course, it would still be wonderful to equal Forrest and return home with my head held high. But whenever I'd imagined the end, it was with Nads there. Having her only on a phone call thousands of miles away just wasn't right. I needed a different ending.

Chapter 54

KEEP MOVING FORWARD

Mississippi, Tennessee
Days 379–82
77.68, 48.85 miles

I'd run clear across Alabama. Again. This time had been colder, harder and less exciting, but in many ways so much more rewarding, since it had given me a clarity about what truly mattered to me. I completed my Mississippi Lean on the sign and totalled up my distance. Thirteen thousand, eight hundred and eighty-nine miles. One article had stated that this was the distance Forrest had run, but it was the lowest among the estimates, and I hadn't come this far to turn around and limp back home without at least making a bit of a scene for Peace Direct and WWF. I had a few more miles in me yet.

Running into the path of some very large but mercifully obliging big rigs, I counted my blessings that it was two lanes in each direction and quiet enough for them to see this vision in neon yellow. I still lost my cap a few times in their backdraughts. I settled into a run one, walk half ratio, with shorter breaks and regular stretching.

During my lunch break on a patch of grass, I did an impromptu bit of research about how early a baby could get a passport and

fly. I immediately called Nads and floated the idea of her and Bee coming out to finish with me – but only if she wanted to be there. I was expecting more hesitation, but her opinion was that if it could be done, she'd be up for it. Despite the uncertainty as to whether my hare-brained scheme would be able to happen or not, the excitement of us all being there together got me grinning widely as I started my next run.

The nature of the terrain meant that the only time I'd see people apart from truckers would be at my breaks. I met one woman in love with the *Downton Abbey* ideal of England who was amazed that I'd ever want to leave. What was it with these Southern Anglophiles? It was all rather flattering to be so appreciated, being from a nation that can be loved or hated depending on where you were in the world. She looked into my eyes with conviction and told me that a 'nice Englishman such as yourself' should be staying in better places than the Value Inn.

A sign for Tupelo planted an earworm that I couldn't shift, the song of the same name by Nick Cave – a natural fit for the South – and its locomotive rhythm pulling me along the highway. Crossing into Benton County, the local highway authority had rightly decided that rumble strips were the devil's work and cast them into the bayou for twenty glorious miles. It put a smile on my face all the way to Marshall County …

I didn't like the roads in Marshall County and that's all I have to say about that.

I was only in Mississippi for two days, then Tennessee for the same, before I hit Arkansas for a substantial crossing. After a satisfying Tennessee lean, I saw the rumble strips stop and a shoulder as wide as a king-size bed open up before me. Already on the outskirts of Memphis, sidewalks and bike lanes came to my rescue and places to hide from the rain and change kit were plentiful.

I reached my finish line by Oak Court Mall, outside Memphis, not yet realising that I'd passed the 14,000-mile mark about ten minutes ago. If only Nads were here to arrange the banner.

Last time I was in Memphis, things were exceedingly tough. It was the second time that I'd thought the game was up, barely 2,000 miles into that leg, as I aggravated a quad pull into a grade two tear. It was a strange, uneasy feeling for me to be here again after all this time, still physically tender and emotionally raw from my most recent crisis of faith. Last time I'd been resting the quad tear and cleaning Jenny, so I'd not seen much of the great city. This time, though, I had a little time to go sightseeing.

I went to Sun Studios, which can lay claim to being the birth-place of rock 'n' roll. The careers of Johnny Cash, B.B. King and that Elvis fella launched here, and in later years Def Leppard and U2 among countless others caught some of the magic instilled here. A trip to Graceland was on the cards too, despite my having always been a bit ambivalent towards the King (although he was taught to dance by young Forrest in the film). Along with Buddy Holly, Chuck Berry and Little Richard, Elvis was a colossal influence on four lads from Liverpool who went on to change the world. Standing by the gates of his estate and reading the messages of love and loss from the four corners of the globe, I got it.

An Englishman's home is his castle, went the expression, but whoever said that obviously never considered the castle-like homes of Memphis. These huge showy monuments to wealth were hiding behind huge walls and gates, immediately adjacent to some of the most run-down neighbourhoods I'd ever seen. Memphis apparently has the fifth-biggest gap between the rich and poor in the United States, and though I'd run through the other four cities too, never had I seen it in such stark terms. I saw many more smiling faces in the poor areas, proving that while

money can't buy you love, it goes a long way to putting turrets on the corners of your house.

Martin Luther King believed that 'people fail to get along because they fear each other; they fear each other because they don't know each other; they don't know each other because they have not communicated with each other'. In the city where his life tragically ended, it was heartbreaking to see that people's money was being used not to tear down these barriers to interacting, but to build modern, oversized versions of castles, complete with intercom and a security guard.

The Lorraine Motel was the scene of Martin Luther King's assassination. The motel itself is now part of the National Civil Rights Museum. While I thought it a fitting monument to his life and legacy, across the street, in this city of contrasts, a lone protesting voice camped outside the gates. Jacqueline Smith was the last resident of the Lorraine Motel, having served as a housekeeper. When she was evicted to make way for the museum, she set up camp outside and has remained there for thirty years, decrying the gentrification and displacement of the priced-out black communities that the museum and other developments were at the centre of. Maybe she was the monument to Martin Luther King's life that we all needed to notice.

Outside the museum, a wrought iron gate in the form of an excerpt from his famous 'Mountaintop' speech caught my eye: 'I may not get there with you, but I want you to know that we, as a people, will get to the Promised Land.' I felt the onset of the sensation you get in your throat when you're about to choke up with a solitary tear and though I tried to fight it, I suddenly found myself bawling in the street, glad of my three-wheeled friend for support.

My mood lifted as I left Tennessee for the last time, hopefully running my way out of injury. I moved on, crossing the Mississippi

for the fifth and final time, which of course meant I was now back in Arkansas.

I took one last long look down the Big River before I pressed play on something very special indeed. My best good friend Simon, who'd sent me a playlist during my first visit to Texas, had compiled another special one for me. He'd contacted many of my closest pals to nominate a song that reminded them of me and to say a few words of encouragement. Without any idea about how long the playlist would be or who would pop up to brighten my day, I ran to the uplifting messages and song selections of all kinds of people that I love.

As I reached my final mile for the day, a voice came online over the tune of the National's 'I Need My Girl'. It was Nads, sending a message laced with such pride and sadness about how much she wished she could be there at the finish and how amazed baby Bee would be to hear about my adventures in years to come.

Thanking my lucky stars that I'd proposed the solution to her missing out before I heard this message, I could also feel a lump in my throat, and I thought about another set of words that had been haunting and inspiring me all day. If ever I doubted myself, I'd rely on the wisdom of Martin Luther King Jr: 'If you can't fly then run, if you can't run then walk, if you can't walk then crawl, but whatever you do, you have to keep moving forward.'

Chapter 55

A RETURN TO HOPE

Arkansas
Days 383–89
268.75 miles

Arkansas had been my big surprise of the second leg. Great food, a green landscape and wide, wide shoulders on the road; the people were kind to a fault and, of course, there was that old bag o' bones I'd encountered on Highway 70 that we named Hope, after saving her from the wrong end of a farmer's gun. How could I feel anything but warm and fuzzy about being back in the Nature State?

I'd broken this final leg into three sections: the Deep South, which I'd just completed; the South Central of Arkansas, Oklahoma and the Texan panhandle; and finally the desert awaiting me in New Mexico. So began the second section, the flatlands, and it was surprising and somewhat comforting that it played to type, with the bare fields and leafless trees giving a feeling of endless space, only punctuated by the odd grain silo and lone farmstead. I set a course for Wynne, the City with a Smile. I'd fit right in there, I thought.

The Arkansas roads served me well as I clocked up my first forty miler, and a murmuration of starlings ducked and swirled

371

into all manner of shapes above me, at one point cleverly taking the form of a flying pig on the sky for my amusement. Or maybe my eyes were playing tricks on me. Soon after, an arrowhead of geese streaked south across the blue canvas; I would see thousands of their buddies resting in the fields later, before I found a pair of plastic duck wings on the road. They made a fine hood ornament for Pramsolo.

I arrived in Bald Knob. Signs hammered into the roadside implored the locals to vote for Pat Garrett as County Sheriff. The same fella shot Billy the Kid in 1881 in New Mexico, so if ever there was proof that Arkansas was good for you, this was it.

Highway 31 could have been the road to Romance for me, if I wasn't heading straight across it, bypassing the town with the best name I'd seen a sign for since, well, Bald Knob. The five-mile detour in the direction of the town's post office to send a Valentine's card home just for the cool postmark was a few too many. Romance just wasn't on the cards.

My shadow loomed large on the morning of 2 February. It was Groundhog Day, and the legend goes that if the groundhog were able to see his shadow, it would mean six more weeks of winter. I decided I'd take six weeks of winter in return for six more weeks of running, especially as I was now back in the groove at 80 per cent of my top pace, with only an occasional grumble from the pins.

I headed deep into Pope County and passed New Hope, sending my thoughts back to that special dog Nads and I had rescued and fallen for, who was now adopted and chasing her tail somewhere in the Massachusetts snow.

Along with Nuclear One, Arkansas' only nuclear power plant, whose main evacuation route provided my morning's miles, the state seemed to have a lot of classic car junkyards. I spotted two

old Jaguars, side by side, rusting away their days in a crowd of American jalopies. I passed the Arkansas chapter of Boozefighters Motorcycle Club, which I presumed was steeped in sobriety but was quite the opposite. They're big fans of booze *and* fighting, so woe betide you if they cross you, especially seeing as Robert Patrick, famous for being the T-1000 in *Terminator 2*, ranks among their members.

Lunch was at a local independent restaurant brilliantly named Dinner Bucket. Debbie and the good folk of New Blaine's finest eatery not only picked up my tab but sent me off with a goodie bucket, the *pièce de résistance* of which was a slab of chocolate cake so exquisite that it made up for my dinner being unexpectedly covered in that white stuff they call 'gravy' in the South. I could handle the alternative spellings and the fact that 'pavement' here meant the actual traffic lanes of the road rather than the sidewalk, but I simply could not have gravy's good name being tarnished in that way. America, it's bad enough you calling those crumbly breakfast breadcake things 'biscuits'.

I ended the day in a budget motel where I had to politely explain to the chap at the desk that I was unable to tell him my PIN number so he could input the digits, as it's meant to be a secret. There was quite a standoff, but he eventually relented and handed the card machine over in what was a major leap forward into a brave new world.

Forty-three miles away lay Fort Smith, the second-biggest city in Arkansas and the final frontier before Oklahoma. The country was showing signs of grinding to a halt for the Super Bowl, the biggest sporting occasion in the land, and the only way I would make it in time would be to maintain discipline. I used a new motivational tool, breaking my day down into four 'downs', like American football, with the aim of touching down on a bar stool

by 5.30 p.m. Waves and greetings followed me throughout the day, and I even had time for a shower before I headed for the Bricktown Brewery, an Oklahoman institution that had sneaked over the state line, to watch the game. A seasoned barfly and adept at sticking out like a sore thumb, I made friends fast while the Philadelphia Eagles managed to win their first-ever Super Bowl title. Most of the country rejoiced in a genuine underdog triumph.

I imagined a good few Philadelphians would be nursing a hangover in the morning while I was up at first light and finally took a look around town rather than at the minutes ebbing away on my watch yesterday afternoon. The city was bedecked with street art, with whole buildings being turned over to murals depicting a modern take on the city's Western and indigenous past; hidden sculptures emerged from around the corner of a parking lot and giant arrows, fallen from the sky, dug into the earth of a central green, a mile shy of where some giant Cherokee might have fired them as a parting shot to his imprisoners.

I too had to leave Arkansas, with as heavy a heart as before, but this time I was in better shape, ready to sample more than a bitten-off corner of the Sooner State. Better late than never.

Chapter 56

GETTING MY KICKS

Oklahoma
Days 390–99
361.34 miles

As I sipped my strawberry malt shake in Bubba's Dairy Bar (I haven't made the name up, *Forrest* fans, I assure you), elbows leaning on my red-and-white-check tablecloth, I imagined generations of cheerleaders hopping out the back of a top-down Cadillac, sassy waitresses topping up the local sheriff's coffee, teenage love, two straws in one drink and football players shelling dimes into the Wurlitzer for Bill Haley to rock the clock and everyone within earshot.

Oklahoma. I revelled in the openness of the land and the towns that I'd never heard of and instantly loved, such as Muldrow, Sallisaw and Vian. This was the Oklahoma I'd wanted all along.

I crossed the Arkansas River for the last time. Everything seemed so final now. Any goodbyes would be just that, no chance of returning and seeing the same smiles again. I recalled the words of Paul Wheeler, another crosser, who said he spent a lot of time wishing the days away until he got within sight of the end and wished he hadn't. Now I could feel them slipping through my fingers like sand.

I was in a rush to get to Oklahoma City for a flight to Vegas and then upwards to Salt Lake City, where one reunion definitely was going to happen. Jenny was approaching the final stages of her repair, and if there was any chance of Nads and Bee joining me in a couple of months, this was my chance to move Jenny to Flagstaff, Arizona, for the finale. Before I could hope to see my girls, though, company was on the way in the form of Simon, the playlist maestro and sneaky GoFundMe promoter, Rich Beer, who'd run with me across Arizona way back in 2016, Ian, a Liverpudlian known to all as Biscuit, and Paul, a Mancunian dead ringer for Enrique Iglesias, also known as Post. They'd offered to do the driving legwork and we were set for a road trip if I could hold it together for another 150 miles.

If that was motivation, the news over breakfast that freezing rain was on the way certainly wasn't. I'd half-wondered if I'd encounter a tornado during my time in Oklahoma, but whatever freezing rain was, it sounded pretty awful. I was glad of a quiet heater and a warm shower but also a ray of Australian sunshine arriving in the form of Amy, one of my former students at the University of Melbourne, who was now studying to become an equine medicine specialist at Oklahoma State. On the drive back from dinner, the freezing rain hit and I saw what all the fuss was about. Water falls as rain but forms ice as it hits the ground, which was terrifying in the car. Australia might boast its deadly, poisonous creatures but this kind of thing never happened Down Under.

The next evening, while taking a warm shower after a cold day – I'd only just got the feeling back in my face – at the Green Country Inn, I got a serious-sounding call to go back to the front desk straight away. I racked my brains, wondering what I could have done.

'Is everything okay?' I asked the lady at the front desk, trying not to feel self-conscious as a couple of guests stared at me curiously.

She smiled at me. 'This lady and gentleman would like to give you something.'

The couple stepped forward and gestured to me. 'These are for you.'

I looked down at their gift and broke into a childish grin. 'You never know what you're gonna get!' I replied. A box of chocolates.

'You must have people do this all the time, right?'

'Nope. You're my first!' Astoundingly, it was true. Of all the acts of generosity I'd received over the past sixteen months, including a number of Forrest-themed gifts, I'd never once received a box of chocolates.

Freezing rain one day then sunny skies the next. You really do never know what you're gonna get. I stepped out into the Oklahoma winter and took off my hat, then my gloves, and by the end of the first run I was down to a T-shirt and one pair of leggings. It was positively balmy on Route 62, the inter-state temporarily abandoned as I headed to Okemah, the birthplace of the folk music rebel Woody Guthrie, a writer of songs that framed America in its place then, now and maybe in a thousand years' time, and was to Bob Dylan what Elvis was to the Beatles.

Okemah was a town that, if not frozen in time, was slowly fading away out of the corner of your eye. I passed a sign for Marvin's Place – 'Where the West really begins' – the former residence of Jim Shoulders, the sixteen-time world rodeo cham-pion. What a name, what a guy. Okemah felt as though it were gently falling asleep, with many of its stores boarded up, but

once a year the town came to life for the annual folk festival held in Woody's honour.

I visited the site of his former house, where a bare patch of earth and a side wall remained, and a tree carving read, 'This land is your land', repeating Woody's mantra to all those who call America their home. I read about efforts to rebuild his home on the original site and realised that I might have been wrong to think of Okemah as decaying. Instead, I guessed it was only breathing out, in the constant cycle of expansion and contraction that has and will be played out in towns and cities all over this huge country. The diner where I stopped for lunch had more than enough people ordering their hash browns and coffee. I was probably sitting opposite one of the people who would hammer the nails into the boards of the rebuilt Guthrie home. I resolved to make sure I ate in home-spun diners like this more often.

Ten miles down the road was the town of Boley. A historical marker described it as one of the first designated 'black towns', after a roadmaster convinced the local railroad that 'blacks could govern themselves'. It made for uncomfortable, embarrassing reading. The freed population made a great success of the town until the railroad went bust and trade went elsewhere. Though it had long since moved on from being an exclusively one-race town, the only industry of note left now, tragically, was a correctional centre. This felt like a bad metaphor.

Woody Guthrie, way ahead of his time, wrote about the disparity between rich and poor, black and white, and of a lynching of a mother and son in the area who were accused of killing the local sheriff. It was alleged that Woody's father was part of the mob that took part, which made it all the more remarkable that he refused to let this lie and spoke out at a time when it wasn't easy to do so.

It's crazy to think that we're still not at the end of the road that Dr King talked about, but when you think about how dark the night had been, the despair people felt when they were starting down that way is hardly surprising. For such a young country, America had an incredibly complex past.

If yesterday was where the West began, this was where spring appeared desperate to gain a foothold. Sitting in the sun, I was greeted by a little canine friend. I don't think she was a stray, as there was a small settlement just over the rise, but she was heavily pregnant and looking as though she could do with a bit more sustenance. I still had a couple of tins of cocktail sausages from the goodie bag I received from the Dinner Bucket, and my little friend needed no second invitation to polish them off.

It was time to put my foot down, to reach Oklahoma City and my flight to Las Vegas. I was excited to see my friends and I wondered what it would have been like if they'd joined me for the whole run. I had a sneaking suspicion that we might not have got much further than New Orleans, never mind five whole crossings.

Good news came from the newsroom itself, with CBS Washington anchorman Adam Longo, who had covered my story back in DC on leg 2 and stayed in touch since, delivering the bulletin that his wonderful aunt Lori was happy to give Pramsolo a home while I was away.

A few hours later, I was in Las Vegas with my friends. I don't know if it was the time difference, the day off from running, the amusement of photo requests from tourists who didn't know about the run but sure recognised who I looked like, the oxygen that they pump into the casinos or just all-round excitement, but we were up until 4 a.m. It was a relief to relax and not monitor

every twinge of discomfort, and then sleep in a way I hadn't managed since being back in the US.

Despite everything it tried, Vegas would not blow this mission off course. The original plan had been to pick Jenny up in Salt Lake City and deposit her in Arizona for the big finish, but news had arrived that she'd not been fixed and, worse still, the insurance company might write her off completely. I still needed to head to Salt Lake City to pack all my remaining belongings, in case this was a final goodbye, so we headed towards Ely on Highway 93 in the SUV hire car, which would become my support vehicle in a few days. The excitement of being back in the desert filled my soul, and instead of fretting, I decided to take on the role of a dedicated tour guide.

We went past the crash site in Nevada, and I retrieved a piece of broken indicator light as a memento. While we were standing there, Biscuit suddenly took off running down the road. It was completely unannounced and the rest of us watched him disappear into the distance, wondering what had got into him. He just kept on running.

We got back in the car and caught up with him and he hopped in. He must have run a mile. 'I just wanted to see what it was like for you, on the old Pony Express route,' he said with a beam. He got it, for sure – the desert wind, the thrill of isolation in the vastness of the desert. I was glad for him that he wouldn't experience the injuries and hardships too.

The less said about Salt Lake City this time the better. There was no definite repair date for Jenny, which meant I couldn't even plan for the finish. It had, staggeringly, been the best part of a year since the accident. I despaired at the pile of once-essential kit that was now no longer required, and I was frustrated that this stopover was such a waste of time.

We set a course back to Oklahoma City as quickly as possible.

I revelled in having a support crew for a few days, and the way back delivered Arches National Park in Utah, with the famous red earth covered in a blanket of snow. We were among only a few hardy souls who were lucky enough to see the Park in such an unusual state. That night we went for a 'romantic' Valentine's Day meal in Oklahoma City before I would return to my toughest mistress, the road.

A couple of my friends are not the type to stay in the kind of hotels I'd been frequenting on the road, and I didn't complain when we stepped up the quality level in the city. But it made for a strange start in the morning – I'd never taken a cab to a restart point before.

This was the last full day of our five days together, so my support crew decided to join me for a run or two. Biscuit was first up, and he joined me in the humiliation of missing all three of our free throws with the local Fire Department, who were facing off on the basketball court as we ran past. My NBA dream was confirmed as over before it began – *again*. Post and Si completed a few miles between them and had their names etched onto the bottom of the leaderboard of those who had run the most miles with me during the trip. Aunt Lori joined us in the evening to reunite me with Pramsolo, and pizza, ale and live music followed.

Cometh the hour, cometh the man. Making his comeback into the running arena was Richard Beer, eager to cement his place at the top of the leaderboard. He clocked an impressive half-marathon with me, before he had to call it a day, as he hadn't been feeling well. I would later learn that he needed oxygen on the way back home, and the illness in question was in fact pneumonia. True grit.

To top things off, I got to see my very first living, breathing armadillo – my first on this trip. It appeared on World Pangolin

Day, but who's counting? I could understand why they got run over. They can run at a fair click, but you have to get pretty much within touching distance before they'll bother. I nudged him north, helping him get off the road as quickly as he could be encouraged.

The company of my friends had made the past days feel free, and I was sad to see the boys go. I wished they could have stayed longer, but now they were gone it was back to the old routine of getting myself from Oklahoma to Texas.

A wonderful fella named Nelson Anglin, who had been following the run ever since I'd been in Kentucky, messaged me and offered to pay for my next two motels en route, in return for one thing: 'The only thing I ask is that you share the message that there are still good people in this world. People that still care about people. People that still want to help people. That all the negative we hear about instead of all the good in this world isn't a true representative of what I really believe people are capable of.' I responded saying that I'd like nothing more.

I was at the point where America turned from green to brown on the map, though winter had blurred the lines a touch. Barring the signs at the side of the road, there wasn't much to separate Route 66 from many other rural roads in Oklahoma. This took me past the 'Lucille' gas station, where the owner Lucille Harmon, known as the Mother of the Mother Road, would often barter with or give free gas to migrants from the east heading to the West Coast in search of work, and was famous for serving ice-cold beer to the residents of nearby Weatherford. The gas station became a tourist shop when Lucille passed in 2000. Still, it stands as a monument to a way of life in a country that has migration woven into its fabric. Outside, a quote on a marble plinth from 'Oklahoma's Favorite Son' Will Rogers asked, 'What

constitutes a life well spent? Love and admiration from your fellow men is all that anyone could ask.'

Cheers, Lucille. Cheers to the guy who came up to me with twenty dollars as I lay in the sun on the grass at Love's Travel Stop, after he'd seen the news article. Cheers to the two families who offered to put me up for the night, having seen me on the Route earlier in the day. People did care, Nelson, and just like you, people still wanted to help.

Nowhere is perfect, of course. I woke up to the first news broadcast I'd seen about the Stoneman Douglas High School shooting in Florida, which then cut to a commercial for a gun and knife show. Surely I wasn't the only person to think that was deeply inappropriate? It was one area of American culture that I'd never get used to, and I tended to keep quiet about it when talking to people, unless I was certain we shared the same views.

Out on the road, I fiddled with the dial on my radio to pick up the local station, which today was KKZU the Zoo – 'Rockin' on Route 66'. A guy pulled up to see if I needed a ride just as Radiohead began singing a heavily censored version of 'Creep'. Despite quite fancying the idea of becoming a hitchhiker on the coolest road in the world, I thanked him with a smile and moved on. Thom Yorke was singing about not belonging here, but I didn't feel that way any more. On Route 66 I was part of the scenery, and just by being here I was adding to history in my own little way.

Chapter 57

PANHANDLIN'

Texas
Days 400–04
182.97 miles

The radio started to crackle as I got further away, and one of the last things it provided was an ominous weather forecast of a huge thunderstorm thirty miles to the east. In front of me the beginnings of a sunset were being painted across the sky, but you had to look behind you once in a while or you'd miss half the beauty. There it was: huge red and purple thunderclouds in the distance, with lightning bolts smashing into the Oklahoman dirt and thunderclaps that suggested it was far closer than thirty miles. Welcome to Texas.

The storm spirited spring away, leaving behind an icy wind that laughed directly in my face and temperatures as low as −17°C with windchill in the following days. I had to switch off a CNN debate between the students of Stoneman Douglas and the gun lobby, thanks to the NRA representative appearing to live in some sort of alternative universe. Did NRA stand for No Rational Arguments? I gave similar treatment to coverage of a pro-life organisation endorsing an electoral candidate who stated that all abortion, regardless of reason, was an act of evil.

There were some aspects of America that I would never see eye to eye with.

I found more sympathetic voices when I took a break at the gateway to the Peace Farm, situated adjacent to the Pantex nuclear weapons plant, the biggest place of assembly for nuclear weapons in the Western world. The farm stood as a 'visible witness against' the concept of nuclear warfare.

I passed through Amarillo and Cadillac Ranch, where ten old Cadillacs jutted out, half-buried in the ground. Visitors were encouraged to paint these cars with their own art and messages, but with the shadows lengthening and the news that I was going to meet legendary runner John Peele, I decided to leave channelling my inner Banksy for another day.

John had, along with Brian Hassell, run from Daytona Beach, Florida, to Santa Monica in 1977 on a completely vegan diet. John was grilled about his run by the *Forrest Gump* film-makers. From my experience thus far, the film appeared to be an incredibly accurate representation, from the change in Forrest's running style as he progressed to the wonder at the environments he found himself him, the eclectic nature of the people he met and, of course, the fatigue he felt at the very end. It was an honour to have John along for the morning.

At lunch, I checked in on Nads, who was just over a month away from D-Day. Some days, like today, I just missed her like crazy, and I felt guilty about her being on her own. I was mightily relieved to hear she was in good spirits and with no worries to report. It still didn't stop me from feeling pretty useless from this distance.

The town of Adrian was my goal today, the exact midpoint of Route 66 – 1,139 miles from Lake Shore Drive, Chicago, and the same to Santa Monica Pier. I stayed at the Fabulous 40 Motel, where the new owner, Ramona, was trying to breathe a bit of life

back into it after taking over a bit of a wreck. She gave me the best room in the joint and told me to get comfortable there or in the clubhouse, where a great breakfast would be on offer in the morning. I gave in readily to sleep, knowing that tomorrow I could say I'd run across Texas in *five* days this time. The desert of New Mexico awaited.

I woke in the small hours of Friday morning breathing heavily, and before long nausea overtook me and I spent the rest of the morning doubled over in the bathroom. I had picked up a stomach bug from somewhere – undercooked chicken, maybe a bad hotdog? – though I knew that, realistically, it could just as easily have come from touching the wrong doorknob. Rather than searching for blame, I concentrated on not dying and sipped water in between clocking up the miles over the three yards to the toilet and back. I wasn't going anywhere soon.

I was forced to wait the situation out. Saturday rolled into Sunday and I was still feeling wretched. I couldn't face food, let alone keep anything down, and I was unbelievably weak. I kept the worst of it from Nads to stop her worrying, and seeing as I could hardly string a sentence together there was little point in phone calls anyway. I made just the one, to Thaivi, who, as an ER doctor, was well placed to advise me of the way forward and allay my fears of running up a huge medical bill.

It looked like Texas wasn't ready to let me go just yet, as Sunday became Monday then Tuesday. Even though I was well enough to cross the road for supplies, there was no way I could run or be out on the roadside with my intestines like this. Ramona looked in on me and checked I was doing okay, and she dropped in an envelope containing an expressly couriered parcel of every gastrointestinal drug worth its salt, all the way from my angel Thaivi in Marietta, Georgia.

Spending several days bedridden at least afforded me the

opportunity to evaluate my plans. Bee was due in four weeks, on 27 March, and I had a flight booked from Las Vegas to Atlanta and then home in seventeen days. While I could still reach Monument Valley in that time, Nads and I had already decided that as long as we could get a passport in time for baby Bee, they'd come over with me for the grand finale and make my dream come true, so I needed to decide where I would draw to a temporary halt. 'I'm pretty sick, I think I'll go home now' was not the way I wanted this scene to end.

My mind was cast back to my original goal, to run 15,248 miles, almost five times across America, and see if Forrest's run was possible. I was so close now, about 450 miles. I could certainly do that *if* I could still hold it together. A marathon a day, roughly, for two and a half weeks. It sounded difficult on paper, but I did have a decent weight of evidence behind me by now to prove it was possible.

On Tuesday, I went to the desk to hand over another night's money to Ramona. She shook her head and said, 'You've paid enough. Rest up. Get well.' I owe her eternal gratitude. She was deep into renovations and I know that money would have helped, but her compassion ran deeper than her need for another hundred bucks.

Wednesday morning, I woke up and felt great. Time to test life on the road. I rummaged through my bag and fished out a pair of shorts and a T-shirt. Pulling on my running shoes for the first time in a while, I ran half of a mile into town, then back, repeating it another two times. All was well. Walking back to my room, the field of distant wind turbines blinked red and disappeared, before twinkling back into life, like a sinister intermittent constellation, echoing the last time I'd camped, way back in Wyoming. Tomorrow was the day. Tomorrow was going to be a good day. Of course it would be. A friend was on the way.

Ben had come to capture the final days of the run. Normally I'd have hugged him, but it was probably best avoided, all things considered. Ramona, excited and clearly relieved not to have to call an ambulance or a coroner, ensured that any words I had were difficult to get in edgeways. She didn't care about catching what I'd had and gave me a huge hug goodbye before she returned to work on the Fabulous 40.

Before the sun set on the first day of March, Ben and I got going. Thanks to the last five days, I was lighter on my feet, having lost over six kilos – or thirteen pounds, if that's your bag – but at least I had moral and logistical support once more.

I loved Texas with all my heart, but it was time to say goodbye, with the mid-point of Route 66 providing start-line perfection. New Mexico was less than a marathon away and Old 66 would fizzle into dirt, putting me onto a Texas interstate for the first time since I'd panicked my way over a desperate mile-long stretch into Beaumont, less than 500 miles into the journey. As I later discovered, it's completely legal to run on the interstate in almost all of Texas, so I'd worried and rerouted at times for nothing. Looking back, I'm happy to say that ignorance was bliss, thanks to the countless encounters, stories and memories that would have passed me by if I'd blazed a trail down the interstate looking for home comforts while my best life would have been lived a few miles away in Smallville, Texas. Life lived at a slower pace is life lived to the fullest.

Chapter 58

FROM THE BOTTOM UP

New Mexico
Days 405–14
400.91 miles

Aid packages: last pair of trainers from
Johnny Wildhorse

By the abandoned post office of Bard, a fully deceased ghost town, I pulled out my holdall from Pramsolo's midriff, took off his left wheel and collapsed the frame down after a short but sweet foray into the desert, packing him into the trunk of Ben's hire car. 'Thanks for getting me here, buddy,' I said under my breath as I withdrew him from active duty. Seven thousand miles, seven punctures, one new set of wheels, a catastrophic double frame break, two-and-a-half thousand miles ago and a multitude of cargo lost en route; through water, mud, snow and now, hanging your wheels up with the desert sand in your treads. You'd been the most faithful of friends. Happy retirement, Pramsolo. You were the best of us. I might have a different job for you in the future, though.

Ben and I got on like a house on fire, though his snoring was an issue when we shared a room and we soon came upon some

'creative differences' about how to collect footage for his documentary. When I got talking to a fella heading to Austin for the South by Southwest music festival, we shared some mutual beard admiration and I learned about a way of cultivating crops using a supercomputer and his writing of a book about how we're all being controlled by a police state. When I sat down with Ben afterwards, he said, 'That would have been really good to have recorded. Reckon you can wear the radio mic all the time?'

My face fell. 'Er, I'd rather not, mate.' I was tired and not in the mood to have every grunt, pee behind a bush and out-of-tune song I sang along to recorded for posterity. Having just freed myself from the burden of pushing Pramsolo, carrying a mic pack suddenly seemed like unnecessary weight. In my breaks, I liked to zone out and chat with locals and friends. I needed this time to be relaxed and unstructured, not a deep dive into my emotions. I realised that I'd have to compromise somewhat, and I respected Ben and wanted his time to be worthwhile, but he'd caught me at a bad time. The problem was that, having come this far, I knew there would be more of those on the way.

A barbed-wire fence kept me straying from Old 66 into the barren fields, and for a stretch it was adorned with around a hundred running shoes, tied on by their laces. I had none to spare or I might have got involved. At the centre of this bizarre monument to the athletic life was a placard whose left side had been covered with another sign praising the Lord for 'Blessing the USA with a good, godly, wise, budgeting, protecting, humane political leader: President Trump'. I wasn't sure how many of those adjectives stacked up, but it definitely wasn't *all* of them. The right side offered some sage advice at least: 'Let us run with endurance the race that is set before us.' That was good enough for me.

I was happiest when I was running freely. Finally, I was seeing the towns I'd spent miserable hours looking at from my sickbed

jump from the map and into my view. I even saw my first cactus in almost six months. I'd been thinking of a way to help Ben out, and I suggested getting a hydration pack to attach the mic to. It would also be useful for me now that I didn't have Pramsolo. Ben was thoroughly in favour. Crisis averted.

Next came Santa Rosa on a tranquil, deserted old side road. Each hop to a new town meant forty or more miles passed by with barely a sign of civilisation off the asphalt. With my eyes wandering over the empty surroundings and music on loud, I could drift off to wherever my mind wanted to be. More than ever, it went back home to Nads.

A new steely focus had set in. I'd found a new rhythm that was propelling me forward like never before. I was in the zone, only a few miles from my day's end, which promised ice cream. I saw a trucker pull up on the hard shoulder and get out. Assuming he'd had some sort of mechanical issue, I was about to call out from my vantage point to check if he was okay. Before I could, he turned to face his truck and pulled down his pants to reveal his big hairy butt and family jewels, then proceeded to lighten the load. My eyes are still burning from the unwelcome sight, but as I ran past, I thought to myself: 'S**t happens, sometimes.' I'd been there before.

Ben and I were sharing a room, and his snoring – first following his flight, now following a couple of beers – was becoming a problem. It made me tired and grumpy – as if my mood swings weren't already wild enough – and I found it hard to be sociable to a generally chipper Ben, who, of course, wanted to capture everything, true to life, which was the last thing I wanted to be doing. *Can you just let me sit here quietly, eat some rubbish and read the news on my phone?*

Today I would reach the 15,000-mile mark. The sign that Nadine had made for me 13,000 miles previously was set for its

last engagement. This sign reminded me of her, and it felt like our moment. Even though she couldn't be there, I wanted to save this just for us. Ben knew the marker was coming up and wanted to film it, of course, so I came up with a plan that would allow both things to happen – or so I thought.

As I approached the final few hundred metres, Ben pulled alongside me. 'Where are we doing it?'

I pointed down the road. 'About a mile down there, there's a good turning point for the car.'

Ben nodded and drove off. I held up my watch to see the day's total tick to 31.47 miles. This was the 15,000-mile marker. I set my camera up on a fence and had my moment. This was for me and you, Nads. I took a moment to absorb the enormity of running 15,000 miles. I couldn't believe I'd come this far and my journey was just a few days from completion – only 248 miles away. But what I'd hoped would be a celebratory moment turned into a complete anti-climax. I felt bad for misleading Ben, even though I'd made the right choice for me. Guilt was a powerful thing.

Ben was waiting for me at the spot I'd sent him to. 'Where've you been? You've been ages!'

Nothing for it but to bite the bullet. 'I wanted to take the photo with just me. We can do it again now, though.'

Cue apoplexy. If I'd hoped Ben would be content with a secondary photoshoot, given that most of my measurements and landmark distances were not 100 per cent accurate anyway, I was sorely mistaken. He was furious that I'd not been straight with him.

All I could do was apologise, explaining that this was a hugely personal thing and I'd been struggling emotionally the last few days. Ben had been keen for an as-it-happened documentary, and I'd undermined his trust and the project's integrity. I should have

appreciated how much he'd been looking forward to the moment too and, on reflection, I ought to have brought it up with him earlier.

Ben left for the motel and I ran on, thoroughly deflated. When I arrived at the motel after dark, I was relieved that it appeared he, like me, wasn't one for bearing grudges. He smiled as he let me into our room, then said, 'I think I've just seen a bedbug.'

When he described it, I thought it sounded too small. Too jumpy. 'That's a flea. Not good.'

My leg was itchy. Though I'd been in the room barely two minutes, I'd already taken three bites on my calf. 'We're not staying here, Ben. I'll go and have a word.'

One refund later and we were in another motel a mile up the road. I went out for a food run and returned with corn dogs, drinks, bananas, chocolate and a swiss roll as peace offerings. There was a police car outside, so I asked the lady at the desk why the police were here.

'Some guy came in and put an AK-47 bullet on the desk, said it had my name on it then walked off.' She said this completely deadpan, as if I'd asked her about the weather.

Out of the frying pan, into the fire. Every day was an adventure.

Albuquerque, deep in *Breaking Bad* country. I did pass through one area featuring boarded-up buildings and angry meth users berating me at street corners, though it wasn't really representative of the place. I photographed a fast-food joint called the Dog House, complete with neon dachshund, only because I liked hot dogs so much. Later, I learned that it featured in the final series.

My troublesome groin flared up again. I managed two miles before I caught up with Ben, who had gone ahead to scout locations. I found him talking to a homeless man lying on a mattress

in the dirt at the side of the road, beyond the city limits. Ben gave him the second half of his pizza that he'd saved for lunch, an insight into the kind nature that I'd come to know.

Running took a back seat as I walked at a snail's pace over the historic Rio Puerco Bridge on Old 66, with its retro pit stop watching the cars hurtle down the interstate past the glitzy 66 Casino. Walking pace felt right, given my surroundings, so it continued until a marathon was on the clock.

Though my stretching was relatively pain-free that evening, I made the decision not to even attempt running for another day or two. I was feeling more fragile as the days went on, and at this late stage I didn't dare risk having it all crash in on me. I was destined for a lonely walk down the interstate.

Time seemed to ebb away when I was walking compared to running, and any distance goals always ended up being over-ambitious. I accepted my fate and made the best of my relaxed pace, calling Nads to keep myself company. Bee was now due in twenty days, and Nads was getting a little anxious about her arriving early. I firmly reassured her that if there was any movement I'd get Ben to rush me straight to the airport and I'd be back by her side within twenty-four hours, whatever it cost. She also told me that she'd painted Bee's room, which made me sad that I wasn't there to help, but also really proud of her.

San Fidel, with its collection of ruined Spanish-style buildings, felt Mexican. Frontier. Real. Trailers nestled in the scrub, in the middle of nowhere. I wanted to knock on their doors and hear all about their stories, why they came, why they stayed. Ben was waiting in the dark, three miles west, at an abandoned motel – just after the abandoned gas station.

It had been two days of walking and careful stretching, so gradually I started to throw some running back into the equation. If I got rushed back early because of Bee, it made sense to

make as much progress as I could handle beforehand. The same struggle against decay was raging in Grants, with the fresh lick of paint on an old motel being jealously regarded by the establishment over the road where weeds, peeping through broken windows, were now the only customers. Not that the town was going down without a fight, with a new drive-thru monument allowing you to frame a photo of you and your ride for posterity, while a mural of a chopper rider made me want to one day ride through here, Dennis Hopper-style. I can't even ride a motorbike but I'd bought the leathers in my mind already.

There was something cool and iconic in all this decay around us. Ben revelled in it too. 'Bloody hell. This place is incredible,' he said. It didn't get better than drinking beer in the Route 66 Junkyard Brewery, in a graveyard of classic cars that would have lived and maybe even died on Old 66 when it was no more than middle-aged. There was probably a driveshaft or hubcap somewhere in there that had even seen prohibition.

I went over the Continental Divide for the final time, where the last of the snow hid under the bushes, 7,245 feet above sea level. Yet again, it was all downhill from here. Running was free and easy, and though I barely broke beyond a canter, it made up the majority of my progress to Gallup, purportedly the most patriotic town in America in 2013. While the Stars and Stripes dominated, it was maybe the poster saying there would be 'Hell Toupee if people messed with the USA' that did it. I couldn't imagine what they were implying.

Despite Ben's excellent company, I was running out of steam. I was injured and I was ready to see Nads again. Opposite Speedy's Truck Stop on the Arizona side, the last state I would run clean across, I did my penultimate Lean of the trip and, I felt sure, the last I would do alone.

Chapter 59

A LINE IN THE SAND

Arizona
Days 415–17
120.24 miles

In Speedy's Truck Stop I caught the eye of a Dutch couple who were travelling the whole of Route 66 in an RV with their eight-month-old daughter. I shared my journey with them but was far more interested in theirs and how they coped with having their little one with them – an eye on the future.

In the morning, according to my calculations, my mileage would reach 15,248 miles, the distance Forrest ran. I made sure Ben was fully in the loop this time, but he must have thought his luck was out when, inside the final mile, the road disappeared and I continued onto soft sand.

There was no way I would leave him behind this time, so I waited for him and jogged slowly, so he could jog with me, carrying his camera. The full end of the run in Monument Valley, if it happened, would potentially be a circus. With just the two of us here for this finish, it was the purest, most intimate way I would experience the end. The grand finale could be the party; this, to me, was the official stamp, the commemoration. Whatever happened after this point, I couldn't go wrong.

My eyes were fixed on my watch: 0.2 of a mile to go … 0.1 … and then – nothing. Here I was, 15,248 miles, the distance from the North to the South Pole then throw in a run from Santa Monica to New York on top for good measure. The question had been asked: could Forrest Gump have possibly survived his epic run? The answer had arrived just outside the Petrified Forest National Park.

I took a photo of my feet at this line in the sand. I traced the words 'Gump 15,248' in the copper earth and silently thanked all the people who'd helped me achieve this goal – Nads, of course, but also the countless people who had offered kindness, companionship and support. My breath froze in the air and sweat squelched in my shoes while I dwelt on the pain and the injuries and the stunning landscapes of the most diverse nation on earth. Then I thought about my mum and wished that she were here too.

Ben understood the enormity of the situation for me and had remained at a respectful distance, camera whirring away. I sank down on my haunches and a giant lump formed in my throat. I was breaking down in tears, but to prevent me from making a complete spectacle I took out a Sharpie, headed to an iron girder sticking out of the ground and wrote:

Rob Pope was here.
15,248 miles run, just like my best good friend Forrest Gump, for WWF and Peace Direct.
12 March 2018
All you need is love.

It was, of course, a finish without a finish. Over the next few days I continued running towards a last landmark before going home, the perfect place to place my bookmark. The Twin Arrows

Trading Post was the scene of Forrest being muddily drenched by a big rig driving through a puddle. An enterprising guy looking for an idea for a T-shirt gave him a yellow one to wipe his face, as 'nobody likes that colour anyway'. Have a nice day? Yes, I did. In the spring Arizona sunshine I felt the joy of every runner who was out on the trails or roads that day without a care in the world, loving what they were doing purely for the essence of it. I was bordering on euphoria for almost two solid hours, and for someone who loves to run but is prone to raising an eyebrow at the notion of the oft-mentioned 'runner's high', I was happy to go with it.

The Twin Arrows was a sorry sight. The casino of the same name on the other side of Highway 40 had taken the trade and now the site lay in graffiti-strewn ruins, windows smashed and forecourt overgrown, though the two twin giant Navajo arrows stood defiantly, embedded in the concrete. As I leaned on one of the arrows, on my last full day on the trail of Route 66, I swear I could hear the opening salvo of 'Johnny B. Goode' on the breeze.

The lap of honour, the full stop, the *moment* would be another five or six days from those Twin Arrows. Exactly when that would be was still very much in the air. First, I was flying home. Bee was due in twelve days, and we had to get through that before I made any formal plans for the grand finale. Despite that, it didn't stop my last ever couch-surfing host of the trip, Elliot Alford, who took me and Ben to celebrate in Historic Brewing, nor the bartenders, Ethan and Austin, from rashly pledging to show up, whenever it was.

Ben and I would part ways in Las Vegas. He was going home to his fiancée and a mountain of editing. And me? I had decided on one final mission before heading home to Nads and fatherhood. The slopes of Grandfather Mountain were now bathed in

nothing but sunshine, and I needed one more photograph for my *Forrest Gump* scrapbook. After a short hop to Atlanta, Thaivi kindly handed over the keys to her car for the five-hour drive to the Appalachians and the site of some unfinished business. I wore the obligatory Cortez and cap, long stripy socks, short red shorts – all topped off with a blue check shirt I'd known was perfect for the job the moment I was given it, in Cookeville TN.

I was above the trees, still with a little snow for company and rounding the Forrest Gump Curve, complete with a sign to mark the occasion where it was likely Jim Hanks (Tom's brother and running double for the film) did the same. I felt so many emotions at this point it was hard to separate them out, everything from pride to sheer wonderment at the beauty of it all, the velvet green hills rolling towards Tennessee, pricked by the odd snow-covered peak and the air as fresh as a melting glacier. But mostly I thought of Nads.

THE MOST BEAUTIFUL THING I'VE EVER SEEN

Interlude

I returned home to Liverpool to see Nads looking more beautiful than I'd ever seen her. She'd dealt with everything so incredibly well, while I'd been on what some might call a very personal mission. The living room was freshly painted, a nursery had emerged from the room where I remember sitting on my own grandfather's lap wearing my new Spiderman outfit on an early 1980s' Christmas morn. Nadine asked me if I felt tired. Mothers and mothers to be of the world, you have my eternal respect.

Just after midnight on her due date, Nadine mentioned that she felt a little uncomfortable. Baby Bee was on the way. Nadine's mum Sue, who'd made the trip from Kent, was woken, and Nadine's best friend Alice was summoned from across the Pennines in the dead of night. It soon became clear that this was going be less of a marathon and more of an explosive sprint.

Alice made it just in time, running from the parking lot to join us in the Liverpool Women's Hospital. Nadine powered through with the same resolve that got us through the northern plains, with only a touch of gas, interspersed with some ripe language. At 6.34 a.m. on 27 March 2018 we welcomed Bee Catherine

Pope into the world. I was glad that I'd learned a few days previously that babies are often born purple, as I think I'd have fainted otherwise, but as I looked at this 8lb 1oz of screaming plum on the delivery-room scales and then held her for a couple of hours, I knew that she was the most beautiful thing I've ever seen.

We received a humbling amount of love from well-wishers and became fully signed-up members of the sleep-deprivation club. I could have continued basking in the love, or let tiredness get in the way, but I was still conscious that I hadn't signed off at Twin Arrows. I couldn't break that promise I'd made to my mum to 'do one thing in my life that made a difference' in the first few days of Bee's time on this earth. I owed a grand, formal finish to the WWF and Peace Direct. I had to get to Monument Valley.

I decided that, if things went well, I'd attempt three competitive marathons in three weeks, with the aim of continuing my unblemished sub-three-hour record. And so, at twelve days old, Bee accompanied daddy on his first UK race in almost two years, at the Manchester Marathon.

I knew the fast, flat course shouldn't be too risky, despite my recent injury gripes. It was more the thought of recovering for two more that worried me. Pacing some local club runners from Liverpool to their first sub-three proved quite the honour and a 2:55:12 was comfortably under the mark. Brighton the following week was a slight step up in difficulty, but also importance, as it was the 'home' race of the WWF and #TeamPanda. Two passes under the famed Panda Bridge provided a solid 130 decibels of screamed encouragement that carried me to a 2:52:09.

The highlight of the day was undoubtedly a chance meeting with Nick Cave himself. He was politely listening to my going complete 'fanboy' when he took the time to peer into the pram carrying a sleeping baby Bee and deliver the following lyric: 'A baby. Nice!'

Lastly, and by no means least, it was the big one. The London Marathon, a race I'd completed nine times, going back to 1997. My mum had accompanied me on all my appearances up to her death in 2002. This time I sought to make another mark by attempting to become the fastest-ever film character to complete the 26.2 miles. I imagine you have a decent idea of which character I'd chosen. This came with the stipulation that I needed to wear identifying markers on my kit that this was an 'Official Guinness World Record Attempt' and the small matter of an interview with sports anchor Gaby Logan, live on BBC One, going out to a few million people. Things had gotten a little serious.

I had a 2:39 in my sights set by a chap dressed as Elsa from *Frozen*, and though I thought I'd have to let it go as 15,000-plus miles came home to roost a lot earlier in the course of the race than I'd have liked, I crossed the line in 2:36:28, whereupon I was congratulated by Gaby herself, who said she never doubted me. I rubbed shoulders with two of the greats of world distance running, Eliud Kipchoge and Mo Farah. Despite having run themselves into the ground, they were complete gentlemen and seemed interested in my run. Mo took a selfie of the pair of us. I doubt we'd ever be involved in a close photo finish, so I'd always treasure this instead.

That would be the first of many a selfie over the next few days, but if I'd hoped my new-found fame would provide an upgrade from economy class, I'd be disappointed. Nads and a four-week-old baby Bee, complete with a hastily arranged passport, were next to me.

The American immigration official still looked just as serious as the last one. 'Purpose of your visit?'

'Running across America. Finishing.'

Chapter 60

I'M PRETTY TIRED. I THINK I'LL GO HOME NOW.

Arizona
Days 418–22
209.51 miles

We met Ben at Las Vegas airport and our entourage was set to continue growing, as later that night we'd be reunited with Liv, arriving from Salt Lake City with a particularly honoured team member. Jenny had finally been passed fit to resume service. It was a special moment to step aboard for one final adventure together.

The nights were still too cold for a baby to sleep in an RV, and Nadine deserved a little more comfort, so while we would stay in motels, Liv would look after Jenny, as well as providing support duties once more. This time, she'd be logistics chief not just for yours truly, but Nads and Bee. It was a tough first night, with a tearful Nads trying to soothe a very confused Bee, who had woken at her usual UK time, barely an hour after we'd gone to bed.

At the Twin Arrows I clung onto the arrow nearest the road for just a little longer than intended before I set off. Though the adventurer in me wished for a few thousand miles more, the pull of home and new life as a father, with the knowledge that I was

not in the greatest of shape, kept me grounded and pushed me off. The concrete of the interstate pounded my quads, still sore from the London effort two days previously, before I escaped onto a dirt track that would deliver me safely back to Route 66 and a decisive right turn north, at Flagstaff.

Arizona in the daytime was markedly hotter than I remembered it, and whether it was a matter of the heat, hydration, the sudden need to be reacquainted with altitude, or plain and simple jetlag, I didn't know. I stumbled into town to the post office to collect a precious package, inbound from Brooklyn, New York. It wasn't the sort of item I could have left to collect some other time. Tearing open the packaging, I inspected the contents and felt its weight in my hand, before carefully rewrapping it and stuffing it into my waist pack, for the climb through the Coconino Forest to a height of 7,300 feet.

I only had four days remaining, but they would be touching on fifty miles and deserved respect. My first day back on the road felt harder than I remembered. However, I was rewarded by the arrival of Mathew, who with his mum, Lorene and sister Iris, had driven thirty hours all the way from Beaufort. He'd come to share in the final few days and to maybe, just maybe, capture that shot of a lifetime.

Mathew hit it off with Ben, and they became animated, enthusiastic collaborators in looking for the best shot. I left them to it mostly and focused on the spectacular sandstone buttes of Monument Valley upon our return to the Navajo Nation.

Orlando, a local from the reservation, had stopped by and posted about the run on the local social channels, which escalated into a visit from the local paper, the *Navajo-Hopi Observer*, and a near-constant stream of honks and whoops of 'Run, Forrest!' on the way to Tuba City. The area was the home of the Navajo or 'Diné' code talkers – one of the only unbroken codes

in the Second World War, created with their traditional language – a wonderful fact and a nod to the importance of maintaining indigenous culture.

A car pulled up around a hundred yards in the distance, and to my surprise out stepped Raimey and young Benjamin, all the way from Danville, ALA-BAMA, who attached themselves to the route as an official cheer squad for the remainder of the trip.

I met Jona, a Navajo farmer who still managed to run fifteen to twenty miles on top of his day job, even in summer, on the sort of terrain where rattlesnakes were melting on the road and sun-bleached cattle skulls were dotted in the red dirt either side of the asphalt. He had put in almost forty miles by the time he found me, because it was such 'a beautiful day'. We ran a few miles together – a request I'd never refuse – before he headed home.

Climbing to almost 7,000 feet, the desert became punctuated with greenery that the local sheep were making the most of while it lasted. I was investigated and then followed for a while by their sheepdog, until he'd seen this lone wolf off over the summit and down into Kayenta, the final town I'd run through. The final town. I said that over and over, first in my head and then out loud, when the sheer incredulity of it dawned on me and was deemed worthy of someone hearing it, even if it was only a long-nosed leopard lizard, a red-tailed hawk or the runner-eating mountain lions that were reported to have been watching my progress from the mesas that day.

I ran with Owl Rock on my left and the leviathan that was El Capitan to the east, rising from the desert floor like Liverpool's huge gothic cathedral. Although having a crew with me made for some exhilarating highs, there were many moments during these final days when I felt extreme sadness. I'd received awful news about a dear friend and former student of mine, Flynn Hargreaves,

just before I got back to the UK. As for far too many, the world had become too much to take for Flynn and he'd checked out. He was one of the kindest souls you could ever wish to meet, and I'd done an ultra-marathon with him just before I started this adventure. We'd shared many evenings together in Melbourne, discussing music and getting up to mischief. Flynn had been planning to come out and run with me for these final few days, and I felt a great sense of loss at not having him with me, either running alongside or just on the other end of a phone line. I wished I'd called, or sent him a photo from Twin Arrows, where I'd pictured us starting off together on an adventure into Navajo lands. He was and will forever be with me, here.

I missed my mum too, of course. She was one of the inspirations for this whole journey. I felt her with me in a very real way, and whenever times had been tough I'd done my very best for her.

I'd hoped that the whole of the fifth leg would be a lap of honour. Instead, it had become the hardest and most prolonged ordeal of all. In terms of authenticity, it couldn't have been more faithful. At the point when he turned around to face his followers and told them that he'd had enough, Forrest wore the look of a truly beaten, broken man. No wonder Tom Hanks won that Oscar – if you'd told me suddenly that I needed to do another thousand miles, I'd have crumbled. I was done. Happy, but done. The distance remaining was 26.2 miles, a marathon – my 600th. Tomorrow was the day.

On the bed of the Monument Valley Inn, I laid out my kit for the day. The problem with getting to this point a little bit quicker than Forrest's three years, two months, fourteen days and sixteen hours was that it was now the height of spring, and considering we were in Arizona, that was as hot as it usually got for an

Englishman. There was no way I'd be wearing a two-layer rain poncho and the track bottoms that you see Forrest wearing in the final scenes, so I combined my gear from the whole run: the red shorts I wore across the pretend Mississippi (the Harbor River in South Carolina); the Tennessee socks gifted by the local cycle shop in Cookeville; the Marshfield High Pirates Cross Country team shirt from Pre's home track in Coos Bay; the fluoro Nike Pegasus courtesy of Jonny Wildhorse. Of course, to top it all, the same red Bubba Gump cap – now more of a sun-bleached pink – that I'd placed on my head a year and a half ago, just after my last haircut, the number 24, high an' tight.

Early in the morning, I whispered a farewell to Nadine and little Bee. I'd have the coming years to ensure that Bee made far more of a difference than I'd ever do. I hoped that maybe the photos and stories I'd have to tell of this incredible land and the people that populated it would inspire her to do just that.

I headed to the parking lot, where Raimey and the Bens stood in the half-light, ready to escort me to my starting point. Chandler, whom we met in a burger bar a couple of days ago and who wanted to run with me today, was there. Jona too. I took one last look over my shoulder at the two rocky giants and kicked my feet into the gravel for the last time at the beginning of a day. It was time to run.

Chandler, about whom I'd had doubts about lasting the pace given his preferred discipline of powerlifting, proved me wrong and was as good as his word, while Jona, as expected, took it in his easy stride. By the time we met with the crew, several more local Navajo people had joined, alongside Paul Duffy, my school friend who'd joined me on the road during my first physical cracks in Houston and later helped us so much in San Francisco. All told, there were about twenty people in the crew now. There was a bit of a party atmosphere in town, as I did my final Lean

on the state sign of Utah, holding baby Bee in my arms as we entered the Beehive State.

Rest stops were brief, like an aid station in an ultra, pausing only to take on necessary fluids and share a few words, as the aim was to run this last stretch in one go. During one stop, a lone runner made his way towards us and cried out in a French accent, 'What is going on? What is this?'

Before I had the chance to explain, Chandler did the job. 'This is Forrest Gump, man. He's run five times across America to do the run and we're going to the point where he stopped in the movie!'

'Hang on, for real? Wait, I have to tell my wife. I get to meet Forrest? Amazing. I will run with you.' Our new friend was Garmin France's Jonathan Metge, who just happened to be a good ultrarunner himself.

As we prepared to set off, a vehicle pulled onto the gravel and out stepped a man dressed for an occasion far greater than a run down a desert highway. Long, plumb-straight black hair cascading down onto the collar of his blindingly white shirt, his black trousers, leather boots and waistcoat were topped off with a bolo tie and flashes of silver and turquoise on his hand-crafted rings. In his hand was a Navajo double flute. 'My name is Travis,' he said. 'Would you allow me to play you some music, to guide you on your way?'

I'd wondered a few times what the soundtrack of my final day would be. Thanks to the company I was in, I'd had no need for my music today, so Travis's hauntingly beautiful and dramatic rendition of a Navajo ceremonial was all I needed to float with me as we set off for the run after our final break. By way of compromise, as I drew close to the final mile, I led the group in a rendition of 'Highway to Hell', though I was in running heaven.

I was running with Chandler, Jona and Paul, and we were joined by Ethan and Austin from Historic Brewing in Flagstaff

and a couple of their pals, as well as many local Navajo. It made the run easy and relaxed. Children would join for small stretches before running out of breath, but reappear a mile down the road for more.

A mile from the end, I stopped one last time, turned my top around to present a solid black front, pulled on those black track pants and the two coats I'd combined to create the closest thing I could to Forrest's raincoat, and finally the Cortez. Once more unto the breach, dear friends. I was sweating profusely before I set off and it was only going to get hotter from here. Our group had swelled to around thirty, who wouldn't be stopping, out of breath or not, until I did. Tailing us were two Navajo fire trucks. Cars raced past, tooting their horns with waves and shouts.

The local Utah Highway Patrol were next, sirens blaring: 'GET OFF THE ROAD! You're causing an obstruction!'

I indicated that I was already over the white line and off a road that we were entitled to be on anyway. The patrol car turned and sped to where Ben was filming the highway snake. I imagined Ben would be thankful that he'd applied for the relevant permits. He was an extremely diplomatic and polite guy, but I still felt nervous it might all go wrong. 'Ethan, man,' I said. 'We're in trouble. This is going all kinds of wrong.'

No reply came as the officer sped ahead for the final half-mile to what looked like a hell of a gathering at the Point: lots of cars parked up the side of the road, a camera crew and a huge crowd of a hundred or more people.

I watched him anxiously, but from behind me one of the throng said, 'He ain't gonna stop nothing, man. This is Navajo country. He'll see that.'

We were on the final approach. We passed Travis, beating out a tribal rhythm and chanting to the heavens, while I fumbled with my waist pack to check I had my cargo and pushed it

around the back, out of view. To the left of the road was Jenny, with Mathew's sister Iris standing on the roof, filming our approach. The patrol car was now parked to the side of the road, seemingly off-duty.

I'd worked out the location where Forrest would have stopped by cross-referencing the scene with satellite images. Ben had urged me to go to the site beforehand and put markers on the road and check angles, to give the filming of the scene a 10 per cent chance of coming off, but I knew I couldn't allow myself to catch sight of those famous rock formations of Monument Valley until it was real. What was more important to me, the shot or the run? I accepted the fact that I was unlikely to win six Oscars.

I looked down at my feet and then at the group gathered behind Jenny, including our patrolman, who'd held back oncoming traffic. There too, smiling and holding the handle of baby Bee's buggy, was my Jenny. I would come back to her, but first I had to say something. I'd known what I was going to say for years. Slowly turning around, I paused and looked at the group gathered behind me.

Liv spoke up. 'Quiet, quiet! He's gonna say something!'

I looked down 163, beyond the gathered runners to Eagle Mesa, Setting Hen, Brigham's Tomb, Stagecoach, Sentinel and the Mittens, the ancient sandstone mesas familiar to millions. They rose from the desert floor into the haze of wispy clouds and azure sky, forcing a pause longer than the one I'd intended.

'I'm pretty tired. I think I'll go home now.'

Slowly, accompanied only by the noise of the wind, I trudged back to the group, who parted to allow me to walk through them.

'Now what are we supposed to do?' came a mock-aggrieved voice.

'Only joking – not done yet!' I replied, to much confusion. This was not part of the plan, but I only had eyes for Nads. I

walked up to her and said, 'Nads, I just want to say thank you, for being so amazing and for all your support ...' My voice was cracking with every word as I crouched down, partly out of tiredness but mostly out of tradition, onto one knee.

She looked at me awkwardly. 'Rob, this is weird.'

I reached into my waist pack and retrieved the contents of the top-secret package. It was a small grey box.

'Oh, my God. Don't you dare, don't you dare!'

I opened it and held it up for her. 'Will you marry me?'

'Yes. Yes!' she replied, hand over her mouth. Wild cheers erupted all around us. To my relief, she was in the mood to help me get back up again. I had just run a marathon, after all. She squeezed me so hard I could have popped. We was like peas and carrots.

I turned to face all those present and melted into a hundred embraces, handshakes and exclamations, before being handed a lovely card wishing me well for the future, with an old-style bottle of Dr Pepper, which was guzzled like the champagne that follows a Formula One race. I posed for an endless stream of photos in the middle of 163 with everyone who wanted one. I never wanted it to stop.

Eventually, the crowd dispersed – much to the highway patrol's relief. Travis was still with us, and he ventured over to baby Bee and asked Nads if he could give her a Navajo blessing to guide her wherever she would venture.

Like a victor reluctant to leave the scene of a triumph long after the crowds had gone home, I had a whisper in my ear that we should be thinking about doing the same. That was okay by me. The adrenaline had faded. Baby Bee gave out a cry, and I got it. I was going to be pretty tired now. For quite some time.

Back in Flagstaff that evening, I tried to grasp what I'd just achieved. It was too large to get a handle on, and the slow

413

realisation would drip like a tap over the coming days and months. Over eighteen months of my life, I'd traversed deserts, forests and farmlands, salt flats and mountains, ghost towns and some of the greatest cities in the world. I'd slept rough, in shacks, sheds and hostels, and stayed with countless kind and generous people who had shown me their trust. I'd encountered a forest fire, blizzards, run in relentless rain and searing heat; I'd coped with sickness and more injuries than I could count; I'd been eaten by mosquitoes and worse; I'd had near misses with aggressive drivers, been actually hit by an inattentive one, avoided a bear and a galloping bull moose. I'd jumped fences, fallen down hillsides, stumbled through razor-sharp bushes, waded across rivers. I'd been chased by people and dogs, and run with vultures circling overhead. I'd sung, I'd danced, I'd cried. I'd become a father.

I'd met rich and poor, all races and backgrounds, young and old, and most were angels walking the same roads as me. I'd run through a country riven by political division, boiling over on the airwaves, with a huge wealth gap and many miles left to walk on the journey Martin Luther King spoke of. Whether people endorsed the slogan 'Make America Great Again' or not, I'd seen time and time again that people wished to be kind and generous, to make a difference.

John McCain's words in the final letter he would ever write were: 'Do not despair of our present difficulties, but believe always in the promise and greatness of America'. So, as people melted away to their homes and workplaces, talking of the day they saw Forrest Gump finish his epic run, I had complete faith in their ability to bring love, joy and fortune to those in their care, to those they met and to the US of A as a whole.

Throughout the whole of my journey, I had endeavoured to make good on my mum's request: 'Do one thing in your life that makes a difference.' I always was a momma's boy, just like

Forrest, so I sure hope I made her proud. I hope to, still. In this regard, one event, very small yet tremendously moving, comes back to me again and again. It was so special and profound to me that I've saved it for the very end.

One morning, I was rolling along with Pramsolo, paying little heed to my surrounds, when I heard a voice to my left. It was a mother, trying to catch my attention. Her son had seen me and wanted to do something to help me out.

'Have you got a baby in there?' he asked.

'Ha! No. Just stinky shorts and other things.'

'We made these in church for people who don't have much. You can have this one.' He handed over a ziplock bag which contained, among other things, a few toiletries, some biscuits, a tin of tuna and a very delicate comb. Too delicate for my entangled mess, but perfect for a baby. It's now baby Bee's comb, so I'm reminded of that boy's act of generosity every day.

America, I thank you from the top of my cap to the bottom of my worn-out soles. I hope a few of you will have the courage to do something crazy for the greater good, and for the rest, just think how you can 'Be More Forrest' in your day-to-day life.

The more miles you follow in a man's footsteps, the more you understand his journey. Maybe if you follow for long enough, you almost become them. With every sunrise, state line, continental divide, ocean and sunset, I realised that, among his many virtues, Forrest was one hell of a philosopher … but that's a story for another time.

Forrest Gump was a man who didn't judge anyone on the basis of background, intelligence or race, because, frankly, what's made you or where you've come from doesn't matter. What does matter is where and what you are now and where you hope to be. Forrest went about his business purposefully and with love in his heart, whether serving with distinction, becoming a shrimp

boat captain or being the best father he could be. He got there without hurting or upsetting people along the way. Now, isn't that something? You can do it too – we can all do it. Smile more, help more, do more, be more. If we all did that, the world would be a better place.

'Be More Forrest'. Now there's a slogan for you.

BECOMING FORREST: FASCINATING (I HOPE) FACTS AND STATS

Distance run: 15,621 miles

Days of running: 422

Pairs of shoes: 33

States crossed: 43

Oceans reached: 5

Most-consumed fuel:

> **Solid:** Ham salad and Catalina dressing sandwiches, donuts, hot dogs
>
> **Liquid:** Dr Pepper, craft beer, oatmeal protein shakes
>
> **In case of emergency break glass:** Red Bull
>
> **Soul:** American radio, the kindness of strangers, the desert and mountain air

Coolest sights: Shrimpin' boats, the Joshua Tree(s), Santa Monica Pier, the finish line in Boston (twice), the lighthouse, people's smiles when they realised what they thought was happening was happening, that clear mountain lake, the sight of friends and family in Monument Valley

Best songs of the trip: 'Go Your Own Way', Fleetwood Mac; 'Born to Run', Bruce Springsteen; 'Highway to Hell', AC/DC; 'Where the Streets Have No Name', U2; 'I Am the Highway', Audioslave (Spotify search: 'Forrest

Gump – The Long Run' for the tune of the day for EVERY day)

Best animal sightings: the bear in Glacier, the moose in Idaho, every free bird, my South Carolina dolphin, every dog that tried to chase/lick/kill/steal from me

Most dangerous near-misses: the Baton Rouge Mississippi crossing, the Tennessee jack-knife followed by kitchen knife, not getting a ticket for the U2 concert in advance

Shouts of 'Run, Forrest!': at least 500

Boxes of chocolates: 2

ACKNOWLEDGEMENTS

Or, as I like to call it: Time for Heroes

Someone's momma once said:

'Life is like a box of chocolates. You never know what you're gonna get.'

I didn't have a clue what I was gonna get as I set off from the Bragg Mitchell Mansion, apart from *tired* – yet here we are. Almost 16,000 miles in the bag and now, it seems, a book! I hope you've enjoyed what you got and if you did, I'm sure you'll be almost as grateful as I am to the following people.

I'm not one for telling a story in a hundred words when I could use a thousand. Indeed, this book is a diamond prized from a whole heap of crown jewels. Two fine individuals took up their hammers and chisels to shape what you now hold. Firstly, James Millington, a man who maybe had the closest experience to looking out at a continent with the ocean at his back and a big job at hand (a draft almost 400,000 words in length). Secondly, Steve Burdett, who took the load once James had given his all. Gentlemen, I salute you!

I'd also like to thank my small but perfectly formed team of proof-readers, the Two Chrises, Beyga and Waugh, who told me I might be onto something. Seems you were right!

A book is nothing if it gathers dust and so to Peter Silcock, free from inspiring me to try and beat you at high school cross-country, you handed the match to Sarah Moorhead (genius author of futuristic crime fiction) who lit the touchpaper on a ginormous HarperNorth shaped rocket that went off like the Fourth of July. To Jon, Alice, Megan, Gen and all the lovelies mentioned at the end, from *the* Tweet to the huge amount of work you've put in – thank you for giving this Northern soul a platform to share my story, as well as the stories of the wonderful people I met and the ones I already knew and loved, in whatever sense. I hope I wasn't too much trouble.

I guess maybe there is just too much kindness in America to fit into a single book. For those of you mentioned in the preceding pages, I want you to know that writing your names was accompanied by a rush of love when I closed my eyes and thought of you. But as you've already had your moment in the sun, I'd like to thank some others, without whom the run would have never been the same:

- Tex and Daryl Rhys Jones, my long-suffering US admin angels and lifelong friends.
- Brad and Karen (and Dottie), from Glacier National Park to your home in Marietta and the day I saw your Airstream head over the horizon in a plume of kindness, you were immense. To quote the big man in our Stagger Lee's dive bar farewell evening: 'I might be wrong, but I don't think so.'
- Mike Judge. It ain't every day you get introduced to an inspiration. Cheers for looking after Pramsolo and the rest of the memorabilia – still! You and the Easleys were my Panhandle holder-togetherers.
- Carolyn and Forrest: Your enthusiasm as providers of the greatest smoothie I'll ever drink, hot tub-unveilers,

insight-givers and conduit to the Grand Bobidians will endure.

- Jess Scutella and Jeff of Lavery's fame – my Gem City diamonds. Jess told me that 'Mileage without knowledge was bullshit' and pledged to turn the run into ink when we meet again, while I hope Jeff's significant other forgave him for his trip to the ATM and Lavery's merchandise stall.
- Jason Moore, Cheryl McWilliams, Frank Prall and Ron of A1 Storage: Cookeville's finest. Tennessee socks, my Grandfather Mountain shirt, cheap tyres, a haven for Jenny and provider of THE BEST smushy story that didn't quite make the book.
- The Spa Pacers, from Dave Hair, Charlie, Jamie and Larry. You made me a Descendant of de Soto *and* an honorary Pacer and that's every bit an honour to me as being State Champion.
- Don, Thelma and Joe Sheneman – my Morristown family. Crystal and Vanessa, my Wendy's angels, it was a pleasure and a deliberate move to pass your way twice.
- The Polichettes – Matt and Christy, Martha, Mike, Mark. My Utah Saints. Not many people got a chapter named after 'em! Matt and Kristy in Nashville, I didn't forget you either!

Finally, to all of you. The smilers, the chatters, the donors, from the Benjamin Club members to Blanca, the lady who offered me her umbrella, then returned with her penny jar in Gallup (no, I didn't take it), the couchsurfing hosts (you are the greatest, the life-savers!), the horn-honkers and wavers, the selfie-takers, dinner-makers and buyers, the likers, re-tweeters and sharers, the ones I ran miles with and for and anyone I raised a glass with. Don't worry, you're all in the Director's Cut!

I formed such strong bonds with so many of you. Some of you took us into your hearts so much you travelled across the ocean to join Nadine and I at our wedding. This will never be forgotten and we are both honoured to feel part of your families – as you are part of ours.

Finally, to our little family. Even a thousand words would fail to describe how much Nadine and Bee mean to me, the former being the reason I made it even half the distance and the Little Wonder inspiring me to be a better person every day. Thank you.

Do they have books in heaven? Would be pretty rubbish if they didn't, I guess.

Ta, mum. I hope I made you proud. You did me.